THE BIG BOOK OF
LAYOUTS

Editor

DAVID E. CARTER

COLLINS|DESIGN

An Imprint of HarperCollins*Publishers*

THE BIG BOOK OF LAYOUTS
Copyright © 2006 by COLLINS DESIGN and DAVID E. CARTER

HarperCollins books may be purchased for educational, business, or sales promotional use. For information, please write: Special Markets Department, HarperCollins Publishers, 10 East 53rd Street, New York, NY 10022.

First Edition

First published in 2006 by:
Collins Design
An Imprint of HarperCollins*Publishers*
10 East 53rd Street
New York, NY 10022
Tel: (212) 207-7000
Fax: (212) 207-7654
collinsdesign@harpercollins.com
www.harpercollins.com

Distributed throughout the world by:
HarperCollins*Publishers*
10 East 53rd Street
New York, NY 10022
Fax: (212) 207-7654

Book design by Designs on You!
Suzanna and Anthony Stephens

Library of Congress Control Number: 2006930941

ISBN-10: 0-06-114993-4
ISBN-13: 978-0-06114993-1

Printed in China by Everbest Printing Company through Crescent Hill Books, Louisville, Kentucky.

First Printing, 2006

TABLE OF
CONTENTS

First, you gotta get their

ATTENTION!

So, when a [pick one:]

- ☐ ART DIRECTOR
- ☐ VISUAL ARTIST
- ☐ GRAPHIC DESIGNER

starts a project, the beginning step is the layout.

To put it simply, a good layout attracts attention, then leads the viewer's eyes through the piece the way a conductor leads an orchestra.

Good layouts are the beginning of all effective visual communications, and bad layouts… well, bad layouts quickly kill the potential effectiveness of a piece faster than you can say "Ben Day."

This book has a single purpose: *to help designers create inspired layouts*. Within these covers, you will find more than 750 effective layouts. Each was selected for its ability to help you in the process of what I call "solitary brainstorming."

D. Carter himself

WHAT MAKES

DESIGN

UNIQUE

AND

IMELESS

?

DESIGN FIRM
A3 Design
Charlotte, (NC) USA
PROJECT
Unique and Timeless Design
DESIGNERS
Alan Altman,
Amanda Altman

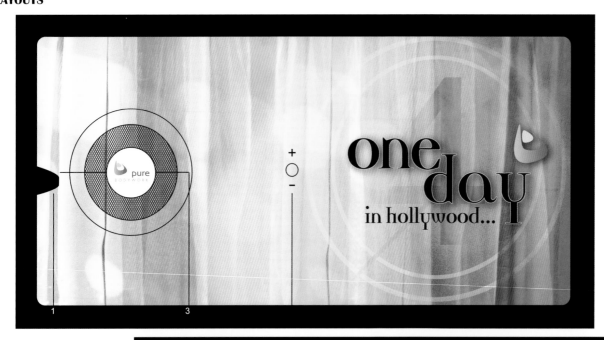

one
day
in hollywood...

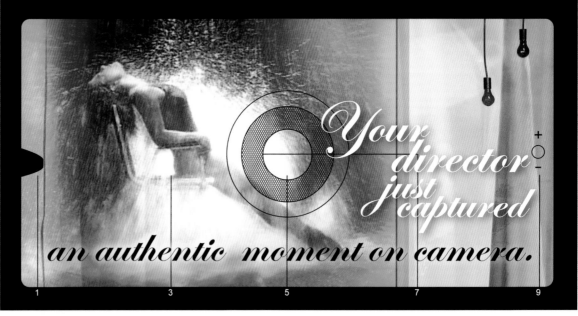

Your director just captured

an authentic moment on camera.

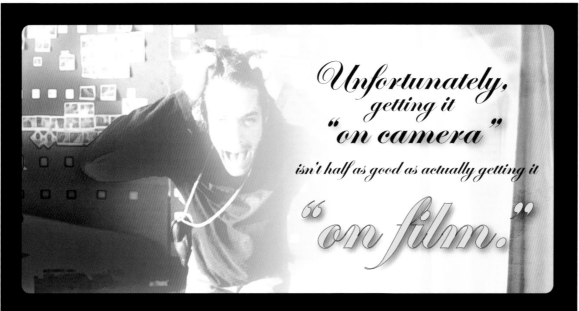

Unfortunately, getting it "on camera" isn't half as good as actually getting it "on film."

1

1 _____

DESIGN FIRM
JUNGLE 8/creative
Los Angeles, (CA) USA
CLIENT
Pure Body Works
CREATIVE DIRECTOR
Lainie Siegel
DESIGNERS
Lainie Siegel,
Justin Cram,
Gracie Cota
COPYWRITER
Scott Silverman

2_____

2_____

DESIGN FIRM
**M. Shanken
Communications, Inc.**
New York, (NY) USA

PROJECT
Cigar Aficionado's
Cigar Companion

ART DIRECTOR, DESIGNER
Chandra Hira

PHOTOGRAPHER
Bill Milne

3_____

DESIGN FIRM
Octavo Designs
Frederick, (MD) USA

CLIENT
National Association of
School Psychologists

ART DIRECTOR, DESIGNER
Sue Hough

3_____

DESIGN FIRM
Velocity Design Works
Winnipeg, (Manitoba) Canada
PROJECT
Child Find
CREATIVE DIRECTOR, ART DIRECTOR,
DESIGNER
Lasha Orzechowski
ILLUSTRATORS
Lasha Orzechowski, Eric Peters

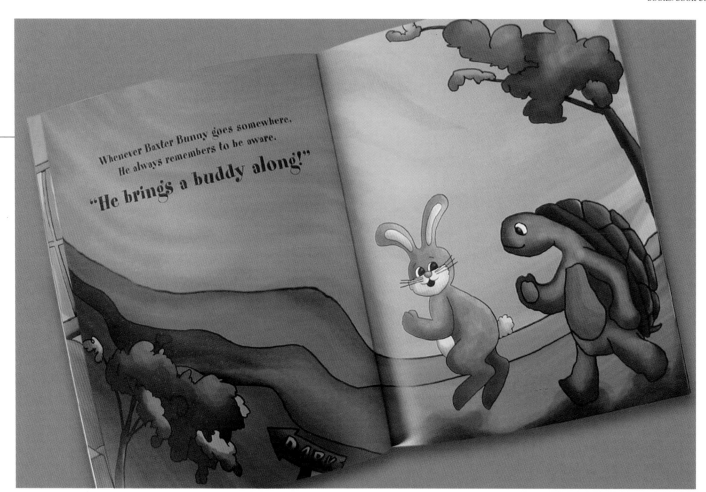

Whenever Baxter Bunny goes somewhere,
He always remembers to be aware.

"He brings a buddy along!"

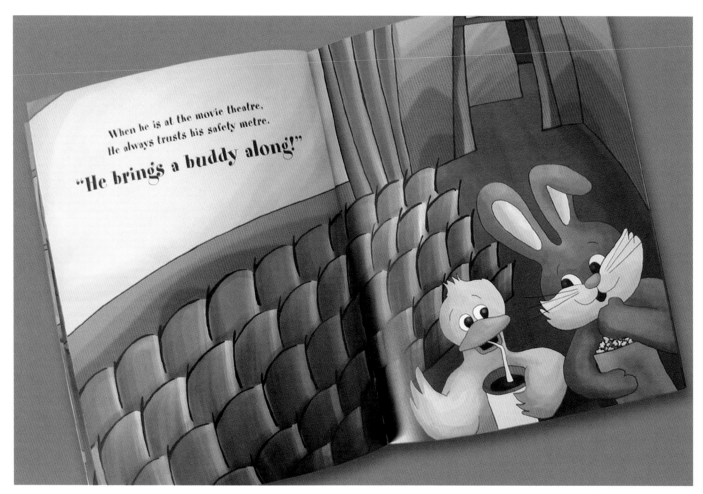

When he is at the movie theatre,
He always trusts his safety metre.

"He brings a buddy along!"

DESIGN FIRM
KROG, Ljubljana
Ljubljana, Slovenia
CLIENT
Presernova druzba, Ljubljana
ART DIRECTOR, DESIGNER
Edi Berk
COPYWRITER
Fran Levstik
ILLUSTRATOR
Hinko Smrekar

BRDAVS! BRDAVS!

Ko prideta na **DUNAJ,** je bilo vse mesto

ČRNO PREGRNJENO;

ljudje so pa klavrno lazili, kakor mravlje,

kadar se jim zapali mravljišče.

Krpan vpraša: »Kaj pa vam je, da vse žaluje?«
»O, Brdavs! Brdavs!« vpije malo in veliko, možje in žene.
»Ravno danes je umoril cesarjevega sina, ki ga je globoko v srce pekla
sramota, da bi ne imela krona junaka pod sabo, kateri bi se ne bal velikana.
Šel se je ž njim skusiti; ali kaj pomaga? Kakor drugim, tako njemu. Do zdaj
se še nihče ni vrnil iz boja.«

KRPAN

veli urno pognati in tako prideta na cesarski dvor, ki pravijo, da je neki silo
velik in jako lep. Tam stoji straža vedno pri vratih noč in dan, v letu in zimi,
naj bo še tako mraz; in brž je zavpila o Krpanovem prihodu, kakor imajo
navado, kadar se pripelja kdo cesarske rodovine. Bilo je namreč naročeno
že štirinajst dni dan za dnevom, da naj se nikomur in nikoli ne oglasi, samo
tačas, kadar se bo pripeljal tak in tak človek.

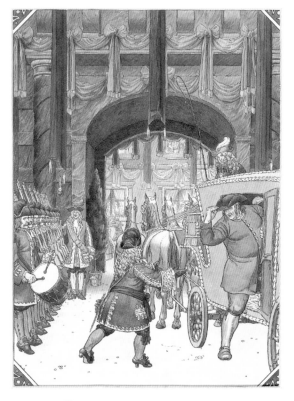

Krpan veli urno pognati in tako prideta na cesarski dvor.

V Notranjskem

stoji vas, Vrh po imenu.

V tej vasici je živel v starih časih

KRPAN,

močan in silen človek. Bil je neki tolik, da ga ni kmalu takega. Dela mu ni bilo mar; ampak nosil je od morja na svoji kobilici anglesko sol, kar je bilo pa že tistikrat ostro prepovedano. Pazili so ga mejači, da bi ga kje skrivaj zalezli; poštenega boja ž njim so se bali ravno tako, kakor pozneje Štempiharja. Krpan se je pa vedno umikal in gledal, da mu niso mogli do živega.

Bilo je pozimi, in sneg je ležal krog in krog. Držala je samo ozka gaz, ljudem dovoljna, od vasi do vasi, ker takrat še ni bilo tako cest kakor dandanes. V naših časih je to vse drugače, se ve da; saj imamo, hvalo Bogu, cesto do vsakega zelnika. Nesel je Krpan po ozki gazi na svoji kobilici nekoliko stotov soli; kar mu naproti prižvenketa lep voz; na vozu je pa sedel cesar Janez, ki se je ravno peljal v Trst. Krpan je bil kmetiški človek, zato ga tudi ni poznal; pa saj ni bilo časa dolgo ozirati se; se odkriti se ni utegnil, temveč prime brž kobilico in tovor ž njo, pa jo prenese v stran, da bi je voz ne podrl. Menite, da je Krpana to kaj mudilo kali? Bilo mu je, kakor komu drugemu stol prestaviti.

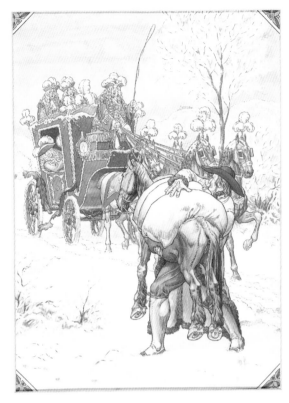

Prime brž kobilico in tovor ž njo, pa jo prenese v stran, da bi je voz ne podrl.

TO IZREČE ...

URNO

zasukneta vsaki svojega konja in

zdirjata si od daleč zopet nasproti.

BRDAVS

visoko vzdigne meč, da bi že v prvem odsekal sovražniku glavo; ali ta mu urno podstavi svoj kij, da se meč globoko zadere v mehko lipovino; in preden ga velikan more izdreti, odjaha

KRPAN

z male kobilice, potegne Brdavsa na tla, pa ga položi, kakor bi otroka v zibel deval, ter mu stopi za vrat in reče:

»No, zdaj pa le hitro izmoli en očenaš ali dva, in pa svojih grehov se malo pokesaj; izpovedal se ne boš več, nimam časa dolgo odlašati, mudi se mi domu za peč; znaj, da komaj čakam, da bi zopet slišal zvon, ki poje na Vrhu pri sveti Trojici.«

To izreče, pa vzame počasi mesarico ter mu odseka glavo, in se vrne proti mestu.

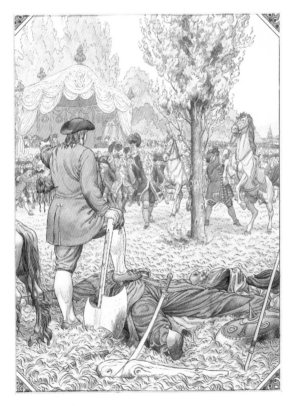

To izreče, pa vzame počasi mesarico ter mu odseka glavo.

GöTTERSPEISEN

DESIGN FIRM
Barbara Spoettel
New York, (NY) USA
CLIENT
Barbara Spoettel
ART DIRECTOR, PHOTOGRAPHER
Barbara Spoettel

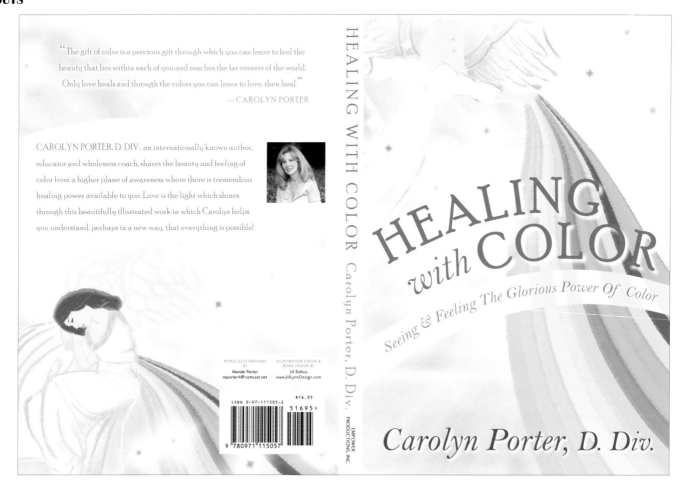

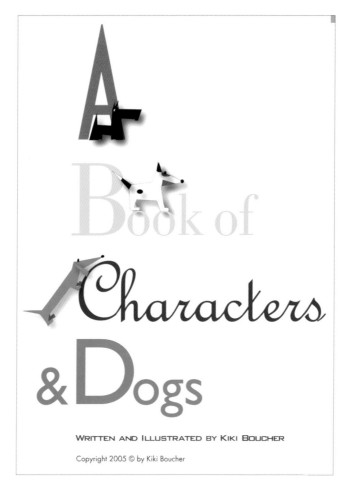

2_____

1_____
DESIGN FIRM
Jill Lynn Design
Jersey City, (NJ) USA
CLIENT
Empower Productions, Inc.
ART DIRECTOR, DESIGNER
Jill Balkus

2_____
DESIGN FIRM
**Acme
Communications, Inc.**
New York, (NY) USA
PROJECT
A Book of Characters & Dogs
DESIGNER
Kiki Boucher

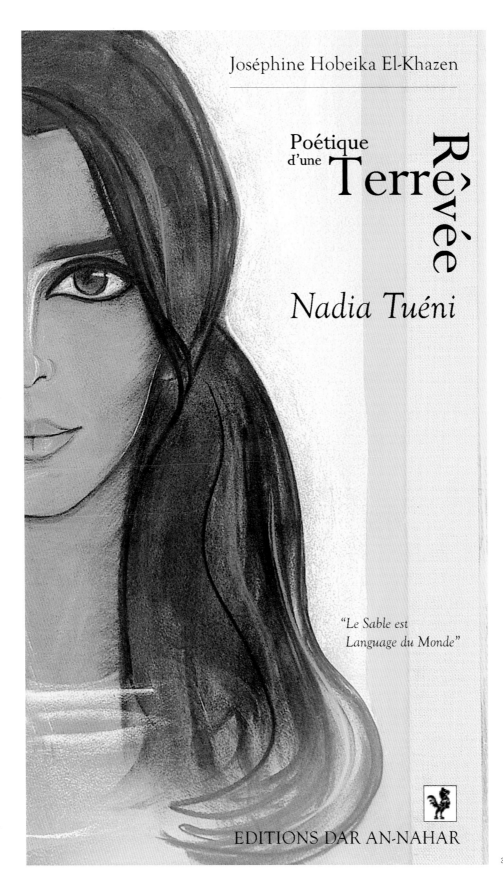

Joséphine Hobeika El-Khazen

Poétique
d'une Terre Rêvée

Nadia Tuéni

"Le Sable est
Language du Monde"

EDITIONS DAR AN-NAHAR

3_____

DESIGN FIRM
Raidy Printing Press
Beirut, Lebanon
CLIENT
Dar An-Nahar
DESIGNER
Marie-Joe Raidy
PAINTER
Cici Sursock
PRINTER
Raidy Printing Press

3_____

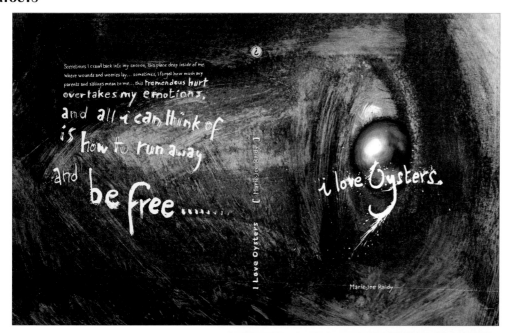

Sometimes I crawl back into my cocoon, this place deep inside of me
where wounds and worries lay... sometimes, I forget how much my
parents and siblings mean to me... this **tremendous hurt**
overtakes my emotions,
and all i can think of
is how to run away
and be free........ [Marie-Joe Raidy]

i love Oysters.

I Love Oysters

Marie-Joe Raidy

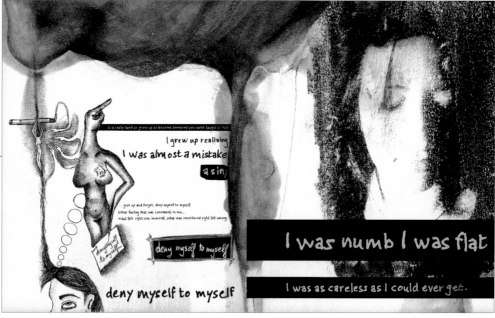

it is really hard to grow up to become someone you were taught to hate

I grew up realizing
I was almost a mistake
a sin

give up and forget, deny myself to myself
bitter feeling that was constantly in me...
what felt right was immoral, what was considered right felt wrong.

deny myself to myself

deny myself to myself

I was numb I was flat

I was as careless as I could ever get.

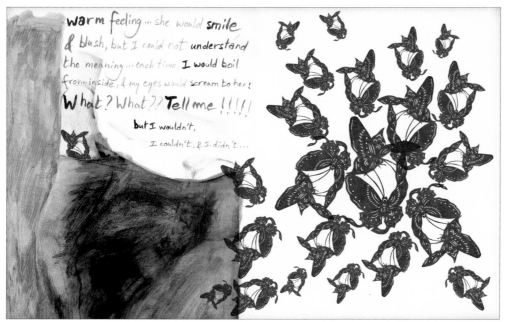

warm feeling ... she would **smile**
& blush, but I could not **understand**
the meaning ... each time, **I would boil**
from inside, & my eyes would **scream to her!**
What? What?? Tell me !!!!!
but I wouldn't,
I couldn't, & I didn't...

DESIGN FIRM
Raidy Printing Press
Beirut, Lebanon
DESIGNER, ILLUSTRATOR, EDITOR
Marie-Joe Raidy
PRINTER
Raidy Printing Press

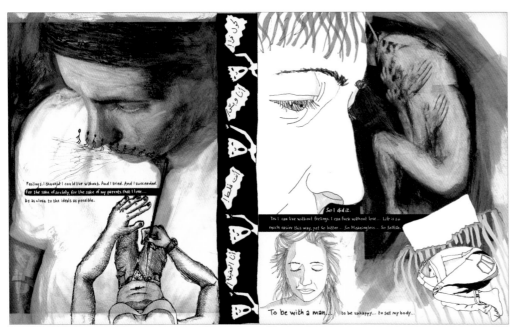

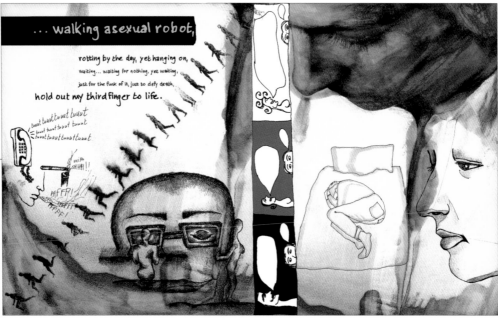

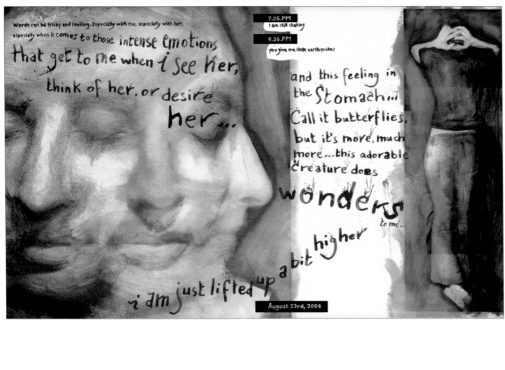

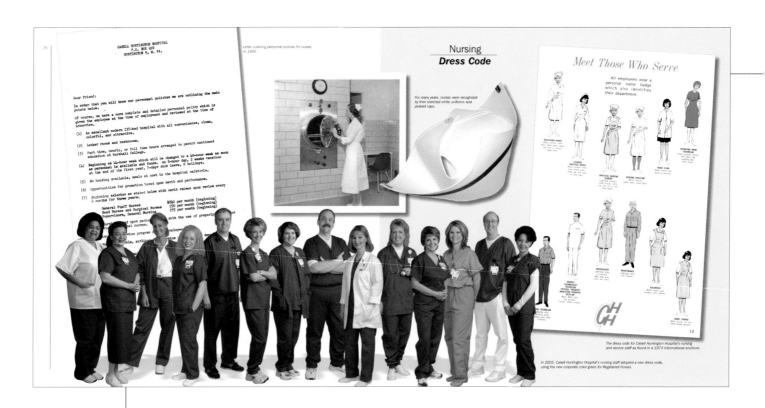

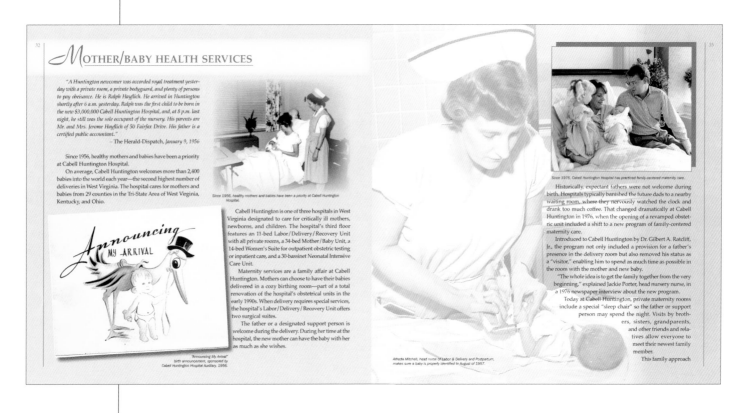

DESIGN FIRM
Designs on You! for
London Books
Ashland, (KY) USA
PROJECT
Fifty Years of Caring

CREATIVE DIRECTOR, EDITOR
Doug Sheils
DESIGNERS
Suzanna Stephens, Anthony Stephens
DESIGN CONSULTANT
Rose Henson

COPYWRITER
James E. Casto
PHOTOGRAPHERS
Rick Lee, David Fattaleh, Rick Haye,
Rose Henson, Kathy Cosco, Doug Sheils,
others

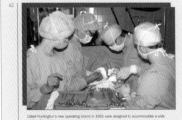

Cabell Huntington's new operating rooms in 1992 were designed to accommodate a wide variety of surgeries.

smaller rooms; equipment was stored in the halls; there were no windows, so you couldn't see what was going on outside."

At the request of Dr. Earl J. Foster and many others, skylights dotted the ceiling of the new suite and a large window offered a view of the outside world.

"You really have to see the 'before' before you can appreciate the 'after,'" said Smith. "The rooms had to be designed to be flexible and accommodate a large variety of surger-

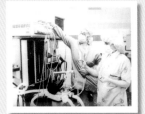

Two surgical nurses prepare for an operation in 1992, shortly after the new surgery suite was completed.

ies. This will easily take us into next century and even well beyond that."

Dr. Foster, chairman of the committee that oversaw design of the new suite, hailed the decision to bring hospital employees and doctors in on the planning.

"We gave every specialty an opportunity to have input into the design—everybody from surgeons to janitors," Foster said. "The workplace should be designed by the grunt who works there, and that's what was done here."

Because of that foresight, people were very happy with the new suite, Foster said.

"The biggest single item for us is the big rooms—a lot of times, you have the luxury of space and people aren't tripping over each other," he said, even though some operations demand enough high-tech equipment to almost fill the operating room. "Simple things like a window to look out of, skylights, a drinking fountain—all improve morale."

Today, with a modern facility, the latest high-tech equipment and a highly trained and capable staff, Cabell Huntington Hospital is prepared for virtually all surgical procedures—from the most routine operations to the most delicate neurosurgery.

In addition, Cabell Huntington Hospital's close association with the Marshall University Joan C. Edwards School of Medicine Department of Surgery has helped it develop into the region's leader in trauma surgery.

"The trauma service basically revolves around the trauma surgeon," said Dr. David Denning, chairman of the Department of Surgery at the Marshall University Joan C. Edwards School of Medicine. "You couldn't have any trauma service of any level without

Dr. David Denning

the participation of the general surgeon. He's the one that responds to the emergency situation, and takes care of the patient when he or she is in the emergency room and the hospital."

According to Denning, Cabell Huntington's general surgeons are backed by a team of surgical subspecialists and residents in orthopedic, plastic, maxillofacial, pediatric, neurosurgical, and other specialties—all of whom work together to provide the community with comprehensive trauma care.

"You couldn't have any trauma service of any level without the participation of the general surgeon."

—Dr. David Denning
Chairman, Department of Surgery
M.U. Joan C. Edwards School of Medicine

The Future of *Surgery*

In recent years, the use of scopes—thin, flexible, fiber-optic viewing instruments—has revolutionized the world of surgery, and in 2003 Cabell Huntington moved to take advantage of this new trend. The hospital opened a tenth operating room, designed with the latest technology for endoscopic surgery, and added a third endoscopic suite, designed to accommodate more sophisticated gastrointestinal procedures.

From endoscopic examinations of the gastrointestinal tract to leproscopic surgery in the abdomen and arthroscopic surgery in the joints, new scopes give surgeons the ability to view internal structures of the body and provide treatment without making large, open incisions.

"The future of surgery is in endoscopy or minimally invasive surgery," says Roger Haught, RN, MBA, CNOR, surgical services director at Cabell Huntington. "Endoscopic surgery uses a less invasive approach to surgery using lenses, cameras and small, fine instruments to do surgery through ports in the skin. It lessens the time in the hospital and results in less trauma on the patient."

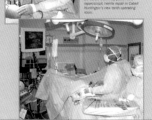

Dr. Gerald McKinney performs a laparoscopic hernia repair in Cabell Huntington's new tenth operating room.

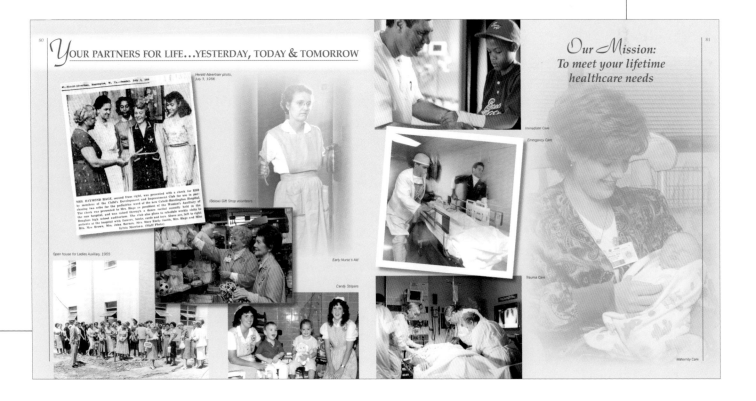

Y OUR PARTNERS FOR LIFE…YESTERDAY, TODAY & TOMORROW

Our Mission: To meet your lifetime healthcare needs

Open house for Ladies Auxiliary, 1955

(Below) Gift Shop volunteers

Early Nurse's Aid

Candy Stripers

Immediate Care

Emergency Care

Trauma Care

Maternity Care

American City

Detroit Architecture
1845–2005

Text by Robert Sharoff
Photographs by William Zbaren

1_____

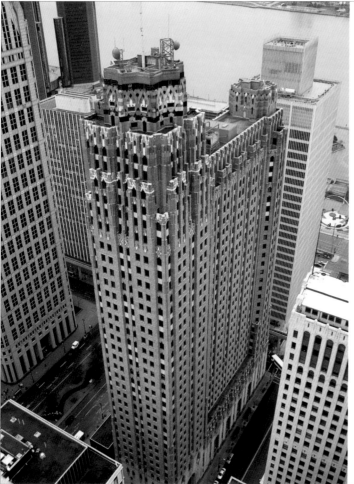

FORT WAYNE

6053 W. Jefferson Avenue
Lieutenant Montgomery C. Meigs
1845 – 50

In its early years, Detroit had many Federal-style structures, and this is one of the few remaining. Built to counter a British invasion that never materialized, Fort Wayne is both striking and a little beside the point. The imposing star-shaped ramparts — designed along lines laid down in the seventeenth century by French military engineer Sebastien Vauban — were obsolete by the time the fort was built. Still, the barracks building, with five symmetrical Federal-style stone bays, is impressively severe and monumental. Montgomery Meigs went on to have a long, illustrious career as a military officer and an engineer. In addition to serving as quartermaster general of the Union Army during the Civil War, he supervised the construction of the dome of the Capitol Building and chose the site for Arlington National Cemetery.

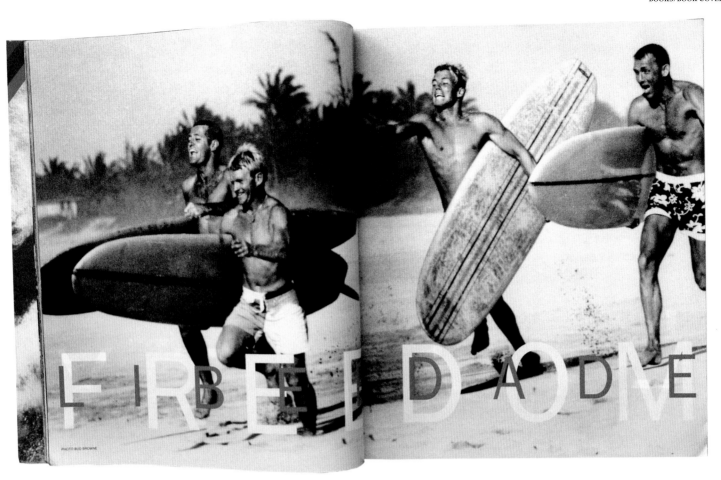

FREEDOM

PHOTO BUD BROWNE

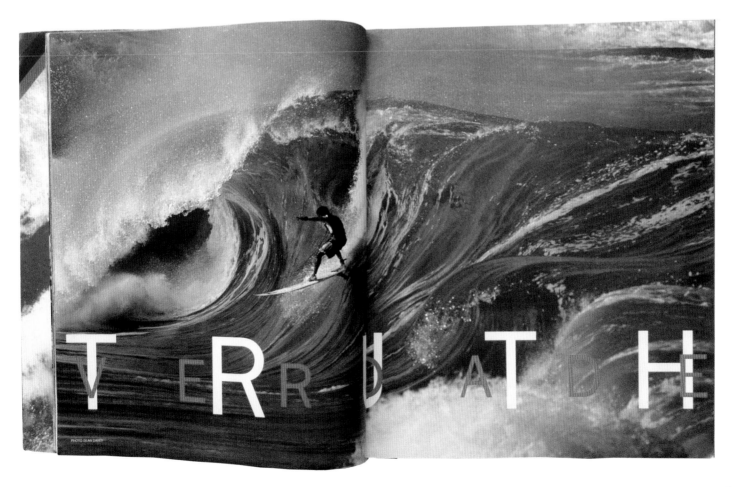

TRUTH

PHOTO SEAN DAVEY

NORTHERN INDIANA
LAKES
MAGAZINE

PEOPLE + LIFESTYLE + HOME + OUTDOORS

THE OFFICIAL PUBLICATION FOR THE GOOD LIFE IN NORTHERN INDIANA

2006 media kit

LAKES

MISSION

Northern Indiana LAKES Magazine, the Official Publication for the Good Life in Northern Indiana, celebrates the people and places ... past and present ... of the Hoosier Lakes Country.

Northern Indiana LAKES Magazine is devoted solely to the people, homes, lifestyles and outdoor activities of the area we love. Every page is suffused with rich features and photography on travel, history, personalities, food, folklore and fun.

CONTENT

Northern Indiana LAKES Magazine is our area's premier lifestyle publication. *Northern Indiana LAKES Magazine* helps our readers experience the very best that Northern Indiana has to offer by showcasing outstanding homes, outdoor adventures on land and water and glorious spectacles of seasonal color. Every other month *Northern Indiana LAKES Magazine* fills its pages with the best in home and interior

design, recreation, music, festivals, businesses, sports, towns, shops, restaurants, people and culture that embody a well-led lake life. Combining award-winning editorial, stunning photography and compelling special features, *Northern Indiana LAKES Magazine* provides a superb review of Northern Indiana's rich history, exposes its extraordinary beauty and celebrates the quality of life that has brought calm and reflection to generations of lake enthusiasts.

Upscale without being uppity, the hallmarks of *Northern Indiana LAKES Magazine* are editorials that will warm your heart, stir a memory or motivate you to action. In the process we make a significant difference in our reader's lives- those that live here, those that wish they did and all those who visit regularly.

READERS

A must read, *Northern Indiana LAKES Magazine* is the premier bi-monthly showcase for our area's retail and service businesses, offering intimate and cost-effective advertising messages to an active, upscale audience.

THE OFFICIAL PUBLICATION FOR THE GOOD LIFE IN NORTHERN INDIANA

editor's letter

WHEN I WAS A CHILD DAD would load the family into the old Rambler station wagon for Sunday drives together. We would often end up near a quiet, secluded lake where my brother Mike and I would hunt for arrow heads or skip stones across the water. It was as magical a moment as any child could ever hope.

Of course, we were not alone in our reverie. For generations Hoosiers have been "going to the lake." And somewhere along the way the notion of "going to the lake" became synonymous with "having a good time." Whether large or small, plain or fancy, calm or crowded, "the lake" has always been a sanctuary, a place of relaxation and comfort that is a million mental miles away from the big ... or not so big ... city.

While admittedly upscale, LAKES Country is hardly uppity. "The Lake" is, without question, one of the few places where one can have a well-made martini while wearing flip-flops. Or enjoy a local micro-brew while casting a line.

It is there we gather with those we love; where we steal away to be alone with our thoughts in times of struggle. It is there we rest and restore world-weary souls. It is there we are refreshed and renewed. It is there we reflect and hear the ancient echoes of ancestors. Little wonder, then, that "the lake" ... whichever lake one may choose ... has always been considered a place of majesty, wonder and, yes, magic. Truly, LAKES Country is a wondrous place.

It is the goal of all at *Northern Indiana LAKES Magazine* to create a rare and unbreakable bond between those of you who know what it means to live, work and play in LAKES Country, and those of us who endeavor, however vainly, to adequately reflect it.

In a place that embodies such diversity, with so many communities, lifestyles and attitudes, it would be impossible to represent them all in any one issue. Thankfully, we look forward to exploring each story in more detail in future issues. Along the way we hope to discover new stories, relationships and friends.

My father and his Rambler are both gone now; my memories of LAKES Country, however, are not. I am pleased to note that there are always new roads to see and different vistas to explore. I invite you along for the ride. I'm sure you'll enjoy the trip.

Warmly,
GREG PERIGO
Editor-in-Chief + Publisher

DESIGN FIRM
Studio D
Fort Wayne, (IN) USA
PROJECT
Lakes Magazine
ART DIRECTOR
Holly Decker

Our readers step inside everything from restored cabins and remodeled Victorians to grand lake-front estates and new log homes, and meet the designers, builders, suppliers and crafts people who created them. *Northern Indiana LAKES Magazine's* affluent readers own homes with average values exceeding $300,000 and enjoy annual household incomes of more than $150,000, resulting in high levels of discretionary spending. In addition, these readers have a passion for causes that are reflected in their generous support of charitable giving.

Northern Indiana LAKES Magazine's readers are at the pinnacle of the Northern Indiana demographic. They are well-educated, affluent and influential and have an active interest in their lake homes, neighborhood associations and communities. *Northern Indiana LAKES Magazine's* readers are exactly the consumers that will respond to your advertising message.

DEMOGRAPHICS

Northern Indiana LAKES Magazine is a subscriber-based publication. Its readers are:

Affluent: Their annual household incomes exceed $150,000 and they live in Lakes Country homes with average values exceeding $300,000.

Educated: 89% have college+ educations.

Female: 60% of *Northern Indiana LAKES Magazine* readers are female.

Rooted: Readers have spent an average of 15 years in Lakes Country.

Active: Nearly 90% participate in civic activities through volunteerism or philanthropy.

In addition, our readers are the opinion shapers of Lakes Country.

· 77.1% are C-Level Executives.

· 39.7% are self-employed or own their own companies.

· 81.2% serve on at least one company Board of Directors.

· 84.9% serve on at least one Board of Directors of a local institution or organization.

· 50% serve on at least three Boards of Directors of a local institution or organization.

Source: Johnson Smith Group, Erdos & Morgan Survey

LAKES

EACH ISSUE PROVIDES

· **Yada Yada Yada:** Intereresting people worth meeting. Sometimes famous, frequently not ... but always, always interesting.

· **Scrapbook:** Your photos of the Lakes Country social scene.

· **Lake Life:** Our section of news and notes from out and about Lakes Country.

· **Diversions:** Your guide to arts, entertainment, events, music, museums and more.

· **Local Flavor:** From down-home and casual to upscale and elegant, Northern Indiana's most comprehensive guide to restaurants, fine food and fun recipes.

· **Of House + Home:** Our peek inside some of the most interesting homes in Lakes Country.

· **P.S.:** The last word in Lakes Country in words and pictures.

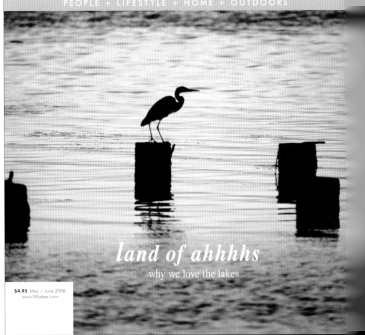

NORTHERN INDIANA

LAKES

MAGAZINE

PEOPLE + LIFESTYLE + HOME + OUTDOORS

land of ahhhhs

why we love the lakes

$4.95 May + June 2006
www.NILakes.com

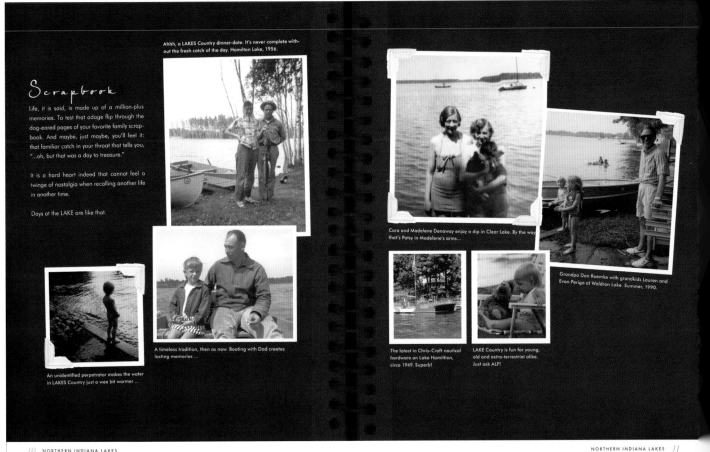

Scrapbook

Life, it is said, is made up of a million-plus memories. To test that adage flip through the dog-eared pages of your favorite family scrapbook. And maybe, just maybe, you'll feel it: that familiar catch in your throat that tells you, "...oh, but that was a day to treasure."

It is a hard heart indeed that cannot feel a twinge of nostalgia when recalling another life in another time.

Days at the LAKE are like that.

Ahhh, a LAKES Country dinner-date. It's never complete without the fresh catch of the day. Hamilton Lake, 1956.

Cora and Madelene Denaway enjoy a dip in Clear Lake. By the way that's Patsy in Madelene's arms...

Grandpa Don Roemke with grandkids Lauren and Evan Perigo at Waldron Lake. Summer, 1990.

A timeless tradition, then as now. Boating with Dad creates lasting memories ...

The latest in Chris-Craft nautical hardware on Lake Hamilton, circa 1949. Superb!

LAKE Country is fun for young, old and extra-terrestrial alike. Just ask ALF!

An unidentified perpetrator makes the water in LAKES Country just a wee bit warmer ...

Bezugspreis € 4,-

SUPERFUND
THE FUTURE OF INVESTING

präsentiert

SPANISCHE HOFREITSCHULE

JUBILÄUMSTOUR 2005

Stadthalle Graz, 2. – 4. September 2005

SPANISCHE
HOFREITSCHULE
2005

PROGRAMM PROGRAMM

Programm

AM LANGEN ZÜGEL

Mit der Arbeit am langen Zügel können nur besonders gut ausgebildete Hengste konfrontiert werden. Conversano Dagmar zeigt Ihnen alle unter seinem Bereiter erlernten Gänge der Hohen Schule – jedoch ohne Bereiter, nur durch leichte Zügel- und Gertenhilfe seines Bereiters unterstützt.

Musik: Pariser Einzugsmarsch von J.N. Walch
Schönplämarsch von C.M. Ziehrer
Regimentskinder von J. Fučik

ALLE GÄNGE UND TOUREN DER HOHEN SCHULE, 2. TEIL

Sie sehen erneut alle Schritte und Bewegungen, die Ihnen bereits im ersten Teil gezeigt wurden – hier jedoch präsentiert allein durch ein besonders außergewöhnliches Pferd und seinen Bereiter, der sein Pferd lediglich mit einer Hand am Zügel führt.

Siglavy Mantua I
Oberbereiter Krzisch

Musik: Das Steigt bei uns im Blut von C.M. Ziehrer
Brucker Lagermarsch von J.N. Kral
Durchmeistermarsch von W.A. Jurek

BEGRÜSSUNG

Musik: Prinz-Eugen-Marsch von A. Leonhardt

PAS DE DEUX

Perfekt ausgebildete zeigen Ihnen das Pas de Deux in vollkommener Linienführung und erlesener Figurendarstellung im exakten Rhythmus der Musik.

Musik: aus der Symphonie Nr. 40 in g-moll von W.A. Mozart

SCHULEN ÜBER DER ERDE

Nur die talentiertesten und intelligentesten Hengste, die über die größte physische Kraft verfügen, können die Bewegungen der „Schule über der Erde" ausführen, die auf natürlichen Verhaltensweisen der Pferde basieren. Vorgeführt werden Levaden, Courbetten und Capriolen – allesamt ohne Bügel geritten, was für die Bereiter besonders schwierig ist.

Musik: Wiener Blut von J. Strauß Sohn

SCHULQUADRILLE

Die Schulquadrille, in der sich die Hengste zum Ballett zusammenfinden, erinnert an die barocke Üppigkeit der höfischen Festlichkeiten.
Sie fordert von Mensch und Tier größte Konzentration, damit die perfekte Umsetzung der kompliziert choreographierten Figuren mit der für die Spanische Hofreitschule Wien bekannten Präzision und scheinbar spielerischen Leichtigkeit gelingt.

Musik: Aus der Arlesienne Suite von G. Bizet
Polonaise von F. Chopin
Gavotte im alten Stil von L. Riedinger
Galopp Passagalia von L. Riedinger
Österreichischer Grenadiermarsch 1784
Prinz-Eugen-Marsch von A. Leonhardt
Radetzky-Marsch von J. Strauß Vater

ALLE GÄNGE UND TOUREN DER HOHEN SCHULE, 1. TEIL

Sie sehen Pferde, die nach den Grundsätzen der klassischen Reitkunst ausgebildet worden. Die Pferde und ihre Bereiter bilden Einheiten, die – durch einen einzigen Willen gelenkt – die schwierigsten Bewegungen scheinbar mühelos ausführen. Die gezeigten Übungen werden von Dressurreitern in den anspruchsvollsten internationalen Wettbewerben gefordert.

Musik: A争copolka von J. Strauß Vater
Aus eigener Kraft von T. Rupprecht
Gernsdeermarsch von J. Wiedemann

ARBEIT AN DER HAND

Durch die hier gezeigten Übungen am kurzen Führzügel werden die Hengste auf die „Schule über der Erde" vorbereitet und lernen zudem die Figur der Piaffe.

Musik: Menuett von L. Boccherini

Musik

Ausführende:
Niederösterreichisches Tonkünstlerorchester
Das Große Wiener Rundfunkorchester
Bläserensemble der Spanischen Hofreitschule

Dirigenten:
Franz Bauer-Theussl
Peter Hofmann
Max Schönherr

Alle Fanfaren:
Josef Heinrich Schmid

16 17

1_____

Die Lipizzaner

DIE WELTBERÜHMTEN LIPIZZANER
VERDANKEN IHREN NAMEN DEM
DORF LIPICA IM HEUTIGEN SLOWENIEN,
IN DESSEN NÄHE 1580 DAS EINSTIGE
HOFGESTÜT MIT SPANISCHEN PFERDEN
GEGRÜNDET WURDE.

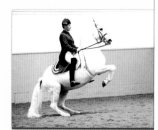

Sie zeichnen sich durch einen vollendeten, edel geformten Körperbau, graziöse Bewegungen, Lerneifer, Lebhaftigkeit, Gutmütigkeit, Mut, Härte und Ausdauer aus. Ihr Erscheinungsbild weist alle Merkmale des typischen barocken Prunk- und Paradepferdes auf.

Ein Lipizzaner besitzt einen ausdrucksvollen Kopf mit großen Augen. Die Nasenlinie ist gerade. Weist sie eine leichte Krummung auf, wird sie als „Ramsnase" bezeichnet. Der Hals ist kräftig, kurz und hoch aufgesetzt und bringt so die Voraussetzungen für die elegante, stark gebogene Haltung. Dazu kommen ein verhältnismäßig niedriger Widerrist, ein kräftiger Rücken, der in eine muskulöse Kruppe ausläuft, betonte Körperproportionen und profilierte Gliedmaßen mit starken, gut ausgebildeten Gelenken und formschöne Hufen. Zudem besitzt der Lipizzaner einen dichten und feinhaarigen Schweif und eine ebensolche Mähne. Seine Größe beträgt 155 bis 158 cm Stockmaß. Der Gang federt und ist besonders grazil.

ZUERST GRAU, SPÄTER WEISS

Die Lipizzaner werden dunkelgrau oder braun geboren. Die Farbe des Haarkleides verändert sich bei jedem Haarwechsel: aus den dunkleren Tönen entwickeln sich über viele Grauschattierungen allmählich hellere. Erst im Alter zwischen sieben und zehn Jahren besitzen die meisten Pferde das schöne weiße Haarkleid des Schimmels. Braune Lipizzaner sind selten. Es gehört allerdings zur Tradition der Spanischen Hofreitschule Wien, dass immer ein brauner Lipizzaner in den Vorstellungen zu sehen ist – als Glücksbringer des Ensembles.

Das Erscheinungsbild der Lipizzaner weist alle Merkmale des typischen barocken Prunk- und Paradepferdes auf.

Die einzigartigen weißen Pferde sind das Ergebnis jahrhundertelanger Zuchtung aus spanischem, italienischem und arabisch-orientalischem Blut.

21

1_____

DESIGN FIRM
designation Studio für
Visuelle Kommunikation
Austria

PROJECT
Spanische Hofreitschule

ART DIRECTOR
Jürgen G. Eixelsberger

aircraft rescue & firefighting

BURN

ARFF PROFESSIONALS SHARE THE MOST INSTRUCTIVE LESSONS FROM PLANNED EXERCISES AND, IN ONE CASE, A REAL-LIFE EMERGENCY.

to Learn

BY SEAN BRODERICK

The first hint of a problem was the landing warning light that illuminated as the Boeing 737 lifted off from El Paso International Airport (ELP) at just after 8 p.m. local time. The pilot requested and received permission to return to El Paso immediately.

Upon touchdown, the troublesome landing gear bogie failed, causing the left wing to strike the runway. The plane skidded out of control, left the runway and came to rest in a reservoir. The wing damage ruptured the fuel tank inside. Fuel began spilling into the water, which was as much as four feet deep in places due to recent rainstorms. The fuel quickly caught fire.

Rescuers were on the scene almost immediately; their trouble began soon after. The dirt road leading into the reservoir had been washed away by the same storms that raised the water level. The unstable ground at the scene surprised responders, causing the second aircraft rescue and firefighting (ARFF) vehicle to reach the scene to "roll over" the first one, ELP ARFF Captain Antonio Silva explained.

The challenges forced rescuers to make some quick decisions. The first: the remaining ARFF units couldn't be committed into the reservoir, so hoses had to be pulled with the trucks sitting some distance from the accident scene.

The good news is that ELP ARFF and emergency-response officials learned quite a bit from the scenario. Even better news is that nobody was hurt, not was anything damaged in the incident—because it never happened.

The early November 2004 "accident" was a tabletop exercise for some 100 people from 40 agencies, led by ELP. Silva presented the exercise to fulfill FAA's requirement that, once every 12 months, Part 139 airports review their emergency response plans. ELP's detailed tabletop exercise went beyond what FAA requires (14 CFR 139.325 dictates that airports "review the [emergency] plan," but practicing it is not required), but such approaches typically yield very positive results.

Such is the case with ELP. Silva said the lessons learned for all involved were "extensive." Several stood out to ELP's

ARFF team, including the importance of knowing airport terrain and how elements like excessive rain can alter that terrain; the importance of having enough structural units on standby when an Alert 2 (aircraft reporting major problem) is issued, so that responders are prepared if the situation escalates to an Alert 3 (aircraft accident); and the need for structural unit members to understand the challenges, including patient extraction, with responding to an incident in the reservoir.

Dealing with casualties is one of the most challenging parts of emergency response to prepare for. Even the most detailed tabletop exercises can't give rescuers a sense of the conditions and difficulties they will encounter when real bodies are waiting at the site of an airport emergency, safety officials acknowledge.

San Francisco International Airport (SFO) held its annual air crash field exercise in September 2004. Some of the more significant lessons underscored during that event dealt with handling casualties. SFO Manager, Emergency Operations & Planning William Wilkinson said.

Establishing "positive perimeter control" around an accident site is key, Wilkinson explained. "Ambulatory persons evacuating the aircraft will tend to keep going as far and as fast as they can from the crash," he said. "This means they might end up in areas where they cannot be found quickly and removed under controlled circum-

2_____

aircraft rescue & firefighting

PERFECT PRACTICE

lessons learned come from training exercises, including tabletop exercises and the live emergency drills that Part 139 airports must periodically do. But airports have emergencies, and when they do, ARFF units get to implement what they know—and learn from it.

In 1996, a Southwest Airlines Boeing 737 en route to southern Florida was the target of a bomb threat via a note found onboard during the flight. The Southwest crew opted to get the plane to the closest airport, and was cleared to Pensacola Regional (PNS). FAA officials alerted PNS's ARFF units that an inbound 737 was in trouble and to prepare for an emergency landing. An Alert 2 was issued.

"We had little time to gather additional information before the aircraft was on final approach," recalled PNS ARFF Captain Marty Sasse. "I staged the ARFF vehicles at the appropriate locations and requested additional structural fire units from outside the airport."

The plane landed and the pilot taxied to a remote part of the airfield. ARFF units, still unsure of what the emergency was, closed in. Only after the ARFF vehicles were near the aircraft did Sasse learn that the emergency was a possible bomb.

Law enforcement officials arrived quickly and discussions ensued over how to proceed, with different parties holding different views. ARFF rescuers wanted to get people off the plane as fast as possible. Since the plane was nowhere near a jet bridge, that would have meant deploying slides. But the Southwest captain wanted air stairs brought out to the aircraft instead.

The decision was made to supply air stairs, and 45 minutes after the plane stopped and shut down its engine, the stairs were in place. Law enforcement officials boarded the aircraft and soon declared the threat a hoax.

In the post-incident debriefs, PNS discussed several lessons learned. Getting as much detail as possible as quickly as possible on an inbound aircraft that has declared an emergency is key, since some emergencies—like onboard fires, for instance—call for immediate intervention by ARFF units, while others—like bomb threats—require ARFF units to stay out of harm's way until it is clear they are needed. The lessons learned from the incident combined with the more intensive focus industry-wide on dealing with terrorist threats in the aftermath of 9/11 helped PNS beef up its procedures.

Morristown Municipal Airport (MMU) in New Jersey recently bolstered its ARFF capabilities and preparedness in a much different way. As part of its mandated tri-annual live fire exercise scheduled for the fall, MMU arranged

stances." This in turn could present several problems, including a delay in getting needed treatment to injured but mobile passengers.

Wilkinson also noted that rescuers must do a better job of ensuring commonly used supplies are at hand, even before specific equipment needs have been established. For instance, during the drill, it soon became apparent that backboards were needed to remove patients from the airplane. Precious time was lost while the request for backboards went down the line to the support area and the boards came forward. "Any such simple/predictable supply item could correspondingly be pushed forward," Wilkinson said. "If they are not needed then they will be returned to medical stock during clean-up."

Yet another lesson learned for SFO dealt with clearing patients from the accident site. Wilkinson said. When moving passengers to safe locations, rescuers must be diligent to ensure that so-called "Green" (cleared) patients don't mix with "Yellow" (contamination possible) patients by ensuring that Greens go through triage to confirm their status before being handed over to transportation. "Absent such positive confirmation a Yellow could mix with the Greens only to be discovered when symptoms manifest themselves and cause a crisis," he said.

Fortunately, since large-scale, on-airport emergencies like plane crashes and structural fires are rare, many ARFF

Firefighters are well aware of the importance of practice — not only the procedures they rely on, but also the tools they use. Airport Professional Services (APS) has developed a training aid for use with firefighting aids that ARFF unit members find indispensable: piercing tools.

APS's Penetration Aircraft Skin Trainer (PAST) has a curved steel base that holds rectangular sheets of aluminum skin. The skin, shaped like an airplane fuselage, serves as a target for everything from handheld tools to boom-mounted penetrators, like Crash Rescue's Snozzle. The PAST's advantages, according to APS: the system provides "realistic, hands-on" penetration training by allowing firefighters to practice on aircraft-like targets. And because the panels are replaceable, the PAST doesn't wear out like other common penetration-training aids, such as old buses or aircraft fuselages, do after multiple sessions.

PASTs have been delivered to several airports, including the Bloomington-Normal, Illinois; Chicago Midway and Kansas City International. The product is the brainchild of APS founder Gary Schott, a four-decade ARFF veteran and fire chief of a Midwestern airport. PAST is priced at $5,995 and comes with four aluminum panels. For more, see www.aps-llc.org.

to bring in a mobile fire trainer from West Virginia University. MMU officials decided to invite firefighters from non-ARFF units that are part of the airport's mutual aid agreement, explained MMU fire chief Doug Reighard. During the planning, officials wore a bit surprised to discover that few of the mutual aid firefights had no ARFF training, and that New Jersey had no recognized ARFF training. "This was the perfect opportunity to not only get our mutual aid [firefighters] trained but to put ARFF on the map in New Jersey," Reighard said.

MMU, with help from the New Jersey Division of Fire Safety (NJDFS), led the development of a state ARFF program, using Virginia's Department of Fire Programs product as a guide. In August, once the program was approved, MMU and the Morris County Fire Academy began classroom work for the mutual-aid firefighters. Coursework consisted of airport and aircraft familiarizations, ARFF firefighter safety and the MMU emergency plan.

On October 19, MMU officials—armed with state approval to do live fire training at a non-sanctioned state facility—closed MMU's cross-wind runway and set up the mobile trainer. During the next four days, three classes of about 30 firefighters each worked with the mobile trainer.

The tri-annual exercise took place on the night of October 22. The scenario: a Dassault Falcon 2000 business jet and a single-engine Piper aircraft collide over the

airport, causing the jet to crash at the approach end of Runway 31 and the smaller aircraft to hit an office building just off airport grounds. The disastrous scenario tested two major elements in MMU's response plan: dealing with a major on-airport incident and testing the mutual-aid plan by requiring some responders that would not normally show up for an on-airport accident to handle the off-airport accident.

"The crash site on the airport grounds was an absolute success due to the realism and the recent training of the mutual aid fire units," Reighard said. "We found that the mutual aid was extremely interested in what goes on at the airport. I believe they finally felt like part of the team rather than being an outsider."

Another lesson that MMU's most recent drill underscored is one that Reighard, who has been involved in three such exercises at MMU and evaluated several more, knows all too well as a veteran of large-scale tests, they require coordination with and support from myriad organizations. Among key participants in the MMU drill that weren't being tested were Suburban Propane, which donated some 4,000 gallons of propane to burn during the on-airport trials, and Morristown High School, which supplied the crash "victims." In other words, much like running an airport holding a successful disaster drill means getting significant cooperation with the local community. Said Reighard: "The major contributors made it all possible."

2_____
DESIGN FIRM
Pensaré Design Group
Washington, (DC) USA
PROJECT
Airport Magazine
CREATIVE DIRECTOR
Mary Ellen Vehlow
DESIGNER
Amy E. Billingham

DESIGN FIRM
New York Magazine
New York, (NY), USA
CLIENT
New York Magazine
DESIGN DIRECTOR
Luke Hayman

THE BIG F

AT 50, I WAS FIRED. IT WAS AWFUL. I LIVED. LEARNING TO EMBRACE **FAILURE** IN A CITY FUELED BY SUCCESS.

BY JAMES ATLAS

THE YEAR I TURNED 50 I was fired from a job. I hadn't been doing well in the job. I didn't have my heart in it, and it showed. I wasn't making a significant contribution. I was superfluous. It was just a matter of time.

Anxious about my performance, I had already gone to see my boss once. "I don't feel encouraged," I said to him. "I'm not invited to meetings, I'm not given assignments." He was new to the job; I had flourished under the previous boss, who had hired me and given me a lot of responsibility.

Photographs by Katherine Wolkoff

ART DIRECTOR
Chris Dixon
PHOTO DIRECTOR
Jody Quon
DESIGNER
Chris Dixon
PHOTOGRAPHERS
Katherine Wolkoff, James Atlas

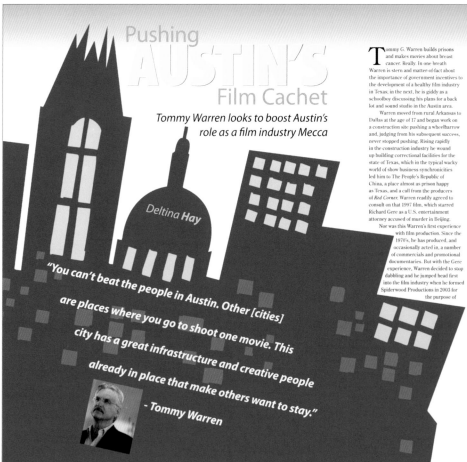

Pushing AUSTIN'S Film Cachet

Tommy Warren looks to boost Austin's role as a film industry Mecca

Deltina Hay

"You can't beat the people in Austin. Other [cities] are places where you go to shoot one movie. This city has a great infrastructure and creative people already in place that make others want to stay."

- Tommy Warren

Tommy G. Warren builds prisons and makes movies about breast cancer. Really. In one breath Warren is stern and matter-of-fact about the importance of government incentives to the development of a healthy film industry in Texas; in the next, he is giddy as a schoolboy discussing his plans for a back lot and sound studio in the Austin area.

Warren moved from rural Arkansas to Dallas at the age of 17 and began work on a construction site pushing a wheelbarrow and, judging from his subsequent success, never stopped pushing. Rising rapidly in the construction industry he wound up building correctional facilities for the state of Texas, which in the typical wacky world of show business synchronicities led him to The People's Republic of China, a place almost as prison happy as Texas, and a call from the producers of *Red Corner*. Warren readily agreed to consult on that 1997 film, which starred Richard Gere as a U.S. entertainment attorney accused of murder in Beijing.

Nor was this Warren's first experience with film production. Since the 1970's, he has produced, and occasionally acted in, a number of commercials and promotional documentaries. But with the Gere experience, Warren decided to stop dabbling and he jumped head first into the film industry when he formed Spiderwood Productions in 2003 for the purpose of producing *The Inner Circle*, since picked up by Porchlight Entertainment for worldwide distribution. The film looks at the singular challenges faced by a woman and her loved ones in the shadow of a mastectomy. It stars Michael O'Keefe and Beth Broderick.

Warren got his feet wet on a number of different levels while making *The Inner Circle*. He is credited with some of the writing, directed the "behind the scenes" production, and supervised the music. "We used two of the Grammy-winning Los Lonely Boy's titles in this feature, as well as the talents of William Stromberg, who was nominated for a Grammy this year."

With *The Inner Circle* in distribution throughout the world, Warren is now off to other projects. In addition to writing and co-producing both a comedy and reality show, he is developing a television series with editor and director Fred Toye (*Alias, Taken*).

Warren shines with boyish enthusiasm discussing the creative challenges he faced in making *The Inner Circle*, but he becomes CEO serious when he turns to the topic of business. "[Texans] have a romance with film and music, and the general public does not quite understand the depth of this business or how big the film and music industry could be in terms of economic development. My goal is to enhance the existing efforts for filmmaking in Texas, especially in the Austin area." To that end, Warren plans to develop "a back lot" off the Colorado River "where filmmakers can have a known location large enough to allow different forms of landscaping, including water, for shooting movies." The Spiderwood lot will be located on 163 acres within the required Screen Actors Guild 30-mile commuting limit. Spiderwood Productions also has plans to build a sound studio that "can be used to test and experiment with new methods for improving the quality of movies while reducing costs and production time."

Warren says that Austin is already an attractive location for many filmmakers.

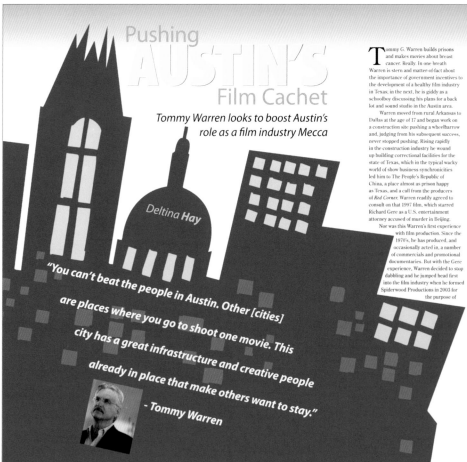
Tommy G. Warren behind the scenes of *The Inner Circle*

"Other states may offer better tax and monetary incentives," he says "but the fact that there are trained crews, film stages, and back lot acreage, makes the Austin area a much better deal for movie making. Austin also has post-production studios to complete the work, and getting permits to shoot is simple."

Austin is also an example of how government and communities can work together to strengthen economic development around creative industries.

Warren points out that, "the Texas Film Commission has been around a long time and helps bring film production into the state. The Austin Film Society has also been a moving force in the region for the movie industry. And the local government has been very active in promoting the film, music, and gaming industries by supporting such entities such as Austin Studios."

In addition, the University of Texas and Austin Community College both have programs that regularly add experienced people to the entertainment industries, therefore building a solid future for radio, TV, and film in the area. "When there's a pool of properly trained crews, it will always help bring in the economic benefits of the entertainment industry. And ACC is exploring the possibility of an Entertainment and Digital Arts Institute that will combine the efforts of private businesses in the entertainment industry to foster a stronger internship program. All of this combined effort is teamwork that will bring more business to the area."

With all of this going for Austin, it is no wonder Warren is willing to take such a risk on the area. "Besides," he says, "you can't beat the people in Austin. Other states are places where you go to shoot one movie. This city has a great infrastructure and creative people already in place that make others want to stay."

For more information on Tommy G. Warren or Spiderwood Productions, visit *www.spiderwoodproductions.com*.

SUMMER 2005

1 _____

2 _____

1 _____

DESIGN FIRM
TAMAR Graphics
Waltham, (MA) USA

CLIENT
Creative Pulse Magazine

ART DIRECTOR, DESIGNER
Tamar Wallace

ILLUSTRATOR, DESIGNER
Christopher Hay

COPYWRITER
Deltina Hay

2 _____

DESIGN FIRM
The College of Saint Rose
Albany, (NY) USA

PROJECT
Genesis Magazine

ART DIRECTOR
Mark Hamilton

DESIGNER, ILLUSTRATOR
Chris Parody

COPYWRITER
Renee Isgro Kelly

DIRECTOR OF PUBLIC RELATIONS
Lisa Haley Thomson

PHOTOGRAPHERS
Paul Castle Photography,
Luigi Benincasa,
Tom Killips

PRINTER
Brodock Press, Inc.

3_____

3_____
DESIGN FIRM
Riordon Design
Oakville, (Ontario) Canada
CLIENT
Riordon Design
ART DIRECTOR
Ric Riordon
DESIGNER
Alan Krpan
ILLUSTRATORS
Jeff Elliot, Dan Wheaton
PHOTOGRAPHERS
Ric Riordon, Alan Krpan,
photos.com, Getty Images

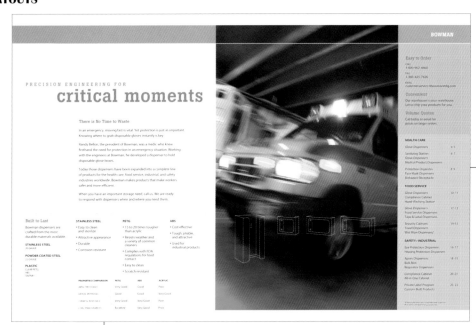

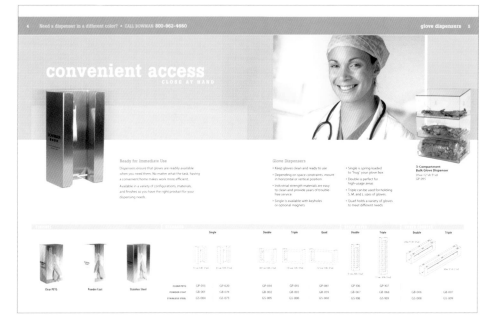

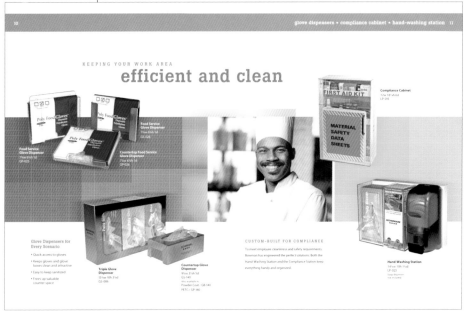

1_____

DESIGN FIRM
belyea
Seattle, (WA) USA
PROJECT
Bowman
CREATIVE DIRECTOR
Ron Lars Hansen
PRODUCTION MANAGER
Sheri-Lou Stannard
DESIGNER
Nick Johnson

excursions

Winging It

Florida's national parks offer a unique opportunity for birdwatchers, as dozens of species migrate to warmer climates.

BY CONNIE TOOPS

Southern Florida's Everglades region—consisting of marshes, estuaries, and subtropical forests—is unlike any other ecosystem. Lush ferns, clasping vines, graceful cypress trees, and salt-tolerant mangroves flourish in the warm, humid climate. Wildlife ranges from vibrant butterflies to stealthy panthers, but birds—with their sporting flamboyant colors, strange shapes, or curious behaviors—are the region's celebrated ambassadors. Bird-watchers flock to south Florida to discover rarities found nowhere else in the country. Everglades and Dry Tortugas national parks and Big Cypress National Preserve, all designated by the American Bird Conservancy as Globally Important Bird Areas, provide excitement for novice or experienced birders.

More than 350 bird species have been documented in Everglades National Park. Nearly two-thirds of them migrate north in summer or south in winter to find abundant food or proper nesting conditions.

ANHINGAS

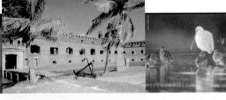

Bird-watchers flock to south Florida to discover rarities found nowhere else.

Everglades National Park

SIDETRIP:
Dry Tortugas National Park

For an unforgettable birding experience far from the beaten path, consider visiting Dry Tortugas National Park. Seven small sandy islands surrounded by azure waves lie 70 miles west of Key West. Discovered by Ponce de Leon in 1513, the islands had no fresh water but their sea turtle (tortugas) translated into meat for hungry sailors. Fort Jefferson, a huge but never-completed brick fort, dominates Garden Key. Overnight camping is permitted on its beach, but visitors must bring all of their own food, water, and supplies.

If you've never visited or birded in such a remote location, join a tour group and let the leaders handle transportation and bird identification. All you'll need are sunscreen and binoculars to savor a once-in-a-lifetime experience.

Travel Essentials

In south Florida, warm humidity prevails much of the year. In the summer months, thunderstorms are frequent and mosquitoes are abundant, and mid-winter cold fronts will put a temporary chill in the air. In addition to binoculars and bird guides, bring drinking water, sunscreen, and insect repellant. You'll find bird checklists for each park at www.nps.gov/oia/NPSBirds.html.

South Florida is famous for birds that bring panache to the flat landscape.

Biscayne National Park

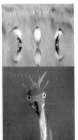

DESIGN FIRM
Pensaré Design Group
Washington, (DC) USA

PROJECT
National Parks Magazine,
Florida Excursions

CREATIVE DIRECTOR
Mary Ellen Vehlow

DESIGNER
Amy E. Billingham

HUF HAUS

THEIR DISTINCTIVE LOOKS — BLACK, WHITE AND GLASS — COUPLED WITH MODERN DESIGN AND CONSTRUCTION METHODS NEVER CEASES TO AMAZE PEOPLE AND ATTRACT BOTH ADMIRERS AND CRITICS. EVEN WITH CRITICS, THE POPULARITY OF HUF HAUS IS GROWING AND SO BRUCE R WILLAN TAKES A LOOK AT WHAT MAKES THESE HOMES SO SPECIAL AND DESIRABLE IN A MODERN WORLD.

DIAMONDS and MICKEY MOUSE from Sotheby's and super on Louis Vuitton — must-haves for anyone who has just about everything already

TIMELESS TRAVEL is also, and has had every bit of romantic and mysterious AFFORDABLE ART for every taste and budget — where to find it

EXCLUSIVE APARTMENTS PROPERTIES AND VILLAS FOR SALE AROUND THE GLOBE

THE WORLD'S MOST DESIRABLE PROPERTY AND LIFESTYLE

HOMES AWAY FROM HOME

SEPTEMBER 2005 ISSUE 20 PRICE £3.90

Huf Haus
Superb Homes from German designers and engineers of excellence for contemporary 21st century living

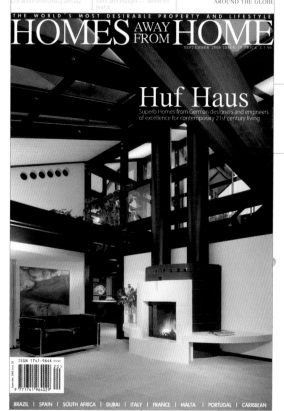

ISSN 1741-9466

BRAZIL | SPAIN | SOUTH AFRICA | DUBAI | ITALY | FRANCE | MALTA | PORTUGAL | CARIBBEAN

1_____

Affordable Art

So, just where do you get decent art that not only gives you pleasure but at the same time doesn't require a second mortgage? Robert Andeson finds the best places to buy affordable art

It is not easy finding works of art that are inexpensive. The auction houses like Sotheby's and Christies rarely have works of note that most of us can afford. The galleries of Mayfair are similarly pricey. But there are alternatives, and if you can place a little faith in the unknown you're bound to find something you like to fill that wall space at a price that you can afford.

For one, try the London Affordable Art Fair. The Affordable Art Fair (AAF) is the leading show in the UK for contemporary art under £2,500. The fair was launched in London in 1999 and now takes place biannually in London and annually in Bristol and New York, with affiliate fairs in Sydney and Melbourne.

Since 1999 the contemporary art market has seen extraordinary growth and the Affordable Art fairs have also boomed, with annual sales rising from £5m in 1999 to £6.5m last year. An average of

one in four visitors buy at the fair and many return year on year. With ten UK fairs under its belt, the Affordable Art Fair is established as an important and popular step on the art buying ladder, making the purchase of buying and collecting original art a reality.

In 1998 Will Ramsay, the founder of the AAF, opened Will's Art Warehouse in Parson's Green to bridge the public's increasing interest in contemporary art and the London gallery scene. He recognised the need for an approach that made people feel comfortable about buying art, however little they know about it, and concerned a gallery that is relaxed and un-intimidating. By concentrating on relatively unknown artists not carrying a premium for reputation, he was able to offer works from £30-£2,500 and give buyers access

to a stable of over 150 artists. This has proved to be a winning formula.

The response to Will's Art Warehouse encouraged Will to take his approach to the next level and in October 1999 he launched the first Affordable Art Fair. Over a period of four days, 93 galleries descended on the marquee in Battersea Park to offer contemporary artwork (original paintings, prints, photographs and sculpture) for under £2,500. Over 10,000 visitors, ranging from first-time buyers to budding collectors, took advantage of the ease of buying, breadth of choice, affordable prices and user-friendly approach at this inaugural event.

This year the Affordable Art Fair returns to Battersea Park, London from 20 to 23 October 2005 with its Autumn Collection. Around 125 galleries will be exhibiting paintings, sculpture, photography and original prints, all priced at under £3,000. This year visitors can also view garden sculpture as well as the Recent Graduate Exhibition, showcasing artists tipped for the top.

So what do you get for your money at the Affordable Art Fair? Well, in addition to broadening the reach of art and welcoming new buyers, the fair also attracts seasoned collectors on the lookout for bright new artists through the Recent

and autumn fairs, no artist can be shown at more than one of the fairs each year.

Following the successful expansion of the Affordable Art Fair in England, Will has launched an AAF in New York and associate fairs in Sydney and Melbourne. The fairs appear to be satisfying the increasing public demand for education about contemporary art and Will hopes to continue expansion in both the United Kingdom and abroad — so watch this space!

Graduates exhibition. This is a rich hunting ground for emerging talent as it showcases the cream of the 2005 art school graduates. Previous graduates showcased at AAF include Sam Herbert, whose work is collected by Charles Saatchi, and Damien Roach, who has subsequently been given shows at Tate Britain and the Venice Biennale.

But this is not the only venue for art on a budget. There are many towns and villages around the UK which host art trails and fairs all year round. Or how about trying the Internet? Yes, the Internet is filled to the cosmic edges with art for sale. Veda Howles, the former South African nurse who set up and co-founded Kaleidoscope Arts — which holds exhibitions and runs the sculpture demonstration area at the Autumn Affordable Art Fair in London — markets and sells her work through galleries, exhibitions and the Internet. Her work of late has been inspired by softly rounded fruits and their intonation of fertility and association with the female figure, her latest work consists of 'fruits' ranging in size from ten to 70cm. She works primarily in bronze with wonderful and unusual patinas, though sometimes she works in resin, porcelain and glass.

CHERRIES IN BOWL 1

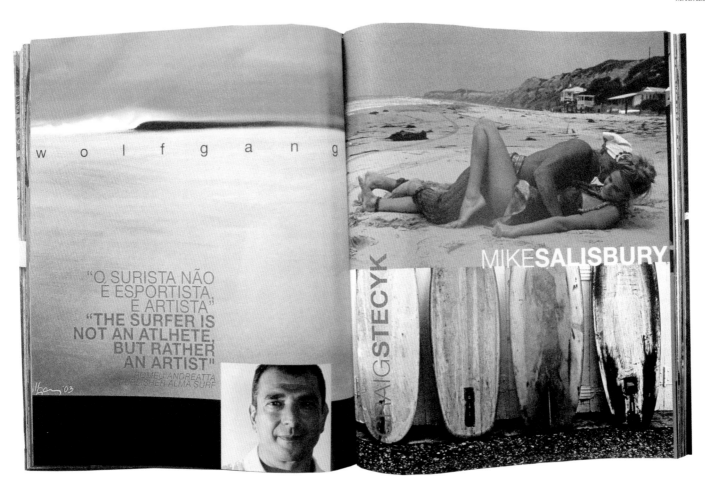

w o l f g a n g

"O SURISTA NÃO
É ESPORTISTA,
É ARTISTA"
**"THE SURFER IS
NOT AN ATLHETE,
BUT RATHER
AN ARTIST"**
ROMEU ANDREATTA
PUBLISHER ALMA SURF

CRAIGSTECYK

MIKE**SALISBURY**

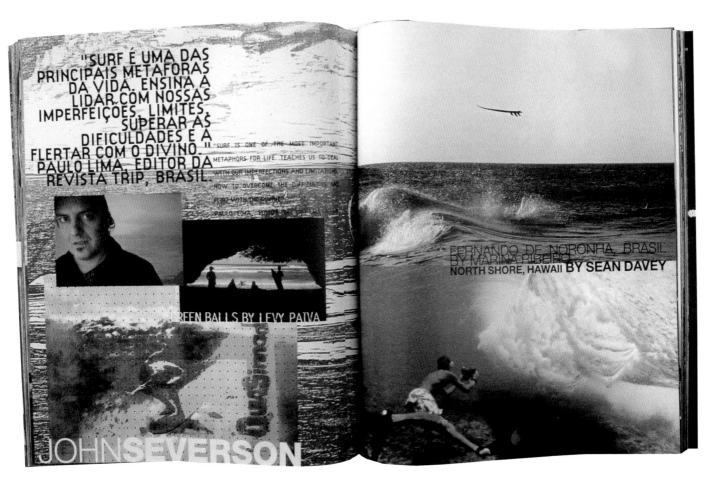

"SURF É UMA DAS
PRINCIPAIS METAFORAS
DA VIDA. ENSINA A
LIDAR COM NOSSAS
IMPERFEIÇÕES, LIMITES,
SUPERAR AS
DIFICULDADES E A
FLERTAR COM O DIVINO.
PAULO LIMA, EDITOR DA
REVISTA TRIP, BRASIL.

"SURF IS ONE OF THE MOST IMPORTANT
METAPHORS FOR LIFE. TEACHES US TO DEAL
WITH OUR IMPERFECTIONS AND LIMITATIONS.
HOW TO OVERCOME THE DIFFICULTIES AND
FLIRT WITH THE DIVINE.
PAULO LIMA, EDITOR OF TRIP MAGAZINE

FERNANDO DE NORONHA, BRASIL
BY MARINA RIBEIRO
NORTH SHORE, HAWAII **BY SEAN DAVEY**

GREEN BALLS BY LEVY PAIVA

JOHN**SEVERSON**

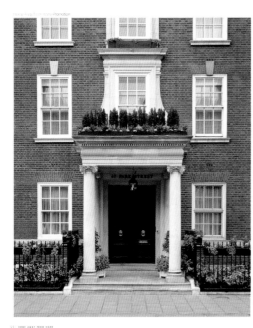

47 Park Street
A return to elegant living

1_____

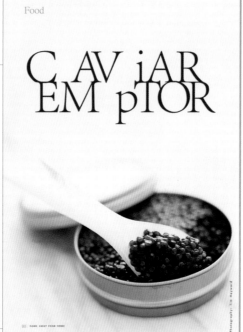

Food

C AV iAR EM pTOR

Tim Haywood

Food

Interiors

Interiors

Number one fan

Charlotte Wilkins

1_____

DESIGN FIRM
Circa 77 Design
Gateshead, England

PROJECT
Homes Away From Home

EDITOR
Sasha Wilkins

PUBLISHER
i2Media

2

DESIGN FIRM
**designation Studio für
Visuelle Kommunikation**
Klagenfurt, Austria

PROJECT
Diplomazia Commerciale

DESIGNER
Jürgen G. Eixelsberger

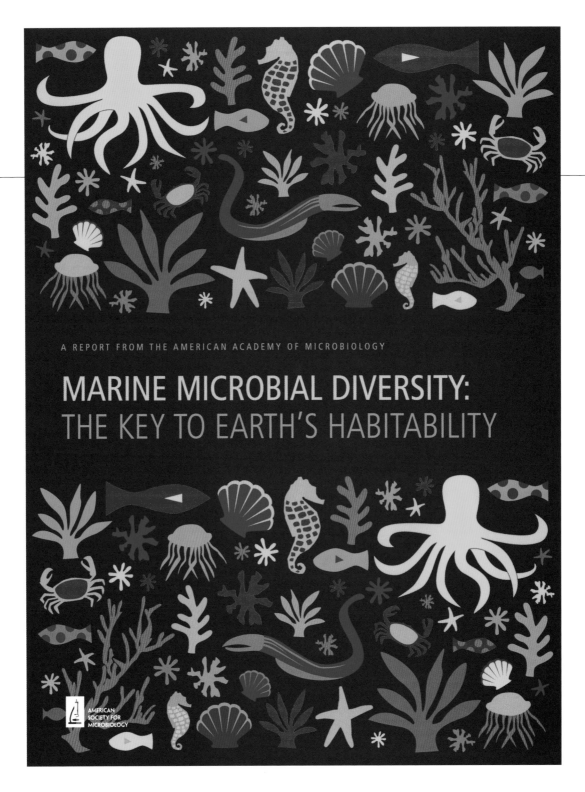

A REPORT FROM THE AMERICAN ACADEMY OF MICROBIOLOGY

MARINE MICROBIAL DIVERSITY:
THE KEY TO EARTH'S HABITABILITY

AMERICAN
SOCIETY FOR
MICROBIOLOGY

DESIGN FIRM
Pensaré Design Group
Washington, (D.C.) USA
PROJECT
American Society for Microbiology
Marine Diversity Report
CREATIVE DIRECTOR
Mary Ellen Vehlow
DESIGNER
Lauren Emeritz

This report is based on a colloquium, sponsored by the American Academy of Microbiology, held April 8-10, 2005, in San Francisco, California.

The American Academy of Microbiology is the honorific leadership group of the American Society for Microbiology. The mission of the American Academy of Microbiology is to recognize scientific excellence and foster knowledge and understanding in the microbiological sciences. The Academy strives to include underrepresented scientists in all its activities.

The American Academy of Microbiology is grateful for the generous support of The Gordon and Betty Moore Foundation.

The opinions expressed in this report are those solely of the colloquium participants and may not necessarily reflect the official positions of our sponsors or the American Society for Microbiology.

A REPORT FROM THE AMERICAN ACADEMY OF MICROBIOLOGY

MARINE MICROBIAL DIVERSITY:
THE KEY TO EARTH'S HABITABILITY

JENNIE HUNTER-CEVERA, DAVID KARL, AND MERRY BUCKLEY

cope with the conditions or by creating barriers to keep the harsh conditions out of their cells.

In cold environments, psychrophilic bacteria cope with the conditions by maintaining flexible membranes and by circulating natural antifreeze compounds throughout the cell. In extremely hot areas of the oceans, hyperthermophilic microbes use subtle changes in their proteins to maximize the number of stabilizing salt bridges and ion pairings that keep enzymes together in the heat. Reverse gyrase, which allows DNA to maintain its structure during replication at high temperatures, is another unique enzyme used by hyperthermophiles.

In areas of high salt concentrations, many halophiles have adapted by altering their proteins, making them acidic, and hence, resistant to the protein-scattering effects of high salt concentrations. Other halophiles circulate osmolytes, small organic molecules that prevent water loss to the highly salty surroundings outside the cell.

The marine environment presents an unparalleled opportunity for studying life in extreme environments. Nowhere else on earth do so many different environmental conditions exist in such compact areas. The oceans are home to extremely high pressures and to the highest temperatures of any aquatic system. Deep sea brines, which have high concentrations of both salts and heavy metals, are singular habitats where life thrives despite the difficulties. Because of these diverse habitats, the oceans are unique with respect to the challenges posed to life and with respect to the wealth of biological diversity that has arisen to cope with those challenges.

IMPACTS OF HUMAN-INDUCED CHANGE ON THE CYCLING OF ELEMENTS IN THE OCEANS

Since the industrial revolution, vast quantities of many important bioelements have been taken from relatively inert or inaccessible sources and released into the planet's air, soil, and water. Inputs to the environment on this scale directly and indirectly impact the oceans, and atmospheric inputs of greenhouse gases have induced rapid climate change. As world populations climb and resource exploitation soars, environmental inputs and climate change are accelerating at an alarming rate. Some significant alterations in the microbial communities of the oceans, and, therefore, in the global cycling of the bioelements, are anticipated in the wake of these escalating changes.

The impacts of global temperature changes resulting from climate changes will be felt by microbial enzyme systems. Different enzyme systems have different temperature optima, so microecological processes in a given area may be depressed or stimulated depending on the nature of the local temperature change (up or down) and the optima of the enzyme systems involved. These changes are not predictable, since the optimum temperature for enzymes are not easy to decipher from an organism's habitat.

In some areas of the world, climate change has resulted in a decrease in rainfall. In Saharan Africa, a decline in rainfall combined with human activities has led to desertification of many areas and encouraged an increase in wind-born dust, resulting in an increase in the deposition of African dust in the oceans. The metals carried in this dust, including iron, are likely to impact marine microbial communities and the cycles they carry out that sustain the biosphere. (As a side note, in China's Gobi Desert, irrigation and other land use practices have actually decreased the size of selected deserts. This has led to a decrease in dust deposition, and could cause iron limitation in the marine waters where dust and the iron it carries is otherwise deposited.)

Human inputs of nitrogen to the oceans, which comprise roughly half of the total nitrogen inputs, are impacting the global cycling of nitrogen in both known and unknown ways. For example, nitrogen pollution has had an impact on nitrous oxide cycling in coastal systems, apparently resulting in a net increase in nitrous oxide production. Nitrogen-burdened, oxygen-depleted coastal regions account for only 2% of the ocean surface area, but these regions contribute about 20% of the nitrous oxide the oceans release to the atmosphere. The concentration of nitrous oxide in the atmosphere is increasing at an accelerating rate, and it is not clear how this trajectory will change with global climate change. It is likely that escalating nitrogen inputs will continue to perturb and transform the nitrogen cycle and that nitrous oxide emissions from the oceans will continue to climb.

Because of their rapid growth rates and metabolic flexibility, marine microbes could possibly serve as a buffer that helps dampen large scale changes resulting from human-induced modifications of the oceans. There is a great deal of uncertainty about how well this dampening effect works in practice, however. It may be that marine microbes have a certain buffering capacity, but when it is exceeded conditions will decline precipitously.

The consequences of global climate change and human inputs of bioelements to the oceans are potentially disastrous. Temperature increases can have an indirect effect on the acidity of ocean water, and thus, on the marine habitat. The solubility of carbon dioxide increases with temperature, and dissolved carbon dioxide combines with water to form carbonic acid (H_2CO_3) which subsequently dissociates into H^+ and HCO_3^-. These materials lower the pH of the water. The concentration of carbon dioxide from human sources is also on the rise. Hence, a decrease in the pH of seawater is expected to

THE CONSEQUENCES OF GLOBAL CLIMATE CHANGE AND HUMAN INPUTS OF BIOELEMENTS TO THE OCEANS ARE POTENTIALLY DISASTROUS

echo the global warming trend and ongoing increases in carbon emissions. Ocean acidification will have a direct impact on corals. They are expected to grow more slowly and become more fragile under these circumstances, decreasing the ability of coral reefs to act as protective island barriers even as storm intensity increases because of climate change.

Climate change may also bring about big changes in the stratification of the oceans, reducing mixing and reducing the output of marine fisheries.

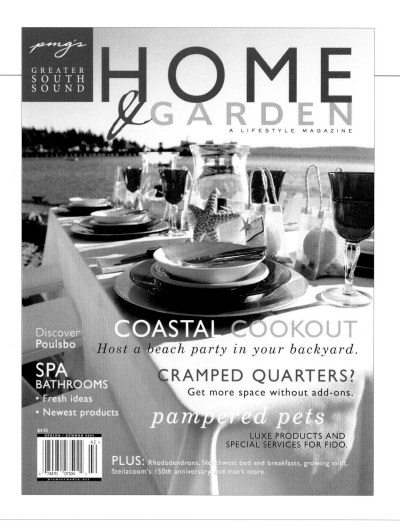

pmg's
GREATER
SOUTH
SOUND

HOME
& GARDEN
A LIFESTYLE MAGAZINE

Discover
Poulsbo

**SPA
BATHROOMS**
• Fresh ideas
• Newest products

$4.95
SPRING / SUMMER 2004

COASTAL COOKOUT
Host a beach party in your backyard.

CRAMPED QUARTERS?
Get more space without add-ons.

pampered pets

LUXE PRODUCTS AND
SPECIAL SERVICES FOR FIDO.

PLUS: Rhododendrons, Northwest bed and breakfasts, growing mint,
Steilacoom's 150th anniversary, and much more.

premiermedia.net

**DESIGN FIRM
Premier Media Group**
Tacoma, (WA) USA
PROJECT
Home & Garden Magazine
ART DIRECTOR
Dallas Drotz

coastal cookout
Host a Beach Party in Your Backyard

When the sun finally makes its appearance, it's time to celebrate—
Pacific Northwest style! Throw a backyard beach party with a
nautical theme and delectable seafood dishes, and pay homage to
Washington's beautiful coast and rich maritime history.

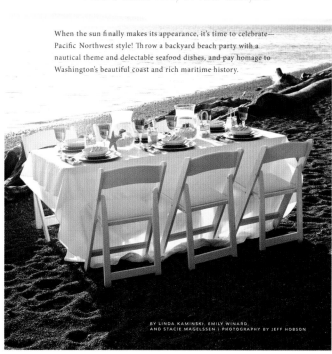

BY LINDA KAMINSKI, EMILY WINARD,
AND STACIE MAGELSSEN | PHOTOGRAPHY BY JEFF HOBSON

the invitations

Keep the invitations simple. Using word or a vendor word processing program, set the document's size to four inches wide and six inches high. Create a thin royal blue border. Use the same color for the invitation's wording, which should be a sans serif font such as Arial. Using strong glue, affix a small sea star to the top left corner. Weave a thin strand of jute ribbon around the invitation twice or three times, knotting it on the backside and cutting off any extra length. Because the sea star is bulky and fragile, it could break when going through the post office's machines if placed in a standard envelope. To ensure it arrives in one piece, place the invitation in an envelope and then place the envelope in a bubble mailer, available at any post office or mail center.

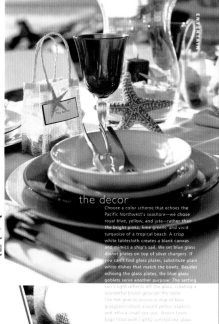

ENTERTAIN

the decor

Choose a color scheme that echoes the Pacific Northwest's seashore—we chose royal blue, yellow, and jute—rather than the bright pinks, lime greens, and vivid turquoise of a tropical beach. A crisp white tablecloth creates a blank canvas and mimics a ship's sail. We set blue glass dinner plates on top of silver chargers. If you can't find glass plates, substitute plain white dishes that match the bowls. Besides echoing the glass plates, the blue glass goblets serve another purpose. The setting sun's light reflects off the glass, creating a wonderful bluish glow on the table. Use hot glue to secure a strip of blue grosgrain ribbon around yellow napkins, and affix a small sea star. Woven favor bags filled with lightly scented sea glass and seashells double as place cards—their weight insures that they won't fly away when the wind kicks up. In lieu of flowers, place two or three hurricane lanterns down the table's center. Fill with light-colored sand (available at most pet stores), blue votive candles, sea dollars, sea stars, and a handful of other small shells.

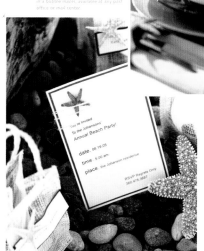

You're Invited
To the Johansons
Annual Beach Party!

date: 06.19.05
time: 5:00 am
place: the Johanson residence

RSVP Regrets Only
360.476.3897

pmg's HOME & GARDEN | 73

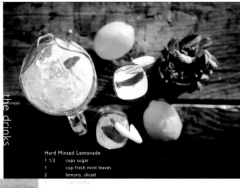

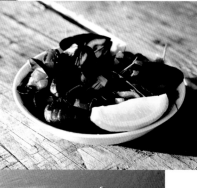

Garlic Roasted Crab

the drinks

Hard Minted Lemonade

1 1/3 cups sugar
1 cup fresh mint leaves
2 lemons, sliced
2 cups vodka
2 cups fresh lemon juice
1 cups club soda

In a large pitcher mix sugar, mint leaves, and sliced lemons. Add vodka and lemon juice. Let stand for 30 minutes. Stir to dissolve sugar. Chill for 30 minutes. Add club soda and serve over ice. Add fresh mint and lemon wedges for garnish.

Mussels in Lemon Cream

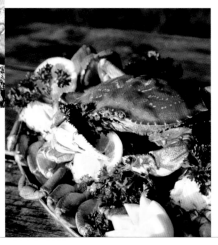

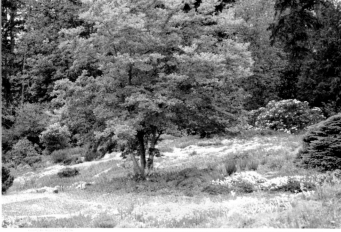

Instead of using individual crab crackers, consider placing a single cracker on each end of the table for your guests to share. We used beautiful rustic wood crab crackers we found from a local companion on the Olympic Peninsula. Not only are these crab crackers functional (they crack a crab easily) and without a lot of the mess associated with smaller crackers) they are gorgeous to look at.

The Menu

DRINK
Hard Minted Lemonade

APPETIZER
Mussels in Lemon Cream

MAIN COURSES
Garlic Roasted Crab
Tomato Bread
Shrimp Caesar with Spicy Croutons

DESSERT
Frosted Sugar Cookies

"FOR THE SHRIMP CAESAR SALAD, SPICY CROUTONS, AND FROSTED SUGAR COOKIES RECIPES, SEND AN EMAIL TO DANA@PREMIERMEDIA.NET AND PUT "RECIPES" IN THE SUBJECT LINE

putting down roots
choosing and caring for landscape trees

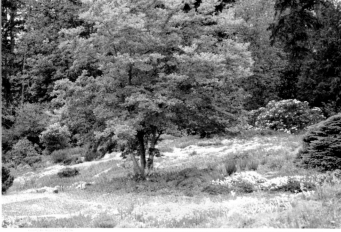

A graceful Japanese maple punctuates the Chase Garden's lovely alpine meadow in spring

When it comes to home landscaping, trees provide much more than vertical appeal. They soften stark edges and make houses feel like homes. Well-placed trees reduce the need for air conditioning in the summer and heating in the winter by providing shade and windbreaks. Trees also remove air pollutants, produce the oxygen we breathe, and combat global warming by removing carbon dioxide from the air and lowering our usage of fossil fuels.

BY PAMELA KOCK
PHOTOGRAPHY BY MELISSA MUNSON AND THOMASINA ROSS

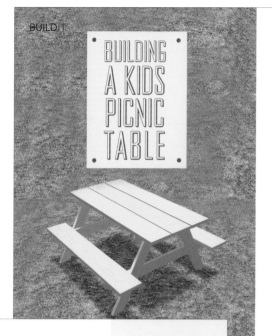

BUILD IT

BUILDING A KIDS PICNIC TABLE

BUILDIT

Just in time for summer backyard fun!
An easy to construct picnic table project that you can build family memories around. After you make your table send us a picture of your project and we may place it on our web site. Visit RealDadMagazine.com for the details.

Materials
The materials used for this project are standard 1 x 6-in. (for the seats and table top) and 1 x 3-in. boards (for legs, seat supports, table supports and braces).

Note: Actual dimensions of 1x 6-in. timbers are approximately 3/4-in. x 5-1/2-in. due to the timber dressing or planing of production. 1 x 3-in. timbers typically measure 3/4 x 2-3/4-in.

Untreated pine is ideal for indoor applications. If the table is to be left outside, choose a timber that has a natural resistance to decay (doesn't rot easily) in preference to a pressure-treated timber. The chemicals in some pressure-treated woods can make for a potentially dangerous eating surface. Redwood is an excellent and elegant choice. Your local timber supplier can advise you of available options.

The Fasteners used are 1-1/2-in. deck or wood screws. A 1-lb. box of all-purpose wood screws should be sufficient for this job.

Tools
Tools needed include:

Power Drill

Circular Saw

Square

Tape Measure

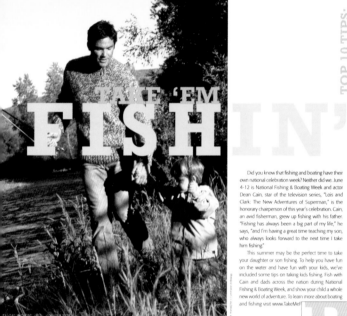

TOP 10 TIPS:

TAKE 'EM FISHIN'

1. **Start small.** Smaller fish are often more abundant, easier to find and easier to catch. Kids think "catching" when adults say "fishing" — going after smaller fish usually means more catching. Use small hooks and add a bobber for more action and greater success.

2. **Go where the action is.** Check with local bait and tackle stores or look up the local fish and wildlife agency in your phone book to find well-stocked fishing spots for ideal first-outing destinations. There are likely one or two only a short drive from your front door.

3. **Get kids their own equipment.** They'll appreciate the experience all the more with their own equipment. Rod and reel combos for kids can be purchased for about $15 at your local sporting goods store. These affordable packaged sets are great for those new to the sport.

4. **Use live bait.** Earthworms, crickets, minnows and other live bait are often the most productive, and collecting them is half the fun.

5. **Keep it short and sweet.** Limit the time you'll be on the water. Leave while enthusiasm's high, before the kids start to get antsy. If you end the day on a high note, they'll be hooked on coming back.

6. **Focus on fun.** Put the kids first. Remember, there's a world of difference between "taking them fishing" and the kids "going fishing with you." Concentrate on their experience and save your casts for another day.

7. **Brush up on the basics.** If you haven't been fishing in a while, the internet is a great source for information. The public service website www.TakeMeFishing.org is a great place to start.

8. **Be safe.** If you're going to have your kids in a boat on the water, make sure everyone wears snug-fitting personal flotation devices at all times. Bring plenty of water to keep hydrated on hot days, and don't forget the sun block.

9. **Let them be captain for the day.** If you're fishing from a boat, take time to teach your kids the basics of how a boat works. You might even teach them how to steer.

10. **Don't forget your camera.** Of course you'll want to capture the moment your child catches his or her first fish. Don't let this memory be the

Did you know that fishing and boating have their own national celebration week? Neither did we. June 4-12 is National Fishing & Boating Week and actor Dean Cain, star of the television series, "Lois and Clark: The New Adventures of Superman," is the honorary chairperson of this year's celebration. Cain, an avid fisherman, grew up fishing with his father. "Fishing has always been a big part of my life," he says, "and I'm having a great time teaching my son, who always looks forward to the next time I take him fishing."

This summer may be the perfect time to take your daughter or son fishing. To help you have fun on the water and have fun with your kids, we've included some tips on taking kids fishing. Fish with Cain and dads across the nation during National Fishing & Boating Week, and show your child a whole new world of adventure. To learn more about boating and fishing visit www.TakeMeF

1 _____

READ, READ: books for children

Books are a great way to spend time with your children, to foster their imagination, and to open new worlds for them. Reading with your child, even your newborn, is an activity every father should relish.

Want to know what kids are reading?
DIANE MANGAN, Category Director of Children's books at Borders Books and Music, has furnished a list of a few of the top selling children's titles available at Borders.

Baby
(0–18 months)

1. Goodnight Moon by Margaret Wise Brown
2. Very Hungry Caterpillar by Eric Carle
3. Brown Bear, Brown Bear, What Do You See? by Bill Martin, Jr.
4. Pat the Bunny by Dorothy Kunhardt
5. Snuggle Puppy by Sandra Boynton

Toddler
(18–36 months)

1. Goodnight Moon by Margaret Wise Brown
2. Happy Baby Colors by Roger Priddy
3. Happy Baby Animals by Jo Douglass and Nerville Graham
4. Cheerios Play Book by Lee Wade
5. Elmo's Big Lift & Look Book by Ann Ross

Preschool
(3–4 years)

1. Tails by Matthew Van Fleet
2. Clap Your Hands: Elmo Puppet by Joseph Ewers, Illustrator
3. Ten Little Ladybugs by Melanie Gerth
4. Elmo's Play Day: Plush Sound Set by Publications International
5. Disney Animals Friends Movie Theater: Storybook and Projector by Sarah Heller

Read Together
(4–6 years)

1. Green Eggs and Ham by Dr. Seuss
2. The Lorax by Dr. Seuss
3. Go, Dog, Go! by P.D. Eastman
4. The Sneetches and Other Stories by Dr. Seuss
5. Are You My Mother? by P.D. Eastman

Learn to Read
(4–7 years)

1. Animal Antics: Now I'm Reading by Nora Gaydos
2. The Cat in the Hat: Cooking with the Cat by Bonnie Worth
3. Dora's Picnic: Ready to Read Series by Christine Ricci
4. Playful Pals, Level 1 by Nora Gaydos
5. Amelia Bedelia: 40th Anniversary Collection by Peggy Parish

Read to Myself
(7–9 years)

1. Summer of the Sea Serpent by Mary Pope Osborne
2. Top Secret Personal Beeswax: A Journal by Junie B. (and Me!) by Barbara Park
3. Junie B., First Grader: Boo ... I Mean It by Barbara Park
4. Captain Underpants and the Big, Bad Battle of the Bionic Booger Boy, Part 2: The Revenge of the Ridiculous Robo-Boogers by Dav Pilkey
5. Junie B. Jones's First Board Set Ever! by Barbara Park

Independent Reader
(8–12 years)

1. The Bad Beginning, Book the First (A Series of Unfortunate Events) by Lemony Snicket
2. Tale of Despereaux by Kate DiCamillo
3. Inkheart by Cornelia Funke
4. The Reptile Room, Book the Second (A Series of Unfortunate Events) by Lemony Snicket
5. Harry Potter Limited Edition Box Set (Books 1-5) by J.K. Rowling

CLASSICAL MUSIC

New Music, With Training Wheels
James Levine and the Boston Symphony ease their audience out of the standard repertory.
BY PETER G. DAVIS

A PPARENTLY CONDUCTORS LIKE to teach as much as they enjoy entertaining people or simply showing off, since nearly all orchestral concerts nowadays have some sort of instructive premise. James Levine has not yet spent a full season as the Boston Symphony's new music director, but he is already giving his audiences plenty of what he thinks is good for them, especially new music. No doubt many listeners object to taking their medicine, but that hardly keeps Dr. Levine from vigorously administering fresh doses. The orchestra's latest visit to Carnegie Hall offered new scores by two of Levine's favorite contemporaries—John Harbison and Charles Wuorinen, both born in 1938—and in between was Stravinsky's severe and tersely compressed twelve-tone *Movements for Piano and Orchestra*, a late work completed in 1959. The Brahms Second Symphony came last—not exactly a sweetmeat, but in this context definitely a spoonful of sugar.

That said, only ears averse to the prospect of hearing new music of any kind would have been offended by this invigorating concert. Harbison's *Darkbloom: Overture for an Imagined Opera* is a positively gorgeous seven-minute curtain-raiser, woven from an assortment of thematic strands that throb with a mysterious lyrical power quite unlike anything I've heard from this composer. The "imagined opera" in this case was to be based on Nabokov's *Lolita*, a project Harbison abandoned after the subject matter began to strike him as untenable in today's climate. Too bad, since he was clearly responding to something in the material with unusual urgency.

Wuorinen's new work is a three-movement piano concerto, the fourth such piece in this composer's huge catalogue. It was composed to order for Levine and

BOSTON SYMPHONY ORCHESTRA
JAMES LEVINE, CONDUCTOR.
PETER SERKIN, PIANO. CARNEGIE HALL.

ORCHESTRA OF SAINT LUKE'S
"POSTCARD FROM PRAGUE."
DONALD RUNNICLES, CONDUCTOR.
IVAN MORAVEC, PIANO. CARNEGIE HALL.

Peter Serkin, who warmed up for it by playing Stravinsky's *Movements* with grace and precision. He then threw himself enthusiastically into Wuorinen's new score, which, without losing its intellectual rigor for a moment, generates a compellingly theatrical play of light and dark moods, all created through a delicious blend of instrumental sonorities, lucid organizational clarity, and clever manipulation of the keyboard's coloristic resources. A virtuoso pianist is required, of course, and Serkin has exactly what it takes to make this concerto glitter.

As for Levine, he gives every impression of being rejuvenated by his new association. In any case, it was high time for him to put some distance between himself and the crazy politics of the Metropolitan Opera after all these years and take over a major American orchestra, where he can settle down and make music without extramusical distractions. That already seems to be happening in Boston, and perhaps this exceptionally gifted musician will fulfill himself at last.

"POSTCARD FROM PRAGUE" was the theme of Donald Runnicles's recent concert with the Orchestra of Saint Luke's at Carnegie Hall. Even though he wasn't Czech, Mozart dominated the proceedings, and why not? He was admired in Vienna, but they loved him in Prague, and the composer wrote some of his noblest scores for that city's discerning audiences, two of them back-to-back in 1786: Symphony No. 38 and Piano Concerto No 25. The former was given a spruce, musically alert performance, but the concerto had a special glow, thanks to Ivan Moravec's exquisitely tailored playing of the solo part.

The two authentic Czech scores on the program are both rarities. The three excerpts from Janáček's *Idylla* for strings had in fact never before been played in Carnegie Hall, and it's a pity the whole suite wasn't offered. This music predates most of the tougher Janáček we usually hear, but that distinctively life-affirming voice is unmistakable in these charming evocations of Moravian country life. A ballet featuring amorous kitchen utensils, Martinů's saucy *La Revue de Cuisine* for six instruments actually leaves Prague far behind as it embraces the jazz-soaked music scene in Paris, where the composer was living and working during the twenties. This is most definitely a postcard from France. Its witty message may have a heavy Czech accent, but that doesn't really matter—some composers seem to feel comfortably at home anywhere, Martinů in Paris no less than Mozart in Prague. ∎

Illustration by Sean McCabe

APRIL 18, 2005 | NEW YORK 79

1_____
DESIGN FIRM
Jill Lynn Design
Jersey City, (NJ) USA
PROJECT
Real Dad Magazine
ART DIRECTOR, DESIGNER
Jill Balkus

2_____
DESIGN FIRM
New York Magazine
New York, (NY), USA
CLIENT
New York Magazine
DESIGN DIRECTOR
Luke Hayman
ART DIRECTOR
Chris Dixon
PHOTO DIRECTOR
Jody Quon
DESIGNER
Steve Motzenbecker
ILLUSTRATOR
Sean McCabe

2_____

1_____

DESIGN FIRM
maycreate
Chattanooga, (TN) USA

CLIENT
Marlin Payment Solutions

CREATIVE DIRECTOR, PHOTOGRAPHER
Brian May

ART DIRECTOR, DESIGNER
Grant Little

COPYWRITER
Kristina Kollar

PRINTER
Creative Printing

2_____

DESIGN FIRM
Greenlight Designs
North Hollywood, (CA) USA

CLIENT
TMG Marketing for PINZ Bowling

CREATIVE DIRECTOR
Tami Mahnken

SENIOR DESIGNER
Melissa Irwin

DESIGNER
Shaun Wood

PHOTOGRAPHER
Darryl Shelly

Advertising
must scream,
whisper
or purr its message
loud and clear
enough to
grab our interest

Ⓙ Ⓦ Ⓓ

BRAND 3 EFFORTS

THE REAL KEY TO MARKET LEADERSHIP IS PERCEIVED QUALITY. BECAUSE QUALITY IS DRIVEN BY PERCEPTION, BRANDING IS A KEY ISSUE IN ATTAINING AND KEEPING MARKET LEADERSHIP. THE POWER THAT SIMPLY COMES FROM BEING A LEADER GIVES A BRAND ALL SORTS OF OTHER ADVANTAGES, FROM BARGAINING POWER WITH DISTRIBUTION TO A GENERAL AURA OF QUALITY.

529.8833 Ⓙ Ⓦ Ⓓ 372.5355

QUALITY MARKETING MATERIALS

THE REAL Key TO MARKET LEA

HIGH OCTANE

MARKETING MATERIALS

Ⓙ Ⓦ Ⓓ

3_____

100% AUTHENTIC
ORIGINAL
VINTAGE ★ STYLE
HONOLULU

NO. 306

LOOK FOR THIS SEAL
IT IS YOUR QUALITY
ASSURANCE ☛ Ⓙ Ⓦ Ⓓ

FIRST & BEST

ACCEPT NO SUBSTITUTES · DEMAND THE FINEST!

3_____

DESIGN FIRM
John Wingard Design
Honolulu, (HI) USA
CLIENT
John Wingard Design
ART DIRECTOR, DESIGNER
John Wingard

DIRTWORKS™ PC
LANDSCAPE ARCHITECTURE
200 PARK AVENUE SOUTH
NEW YORK, NEW YORK 10003

NEW Projects

NEW Photos

NEW Information

Company News

Dirtworks invites you to look
at their updated web site.

www.dirtworks.us

TEL 212-529-2263 FAX 212-505-0904
EMAIL INFO@DIRTWORKS.US

1_____

Your favorite sports teams!
Sold-out concerts! Black-tie award shows!
NOW YOU CAN BE THERE LIKE NEVER BEFORE!

Go. See. Do. More.
Welcome to GES!

The right connection can get you and your clients into any
venue, and into the seats (or suites) that are guaranteed to
make a lasting impression. With GES, you can treat clients
to the hottest events...and escort them to some of the best
seats in the house!

**Why take sky-high ticket
prices sitting down?**

Season tickets can work for some companies, but what
about all those other events your clients are clamoring for?
Unscrupulous ticket brokers? The more we use them, the
broker we get! Five, ten, twenty thousand dollars...how
much will your company spend before you realize there's a
better way to go?

Our clients understand how our membership fees combine to
give us greater buying power. In other words, a better return
on your entertainment investment and access to better
shows, better seats, and better prices.

Be sure to mention this invitation
he first 40 companies accepted for membership will r
good for any event of your cho

**Why settle for just seeing the stars when
you can get treated like one?**

• The connection you need...and no excessive markups

• The freedom to cherry-pick the events you most want to see

• Personal concierge service: golf, dinner and travel arrangements, too

• A one-of-a-kind employee benefit they'll actually use and rave about

2_____

YOU ARE CORDIALLY INVITED
TO DO WHATEVER
THE HELL YOU WANT.

1_____
DESIGN FIRM
Acme Communications, Inc.
New York, (NY) USA
PROJECT
Dirtworks Postcard
DESIGNERS
Kiki Boucher,
Andrea Ross Boyle

2_____
DESIGN FIRM
JUNGLE 8/creative
Los Angeles, (CA) USA
CLIENT
Green Entertainment Services
CREATIVE DIRECTOR,COPYWRITER
Scott Silverman
DESIGNERS
Lainie Siegel, Gracie Cota

WINE SPECTATOR's

bring your own
Magnum Party
in Napa

Marvin R. Shanken, Editor & Publisher, WINE SPECTATOR
Cordially invites you to attend our annual

bring your own
Magnum Party
in Napa

on the occasion of the Napa Valley Wine Auction

Wednesday, June 2, 2004 ▪ 6:30 pm
Tra Vigne ▪ 1050 Charter Oak Avenue ▪ St. Helena

Buffet Dinner and Dancing

We look forward to seeing you...

Thomas Matthews, Executive Editor ▪ Kim Marcus, Managing Editor
Harvey Stelman, Editor at Large ▪ James Laube, Senior Editor
Daniel Sogg, Associate Editor ▪ Tim Fish, Associate Editor
MaryAnn Worobiec, West Coast Tasting Coordinator
Miriam Morgenstern, V. P., Associate Publisher ▪ Cynthia McGregor O'Donnell,
V.P., Managing Director, West Coast ▪ Connie McGilvray,
Senior V.P., Administration/Advertising Sales and Services ▪ Lindsey Hall,
West Coast Account Manager ▪ Paulette Williams, Director, Event Marketing

3_____

3_____
DESIGN FIRM
M. Shanken Communications, Inc.
New York, (NY) USA
PROJECT
Napa Magnum Party
ART DIRECTOR, DESIGNER
Chandra Hira
ILLUSTRATOR
Claire Fraser/Imagezoo

4_____
DESIGN FIRM
A3 Design
Charlotte, (NC) USA
CLIENT
A3 Design
DESIGNERS
Alan Altman,
Amanda Altman,
Steven McGinnis

4_____

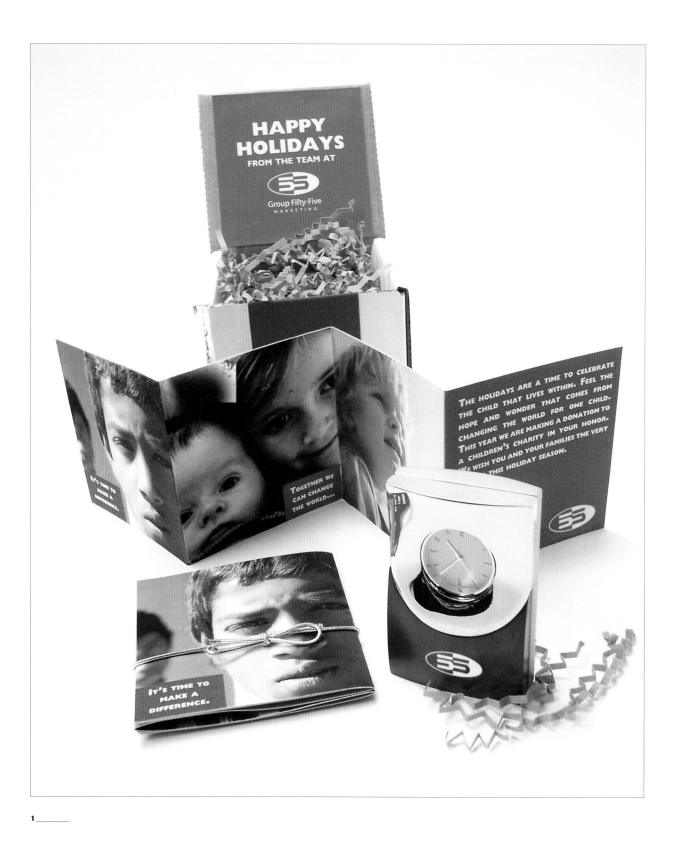

1_____

Sonja Foshee *photographer*

Individual and group portraits are an **investment in your family, preserving the memories of a lifetime.** Sonja Foshee produces **creative, memorable portraits** by spending time with her clients and **beautifully capturing** their style and personality in her images.

CHILDREN'S PORTRAITS | **COLOR ENHANCED PORTRAITS** | **SENIOR PORTRAITS** | **FAMILY PORTRAITS** | **BLACK & WHITE PORTRAITS**

4 _____

1 _____
DESIGN FIRM
Jill Lynn Design
Jersey City, (NJ) USA
CLIENT
The Atlanta Literary Festival
ART DIRECTOR, DESIGNER
Jill Balkus

2 _____
DESIGN FIRM
atomz i! pte ltd
Singapore
CLIENT
Economic Development Board
ART DIRECTOR
Albert Lee
DESIGNER
Lam Oi Ee
COPYWRITER
Kestrel Lee

3 _____
DESIGN FIRM
MC Creations Design Studio, Inc.
Hicksville, (NY) USA
CLIENT
MC Creations
Design Studio, Inc.
DESIGNERS
Michael Cali,
Cynthia Morillo

4 _____
DESIGN FIRM
little bird communications
Mobile, (AL) USA
PROJECT
Sonja Foshee Portraits Card
DESIGNER
Diane Gibbs
PHOTOGRAPHER
Sonja Foshee

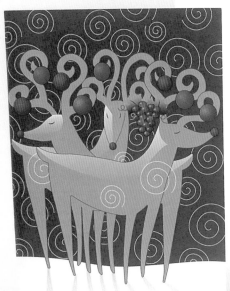

May the
Spirit Of The Season
Be With You
All Year!

Group 55 Marketing

Catch the Holiday Spirit!

1_____

Fully integrated accounting software with powerful Web and analytic capabilities.

With Envision, you're no longer chained to your desk when providing services for your clients. Staff working offsite can securely enter timesheets, submit expenses, and perform other personnel and project management functions via the Internet. The results? *Increased client satisfaction. Enhanced revenue. Lower costs.*

Envision is fully integrated, so your entire organization can easily access hundreds of up-to-the-minute financial reports with extensive drill-down analytic capabilities.

Choose **Small Business, Standard,** or **Enterprise Edition.** Conversion is easy, with full support. All components are included, and no additional seat license fees!

Visit our website for details and receive your FREE gift:
www.envisionaccounting.com/engineering.html

"Envision Accounting met and

exceeded our expectations …

(It) gives us the tools we need

to determine the health of

our business, and to ensure

that we are keeping our

projects profitable."

— **TERRY M. STULC**
PRESIDENT
TRINDERA ENGINEERING, INC.

Envision
ACCOUNTING MADE EASY

13809 212th Drive N.E.
Woodinville, WA 98072

Prsrt Std
US Postage
PAID
Blaine, WA
Permit No. 106

2_____

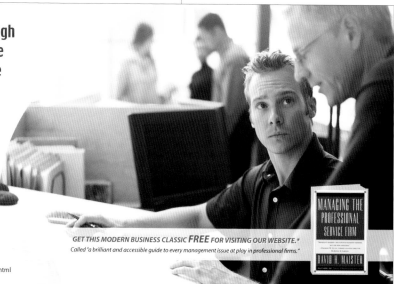

Discover Breakthrough Accounting Software Designed to Enhance Your Profitability

Developed specifically for **engineers** and other **professional service firms,** Envision is packed with advantages that other accounting packages either don't have or charge too much for.

Envision
ACCOUNTING MADE EASY

www.envisionaccounting.com/engineering.html

*GET THIS MODERN BUSINESS CLASSIC **FREE** FOR VISITING OUR WEBSITE.* *
Called "a brilliant and accessible guide to every management issue at play in professional firms."

MANAGING THE
PROFESSIONAL
SERVICE FIRM

DAVID H. MAISTER

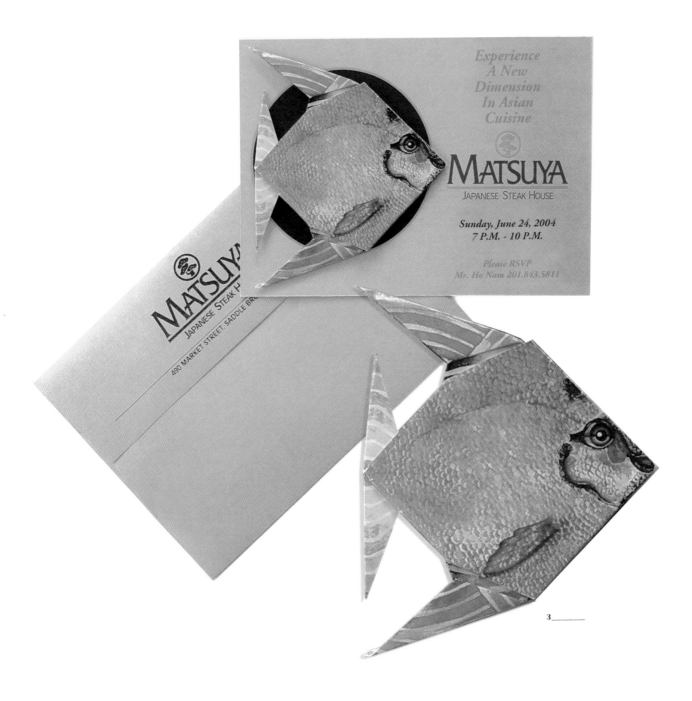

Experience
A New
Dimension
In Asian
Cuisine

MATSUYA
JAPANESE STEAK HOUSE

Sunday, June 24, 2004
7 P.M. - 10 P.M.

Please RSVP
Mr. Ho Nam 201.843.5811

3_____

1_____
DESIGN FIRM
Group 55 Marketing
Detroit, (MI) USA
PROJECT
Group 55 Holiday Card 2004
DESIGNER, ILLUSTRATOR
Jeannette Gutierrez
COPYWRITER
Catherine Lapico

2_____
DESIGN FIRM
Ray Braun Design
Seattle, (WA) USA
PROJECT
Envision Postcard
CREATIVE DIRECTOR
Ray Braun
DESIGNER
Dave Simpson
COPYWRITER
Al Lefcourt

3_____
DESIGN FIRMS
**Stephen Longo Design Associates and
Media Consultants**
West Orange, (NJ) USA
CLIENT
Matsuya Japanese Restaurant
DESIGNER
Stephen Longo
COPYWRITER
Harvey Hirsch

ECHO IS

A THROBBING METROPOLIS

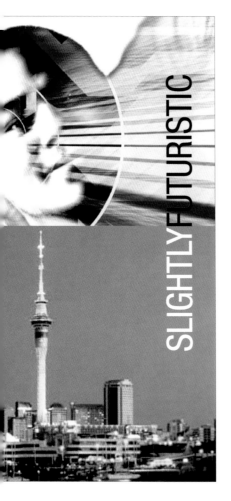

SLIGHTLYFUTURISTIC

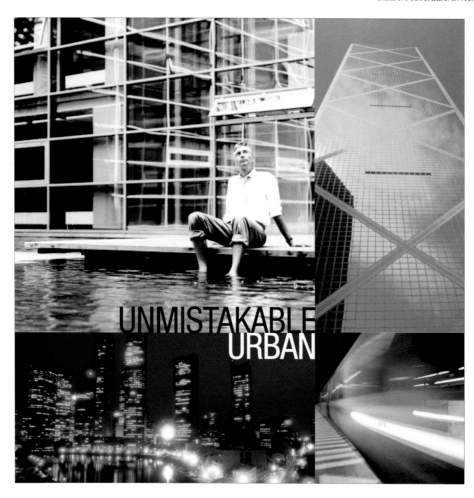

UNMISTAKABLE
URBAN

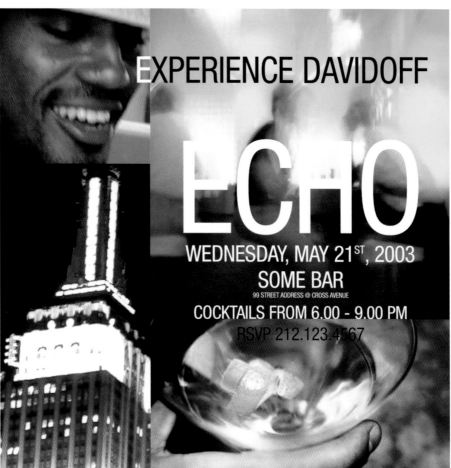

EXPERIENCE DAVIDOFF

ECHO

WEDNESDAY, MAY 21ST, 2003
SOME BAR
99 STREET ADDRESS @ CROSS AVENUE
COCKTAILS FROM 6.00 - 9.00 PM
RSVP 212.123.4567

DESIGN FIRM
Über, Inc.
New York, (NY) USA
PROJECT
ECHO Invitation
DESIGNER
Herta Kriegner

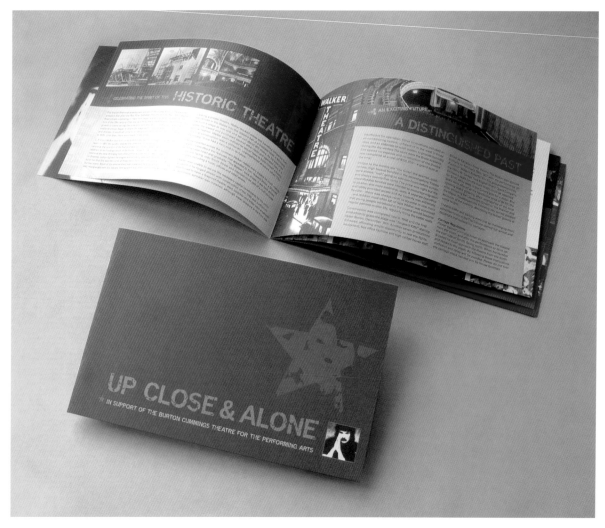

1_____

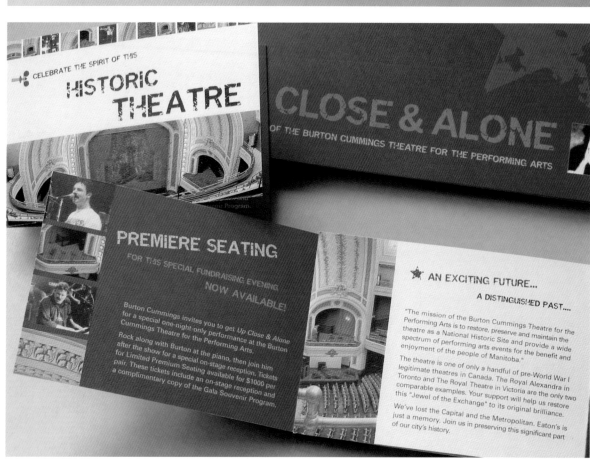

BLACK FRIDAY

Friday, November 25, 2005 6:30 a.m.–10:00 a.m.

Beauty Blowout at New York New York

Voted "Best in Frederick"
for Ten Years

301.695.7777

808 Toll House Ave.
Frederick, MD 21701

new york | new york
HAIR SALON | DAY SPA

2_____

3_____

1_____
DESIGN FIRM
 Velocity Design Works
 Winnipeg, (Manitoba) Canada
PROJECT
 Up Close & Alone
 (Burton Cummings)
CREATIVE DIRECTOR, ART DIRECTOR, DESIGNER
 Lasha Orzechowski

2_____
DESIGN FIRM
 Octavo Designs
 Frederick, (MD) USA
CLIENT
 New York New York Salon and Day Spa
ART DIRESTOR, DESIGNER
 Sue Hough

3_____
DESIGN FIRM
 Wet Paper Bag Visual Communication
 Crowley, (TX) USA
CLIENTS
 Bonita & Lewis Glaser
DESIGNER, ILLUSTRATOR, COPYWRITER
 Lewis Glaser
INSPIRATIONAL GURU
 Milton Glaser
STUDIO
 Wet Paper Bag Visual Communication

ENTERTAINER –
captivating & witty

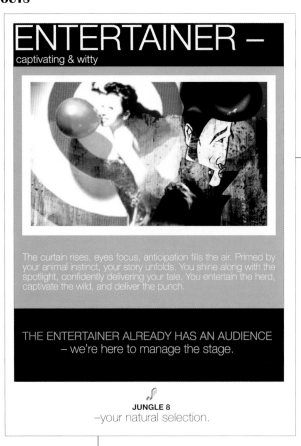

The curtain rises, eyes focus, anticipation fills the air. Primed by your animal instinct, your story unfolds. You shine along with the spotlight, confidently delivering your tale. You entertain the herd, captivate the wild, and deliver the punch.

THE ENTERTAINER ALREADY HAS AN AUDIENCE
– we're here to manage the stage.

JUNGLE 8
–your natural selection.

FIRESTARTER –
– provocateur of innovation

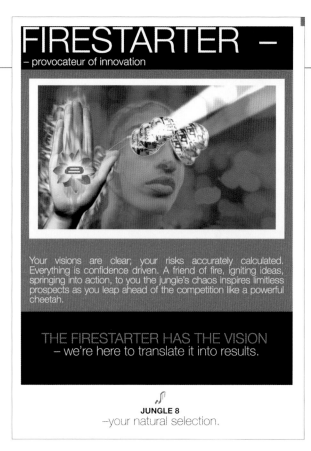

Your visions are clear; your risks accurately calculated. Everything is confidence driven. A friend of fire, igniting ideas, springing into action, to you the jungle's chaos inspires limitless prospects as you leap ahead of the competition like a powerful cheetah.

THE FIRESTARTER HAS THE VISION
– we're here to translate it into results.

JUNGLE 8
–your natural selection.

JUGGLER –
keeping it all going

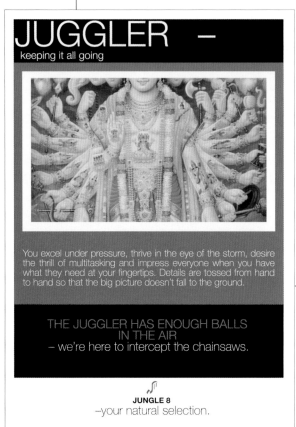

You excel under pressure, thrive in the eye of the storm, desire the thrill of multitasking and impress everyone when you have what they need at your fingertips. Details are tossed from hand to hand so that the big picture doesn't fall to the ground.

THE JUGGLER HAS ENOUGH BALLS IN THE AIR
– we're here to intercept the chainsaws.

JUNGLE 8
–your natural selection.

KING OF THE BEASTS –
proud & strong

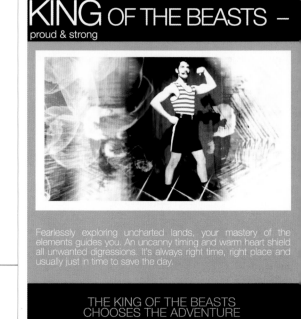

Fearlessly exploring uncharted lands, your mastery of the elements guides you. An uncanny timing and warm heart shield all unwanted digressions. It's always right time, right place and usually just in time to save the day.

THE KING OF THE BEASTS CHOOSES THE ADVENTURE
– we're here to plan your safari.

JUNGLE 8
–your natural selection.

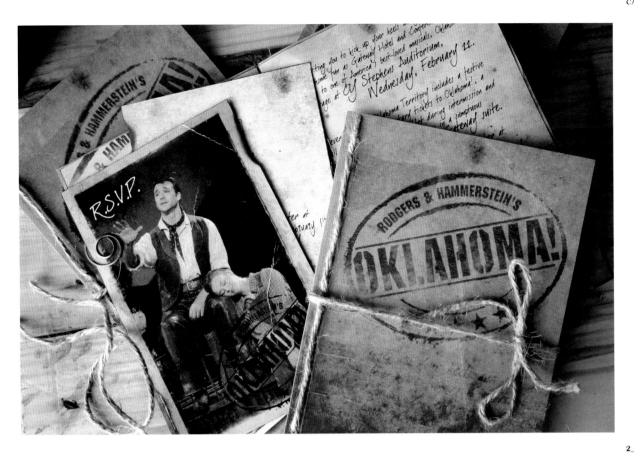

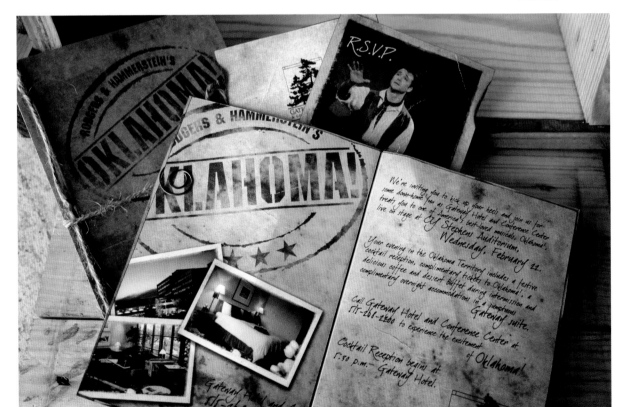

2_____
DESIGN FIRM
EdgeCore
Cedar Falls, (IA) USA
CLIENT
Gateway Hotel &
Conference Center
ART DIRECTOR
Joe Hahn
COPYWRITER
Ruth Goodman
ACCOUNT EXECUTIVE
Scott Stackhouse

1
DESIGN FIRM
Greenlight Designs
North Hollywood, (CA) USA
CLIENT
Jennifer Lowitz, Frederick's
CREATIVE DIRECTORS
Tami Mahnken,
Darryl Shelly
SENIOR DESIGNER
Melissa Irwin
DESIGNER
Shaun Wood

2
DESIGN FIRM
Gutierrez Design Associates
Ann Arbor, (MI) USA
CLIENT
Ann Arbor Ad Club
DESIGNER, ILLUSTRATOR
Jeannette Gutierrez
COPYWRITER, CONCEPT
Joanne Bandoni

November 10-12, 2005 • San Jose, CA

"This year's spectacular 10th anniversary conference event will build and strengthen the global community of coaches by providing inspiration, community, connection, education and enjoyment! "

We expect 1500 international attendees which include experienced:
- Personal and Life Coaches
- Executive and Business Coaches
- Corporate, Organization and Internal Coaches
- ICF Credentialed Coaches

As well as:
- Those interested in coaching as a business resource
- Those interested in coaching as a career choice
- And many others!

Visit www.coachfederation.org for online registration and more information

CATCH THE FIRE!
Early bird registration ends August 31

International Coach Federation®
2365 Harrodsburg Rd.
Suite A325
Lexington, KY 40504
Phone: 1-888-423-3131

RETURN SERVICE REQUESTED

PRSRT STD
U.S. POSTAGE
PAID
LEXINGTON, KY
PERMIT NO. 850

3_____

Be Inspired *Light the Fire*

International Coach Federation®
10th Annual
Conference

November 10-12, 2005
San Jose, California
USA

Honoring the Past — Celebrating the Present — Realizing Our Future

SAVE THE DATE for ICF!

3_____
DESIGN FIRM
JL Design
Plainfield, (IL) USA
PROJECT
International Coach Federation Card
DESIGNERS
JL Design

4_____
DESIGN FIRM
Desbrow
Pittsburgh, (PA) USA
CLIENT
Read! 365
DESIGNERS
Kimberly Miller,
Jason Korey

4_____

1_____

1_____

DESIGN FIRM
Group 55 Marketing
Detroit, (MI) USA

PROJECT
Group 55 Marketing
Self Promotion

ART DIRECTOR, DESIGNER
Jeannette Gutierrez

COPYWRITERS
Catherine Lapico, Jeannette Gutierrez

2_____

DESIGN FIRM
TD2, S.C.
Mexico City, Mexico

CLIENT
Nestlé Food Services Mexico

DESIGNER
Liliana Ramírez,
Adalberto Arenas

Belém do Pará, Belém de Nazaré!

DIZEM QUE O CÍRIO DE NAZARÉ É O NATAL DOS PARAENSES. DIZEM QUE A CHUVA TEM HORA PARA CAIR EM BELÉM, MAS QUASE NUNCA CHOVE NA HORA DO CÍRIO. A MÃE DE JESUS, AQUI, SE CHAMA NAZARÉ. E BELÉM É ONDE JESUS NASCEU. COINCIDÊNCIAS. MAS SERÁ QUE TODAS ESSAS COINCIDÊNCIAS SÃO, DE FATO, COINCIDÊNCIAS?

Feliz Círio de dezembro, o 2º Natal do ano.

Mendes
POR COINCIDÊNCIA, A AGÊNCIA
DO CÍRIO DE NAZARÉ

3_____

4_____

3_____
DESIGN FIRM
 Mendes Publicidade
 Belém, Brazil
PROJECT
 Mendes Christmas Card
DESIGNERS
 Oswaldo Mendes,
 Maria Alice Penna,
 Luiz Braga

4_____
DESIGN FIRM
 Velocity Design Works
 Winnipeg, (Manitoba) Canada
PROJECT
 Pixel Album
DESIGNERS
 Velocity Design Works

1_____

1_____
DESIGN FIRM
Shelly Prisella Graphic Design
Lauderdale-By-The-Sea, (FL) USA
PROJECT
Sant Meera Postcard
DESIGNER
Shelly Prisella

2_____
DESIGN FIRM
Octavo Designs
 Frederick, (MD) USA
CLIENT
 Frederick Festival of the Arts
ART DIRECTOR, DESIGNER
 Sue Hough
ILLUSTRATOR
 Mark Burrier

1

2

1
DESIGN FIRM
**Gutierrez Design
Associates**
Ann Arbor, (MI) USA
CLIENT
Automotive News
DESIGNER
Jeannette Gutierrez

2
DESIGN FIRM
**MC Creations
Design Studio, Inc.**
Hicksville, (NY) USA
CLIENT
MC Creations
Design Studio, Inc.
DESIGNERS
Michael Cali,
Cynthia Morillo

WIR FREUEN UNS IN DER PARFÜMERIE
NAEGELE UNSERE KLEINE INNENSTADT—
DEPANDANCE ZU ERÖFFNEN. ZU EINEM
PREVIEW AM 17. SEPTEMBER LADEN WIR SIE
HERZLICH EIN. BEGINN IST UM 20 UHR.

MAGNOLIA BONBON
IN DER PARFÜMERIE NAEGELE

PHILIPPINE-WELSER-STR. 26
86150 AUGSBURG

TELEFON 0821-3447150

3 _____

DER
KLEINE LUXUS
ZWISCHEN-
DURCH

magnolia bonbon

4 _____

JULY/AUGUST **MARKET WATCH**

ANNUAL **TEQUILA** ISSUE!

TEQUILA CATEGORY REPORT:
• Bartender Roundtable
Discusses What's Hot

• Super-Premiums Lead
Category Growth

LEAD FEATURE:
Supreme Court Ruling
on Direct Shipping of Wine

PLUS:
• A Look At The Pinot Noir Craze
• Retro Cocktails - Brown Spirits
• Bonus Distribution: Texas Package
Store Convention, July 31-Aug. 2

ADVERTISING CONTACTS:

Diane Leech, V.P./Associate Publisher
e-mail: dleech@mshanken.com

Tiffany Kendall, Account Manager
e-mail: tkendall@mshanken.com
Tel. 212-684-4224
Fax: 212-779-3334

Dana Pellegrini,
West Coast Account Manager
e-mail: dpellegrini@mshanken.com
Tel. 707-963-7764
Fax: 707-963-0415

SPACE CLOSING: JUNE 16 · MATERIALS DUE: JUNE 23

3 _____
DESIGN FIRM
Barbara Spoettel
New York, (NY) USA
CLIENT
Magnolia Restaurant,
Augsburg, Germany
ART DIRECTOR, DESIGNER
Barbara Spoettel

4 _____
DESIGN FIRM
M. Shanken Communications, Inc.
New York, (NY) USA
PROJECT
Market Watch Magazine E-Card Promo
Tequila Issue
ART DIRECTOR
Chandra Hira
DESIGNER
Terrence Janis

Private Moments
© 2002– Sharon DeLaCruz

Artistic Moments
Sharon DeLaCruz
© 1987– reprinted 2002

Bath Woman
Sharon DeLaCruz
© 2002

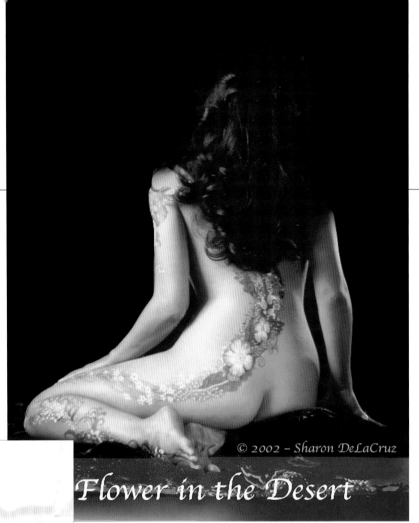

© 2002 – Sharon DeLaCruz

Flower in the Desert

www.mycreativemoments.com

DESIGN FIRM
CRMultimedia
Chicago, (IL) USA
CLIENT
Quilt Designs
CREATIVE DIRECTOR
Sharon DeLaCruz
TECHNICAL DIRECTOR
William Barrett
PHOTOGRAPHERS
Michelle McClendon, James Smestad,
Kenneth Warner, Paul Skelley

87

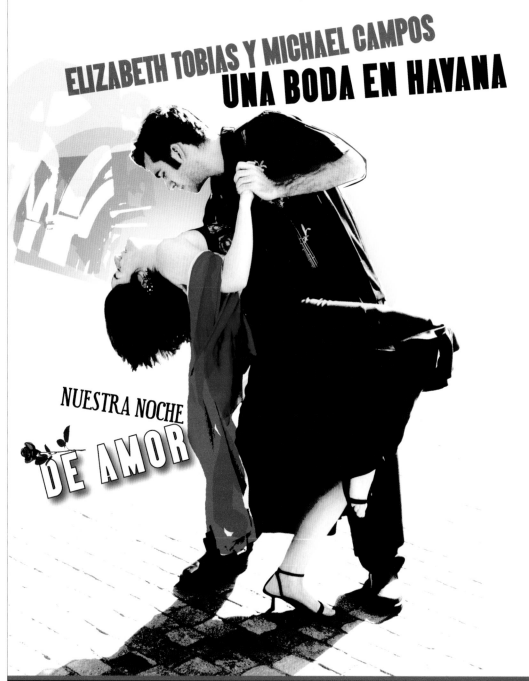

Michael ∙ Elizabeth
July 23, 2005

Michael Campos Y Elizabeth Tobias

SATURDAY THE TWENTY THIRD OF JULY, 2005 AT 6:30 IN THE EVENING
ceremony and reception
THE SPANISH KITCHEN 826 N. LA CIENEGA AVE. WEST HOLLYWOOD

cuban cocktail attire optional / menu includes vegetarian and vegan dishes

For details, hotel information and gift registry,
please visit elizabethtobias.com/wedding
or email mikeandelizabeth@gmail.com

Michael Campos Y Elizabeth Tobias

SATURDAY THE TWENTY THIRD OF JULY, 2005 AT 10:00 IN THE EVENING
champagne, cake & rhumba
THE SPANISH KITCHEN 826 N. LA CIENEGA AVE. WEST HOLLYWOOD

·cuban cocktail attire optional·

For details, hotel information and gift registry,
please visit elizabethtobias.com/wedding
or email mikeandelizabeth@gmail.com

DESIGN FIRM
JUNGLE 8 / creative
Los Angeles, (CA) USA
CLIENT
Elizabeth Tobias &
Michael Campos
CREATIVE DIRECTOR, DESIGNER
Lainie Siegel
PHOTOGRAPHER
Elizabeth Tobias

1_____

2_____

1_____
DESIGN FIRM
Mendes Publicidade
Belém, Brazil
PROJECT
"Eita verão Magazan"
DESIGNERS
Oswaldo Mendes,
Marcelo Amorim,
Walda Marques

2_____
DESIGN FIRM
Greenlight Designs
North Hollywood, (CA) USA
CLIENT
Debbie Mink, MGM
CREATIVE DIRECTORS
Tami Mahnken,
Darryl Shelly
SENIOR DESIGNER
Melissa Irwin
DESIGNER
Shaun Wood

3_____

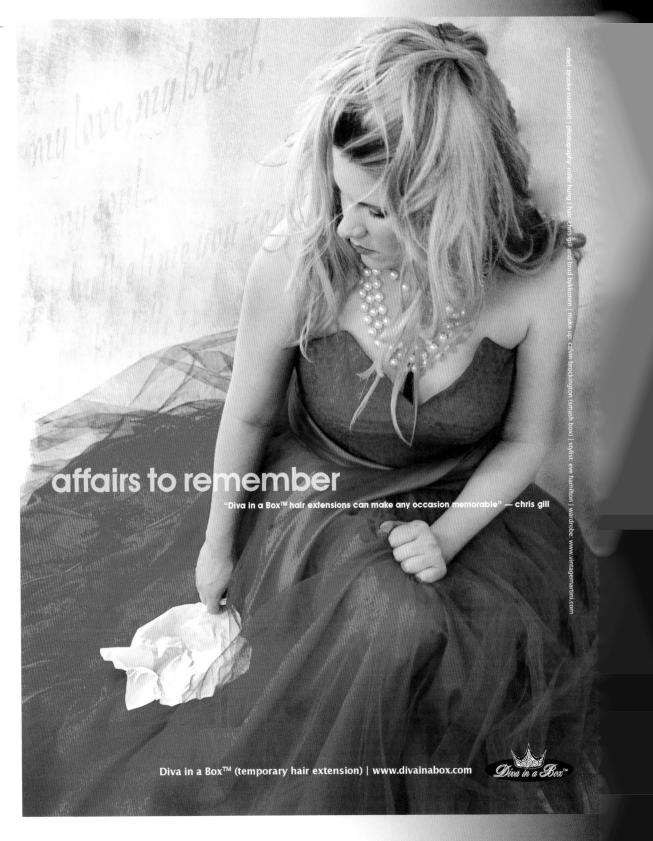

affairs to remember

"Diva in a Box™ hair extensions can make any occasion memorable" — chris gill

model: brooke (student) | photography: miler hung | hair: chris gill and brad bykkonen | make up: calvin brockington (smash box) | stylist: eve hamilton | wardrobe: www.vintagemartini.com

Diva in a Box™ (temporary hair extension) | www.divainabox.com

Diva in a Box™

3_____

DESIGN FIRM
Peterson Ray & Company
Dallas, (TX) USA

PROJECT
Nordstrom ad for Diva in a Box

CREATIVE DIRECTOR, DESIGNER,
COPYWRITER, PHOTOGRAPHER
Miler Hung

6600 WESTOWN PARKWAY IN WEST DES MOINES
ALL YOUR HOME-BUILDING EXPERTS IN ONE PLACE

We make building easy.

There are many aspects to building a home: land, financing, design, insurance, warranty and more. Regency Homes is an expert in every single one, and that means your home-building experience with us is convenient, uncomplicated and easy! Come visit our Design Center and we promise that, by the time you leave, we'll take care of every aspect of the home-building process.

Regency
HOMES

"Central Iowa's Best Builder,
And We Have The Awards To Prove It"

HOME OF THE
2·5·10
WARRANTY
THE BEST WARRANTY IN AMERICA

515-270-1497 319-395-9951 www.regencyhomes.com

ERNST & YOUNG
ENTREPRENEUR
OF THE YEAR
Winner 2004

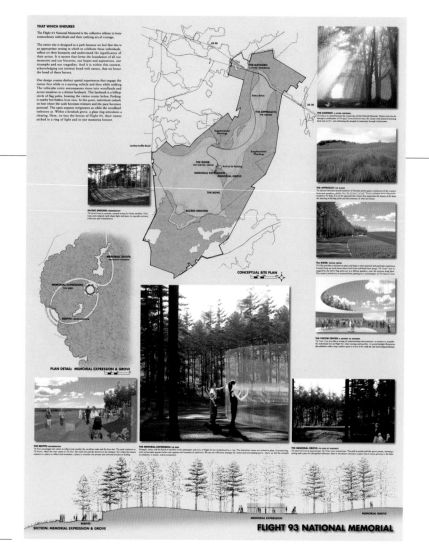

1 _____
DESIGN FIRM
Jeremy Schultz
West Des Moines. (IA) USA
CLIENT
Regency Homes
DESIGNER
Jeremy Schultz

2 _____
DESIGN FIRM
Acme Communications, Inc.
New York, (NY) USA
PROJECT
Flight 93 Competition
DESIGNERS
Kiki Boucher,
David Kamp,
Jamie Meunier,
Aras Ozgun,
Michael Rubin

2 _____

B&W
Bowers&Wilkins

WORLD LEADERS OF INTEGRATED & UPGRADEABLE HIGH-DEFINITION BIG SCREENS, PLASMA DISPLAYS, LCD PANELS. OUR NetCommandTM TECHNOLOGY PUTS YOU IN CONTROL.

LIFESTYLE UPGRADE

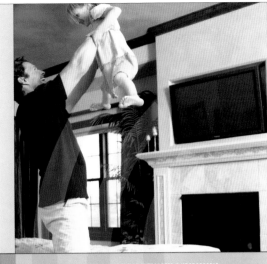

• 181 Channel tuner
• built-in speaker/
 subwoofer combination
 Digital receiver to HDTV
 LT-3050 30" LCD HD
 Upgradeable TV.
 $4499.99 Before Savings

• 181 Channel tuner
• built-in speaker/
 subwoofer combination
• Perfect Color Control System
 (individual control over each color)
• Upgradeable with the HD-5000
 Digital receiver to HDTV
 LT-3050 30" LCD HD
 Upgradeable TV.
 $4499.99 Before Savings

• 181 Channel tuner
• built-in speaker/
 subwoofer combination
• Perfect Color Control System
 (individual control over each color)
• Upgradeable with the
 Digital receiver to HDTV
 LT-3050 30" LCD HD
 Upgradeable TV.
 $4499.99 Before Savings

(((**FINE-TUNE YOUR ROOM'S ACOUSTICS**

Every surface in your room has an effect on the sound before it reaches you—that's why we carry and install acoustical materials designed to control or minimize these effects.

Acoustic foam is great for correcting the most common problems in listening environments, no matter what your room's shape or size, and it comes in varying shapes that provide a range of absorption qualities and design possibilities.

Fabric-wrapped treatments provide you with the best possible acoustics without adversely affecting the décor of the room. They are made of either fiberglass or mineral wool wrapped in acoustically transparent fabric, and are specifically engineered to absorb sound energy. We then mount the panels in the correct configuration to fine-tune your room's acoustics.

BDI

WORLD LEADERS OF INTEGRATED & UPGRADEABLE HIGH-DEFINITION BIG SCREENS, PLASMA DISPLAYS, LCD PANELS. OUR NetCommandTM TECHNOLOGY PUTS YOU IN CONTROL.

• 181 Channel tuner
• built-in speaker/
 subwoofer combination
• Upgradeable with the HD-5000
 Digital receiver to HDTV
 LT-3050 30" LCD HD
 Upgradeable TV.
 $4499.99 Before Savings.

• 181 Channel tuner
• built-in speaker/
 subwoofer combination
• Perfect Color Control System
 (individual control over each color)
• Upgradeable with the HD-5000
 Digital receiver to HDTV
 LT-3050 30" LCD HD
 Upgradeable TV.
 $4499.99 Before Savings

• 181 Channel tuner
• built-in speaker/
 subwoofer combination
• Perfect Color Control System
 (individual control
 over each color)
• Upgradeable with the
 Digital receiver to HDTV
 LT-3050 30" LCD HD
 Upgradeable TV.

3_____

4_____

3_____

DESIGN FIRM
Ellen Bruss Design
Denver, (CO) USA

CLIENT
Fidelity

CREATIVE DIRECTOR
Ellen Bruss

DESIGNER
Charles Carpenter

4_____

DESIGN FIRM
A3 Design
Charlotte, (NC) USA

PROJECT
Mulvaney Homebuilders of Charlotte Ad

DESIGNERS
Alan Altman, Amanda Altman,
Eric Formanowicz

10431 Planters View Drive
Charlotte, NC 28278
Telephone 704. 227. 9722

Planters Walk...pool, cabana, sidewalks and a playground with 2, 3 and 4 bedroom, 2 & 1/2 bath homes starting from the 160's. Minutes to Lake Wylie and easy access to I-77 and 485.

Tuesdays to Saturday 11 to 6
Sundays and Mondays 1 to 6
www.mulvaneyhomes.com

imaginethis.

A home that comes with Stainless Steel appliances including a side by side refrigerator, stainless steel smooth top range and hood, microwave, dishwasher and to top it all off, granite countertops!

planterswalk

www.mulvaneyhomes.com

Now imagine that they were free.

Come by and meet **Heather Brown** at **Planters Walk**. Ask Heather about your FREE housewarming present, and your valued at over $6,000.00. There are only a few of these designer kitchen homes available so hurry in today!

Designer Kitchen package available for a limited time only, subject to change without notice. Actual kitchen may vary from photos.

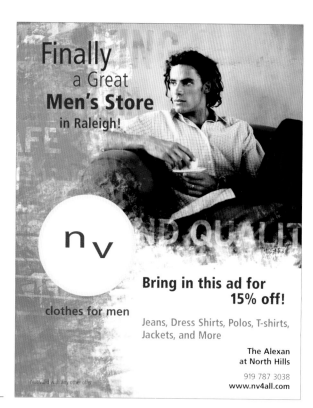

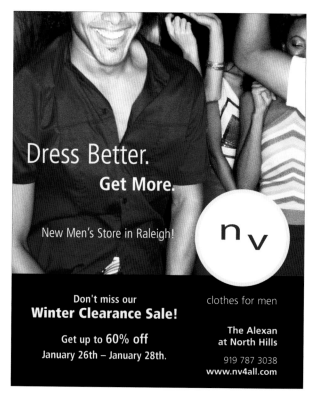

1_____

2_____

1_____
DESIGN FIRM
Little Bird Communications
Mobile, (AL) USA
DESIGNER
Diane Gibbs

2_____
DESIGN FIRM
Jeremy Schultz
West Des Moines. (IA) USA
PROJECT
Iowa Stars Campaign
DESIGNER
Jeremy Schultz

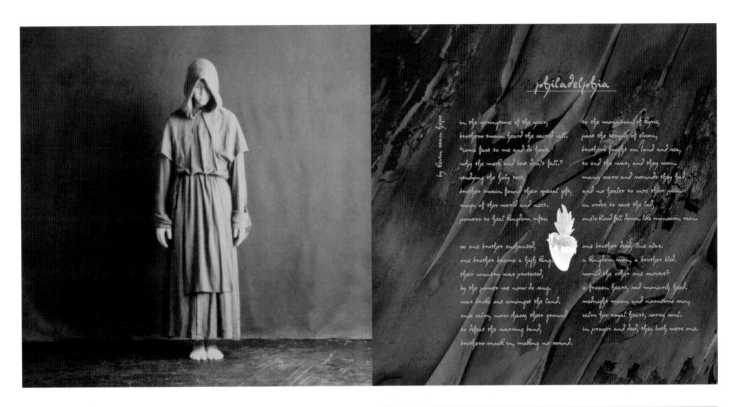

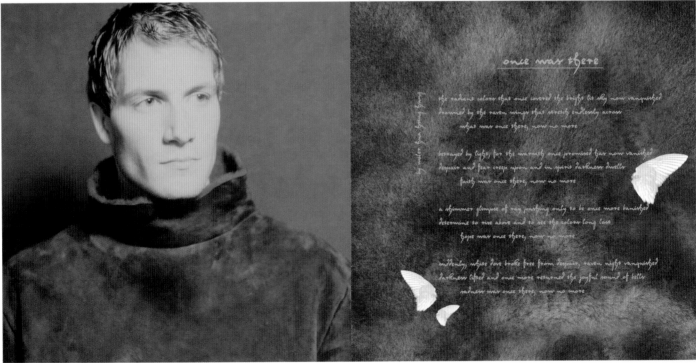

3_____

DESIGN FIRM
Peterson Ray & Company
Dallas, (TX) USA
CLIENT
Book of BE
CREATIVE DIRECTOR, DESIGNER
Miler Hung
COPYWRITER
Kevin Sean Hope
PHOTOGRAPHER
Lee Emmert

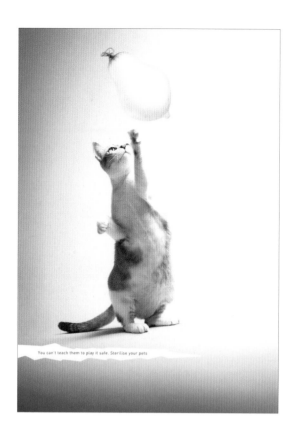

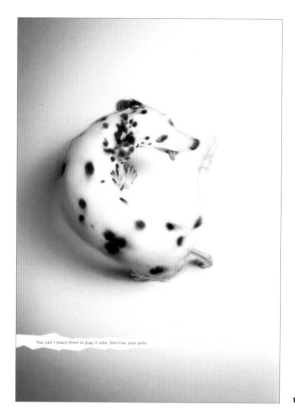

1_____

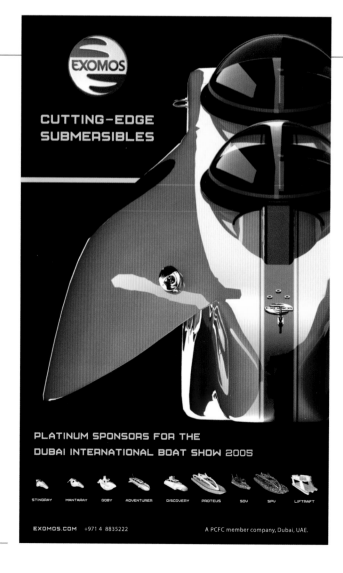

2_____

1_____

DESIGN FIRM
atomz i! pte ltd
Singapore

CLIENT
Agri-Food & Veterinary
Authority of Singapore

ART DIRECTOR, DESIGNER
Albert Lee

COPYWRITER
Kestrel Lee

2_____

DESIGN FIRM
FutureBrand Brand Experience
New York (NY), USA

PROJECT
Exomos Ad

CREATIVES
Avrom Tobias, Tom Li, Tini Chen,
Brendan Oneill, Mike Williams,
Phil Rojas, Antonio Baglione,
Oliver de la Rama, Stephanie Carroll,
Carol Wolf, Mario Natarelli

4_____

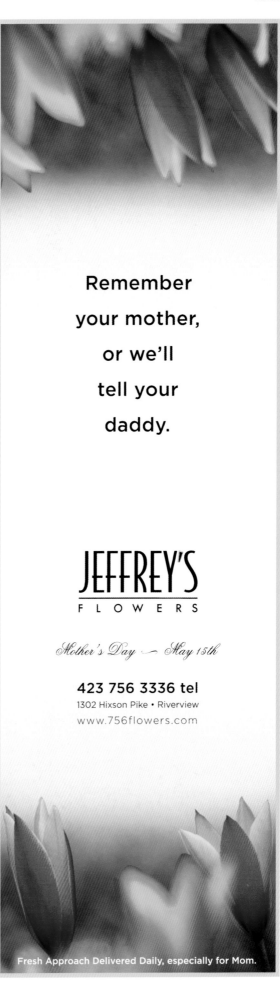

Remember
your mother,
or we'll
tell your
daddy.

JEFFREY'S
F L O W E R S

Mother's Day — May 15th

423 756 3336 tel
1302 Hixson Pike • Riverview
www.756flowers.com

Fresh Approach Delivered Daily, especially for Mom.

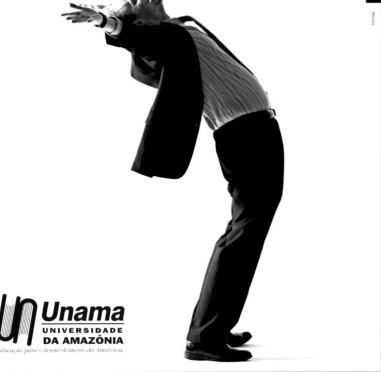

O LIBERAL

Um jornal que teve a coragem de fazer

do seu nome uma declaração de princípios.

Reiterada há 59 anos.

Un **Unama**
UNIVERSIDADE
DA AMAZÔNIA
Educação para o desenvolvimento da Amazônia.

3_____

3_____
DESIGN FIRM
Mendes Publicidade
Belém, Brazil
PROJECT
"O Liberal…"
DESIGNERS
Oswaldo Mendes,
Maria Alice Penna

4_____
DESIGN FIRM
maycreate
Chattanooga, (TN) USA
CLIENT
Jeffrey's Flowers
CREATIVE
Brian May

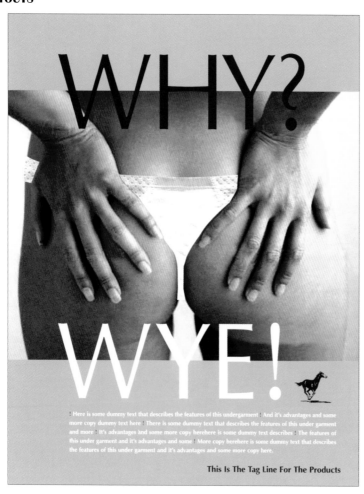

WHY?

WYE!

: Here is some dummy text that describes the features of this undergarment ! And it's advantages and some more copy dummy text here ! There is some dummy text that describes the features of this under garment and more ! It's advantages and some more copy herehere is some dummy text describes ! The features of this under garment and it's advantages and some ! More copy herehere is some dummy text that describes the features of this under garment and it's advantages and some more copy here.

This Is The Tag Line For The Products

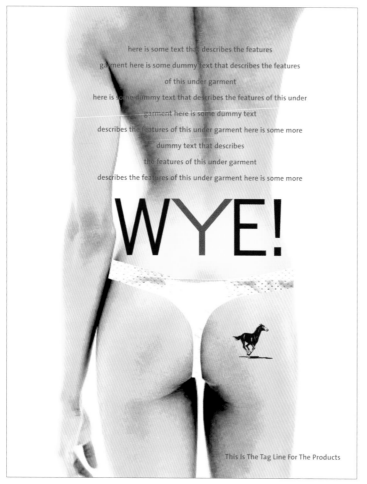

here is some text that describes the features
garment here is some dummy text that describes the features
of this under garment
here is some dummy text that describes the features of this under
garment here is some dummy text
describes the features of this under garment here is some more
dummy text that describes
the features of this under garment
describes the features of this under garment here is some more

WYE!

This Is The Tag Line For The Products

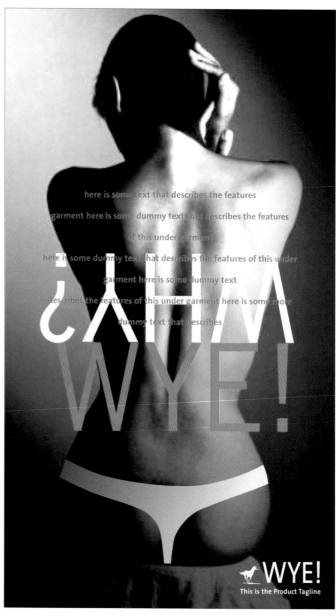

here is some text that describes the features
garment here is some dummy text that describes the features
of this under garment
here is some dummy text that describes the features of this under
garment here is some dummy text
describes the features of this under garment here is some more
dummy text that describes

¿WHY?

WYE!

WYE!
This is the Product Tagline

DESIGN FIRM
Über, Inc.
New York, (NY) USA
PROJECT
WYE Presentation
DESIGNER
Herta Kriegner

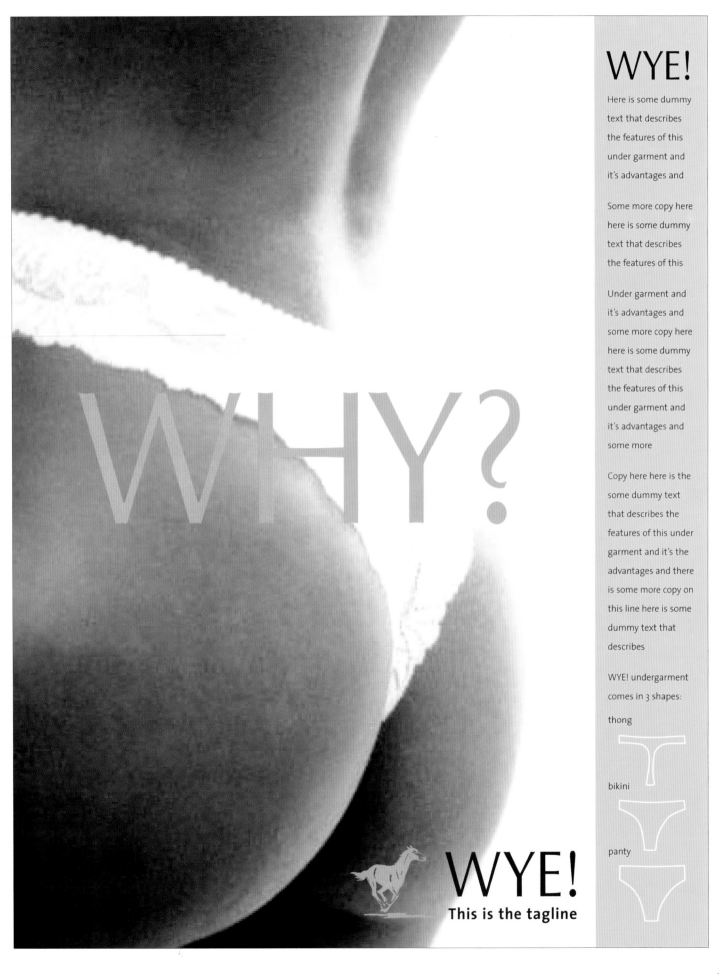

WYE!

Here is some dummy text that describes the features of this under garment and it's advantages and

Some more copy here here is some dummy text that describes the features of this

Under garment and it's advantages and some more copy here here is some dummy text that describes the features of this under garment and it's advantages and some more

Copy here here is the some dummy text that describes the features of this under garment and it's the advantages and there is some more copy on this line here is some dummy text that describes

WYE! undergarment comes in 3 shapes:

thong

bikini

panty

WYE!

This is the tagline

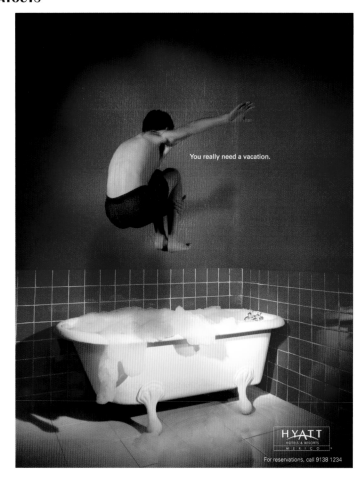

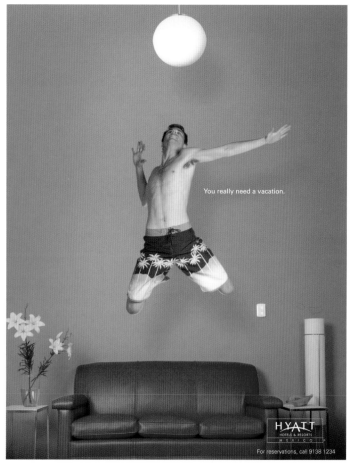

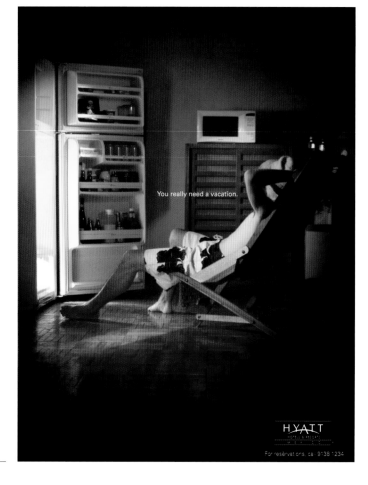

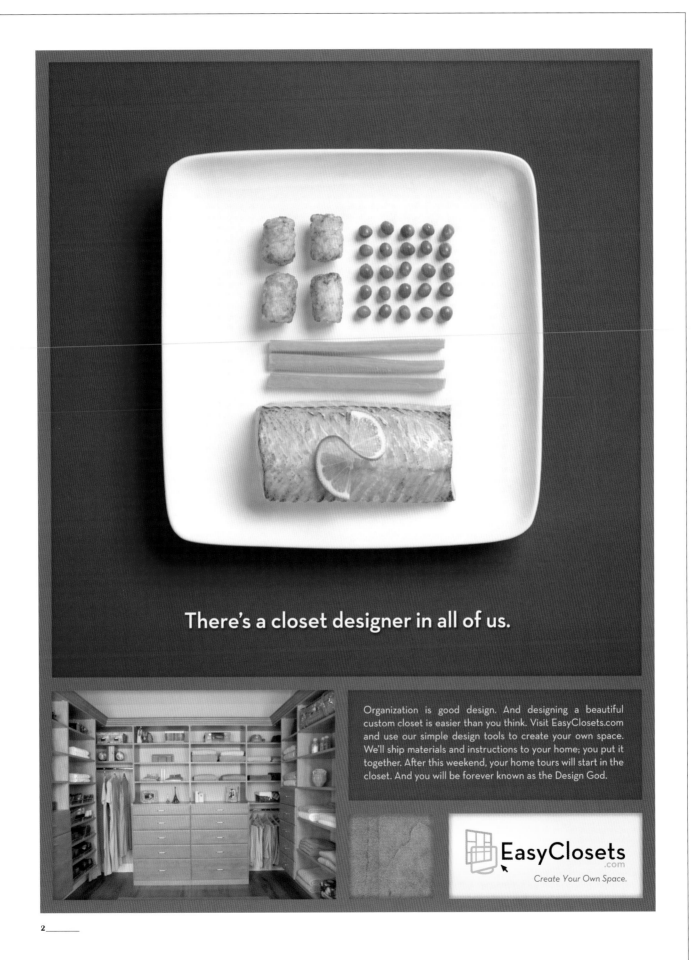

There's a closet designer in all of us.

Organization is good design. And designing a beautiful custom closet is easier than you think. Visit EasyClosets.com and use our simple design tools to create your own space. We'll ship materials and instructions to your home; you put it together. After this weekend, your home tours will start in the closet. And you will be forever known as the Design God.

EasyClosets.com

Create Your Own Space.

2_____

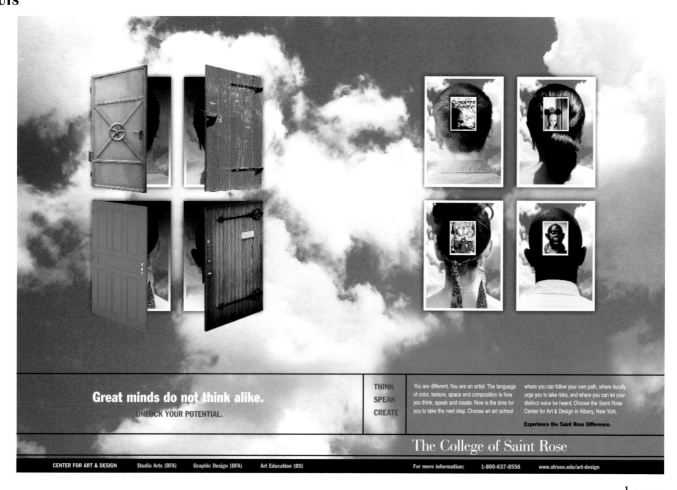

1_____

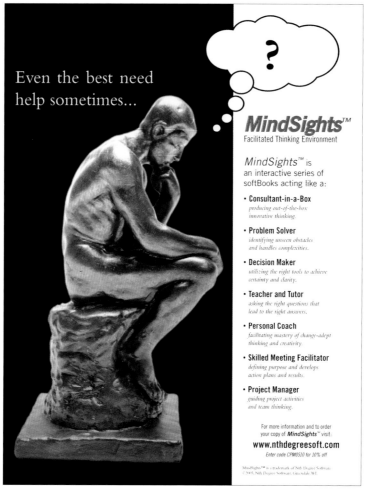

2_____

1_____

DESIGN FIRM
The College of Saint Rose
Albany, (NY) USA

PROJECT
Center for Art & Design Ad

ART DIRECTOR
Mark Hamilton

ILLUSTRATOR
Chris Parody

COPYWRITERS
Mark Hamilton, Lisa Haley Hamilton

2_____

DESIGN FIRM
TAMAR Graphics
Waltham, (MA) USA

CLIENT
Nth Degree Software

DESIGNER
Tamar Wallace

PHOTOGRAPHER
Alan McCredie

EMTEK PRODUCTIONS,INC.

Tel | 1.800.356.2741 | 1.800.428.4889 | 1.626.961.0413

Fax | 1.800.5775771 | 626.336.2812

Brass Accessories

Flush Bolts

Product Code:

▸ 8501 | 6" Brass Flush Bolt, Square Corners with Strike and Screws

▸ 8502 | 6" Brass Flush Bolt, Radius Corners with Strike and Screws

Finish:

Polished Brass
Antique Brass
French Antique Brass
Oil Rubbed Bronze
Satin Nickel
Pewter
Polished Chrome

List Price
$10.50

Casement Window Latches

Side Surface Mortise

Product Code:

▸ 8700 | Casement Window Latch with Side Mount Strike and Screws

▸ 8701 | Casement Window Latch with Surface Mount Strike and Screws

▸ 8702 | Casement Window Latch with Mortise Mount Strike and Screws

Finish:

Polished Brass
Antique Brass
French Antique Brass
Oil Rubbed Bronze
Satin Nickel
Pewter
Polished Chrome

List Price
$7.50

Addendum H · 2004

3_____

3_____
DESIGN FIRM
Mayhem Studios
Los Angeles, (CA), USA
PROJECT
Emtek Brass Ad
DESIGNER
Calvin Lee

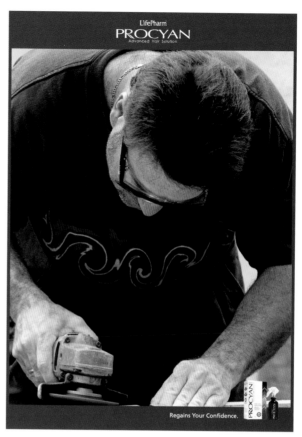

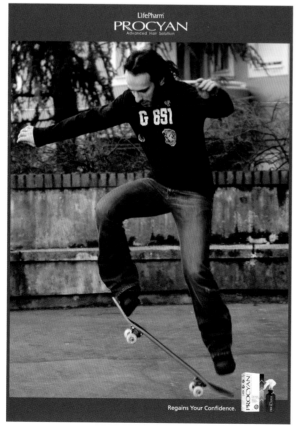

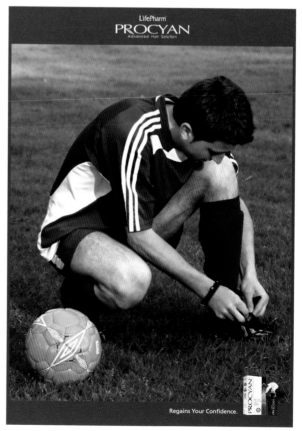

1

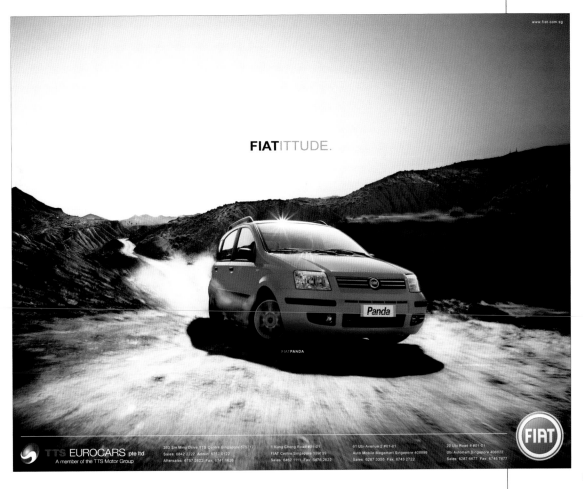

1_____
DESIGN FIRM
Lifepharm Pte Ltd
Singapore
CLIENT
Lifepharm Pte Ltd
DESIGNER
Bernard Chia

2_____
DESIGN FIRM
**Planet Ads and
Design Pte Ltd**
Singapore
CLIENT
Fiat
DESIGNERS
Hal Suzuki,
Michelle Lauridsen

1_____

DESIGN FIRM
FutureBrand Brand Experience
New York, (NY) USA

PROJECT
Taqa Advertisement

CREATIVE DIRECTOR
Diego Kolsky

DESIGNER
Mike Williams

ACCOUNT DIRECTOR
Samar Samuel

PRINCIPAL
Raymond Chan

2_____

DESIGN FIRM
Jeff Fisher LogoMotives
Portland, (OR) USA

CLIENT
VanderVeer Center

ART DIRECTOR
Elizabeth VanderVeer, MD

DESIGNER
Jeff Fisher

PHOTOGRAPHER
Loma Smith

„Ausgezeichnete
Ausbildung."

DI (FH) Caroline Hofstätter, MAGNA Steyr

MEDIZINISCHE INFORMATIONSTECHNIK

⋯⇢ Caroline Hofstätter kam aus Graz an die FH Kärnten und widmete sich dort der
Medizinischen Informationstechnik. Sie absolvierte ein Praktikum bei Flextronics,
wo sie sich später, im Rahmen ihrer Diplomarbeit, mit tragbaren EKG-Geräten
befasste. Inzwischen ist sie auf einem weiteren interessanten Gebiet tätig: Sie
arbeitet bei MAGNA Steyr an der Entwicklung eines mobilen Energiespeichers.

Mehr über die Studienangebote aus Technik, Gesundheit, Wirtschaft und Soziales: **www.fh-kaernten.at**

3_____

„Konventionelle Grenzen
durch Technik erweitern."

Christoph Riedl, Student

EQUIPMENT ENGINEERING

⋯⇢ Christoph Riedl ist Student des Bakkalaureatsstudiums Equipment Engineering
an der FH Kärnten. Dieses einzigartige Studium konzentriert sich auf die kreative
Kombination von Software, Elektronik und Mechanik. So ist auch sein derzeitiges
Entwicklungsprojekt an der FH auf diese Schnittstellen mit dem Menschen
ausgerichtet: sein Team entwickelt eine „Mechanische Hand".

Mehr über die Studienangebote aus Technik, Gesundheit, Wirtschaft und Soziales: **www.fh-kaernten.at**

„Studieren mit Qualität
und Praxisbezug."

DI (FH) Peter Reisner, Infineon Villach

TELEMATIK / NETZWERKTECHNIK

⋯⇢ Bereits im Praktikum, das er während des Studiums Telematik/Netzwerktechnik ab-
solvierte, wurde Peter Reisner klar, dass Infineon der richtige Arbeitgeber für ihn ist.
Auch seine Diplomarbeit verfasste er in diesem Unternehmen. Im Rahmen eines
Trainee-Programmes arbeitete er u.a. an einem Projekt mit, das den Landes-
Innovationspreis 2005 gewann. Heute leitet er selbst ein Automatisierungsprojekt.

Mehr über die Studienangebote aus Technik, Gesundheit, Wirtschaft und Soziales: **www.fh-kaernten.at**

3_____

DESIGN FIRM
designation Studio für
Visuelle Kommunikation
Klagenfurt, Austria
PROJECT
FH University of Applied Sciences
ART DIRECTOR
Jürgen G. Eixelsberger

1_____

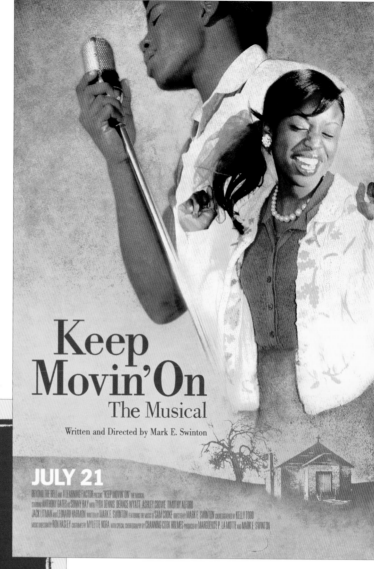

An
original story
set to the music
of the legendary
SAM COOKE

Beyond the Bell and a Learning Factor
Proudly presents

KEEP MOVIN' ON

JULY 21
The Norman J. Pattiz Concert Hall
2955 S. Robertson Blvd., Los Angeles, CA 90034

Tickets Available Through Ticketweb 866.468.3399 or at www.ticketweb.com

1_____
DESIGN FIRM
30sixty Advertising+Design
Los Angeles, (CA) USA
CLIENT
Beyond The Bell
CREATIVE DIRECTOR
Henry Vizcarra
ART DIRECTORS
David Fuscellaro,
Pär Larsson

2_____
DESIGN FIRM
Greenlight Designs
North Hollywood, (CA) USA
CLIENT
Joey Monteiro, Lions Gate Films
CREATIVE DIRECTORS
Tami Mahnken,
Darryl Shelly
SENIOR DESIGNER
Melissa Irwin
DESIGNER
Shaun Wood

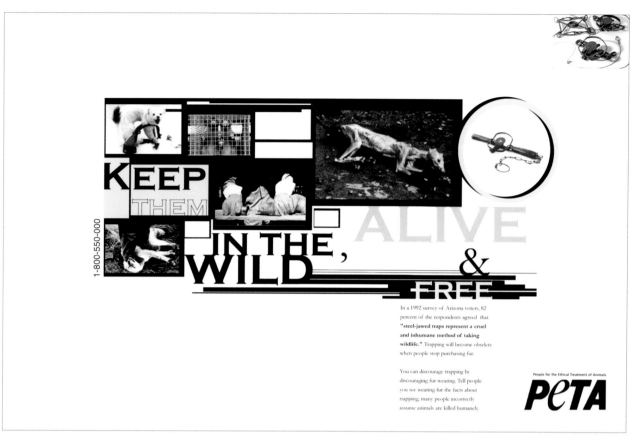

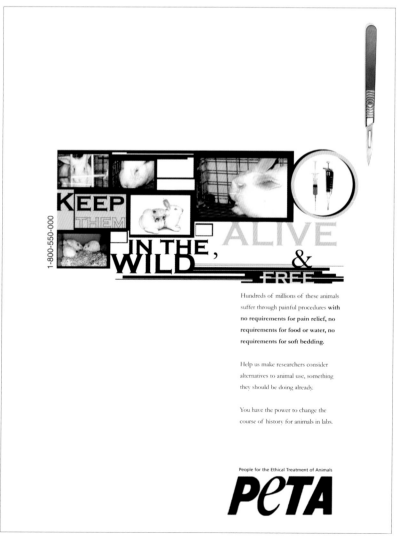

1_____

1_____

DESIGN FIRM
Didem Carikci Wong
Istanbul, Turkey

PROJECT
Peta Ads

CREATIVE DIRECTOR,

ART DIRECTOR, DESIGNER
Didem Carikci Wong

2_____

DESIGN FIRM
Morningstar Design, Inc.
Frederick, (MD) USA

PROJECT
Dan Ryan Builders New
Homes Guide

CREATIVE DIRECTOR, DESIGNER
Misti Morningstar

PHOTOGRAPHERS
Shaun Campbell,
Stewart Brothers

3_____

DESIGN FIRM
The College of Saint Rose
Albany, (NY) USA

PROJECT
Saint Rose Music Ad

ART DIRECTOR
Mark Hamilton

COPYWRITERS
Mark Hamilton,
Lisa Haley Thomson

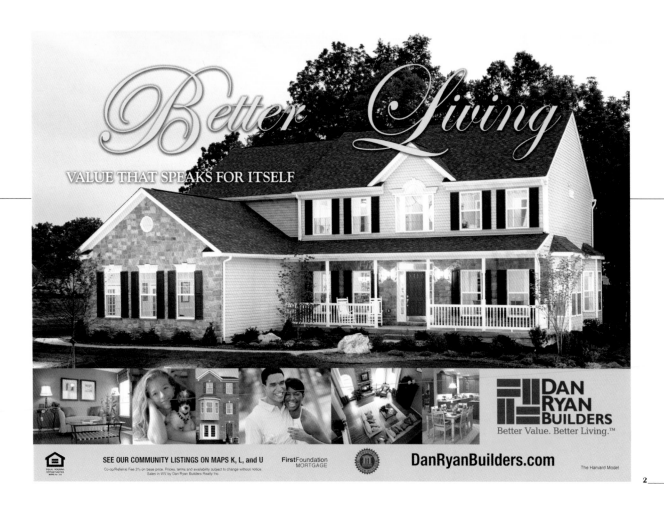
2_____

3_____

LISTEN
COMPOSE
PERFORM

Musicians are artists. The synergy of rhythm, melody and harmony is how they listen, compose and perform—and transform our souls through sound. Encourage the musicians in your life to choose a music program in which they will be urged to express their individuality, experiment with new media and exceed boundaries.

Saint Rose offers bachelor's degrees in music education and music industry, and master's degrees in music education, piano pedagogy, jazz studies and music technology.

Experience the Saint Rose Difference.

The College of Saint Rose

MUSIC EDUCATION (B.S. & M.S. in Ed.) **MUSIC INDUSTRY (B.S.)** **MUSIC (M.A.)** For more information: 1-800-637-8556 www.strose.edu/music

3_____

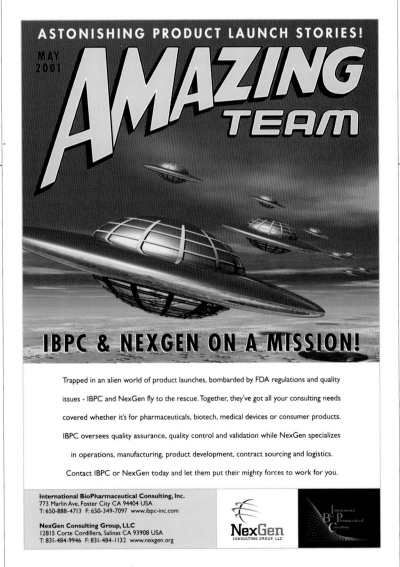

3_____

DESIGN FIRM
Mendes Publicidade
Belém, Brazil

PROJECT
Cidadania na Amazonia
também tem o seu banco

DESIGNERS
Oswaldo Mendes,
Dalmiro Freitas,
Marcel Chaves,
Cássio Tavernard

4_____

DESIGN FIRM
Sandy Gin Design
San Carlos, (CA) USA

PROJECT
NexGen Trade Ad

DESIGNER
Sandy Gin

4_____

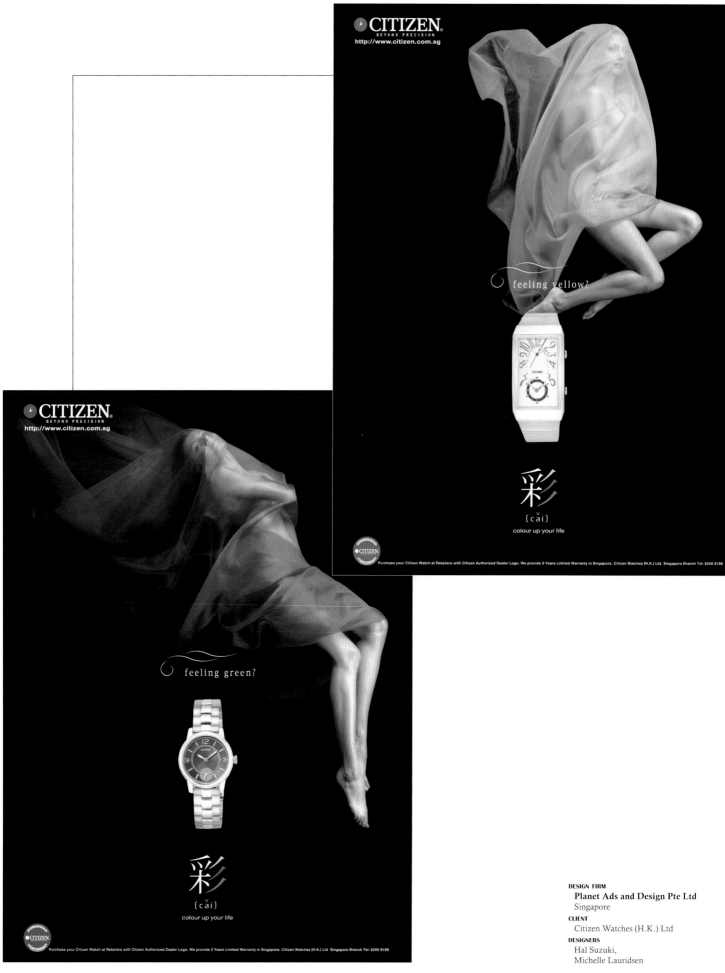

DESIGN FIRM
Planet Ads and Design Pte Ltd
Singapore
CLIENT
Citizen Watches (H.K.) Ltd
DESIGNERS
Hal Suzuki,
Michelle Lauridsen

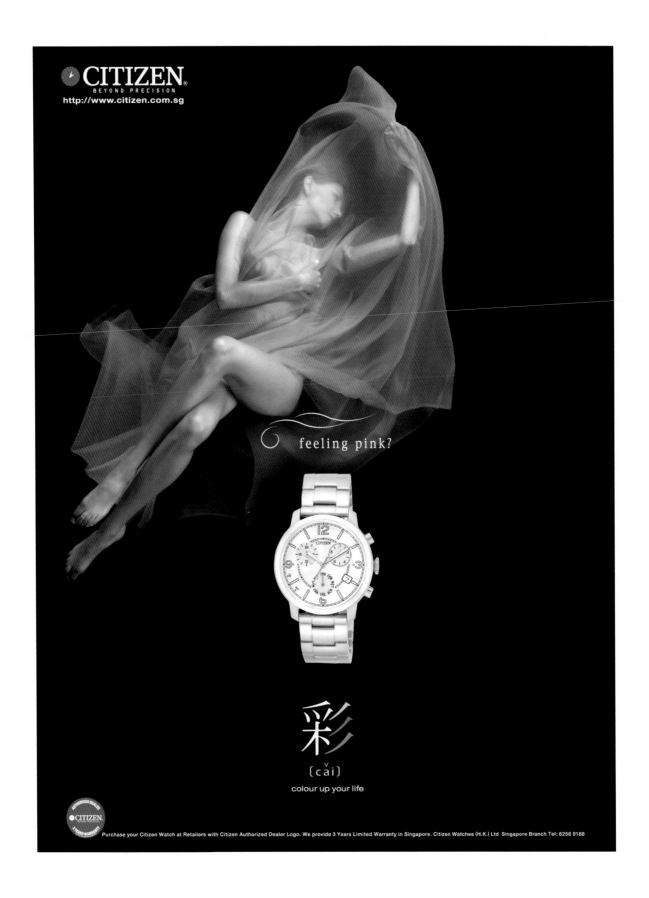

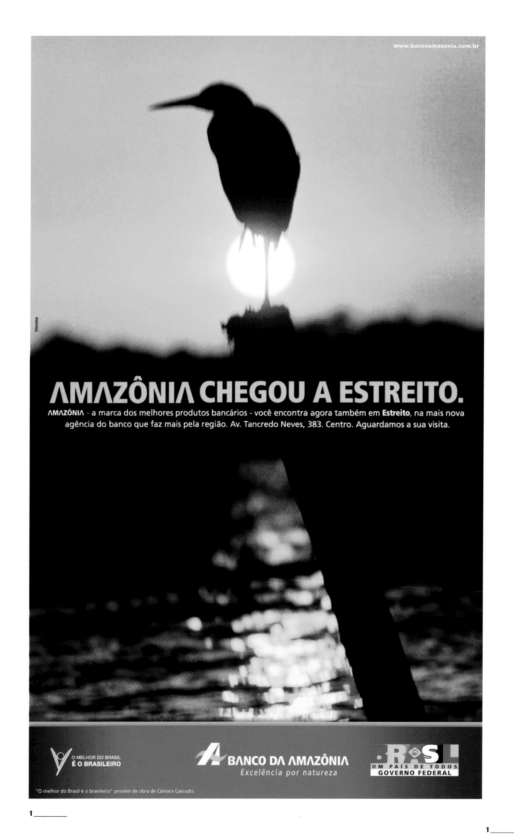

1_____

1_____
DESIGN FIRM
Mendes Publicidade
Belém, Brazil
PROJECT
Amazônia chegou a Estreito
CREATIVES
Oswaldo Mendes,
Marcelo Amorim

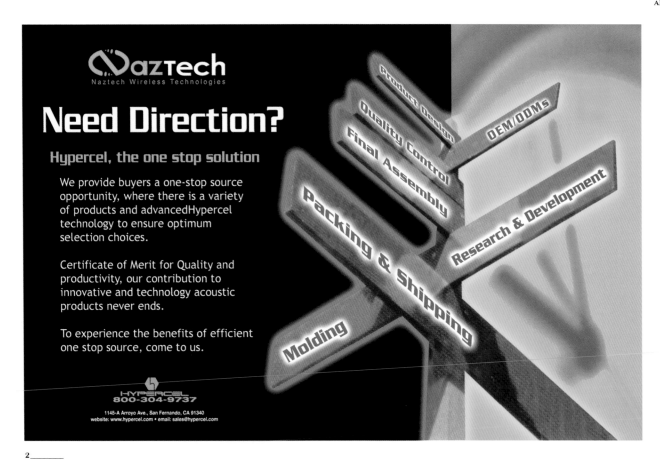

2_____

2_____
DESIGN FIRM
Mayhem Studios
Los Angeles, (CA) USA
PROJECT
Hypercel Ad
DESIGNER
Calvin Lee

3_____
DESIGN FIRM
TD2, S.C.
Mexico City, Mexico
CLIENT
Mauricio Diosdado
DESIGNER
Rafael Rodrigo Córdova

3_____

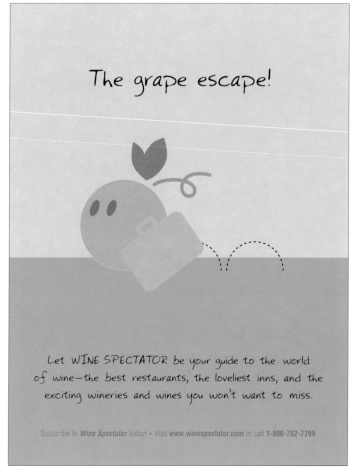

1_____

DESIGN FIRM
M. Shanken Communications, Inc.
New York, (NY) USA
PROJECT
Wine Spectator Subscription ads
ART DIRECTOR
Chandra Hira
DESIGNER
Michelle Hair-Masi
COPYWRITER
Laura Zandi

2_____

DESIGN FIRM
Greenlight Designs
North Hollywood, (CA) USA
CLIENT
Michael Now, DEJ
CREATIVE DIRECTOR
Tami Mahnken
SENIOR DESIGNER
Melissa Irwin
DESIGNER
Shaun Wood
PHOTOGRAPHER
Darryl Shelly

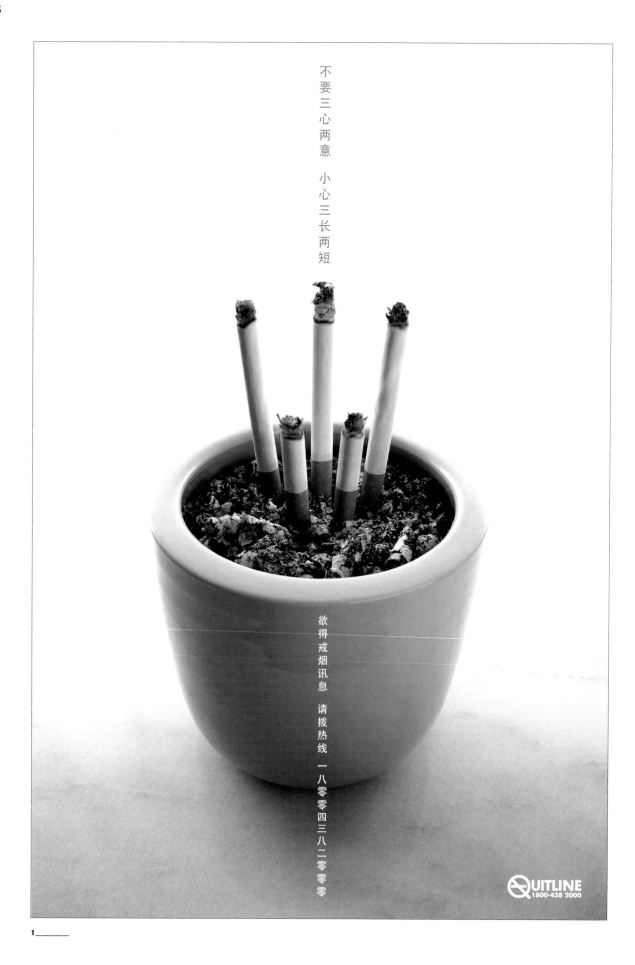

不要三心两意　小心三长两短

欲得戒烟讯息　请拨热线　一八零零四三八二零零

QUITLINE
1800-438 2000

1_____

Fast?

Fast!

Here is some text that explains the Service of V1 Jets. It not only describes that it is save and comfortable but also flexible and fast. You tell us where and when you want to go and we have the best charter companies bid for your business, online, open and honest. This text also mentions the great Concierge Service that comes with the client's booking, all for free.

Comfortable. Fast. Flexible. Safe. www.jetcharter.com *Easy!*

1-800-Fly VJet

V1 JETS
Premier Class Only

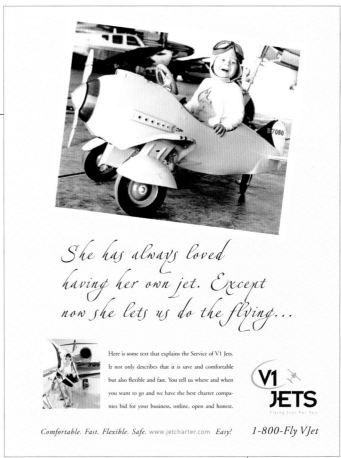

She has always loved having her own jet. Except now she lets us do the flying...

Here is some text that explains the Service of V1 Jets. It not only describes that it is save and comfortable but also flexible and fast. You tell us where and when you want to go and we have the best charter companies bid for your business, online, open and honest.

Comfortable. Fast. Flexible. Safe. www.jetcharter.com *Easy!*

V1 JETS
Flying Just For You

1-800-Fly VJet

We fly you where you love to be. Premier Class Only.

Here is some text that explains the Service of V1 Jets. It not only describes that it is save and comfortable but also flexible and fast. You tell us where and when you want to go and we have the best charter companies bid for your business, online, open and honest. This text also mentions the great Concierge Service that comes with the client's booking, all for free.

Luxurious. Fast. Flexible. Safe. www.jetcharter.com *Easy!*

V1 JETS
Premier Class Only

1-800-Fly VJet

1 _____

DESIGN FIRM
Über, Inc.
New York, (NY) USA

PROJECT
V1 Jets Ad Campaign Presentation

DESIGNERS
Herta Kriegner,
Edita Lintl

1_____

DESIGN FIRM
Morningstar Design, Inc.
Frederick, (MD) USA

PROJECT
Vessel Museum ad

DESIGNER
Melissa Neal

2_____

DESIGN FIRM
Morningstar Design, Inc.
Frederick, (MD) USA

PROJECT
Morningstar Design Inc.
Dynamite Ad

CREATIVE DIRECTOR, COPYWRITER
Misti Morningstar

DESIGNER
Melissa Neal

ILLUSTRATOR
Rachel Rabat

Hip Factor #163 Your glasses should never serve as birth control.

We understand that not everyone wants really hip, fashionable, cool, up-to-date designer eyewear. But in the off-chance you are one of those people, you should take a look at us.

Call 265-2365 today to set up an appointment or drop by any time and check out the hippest eyewear available in Chattanooga.

EPIC OPTICAL
EYEWEAR PROFESSIONALS

801 Chestnut Street
Hip Downtown • Chattanooga

www.epicoptical.com

RECEIVE 10% OFF
just mention this ad

3_____

3_____
DESIGN FIRM
 maycreate
 Chattanooga, (TN) USA
CLIENT
 Epic Optical
DESIGNER
 Brian May

127

1_____

1_____
DESIGN FIRM
Mendes Publicidade
Belém, Brazil
PROJECT
Estrela de Belém
CREATIVES
Oswaldo Mendes,
Doda Vilhena,
Marcel Chaves

2_____

3_____

2_____
DESIGN FIRM
Pertmaster
Houston, (TX) USA
PROJECT
AustraliaFlyerPrimavera Ad
DESIGNER
Brooke Browne

3_____
DESIGN FIRM
Mendes Publicidade
Belém, Brazil
PROJECT
Banco Da Amazônia ad
CREATIVES
Oswaldo Mendes,
Dalmiro Freitas,
Marcelo Amorim

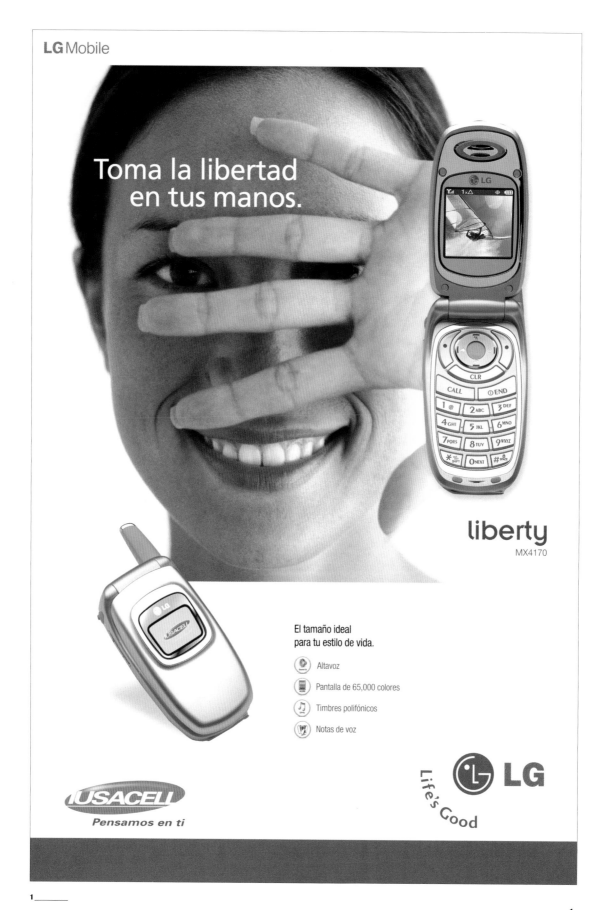

1_____

1_____

DESIGN FIRM
TD2, S.C.
Mexico City, Mexico
CLIENT
LG Electronics
DESIGNER
Gabriela Zamora

RESPOND REFLECT RENEW *The* LEGACY GROVES *of* SOMERSET COUNTY

THE LEGACY GROVES

The concept of *The Legacy Groves* grew from a collective desire to honor and remember those lost on September 11 with a living, growing tribute of trees.

The Legacy Groves of Somerset County are being planted not only in memory of those lost on Flight 93 but also in appreciation of the tide of first responders: the firefighters, emergency personnel, police and other rescue workers who dedicated themselves to aiding others, as well as the volunteers who sustained the community.

Somerset County is an example of volunteerism in America—where mutual caring and trust between community members accomplished so much during those tragic days, and continues today.

WHAT IS A LEGACY GROVE?

The Legacy Groves are a living memorial created with trees to symbolize the continuity of life and reflect hope for the future. Sugar Maples of various sizes and ages are planted in naturalistic groves that offer a quiet place for peaceful reflection for individuals and the community.

WHY THE SUGAR MAPLE?

The Sugar Maple with its vivid autumn foliage is native to Somerset County. Long associated with the area, the abundance of Sugar Maples gave it its traditional maple sugar and syrup industry.

WHERE TO VISIT A GROVE

**The Volunteer Firefighters
Training Center**

This site honors both the county's first responders and the spirit of volunteerism that was so vital in the immediate days after 9-11.

**The Somerset County
Technology Center**

A tree nursery created at the Technology Center assures a continuous supply of Sugar Maples for the groves. The school will involve its forestry and horticulture students in the development and care of the trees, strengthening the ties between the community and *The Legacy Groves.*

It is hoped that these first two groves will inspire others throughout the county to create new groves in other locations—whether near a scenic vista, or historic landmark, besides a public building or on private land.

BECOME A PARTNER

There are donor and volunteer opportunities for local and regional organizations. For more information on how you can participate please contact Kiski Basin Initiatives at 814-467-0836.

The USDA Forest Service Living Memorials Project supports *The Legacy Groves* and other projects in the New York City and Washington D.C./Virginia areas. You can visit their website at www.livingmemorialsproject.net.

OUR COMMUNITY CONNECTIONS

The network of community connections continues to grow. Some of those already involved are Somerset County Technology Center, Somerset Garden Club, Garden Club Federation of Pennsylvania, Westsylvania Heritage Corporation, Somerset County Commissioners, Somerset County Volunteer Firemen's Association, National Park Service, Flight 93 Task Force, Penn State University Extension Service, Conemaugh Valley Conservancy, Community Foundation of the Alleghenies, Somerset County Probation Program, and Kiski Basin Initiatives.

RESPOND | REFLECT | RENEW

©2003 Kiski Basin Initiatives
Landscape Architecture: Dirtworks, PC
Brochure Design: ACME Communications, Inc.

1_____
DESIGN FIRM
Adventium
New York, (NY) USA
DESIGNER
Penny Chuang

2_____
DESIGN FIRM
Acme Communications, Inc.
New York, (NY) USA
PROJECT
Legacy Groves Brochure
DESIGNERS
Kiki Boucher,
Andrea Ross Boyle

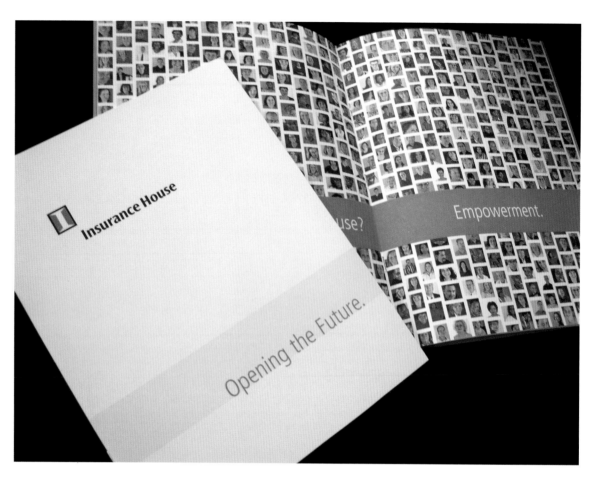

1

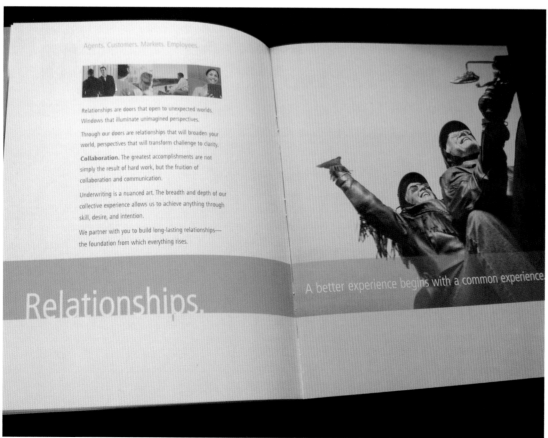

1
DESIGN FIRM
Kiku Obata & Company
St. Louis, (MO) USA
CLIENT
Insurance House
DESIGNER
Paul Scherfling

2
DESIGN FIRM
substance151
Baltimore, (MD) USA
PROJECT
SUNY Plattsburgh Brochure
DESIGNERS
Ida Cheinman,
Rick Salzman

art

Platts
burgh
State
Univer
sity

ART DEPARTMENT

2_____

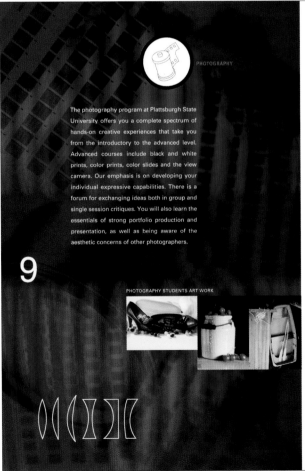

PHOTOGRAPHY

The photography program at Plattsburgh State University offers you a complete spectrum of hands-on creative experiences that take you from the introductory to the advanced level. Advanced courses include black and white prints, color prints, color slides and the view camera. Our emphasis is on developing your individual expressive capabilities. There is a forum for exchanging ideas both in group and single session critiques. You will also learn the essentials of strong portfolio production and presentation, as well as being aware of the aesthetic concerns of other photographers.

9

PHOTOGRAPHY STUDENTS ART WORK

PRINTMAKING

Plattsburgh State University printmaking program strives for an aesthetic balance between process and concept within a informal workshop environment. As an student in printmaking, you will explore various printmaking media, including intaglio, lithography, relief, letterpress and creative bookmaking. Both unique prints, and multiples are produced. While engaging in the creative study of print-making, you will also investigate the history of the discipline and discuss related critical issues in contemporary art that will assist in your creativity.

10

PRINTMAKING STUDENTS ART WORK

Your visual experiences in Printmaking are supported by trips to museums in the area. Take a printmaking course, either as your art concentration area or simply as an art elective, and you'll be studying in a great facility.

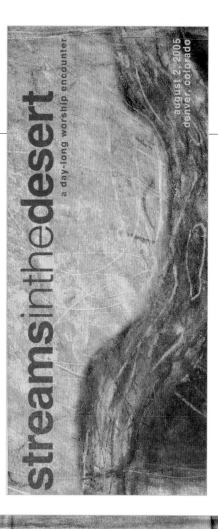

streamsinthedesert

a day-long worship encounter

august 2, 2005
denver, colorado

DESIGN FIRM
Leslie Rubio
Springfield, (MO) USA
CLIENT
General Council of the Assemblies
of God National Music Department
COPY EDITOR
Tom McDonald

john bevere is the author of many top selling books, including *The Bait of Satan* and *Under Cover*. Known for his loving but confrontational style of writing, John's heart is to see the believer come into an intimate and passionate relationship with God. John's multifaceted ministry includes ministering at conferences and churches both nationally and internationally as well as a weekly television broadcast that airs in over 200 nations. He is a frequent guest of Christian Television programming and many notable Christian publications feature his writings.

terry macalmon is an accomplished songwriter and recording artist. One of his songs, "I Sing Praises" has become a favorite in churches across America and around the world. He has also released numerous live worship CDs that capture intimate worship experiences and include original music as well as the familiar. Terry leads worship all over the world and is very sensitive to the ebb and flow of the Spirit. He makes others comfortable with entering into the Lord's presence. They are then drawn into a place of deeper intimacy with the Lord.

registration information

Registration is required and may be done when registering for General Council or by calling the national Music Department at 417.862.2781, ext. 4130. Tickets are $30 per person and include seminar materials and a box lunch.

schedule

8:00 am	check in
9:00 am	worship in the presence of the Lord
	Terry MacAlmon
10:30 am	teaching: The Bait of Satan
	John Bevere
noon	lunch (box lunch provided)
1:00 pm	table discussion and healing prayers
	topics to be announced
3:00 pm	the holy communion

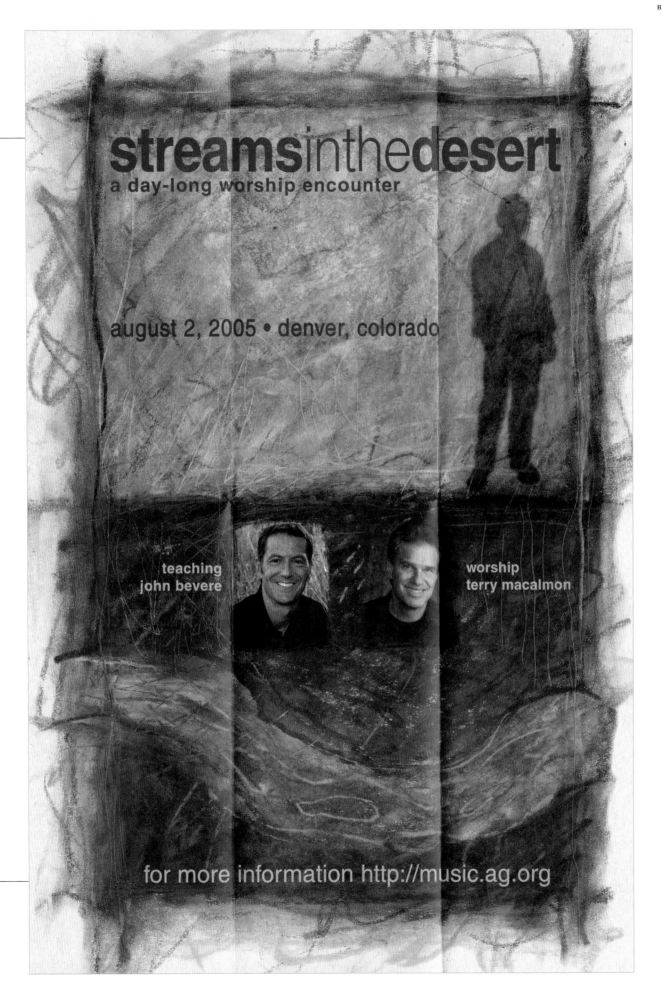

Financial PR
That works

DESIGN FIRM
Adventium
New York, (NY) USA
PROJECT
Financial PR Brochure
DESIGNER
Penny Chuang

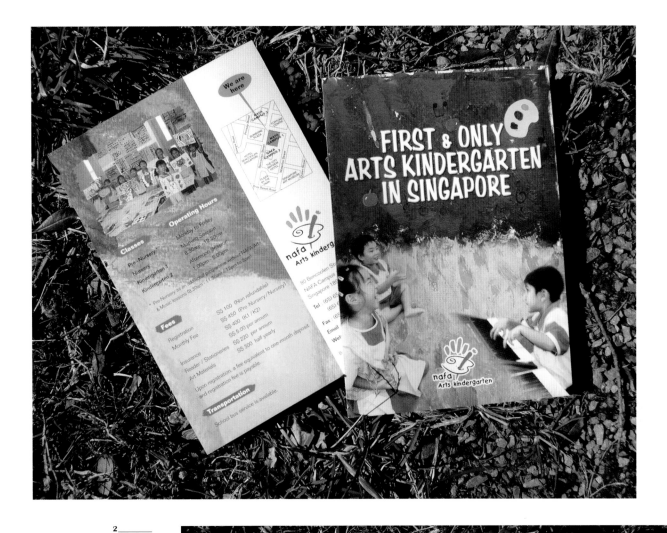

1

DESIGN FIRM
Octavo Designs
Frederick, (MD) USA

CLIENT
Top 2 Bottom
Professional Cleaning

ART DIRECTOR, DESIGNER
Sue Hough

2

DESIGN FIRM
The Designquarters
Singapore

CLIENT
NAFA Arts Kindergarten

DESIGNER
Deborah Ang Bee Kuan

UW MEDICINE
report to the community
WINTER 2006

UW Medicine

DESIGN FIRM
belyea
Seattle, (WA) USA
CLIENT
UW Medicine
CREATIVE DIRECTOR
Ron Lars Hansen
SENIOR DESIGNER
Anne Bryant
PRODUCTION MANAGER
Sheri-Lou Stannard

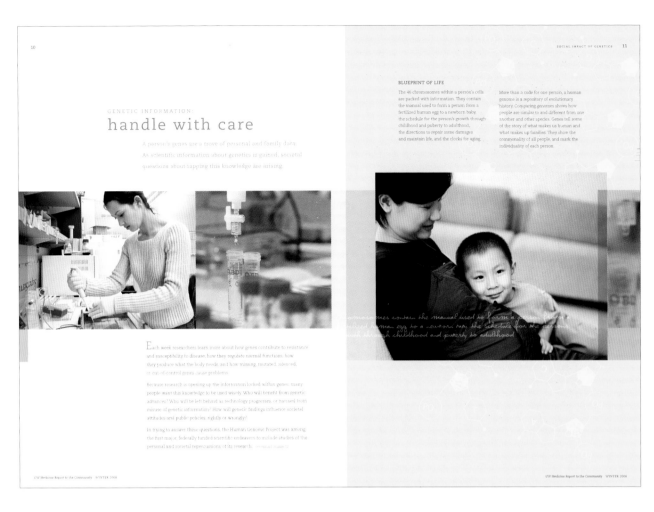

GENETIC INFORMATION:
handle with care

A person's genes are a trove of personal and family data.
As scientific information about genetics is gained, societal
questions about tapping this knowledge are arising.

Each week researchers learn more about how genes contribute to resistance and susceptibility to disease, how they regulate normal functions, how they produce what the body needs, and how missing, mutated, silenced, or out-of-control genes cause problems.

Because research is opening up the information locked within genes, many people want this knowledge to be used wisely. Who will benefit from genetic advances? Who will be left behind as technology progresses, or harmed from misuse of genetic information? How will genetic findings influence societal attitudes and public policies, rightly or wrongly?

In trying to answer these questions, the Human Genome Project was among the first major, federally funded scientific endeavors to include studies of the personal and societal repercussions of its research.

BLUEPRINT OF LIFE

The 46 chromosomes within a person's cells are packed with information. They contain the manual used to form a person from a fertilized human egg to a newborn baby, the schedule for the person's growth through childhood and puberty to adulthood, the directions to repair some damages and maintain life, and the clocks for aging.

More than a code for one person, a human genome is a repository of evolutionary history. Comparing genomes shows how people are similar to and different from one another and other species. Genes tell some of the story of what makes us human and what makes up families. They show the commonality of all people, and mark the individuality of each person.

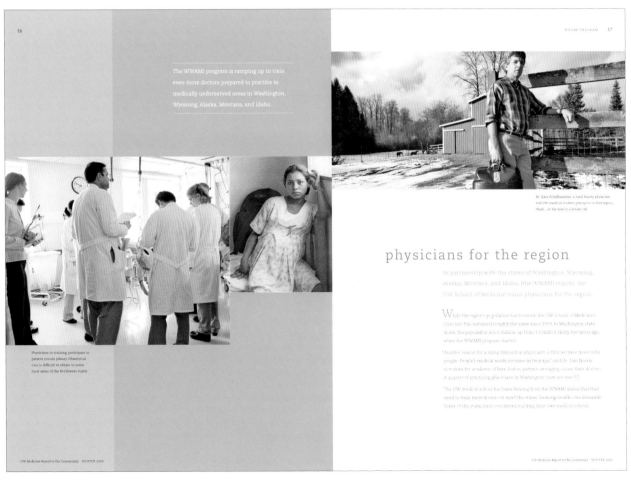

The WWAMI program is ramping up to train
even more doctors prepared to practice in
medically underserved areas in Washington,
Wyoming, Alaska, Montana, and Idaho.

Physicians-in-training participate in
patient rounds (above). Obstetrical
care is difficult to obtain in some
rural areas of the Northwest (right).

Dr. Gary Schilhammer, a rural family physician
and UW medical student preceptor in Darrington,
Wash., on his way to a house call.

physicians for the region

In partnership with the states of Washington, Wyoming,
Alaska, Montana, and Idaho, (the WWAMI region), the
UW School of Medicine trains physicians for the region.

While the region's population has boomed, the UW School of Medicine's class size has remained roughly the same since 1970. In Washington state alone, the population is 6.5 million, up from 3.5 million thirty-five years ago, when the WWAMI program started.

"Another reason for a rising demand in physicians is that we have more older people. People's medical needs increase as they age," said Dr. Tom Norris, vice dean for academic affairs. Just as patients are aging, so are their doctors. A quarter of practicing physicians in Washington state are over 55.

The UW medical school has been hearing from the WWAMI states that they need to train more doctors to meet the states' looming health-care demands. Some of the states have considered building their own medical schools.

1_____

1_____
DESIGN FIRM
Sayles Graphic Design
Des Moines, (IA) USA
CLIENT
Hotel Pattee
ART DIRECTOR, DESIGNER
John Sayles
PHOTOGRAPHER
John Clark

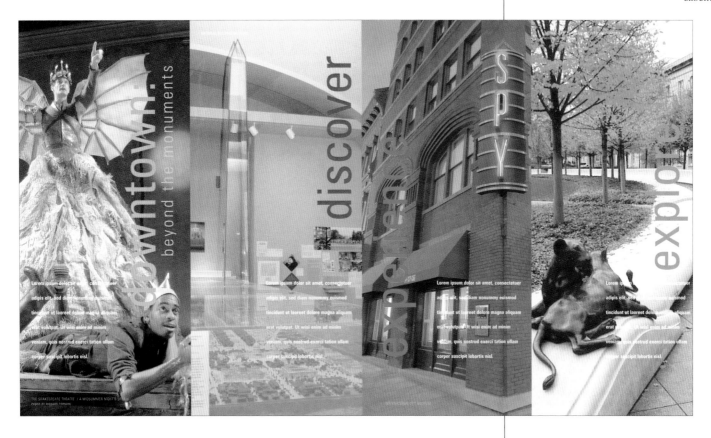

downtown.
beyond the monuments

discover

SPY

explore

experience

Lorem ipsum dolor sit amet, consectetuer adipis elit, sed diam nonummy euismod tincidunt ut laoreet dolore magna aliquam erat volutpat. Ut wisi enim ad minim veniam, quis nostrud exerci tation ullam corper suscipit lobortis nisl.

Lorem ipsum dolor sit amet, consectetuer adipis elit, sed diam nonummy euismod tincidunt ut laoreet dolore magna aliquam erat volutpat. Ut wisi enim ad minim veniam, quis nostrud exerci tation ullam corper suscipit lobortis nisl.

Lorem ipsum dolor sit amet, consectetuer adipis elit, sed diam nonummy euismod tincidunt ut laoreet dolore magna aliquam erat volutpat. Ut wisi enim ad minim veniam, quis nostrud exerci tation ullam corper suscipit lobortis nisl.

Lorem ipsum dolor sit amet, consectetuer adipis elit, sed diam nonummy euismod tincidunt ut laoreet dolore magna aliquam erat volutpat. Ut wisi enim ad minim veniam, quis nostrud exerci tation ullam corper suscipit lobortis nisl.

THE SHAKESPEARE THEATRE / A MIDSUMMER NIGHT'S DREAM
PHOTO BY RICHARD TERMINE

museums

International Spy Museum
Espionage-related artifacts chronicle the history of spying. Advanced ticket purchase advised. Last tour begins one hour before closing. Apr–Oct 9–6, Nov–Mar 10–6. M: Gallery Place/Chinatown. 800 F Street NW. 202-393-7798.

Lillian and Albert Small Jewish Museum
DC's oldest surviving synagogue building was once home to the Adas Israel Congregation. Donation suggested. Sun–Thurs by appointment. M: Judiciary Square. 701 Third Street NW. 202-789-0900.

Marian Koshland Science Museum
New National Academy of Sciences museum explores frontiers of today's scientific research. Daily except Tues. 10–5. M: Gallery Place, Chinatown or Judiciary Square. Sixth and E Streets NW. 202-334-1201.

National Archives
The Rotunda reopened on Sept 18, 2004, returning the Constitution, Bill of Rights, and Declaration of Independence to public display. M: Archives/Navy Memorial. 700 Pennsylvania Ave NW. 866-325-7208.

National Building Museum
Premier museum of design, architecture, engineering, urban planning, and construction. Mon–Sat 10–5, Sun 11–5. M: Judiciary Square. 401 F Street NW. 202-272-2448.

National Gallery of Art
One of the world's finest collections illustrates major achievements in painting, sculpture, decorative arts, and works on paper. Mon–Sat 10–5, Sun 11–6. M: Judiciary Square, Archives/Navy Memorial or Smithsonian. Seventh Street and Constitution Ave NW. 202-737-4215.

National Museum of Women in the Arts
The only museum in the world dedicated solely to women's artistic achievements. Mon–Sat 10–5, Sun 12–5. M: Metro Center. 1250 New York Ave NW. 202-783-5000.

Sixth & I Historic Synagogue
Newly-restored 1908 synagogue tells the story of Washington's Jewish community. Mon–Thurs 9–5, Fri 9–4. M: Gallery Place/Chinatown. 600 I Street NW. 202-408-3100.

NATIONAL MUSEUM OF WOMEN IN THE ARTS

THE CHINATOWN ARCH

theaters

Ford's Theatre National Historic Site
After Abraham Lincoln was shot at Ford's Theatre, he was carried across the street to Petersen House, where he passed away. National Park Service ranger-led tours. Daily 9–5, except during theater performances. M: Metro Center or Gallery Place/Chinatown. 511 Tenth Street NW. 202-426-6924.

GALA Hispanic Theatre
Spanish-language theater dedicated to promoting Latino culture; productions include Golden Age classics and sizzling new musicals. Bilingual headphones available. Sept–June. Performances at the Warehouse Theater; new theater scheduled to open winter 2004-05. M: Mount Vernon Square. 1021 Seventh Street NW. 202-234-7174.

National Theatre
Washington's "Broadway-type" theatre, with 1,676 orchestra, mezzanine, and balcony seats. M: Metro Center. 1321 Pennsylvania Ave NW. 202-628-6161.

The Shakespeare Theatre
Plays by Shakespeare and other classical playwrights, including one free outdoor production each summer. M: Gallery Place/Chinatown or Archives/Navy Memorial. 450 Seventh Street NW. 202-547-1122.

Warehouse Theater
Formed in 1994 to showcase emerging artists from DC and beyond. Call for schedule. M: Gallery Place/Chinatown. 1021 Seventh Street NW. 202-783-3933.

Woolly Mammoth Theatre Company
Edgy new plays and extensive community outreach programs. Performances at the Kennedy Center, the DC Jewish Community Center, and the Warehouse Theater until their new theater opens in spring 2005. 202-393-3939.

galleries and venues

American Immigration Law Center Exhibit Hall
Historic building displays traveling exhibits about our nation's immigrant heritage. Mon–Fri 10–5. M: Metro Center or Gallery Place/Chinatown. 918 F Street NW. 202-742-5608.

Canadian Embassy
Gallery showcases Canadian heritage and culture, with art from across the country. Mon–Fri 9–5. M: Archives/Navy Memorial or Judiciary Square. 501 Pennsylvania Ave NW. 202-682-1740.

Flashpoint
Dynamic downtown venue features emerging visual and performing artists. Mon–Sat 10–6, Sun 11–6, with additional hours during shows. M: Gallery Place/Chinatown. 916 G Street NW. 202-315-1306.

Gallery of Warehouse
Formed in 1994 to showcase emerging artists from DC and beyond. Call for schedule. M: Gallery Place/Chinatown. 1021 Seventh Street NW. 202-783-3933.

Goethe-Institut
Promotes German language and culture through films, exhibits, lectures, and language classes. Mon–Thurs 9–5, Fri 9–3. M: Gallery Place/Chinatown. 812 Seventh Street NW. 202-289-1200.

Interdevelopment Bank Cultural Center (IDB)
Forum for outstanding intellectual and artistic manifestations of member countries, with emphasis on Latin America and the Caribbean. Mon–Thurs 11–5. M: Metro Center. 1300 New York Ave NW. 202-623-3774.

memorials

National Law Enforcement Officers Memorial
Landscaped memorial honors law enforcement officers who have been killed in the line of duty. M: Judiciary Square. E Street between Fourth and Fifth Streets NW. 202-737-3400.

U.S. Navy Memorial & Naval Heritage Center
Striking outdoor plaza honors U.S. sea services. Inside are interactive videos, a gift shop, and a free movie at noon daily. Mon–Sat 9:30–5. M: Archives/Navy Memorial. 701 Pennsylvania Ave NW. 202-737-2300.

coming soon

Newseum
Scheduled to open at its new location in 2007. Visitors can still enjoy the outdoor version of Today's Front Pages, showing daily newspapers from around the world updated. M: Archives/Navy Memorial. Pennsylvania Ave and Sixth Street NW. 888-NEWSEUM or 703-284-3544.

National Portrait Gallery, Smithsonian Institution
Unique collection combines American history, biography, and art; scheduled to reopen July 4, 2006. M: Gallery Place/Chinatown. Eighth and G Streets NW. 202-275-1738, TTY 202-357-1729.

Smithsonian American Art Museum
The largest collection of American art in the world; scheduled to reopen July 4, 2006. M: Gallery Place/Chinatown. Eighth and G Streets NW. 202-633-1000, TTY 202-357-1729.

NATIONAL PORTRAIT GALLERY

2

2

DESIGN FIRM
Pensaré Design Group
Washington, (D.C.) USA
PROJECT
Cultural Tourism DC Brochure
CREATIVE DIRECTOR
Mary Ellen Vehlow
DESIGNER
Amy E. Billingham

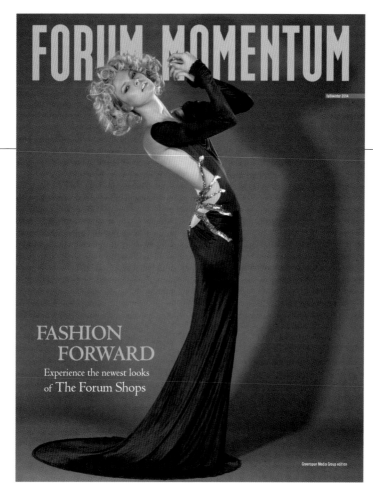

DESIGN FIRM
Greenspun Media Group
Henderson, (NV) USA
CLIENT
The Forum Shops at Caesars
CREATIVE DIRECTOR
Mami Awamura
PHOTOGRAPHER
Alex Cho

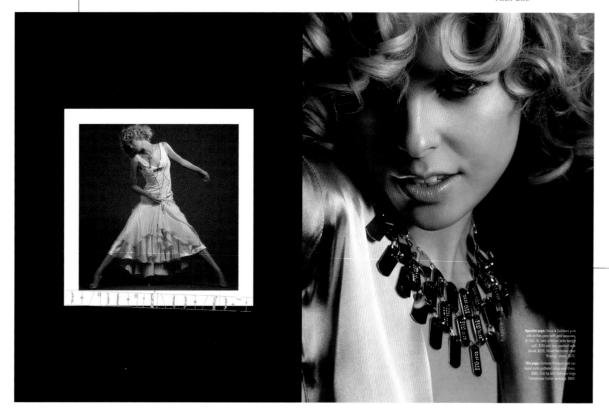

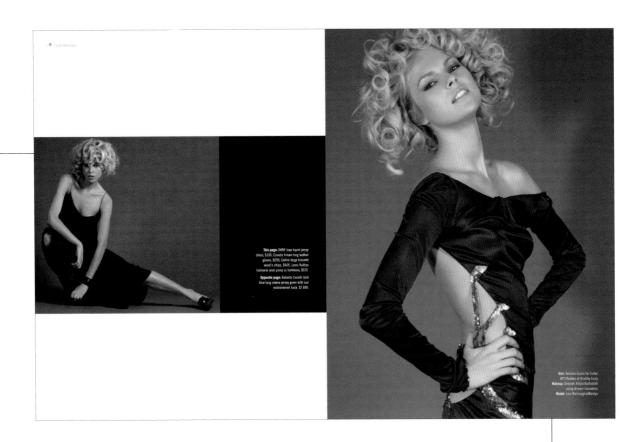

This page: DKNY luxe liquid jersey dress, $195. Escada brown long leather gloves, $250. Celine large bracelet wood'o chips, $405. Louis Vuitton balmoral peal pump in bordeaux, $570

Opposite page: Roberto Cavalli dark blue long sleeve jersey gown with sun embroidered back, $7,440.

Hair: Kenshin Asano for Cutler NYC/Redken at Bradley Curry
Makeup: Deborah Altizio/Kettlstoff using Armani Cosmetics
Model: Lisa Mertwaglia/Marilyn

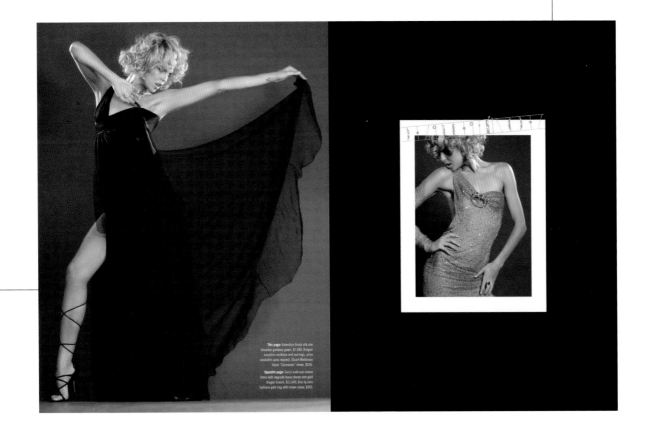

This page: Valentino black silk one shoulder goddess gown, $7,640. Bvlgari sapphire necklace and earrings, price available upon request. Stuart Weitzman black "Gizmozee" shoes, $236.

Opposite page: Gucci nude one-sleeve dress with degrade topaz stones and gold dragon brooch, $11,645. Dior by John Galliano gold ring with brown stone, $265.

153

DESIGN FIRM
Gouthier Design
Fort Lauderdale, (FL) USA
PROJECT
Calvary Chapel Brochure
CREATIVE DIRECTOR
Jonathan Gouthier
DESIGNER
Kiley del Valle

OBEYING
HIS CALL

calvaryChapel

Kevin and Debbie Janes felt called to the min...
past few years. Final confirmation came when...
to meet with For Zion's Sake, a ministr...
Jerusalem. "The pastor told us he neede...
to running a warehouse and discipling...
who could handle administration. H...
were our exact jobs at Calvary," sha...
October with her husband to serv...

"I had the privilege of seeing God work...
field, speaking to them, and confirmin...
circumstances, and through others...
in my position at Calvary, I get to...
Resources Director.

There are many at Calvary Ch...
staff, buildings, materials,...
Debbie who are called to...
every other area of mini...
operate smoothly, it fr...
focus on the people...

AT MINISTRY

1＿＿＿＿

1＿＿＿＿
DESIGN FIRM
New Energy Work Marketing Dept.
Farmington, (NY) USA
CLIENT
New Energy Works Timberframers
DESIGNERS
Deanna Varble,
Iain Harrison

It's Your Move.

MAS Monetary Authority of Singapore

2_____

"You have to be able to see things beyond the little corner and adopt a true-to perspective."

James Chia
Associate, Monetary Policy
Investment & Research Group

MAS Graduate Officer Scheme

Up for the Challenge?

MAS welcomes fresh graduates with little or no working experience as Associates under our Graduate Officer Scheme. We value diversity and look for outstanding graduates with well-rounded backgrounds and personalities, as well as a track record of excellence in any field. Our senior officers have read fields ranging from English Literature and Geography to Computer Science and Electrical Engineering.

Closing date: Mid-December

What it takes.

We're looking for motivated individuals with strongly analytical minds, excellent written and verbal communications skills, leadership abilities as well as team-player qualities. If you have a keen interest in a central banking career and believe you will thrive in a dynamic, rapidly-changing environment, we would like to hear from you.

Your Career with MAS.

Graduate Officers are assigned to a specific department on appointment. You will receive training geared toward providing you with a broad perspective of the Authority's functions. A comprehensive training package will give you a solid foundation for your career. Outstanding officers may be sponsored for postgraduate studies, either locally or overseas.

Graduate Officer Scheme

Life @ MAS

Career Development

MAS sees your development as an ongoing process. We take a broad approach to training and development, believing that learning can emerge from many sources and that your personal growth benefits the entire organisation. You will be given ample opportunities to take a variety of courses, including those in general management and personal development.

In addition, the MAS Educational Sponsorship Scheme encourages our staff to pursue further studies in any field relevant to MAS as a whole.

Life @ MAS

2_____

DESIGN FIRM
atomz i! pte ltd
Singapore
PROJECT
Monetary Authority
of Singapore Brochure
DESIGNER
Tomaz Goh
COPYWRITER
John Low

1_____

1_____
DESIGN FIRM
M. Shanken Communications, Inc.
New York, (NY) USA
PROJECT
IMPACT Magazine
Brochure
ART DIRECTOR
Chandra Hira
DESIGNER
Terrence Janis

Packaging:

Each **Tool Time Watch®** is packaged in a unique metal gift container reminiscent of an industrial tool case. This eye-catching presentation is constructed from durable plastic and aluminum and makes the perfect finishing touch. The gift box is suitable for home display suggesting a multipurpose use, such as a great place to store loose change.

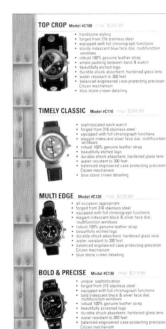

TOOL TIME WATCHES are unmistakably designed for every workingman or woman, tradesman or artisan, sportsman or athlete, professional or weekend tinkerer. Whatever your life demands, **TOOL TIME WATCHES** stand up to the challenge.

The **TOOL TIME WATCH COMPANY** mission is to create a lifelong relationship with our customers by delivering value through our streamlined production of quality watches at a price point that is commensurate with the working person, tradesman, artisan or sportsman budget by providing durable products that stand up to vigorous usage. Every **TOOL TIME WATCH** is designed to provide pride in ownership, offering the quality features, usually found in products that retail well over $1000, at a fraction of the cost.

All **TOOL TIME WATCHES** are built to meet rigid testing standards, assuring dependability time & time again. All styles are:

- tested to 100 hammer slams
- covered by a 5 year warranty
- forged from 316, non-magnetic stainless steel
- technically sound -- precision Citizen engineered
- water resistant to 300 feet
- durable shock absorbent mineral hardened crystal lens
- sturdy & resistant screw-back case

TOOL TIME WATCHES have a FREE LIFETIME battery replacement program*

Consistent reliability delivered with each **TOOL TIME WATCH** we make.

*Purchaser is required to complete and return a warranty card to **TOOL TIME WATCH COMPANY** with 30 days of purchase. During the life of the watch to the original owner, to **TOOL TIME WATCHES** will replace the battery free of charge. For battery replacement, the purchaser must send the watch to **TOOL TIME WATCH COMPANY** in a prepaid postal package. Included in the parcel, the owner must provide a check or money order for $4.35 to cover return shipping and handling costs (S&H). **TOOL TIME WATCH COMPANY** will replace the battery, reseal the case and mail back to the customer in a freight-prepaid parcel.

TOOL TIME WATCH COMPANY
5545 Avenida Adobe
Yorba Linda, CA 92887
P: 714 693 4606 • F: 714 693 8451
Lainie@tooltimewatches.com

TOOL TIME WATCHES®
-the essential tool, for work, for life

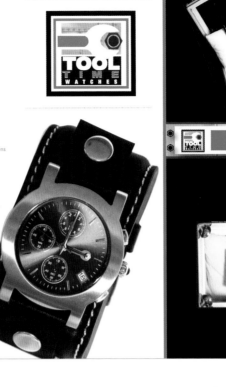

2_____

TOP CROP Model #C100 msrp $249.99
- handsome styling
- forged from 316 stainless steel
- equipped with full chronograph functions
- sturdy iridescent blue face dial, multifunction windows
- robust 100% genuine leather strap
- ample padding between band & watch
- beautifully etched logo
- durable shock absorbent, hardened glass lens
- water resistant to 300 feet
- balanced engineered case protecting precision Citizen mechanism
- blue stone crown detailing

TIMELY CLASSIC Model #C110 msrp $249.99
- sophisticated work watch
- forged from 316 stainless steel
- equipped with full chronograph functions
- elegant iridescent silver face dial, multifunction windows
- robust 100% genuine leather strap
- beautifully etched logo
- durable shock absorbent, hardened glass lens
- water resistant to 300 feet
- balanced engineered case protecting precision Citizen mechanism
- blue stone crown detailing

MULTI EDGE Model #C120 msrp $229.99
- all occasion appropriate
- forged from 316 stainless steel
- equipped with full chronograph functions
- elegant iridescent black & silver face dial, multifunction windows
- robust 100% genuine leather strap
- beautifully etched logo
- durable shock absorbent, hardened glass lens
- water resistant to 300 feet
- balanced engineered case protecting precision Citizen mechanism
- blue stone crown detailing

BOLD & PRECISE Model #C130 msrp $219.99
- unique sophistication
- forged from 316 stainless steel
- equipped with full chronograph functions
- bold iridescent black & silver face dial, multifunction windows
- robust 100% genuine leather strap
- beautifully screened logo
- durable shock absorbent, hardened glass lens
- water resistant to 300 feet
- balanced engineered case protecting precision Citizen mechanism
- blue stone crown detailing

CHALLENGE PROOF Model #D200 msrp $179.99
- sport beautiful, dress appropriate
- forged from 316 stainless steel
- sporty iridescent black & silver face dial, date window
- specialized polyurethane band
- water, paint and most chemical resistant
- beautifully screened logo
- durable shock absorbent, hardened glass lens
- water resistant to 300 feet
- balanced engineered case protecting precision Citizen mechanism
- blue stone crown detailing

FLEX EFFECT Model #D210 msrp $169.99
- strikingly versatile
- forged from 316 stainless steel
- genuine leather, fabric & Velcro strap
- beautifully screened logo
- durable shock absorbent, hardened glass lens
- water resistant to 300 feet
- balanced engineered case protecting precision Citizen mechanism
- blue stone crown detailing

CHOICE PLUS Model #D220 msrp $169.99
- impressive style
- forged from 316 stainless steel
- elegant iridescent white face dial, date window
- sturdy 100% genuine leather strap
- durable shock absorbent, hardened glass lens
- water resistant to 300 feet
- balanced engineered case protecting precision Citizen mechanism
- blue stone crown detailing

MIGHTY MUSCLE Model #D230 msrp $179.99
- robust quality
- forged from 316 stainless steel
- sturdy iridescent black & silver face dial, date window
- beautifully screened logo
- durable shock absorbent, hardened glass lens
- water resistant to 300 feet
- balanced engineered case protecting precision Citizen mechanism
- blue stone crown detailing

FLUID FORCE Model #D240 msrp $179.99
- suited for an active lifestyle
- forged from 316 stainless steel
- sporty iridescent black & silver face dial, date window
- specialized polyurethane band
- water, paint and most chemical resistant
- beautifully screened logo
- durable shock absorbent, hardened glass lens
- water resistant to 300 feet
- balanced engineered case protecting precision Citizen mechanism
- blue stone crown detailing

ALL TIME MASTERY (ATM) Model #D250 msrp $169.99
- simplistic elegance
- forged from 316 stainless steel
- sturdy iridescent black & silver face dial, date window
- specialized polyurethane band
- water, paint and most chemical resistant
- beautifully screened logo
- durable shock absorbent, hardened glass lens
- water resistant to 300 feet
- balanced engineered case protecting precision Citizen mechanism
- blue stone crown detailing

TIME IMPRESSION Model #R300 msrp $129.99
- show stooping style
- forged from 316 stainless steel
- elegant iridescent black & silver face dial, date window
- water, paint and most chemical resistant
- beautifully screened logo
- durable shock absorbent, hardened glass lens
- water resistant to 300 feet
- balanced engineered case protecting precision Citizen mechanism
- blue stone crown detailing

MODERN EDGE Model #R310 msrp $99.99
- elegantly executed
- designed in Denmark
- forged from 316 stainless steel
- sturdy iridescent black & silver face dial, date window
- robust 100% genuine leather strap
- beautifully screened logo
- durable shock absorbent, hardened glass lens
- water resistant to 300 feet
- balanced engineered case protecting precision Citizen mechanism
- blue stone crown detailing

TIME BALANCE Model #R320 msrp $119.99
- unique & individual
- forged from 316 stainless steel
- elegant iridescent black & silver face dial, date window
- ample padding between band and watch
- beautifully screened logo
- durable shock absorbent, hardened glass lens
- water resistant to 300 feet
- balanced engineered case protecting precision Citizen mechanism
- blue stone crown detailing

GO POWER Model #R330 msrp $109.99
- casually refined
- forged from 316 stainless steel
- stylistic iridescent black & silver holographic checkered pattern face dial
- specialized polyurethane band
- water, paint and most chemical resistant
- beautifully screened logo
- durable shock absorbent, hardened glass lens
- water resistant to 300 feet
- balanced engineered case protecting precision Citizen mechanism
- blue stone crown detailing

SMOOTH FORCE Model #R340 msrp $119.99
- rewarding taste
- forged from 316 stainless steel
- elegant iridescent white & silver face dial
- specialized polyurethane band
- water, paint and most chemical resistant
- beautifully screened logo
- durable shock absorbent, hardened glass lens
- water resistant to 300 feet
- balanced engineered case protecting precision Citizen mechanism
- blue stone crown detailing

TIME PACE Model #R350 msrp $89.99 **TIME STEP*** Model #R360
- casual elegance
- forged from 316 stainless steel
- sturdy iridescent white & silver face dial
- beautifully screened logo
- durable shock absorbent, hardened glass lens
- water resistant to 300 feet
- balanced engineered case protecting precision Citizen mechanism
- blue stone crown detailing

TIME PACE*	TIME STEP*
specialized polyurethane band water, paint and most chemical resistant	robust 100% genuine leather strap

STRONG SHOW Model #R370 msrp $109.99
- durability driven
- forged from 316 stainless steel
- elegant iridescent white & silver face dial
- robust 100% genuine leather strap
- beautifully screened logo
- durable shock absorbent, hardened glass lens
- water resistant to 300 feet
- balanced engineered case protecting precision Citizen mechanism
- blue stone crown detailing

POWER TOUCH Model #P900 msrp $79.99
- promotional item*
- equipped with full chronograph functions
- fitting yellow tone dial & face + multifunction windows
- adjustable Velcro band
- manufactured from durable ABS plastic
- beautifully etched logo
- covered by a 1 year warranty

(Only Tool Time Watch ® style that is not made with a stainless steel casing)

Model Name	Model #	MSRP	Map	Cost
TOP CROP	C100	249.99	99.99	44.75
TIMELY CLASSIC	C110	249.99	99.99	44.75
MULTI EDGE	C120	229.99	99.99	41.10
BOLD & PRECISE	C130	219.99	89.99	41.10
CHALLENGE PROOF	D200	179.99	59.99	29.73
FLEX EFFECT	D210	169.99	54.99	28.55
CHOICE PLUS	D220	169.99	54.99	27.90
MIGHTY MUSCLE	D230	179.99	59.99	29.73
FLUID FORCE	D240	179.99	59.99	29.93
ALL TIME MASTERY (ATM)	D250	169.99	59.99	29.73
TIME IMPRESSION	R300	129.99	49.99	24.85
MODERN EDGE	R310	99.99	34.99	16.04
TIME BALANCE	R320	119.99	59.99	31.06
GO POWER	R330	109.99	54.99	26.55
SMOOTH FORCE	R340	119.99	59.99	28.33
TIME PACE	R350	89.99	49.99	22.22
TIME STEP	R360	89.99	49.99	22.22
STRONG SHOW	R370	109.99	54.99	25.55
POWER TOUCH	P900	79.99	24.99	12.98

2_____

DESIGN FIRM
JUNGLE 8 / creative
Los Angeles, (CA) USA
CLIENT
Tool Time Watches
DESIGNER, COPYWRITER
Lainie Siegel
PRODUCTION ARTIST
Joe Talkington

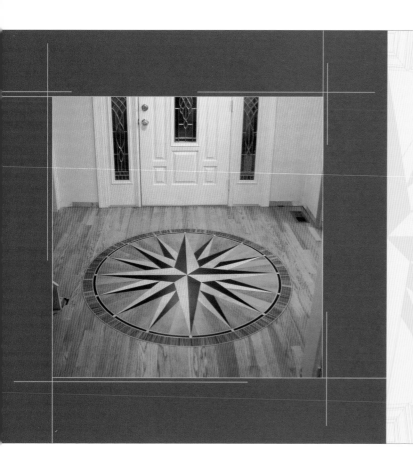

□

CREATED WITH PRECISION...
DESIGNED WITH PASSION

M Majestic Wood Floors has been serving the greater metropolitan area for nearly a decade. Founded in 1996 and striving for perfection ever since, we treat every job as if it is our only one. We are large enough to handle any size job, but also small enough to give each and every one the care and attention that it deserves. Our products have graced the architecture of many of the district and surrounding area homes, custom designed for each one.

In April of 2003, Majestic won the National Wood Floor Association's "Floor of the Year" award in the members choice expert division. Since, we have been featured in *"Floor Covering Weekly", "National Floor Trends"* and *"Hardwood Floors"* magazines. We would like the opportunity to design a floor of the year for you.

■ MAJESTIC WOOD FLOORS

1_____

1_____
DESIGN FIRM
Octavo Designs
Frederick, (MD) USA
CLIENT
Majestic Wood Floors
ART DIRECTOR
Sue Hough
DESIGNERS
Sue Hough, Mark Burrier

2_____
DESIGN FIRM
Mayhem Studios
Los Angeles, (CA) USA
PROJECT
Emtek Brochure
DESIGNER
Calvin Lee

MODERN LEVER & KNOB STYLES

EGG LEVER

ZURICH BLUE KNOB

LUZERN LEVER

EMTEK

2

MODERN LEVER & KNOB STYLES

SLEEK, STREAMLINED, ENERGIZED, THESE LEVERS CAN BE USED TO COMPLIMENT EITHER EURO-MODERN OR AMERICAN 50'S DECORATING THEMES. CONSTRUCTED FROM SOLID BRASS AND ETCHED GLASS.

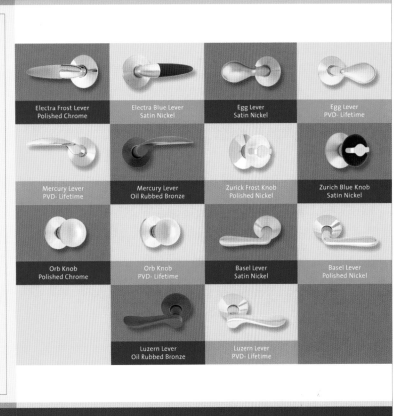

Electra Frost Lever
Polished Chrome

Electra Blue Lever
Satin Nickel

Egg Lever
Satin Nickel

Egg Lever
PVD- Lifetime

Mercury Lever
PVD- Lifetime

Mercury Lever
Oil Rubbed Bronze

Zurich Frost Knob
Polished Nickel

Zurich Blue Knob
Satin Nickel

Orb Knob
Polished Chrome

Orb Knob
PVD- Lifetime

Basel Lever
Satin Nickel

Basel Lever
Polished Nickel

Luzern Lever
Oil Rubbed Bronze

Luzern Lever
PVD- Lifetime

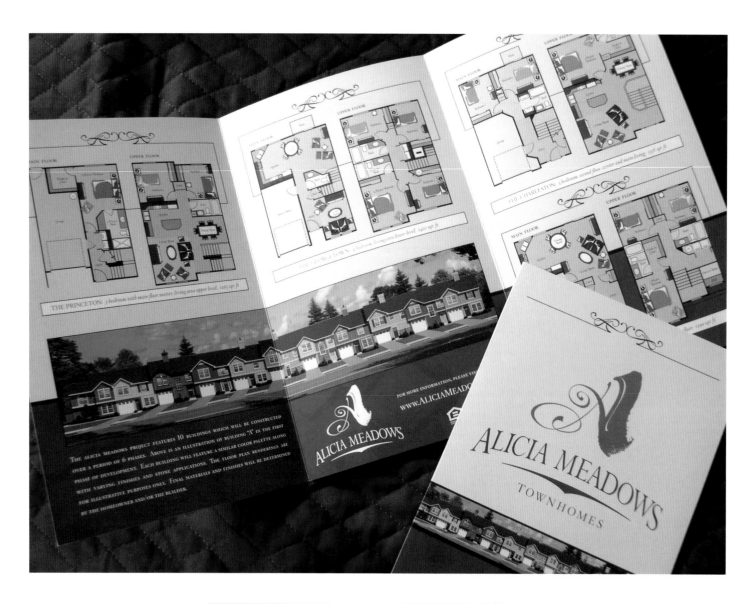

1_____
DESIGN FIRM
Colin Magnuson Creative
Tacoma, (WA) USA
CLIENT
Alicia Meadows LLC
DESIGNER
Colin Magnuson

2_____
DESIGN FIRM
Jeremy Schultz
West Des Moines, (IA) USA
PROJECT
The World Food Prize Brochure
DESIGNER
Jeremy Schultz

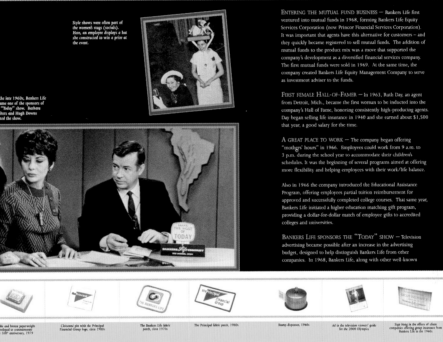

Style shows were often part of the women's stags (socials). Here, an employee displays a hat she constructed to win a prize at the event.

In the late 1960s, Bankers Life became one of the sponsors of the "Today" show. Barbara Walters and Hugh Downs hosted the show.

ENTERING THE MUTUAL FUND BUSINESS — Bankers Life first ventured into mutual funds in 1968, forming Bankers Life Equity Services Corporation (now Princor Financial Services Corporation). It was important that agents have this alternative for customers – and they quickly became registered to sell mutual funds. The addition of mutual funds to the product mix was a move that supported the company's development as a diversified financial services company. The first mutual funds were sold in 1969. At the same time, the company created Bankers Life Equity Management Company to serve as investment adviser to the funds.

FIRST FEMALE HALL-OF-FAMER — In 1963, Ruth Day, an agent from Detroit, Mich., became the first woman to be inducted into the company's Hall of Fame, honoring consistently high-producing agents. Day began selling life insurance in 1940 and she earned about $1,500 that year, a good salary for the time.

A GREAT PLACE TO WORK — The company began offering "mothers' hours" in 1966. Employees could work from 9 a.m. to 3 p.m. during the school year to accommodate their children's schedules. It was the beginning of several programs aimed at offering more flexibility and helping employees with their work/life balance.

Also in 1966 the company introduced the Educational Assistance Program, offering employees partial tuition reimbursement for approved and successfully completed college courses. That same year, Bankers Life initiated a higher education matching gift program, providing a dollar-for-dollar match of employee gifts to accredited colleges and universities.

BANKERS LIFE SPONSORS THE "TODAY" SHOW — Television advertising became possible after an increase in the advertising budget, designed to help distinguish Bankers Life from other companies. In 1968, Bankers Life, along with other well-known

DID YOU KNOW?

Earl Rosell, an agent in Billings, Mont., was featured in a movie with Dustin Hoffman in 1970. The movie, "Little Big Man," was filmed on Rosell's ranch.

In the 1950s and 1960s, The Bankers Life was a big draw for young women – many just out of high school. Many of these young women came from small towns outside of Des Moines. They'd arrange for housing in Des Moines during the week, returning home on the weekends. On Fridays, they'd drop their suitcases in the lobby and pick them up at the end of the day before heading out of town. At the time, these young women were known as "Bankers Life girls."

In 1956 the company approved a mortgage loan for a home to be built in Pacific Palisades, Calif., for Ronald and Nancy Reagan.

In the 1960s, only supervisors had phones on their desks. If an employee had a phone call from outside, the employee picked up the message from the receptionist at lunch time.

Marble and bronze paperweight developed to commemorate the 100th anniversary, 1979

Cloisonné pin with the Principal Financial Group logo, circa 1980s

The Bankers Life fabric patch, circa 1970s

The Principal fabric patch, 1980s

Stamp dispenser, 1940s

Ad in the television viewers' guide for the 2000 Olympics

Sign hung in the offices of client companies offering group insurance from Bankers Life in the 1940s

2_____

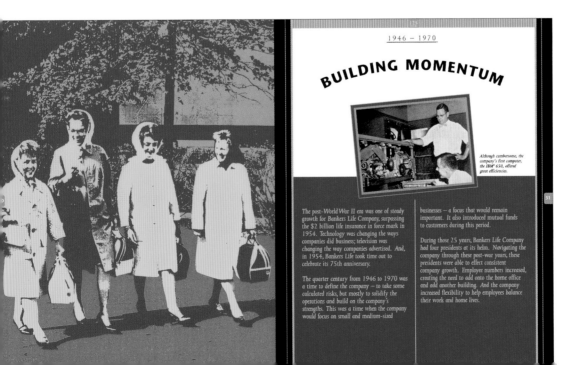

1946 – 1970

BUILDING MOMENTUM

Although cumbersome, the company's first computer, the IBM 650, offered great efficiencies.

The post-World War II era was one of steady growth for Bankers Life Company, surpassing the $2 billion life insurance in force mark in 1954. Technology was changing the ways companies did business; television was changing the way companies advertised. And, in 1954, Bankers Life took time out to celebrate its 75th anniversary.

The quarter century from 1946 to 1970 was a time to define the company — to take some calculated risks, but mostly to solidify the operations and build on the company's strengths. This was a time when the company would focus on small and medium-sized

businesses — a focus that would remain important. It also introduced mutual funds to customers during this period.

During those 25 years, Bankers Life Company had four presidents at its helm. Navigating the company through these post-war years, these presidents were able to effect consistent company growth. Employee numbers increased, creating the need to add onto the home office and add another building. And the company increased flexibility to help employees balance their work and home lives.

Maryland Food Stamp Nutrition Education

Evaluation Report
Fiscal Year 2005

DESIGN FIRM
**The University of Maryland
Cooperative Extension**
Columbia, (MD) USA

CLIENT
The University of Maryland
Cooperative Extension—
Food Stamp Nutrition Education Program

DESIGNER
Trang Dam

FSNE
changes
lives

Achievements and Recommendations

In fiscal year 2005, we made several innovative efforts to increase the efficiency and utility of the program evaluation. First, in response to concern over the formatting of the pre/post behavior change evaluation tool, the evaluation team tested modifications to the format in two program sites. This testing revealed reduced error among participants completing the evaluation, and the new format was adopted for use. Second, new evaluations were collected for teacher trainings and Color Me Healthy programs. Third, Elaine A. Anderson, Ph.D. and Marta McClintock-Comeaux, MSW, conducted a meta-evaluation of the program to examine program planning, implementation, and outcomes over the last four years. Dr. Anderson provided recommendations for future FSNE programming. Fourth, educators moved to full-scale use of consent forms and participant tracking. These evaluation achievements, along with the many positive impacts made by educators and program staff, have increased the effectiveness of FSNE each year.

In reflecting upon evaluation results for fiscal year 2005 and the program meta-evaluation, several challenges and opportunities for improvement emerge. First, a major limitation of the pre/post behavior change evaluations is that program staff are unable to determine whether people's intentions to change behavior translate into actual behavior change. Second, the match between program goals and objectives and the evaluation techniques used to determine success need to be strengthened. Third, some evaluation techniques and formatting need to be better suited to participants' abilities to address evaluation questions. Fourth, as the sources and quantity of evaluation data increase, the time constraints for analyzing data have become more burdensome for evaluation staff. Finally, the collection and tracking of consent forms from adult participants completing pre/post behavior change evaluations have become burdensome to educators.

In order to address these emerging problems, we have proposed the following improvements for fiscal year 2006 and 2007 program evaluation. The evaluation staff will conduct post-lesson interviews with participants

Maryland Food Stamp Nutrition Education Evaluation Report • Fiscal Year 2005

Of 142,443 total FSNE participants, 103,485 were adults, 34,727 were youth, and 4,231 were agency staff or teachers.

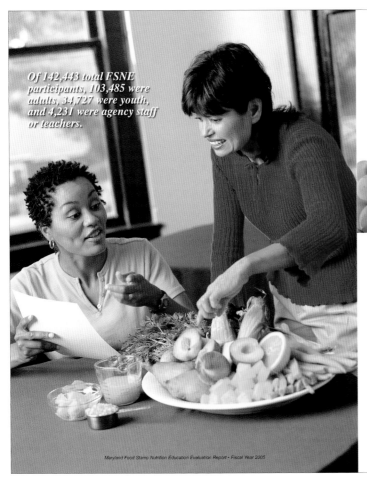

Evaluation Project Overview

The 2005 program evaluation includes analyses of contact data, pre/post behavior change quantitative data, qualitative data, and quantitative data from the *WalkWays* program. Participant contact data was collected via the Maryland Cooperative Extension Reporting System. Pre/post behavior change quantitative data was collected through the use of a standardized question bank, measuring the extent to which learners indicate an intention to change specific behaviors. Intent to change responses were used as a proxy measure for pre-post evaluation methods. Consent forms were collected for each adult participant who provided pre/post behavior change data (see Appendix G). Qualitative data in the form of stories, photographs, newspaper articles, and educator reports were collected and analyzed for themes. Quantitative data from WalkWays program participants was collected in the form of walking logs that recorded each participant's stage of change for engaging in physical activity before and after the program, as well as their steps per week throughout the duration of the program.

In this report, program and participant data are presented, as are recommendations from a program meta-analysis. Program evaluation achievements, areas in need of strengthening, and evaluation plans for fiscal year 2006 are included. County data is available to each county for their program planning and reporting purposes. County data includes project summaries, participant demographics, and pre/post behavior change data. Recommendations to strengthen program implementation and evaluation also are included.

Maryland Food Stamp Nutrition Education Evaluation Report • Fiscal Year 2005

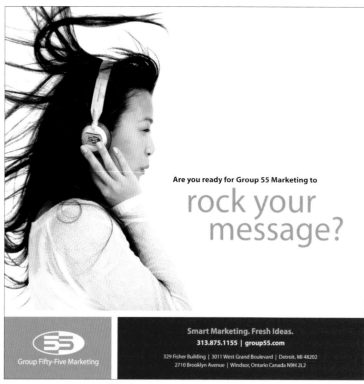

Are you ready for Group 55 Marketing to

rock your message?

Smart Marketing. Fresh Ideas.
313.875.1155 | group55.com

329 Fisher Building | 3011 West Grand Boulevard | Detroit, MI 48202
2710 Brooklyn Avenue | Windsor, Ontario Canada N9H 2L2

Group Fifty-Five Marketing

DESIGN FIRM
Group 55 Marketing
Detroit, (MI) USA
PROJECT
Group 55 Marketing
Corporate brochure
ART DIRECTOR, DESIGNER
Heather Sowinski
COPYWRITERS
Catherine Lapico,
Jeannette Gutierrez,
David Horowitz, Dave Warner

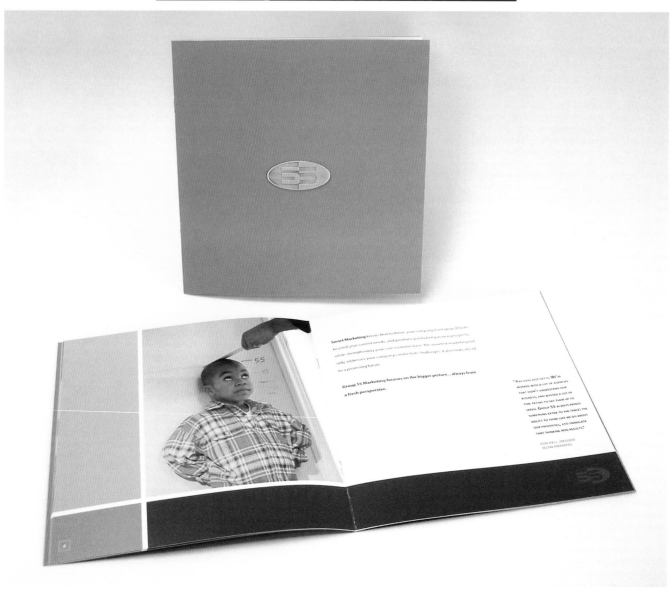

Smart Marketing never forgets your company's values, mission, and core competencies. It builds an image firmly oriented in your company's unique personality, and expresses that personality in a campaign that's both memorable... and compelling.

Group 55 Marketing finds your company's true north... and stays true to it.

"FROM DAY ONE, GROUP 55 GRASPED OUR UNIQUE PARTNERSHIP-DRIVEN BUSINESS STRATEGY AND SERVICE CULTURE. FROM START TO FINISH, THEY HAVE MANAGED PROJECTS EFFICIENTLY, CONFIDENTLY, AND WITHIN BUDGET. WE ESPECIALLY APPRECIATE THEIR ADAPTABILITY, AVAILABILITY, AND CREATIVITY."

LINDA DESIMONE,
CORPORATE COMMUNICATIONS MANAGER,
AMERISURE INSURANCE

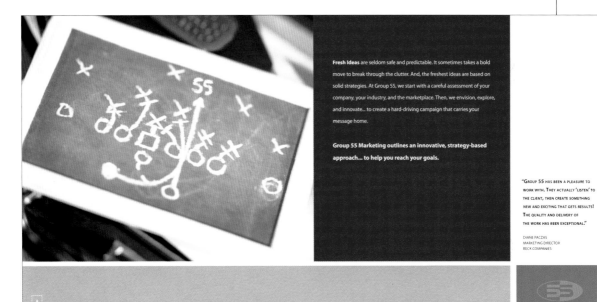

Fresh Ideas are seldom safe and predictable. It sometimes takes a bold move to break through the clutter. And, the freshest ideas are based on solid strategies. At Group 55, we start with a careful assessment of your company, your industry, and the marketplace. Then, we envision, explore, and innovate... to create a hard-driving campaign that carries your message home.

Group 55 Marketing outlines an innovative, strategy-based approach... to help you reach your goals.

"GROUP 55 HAS BEEN A PLEASURE TO WORK WITH. THEY ACTUALLY 'LISTEN' TO THE CLIENT, THEN CREATE SOMETHING NEW AND EXCITING THAT GETS RESULTS! THE QUALITY AND DELIVERY OF THE WORK HAS BEEN EXCEPTIONAL."

DIANE PACZAS
MARKETING DIRECTOR
BECK COMPANIES

Smart Marketing sweats the details...from exceptionally thorough research, to finding the most effective vehicle to reach your audience. Smart marketing asks the right questions... to create a campaign with muscle, where each element works hard on many different levels to communicate your company's message.

Group 55 Marketing. We're about performance. And results. And we never forget the most important number of all... your bottom line.

"GROUP 55 CREATED AN OUTSTANDING CAMPAIGN FOR US, AND POTENTIAL CLIENTS HAVE ACTUALLY CALLED US TO SAY HOW IMPRESSED THEY ARE. GROUP 55'S ABILITY TO DELIVER GREAT WORK IS MATCHED BY THEIR ATTENTION TO DETAIL, AND TIMELY COMMUNICATION. THEY'RE ALWAYS 'ON', ALWAYS THINKING. I FEEL OUR ACCOUNT HAS THEIR FULL ATTENTION."

BERND RONNISCH
PRESIDENT
RONNISCH CONSTRUCTION GROUP

greater
than
the
sum

SELECTIONS FROM
THE CRAIG ROBINS COLLECTION OF CONTEMPORARY ART

as a collection, the contemporary art
acquired by miami-based developer
craig robins defies neat categorization.
combining a cutting edge outlook with
unusual range and depth, robins has
selected impressive works by many of
the brightest names in contemporary art.
but it is immediately clear that this
collector is responding in a very
personal way to pieces that speak
on both emotional and formal levels.
ranging from minimal and serene
to politically charged and arousing,
the robins collection covers a spectrum
of aesthetic interests.

university GALLERY

cover art: PAUL MCCARTHY / **pot head**, silicon rubber, 33.5"x42"x48"

1_____

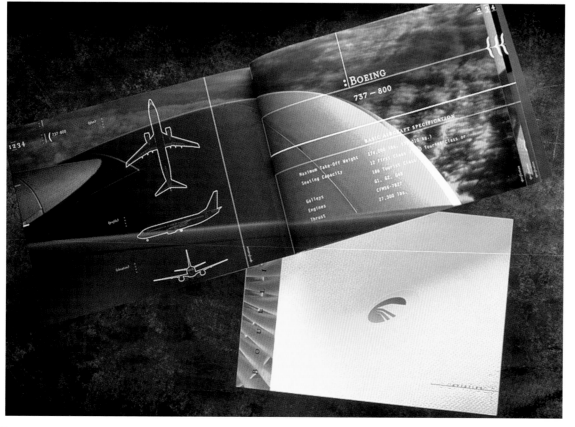

2_____

1_____
DESIGN FIRM
Connie Hwang Design
Gainesville, (FL) USA
PROJECT
Greater Than the Sum
Exhibition Brochure
DESIGNER
Connie Hwang
COPYWRITER
Amy Vigilante

2_____
DESIGN FIRM
**Hornall Anderson
Design Works**
Seattle, (WA) USA
CLIENT
Boullioun Aviation Services
DESIGNERS
Jack Anderson,
Katha Dalton,
Ryan Wilkerson,
Belinda Bowling

3_____
DESIGN FIRM
Kiku Obata & Company
St. Louis, (MO) USA
CLIENT
McCormack Baron Salazar
DESIGNER
Rich Nelson

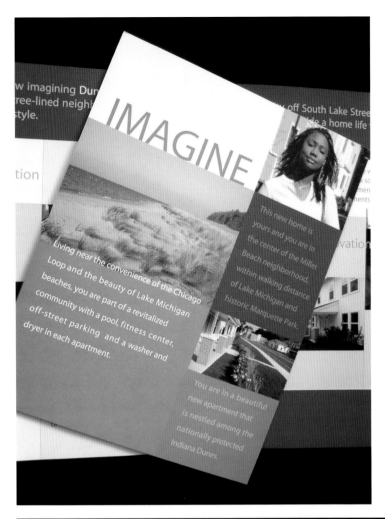

Living near the convenience of the Chicago Loop and the beauty of Lake Michigan beaches, you are part of a revitalized community with a pool, fitness center, off-street parking and a washer and dryer in each apartment.

This new home is yours and you are in the center of the Miller Beach neighborhood, within walking distance of Lake Michigan and historic Marquette Park.

You are in a beautiful new apartment that is nestled among the nationally protected Indiana Dunes.

IMAGINE

3

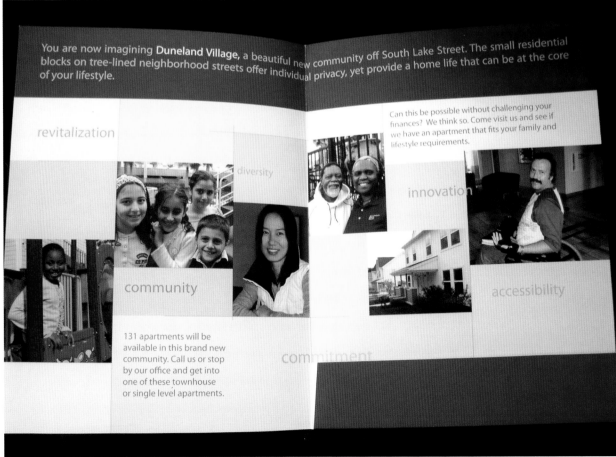

You are now imagining **Duneland Village**, a beautiful new community off South Lake Street. The small residential blocks on tree-lined neighborhood streets offer individual privacy, yet provide a home life that can be at the core of your lifestyle.

revitalization

diversity

community

131 apartments will be available in this brand new community. Call us or stop by our office and get into one of these townhouse or single level apartments.

Can this be possible without challenging your finances? We think so. Come visit us and see if we have an apartment that fits your family and lifestyle requirements.

innovation

accessibility

commitment

173

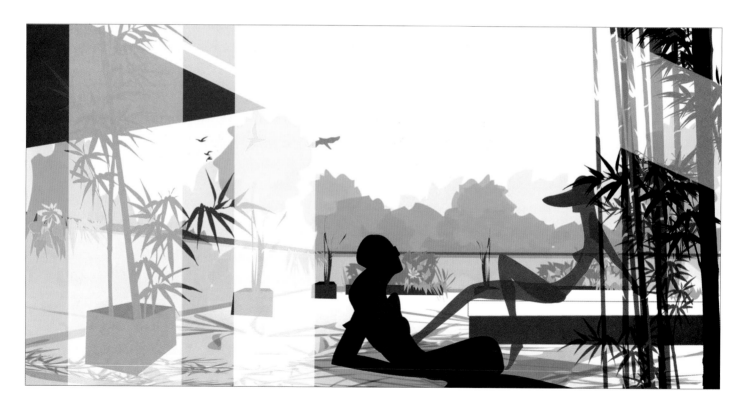

DESIGN FIRM
Maurius Fahrner Design
New York, (NY) USA
CLIENT
Jakob Juergensen
Immobilien GmbH
ART DIRECTOR
Marius Fahrner
ILLUSTRATOR
Barbara Spoettel

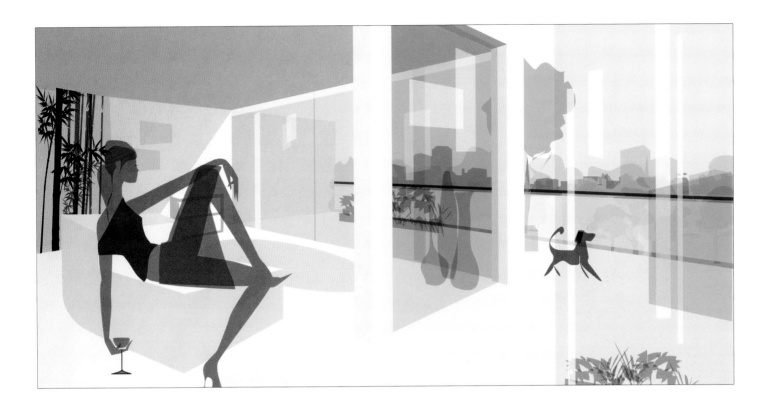

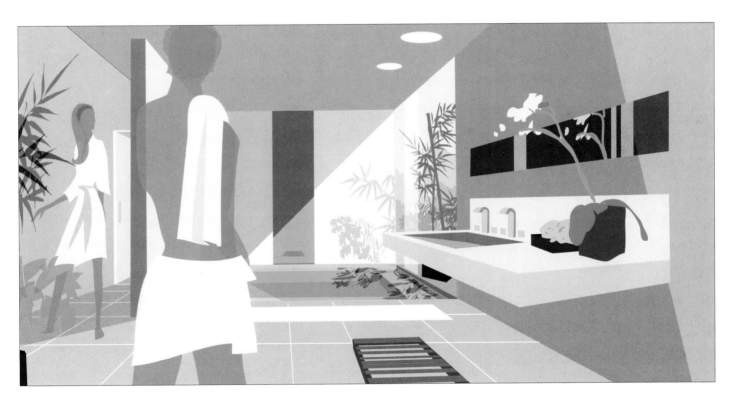

1_____

1_____
DESIGN FIRM
Audra Buck Design
Birmingham, (AL) USA
ART DIRECTOR, DESIGNER
Audra Buck

2_____
DESIGN FIRM
Corel Marketing Services & Epoxy
Ottawa, Canada
CLIENT
Corel Painter IX

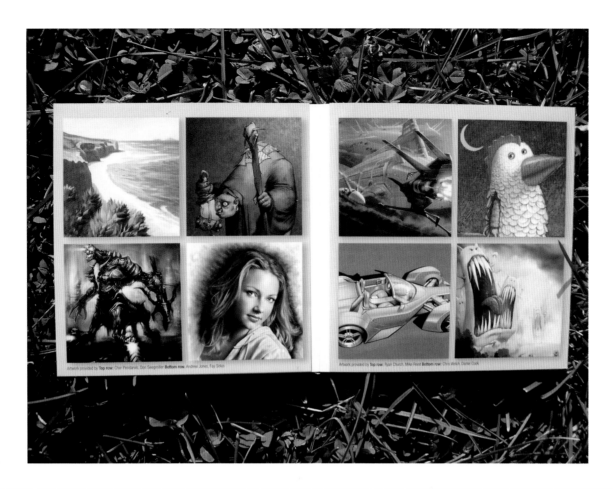

2

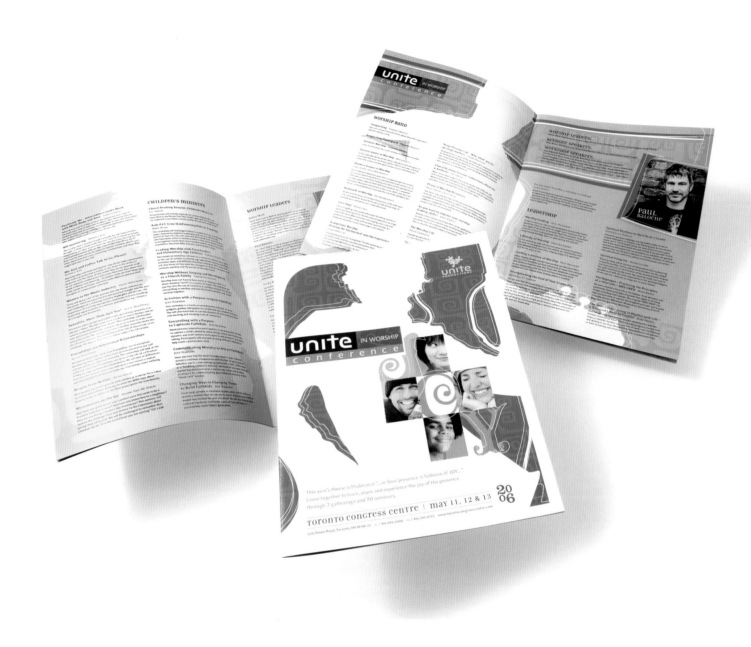

DESIGN FIRM
Riordon Design
Oakville, (Ontario) Canada
CLIENT
Unite Productions
ART DIRECTOR
Shirley Riordon
DESIGNERS, ILLUSTRATORS
Dawn Charney, Shirley Riordon

COMMONLY ASKED QUESTIONS

Where is Slovenia?

This is usually the first question asked when putting forward Slovenian wines. A bit of surrounding information and a basic map will provide you with the answer. At the crossroads of Western and Central Europe, Slovenia rests, with Austria to the north, Italy to the west, Hungary in the east and Croatia to the South. A short stretch of the Adriatic Sea shapes Slovenia's beautifully picturesque, rocky coastline. The Julian Alps ascend along the Italian and Austrian borders, with wooded hills and fertile fields prevailing as one moves south and east, as the lush and verdant valleys roll west toward the sea.

Why haven't I heard about Slovenian wine before?

Slovenia is a very little country with a population of only two million people. Compared to most wine exporting nations, they just don't produce a lot.

Does Slovenia have a tradition of winemaking?

Slovenia is home to the oldest continuously producing vine in Europe - it is over four hundred years old.
Indeed, it is no surprise that Slovenian vineyards have been producing high quality wine for many years.
This tradition has been carried on by a new generation of private winemakers, who creates their own unique and distinctive techniques that rival the best wine found anywhere in the world.

WINES FROM SLOVENIA

Wines From SLOVENIA

Editor
TOMAŽ SRŠEN

SLOVENIA
The Wine Country
AT THE SUNNY SIDE
of the ALPS

Basic facts:
All vineyards: *24,200 ha*
Total annual production: *98,000,000 L.*
Average annual consumption per capita: *41 L.*

Slovenia has always been *the crossroads between* north and south, east and west; travellers brought viticultural knowledge from all the prominent viticultural nations. Accordingly, French, Italian, and German influences are evident both in the growing and production of wines as well as in the terminology. Varietal wines are predominantly named after the grape, while blended wines frequently carry the name of the producing region; the terminology for high-quality and predicate wines is similar to the German.

Gorenjska
Podmurje
Primorje

7

2_____

Winegrowing Regions
OF
SLOVENIA

Tree winegrowing regions:
Primorje: *6,500 ha (16,200 acres)*
Podravje: *10,200 ha (25,600 acres)*
Posavje: *7,500 ha (18,700 acres)*

Vitis vinifera can only be *cultivated in climate* zones where the average yearly temperature is between 14-15 °C and cannot grow, much less produce quality wine in areas with a yearly average below 10 °C. These climatic conditions are only achieved between 30 °N and 50 °N in the northern hemisphere and 30 °S and 50 °S in the southern hemisphere, and even there only in regions where the summer heat is moderated by proximity to the sea or other large bodies of water. The vine may grow closer to the equator, but the resulting grape would only accumulate abundant sugar and pigments with aromatics and acids too scarce for production of quality wine. Further north and south, the temperatures are simply too low, the summers too short, and the spring frosts too severe for the gentle shoots.

Primorje
Podravje
Posavje

29

2_____
DESIGN FIRM
KROG, Ljubljana
Ljubljana, Slovenia
CLIENT
Ministry for Agriculture, Forestry and Food of the Republic of Slovenia
ART DIRECTOR, DESIGNER
Edi Berk
EDITOR
Tomaz Srsen

Makers of Hawaii's Finest Ukuleles Since 1916

KAMAKA UKULELE

1_____

Aloha Kakou!

Welcome to Kamaka Hawaii, Inc., makers of Hawaii's finest ukuleles, and the home of the original Pineapple Ukulele! Kamaka Hawaii was established in 1916 in the Territory of Hawaii, and is a family-owned and operated business. The Kamaka family has been dedicated to building skillfully-handcrafted ukuleles for nearly a century. The heritage of ukulele making at Kamaka Hawaii is preserved by second and third generation Hawaiian luthiers, as well as the many talented craftsmen at the Kakaako factory in Honolulu.

A tradition of excellence is the foundation of Kamaka Hawaii's reputation. Kamaka ukuleles are world-renown, and possess a lasting, rich tone that cannot be duplicated. The process of making a Kamaka ukulele is an art that involves design, redesign, and experimentation to produce instruments with the tonal and playing characteristics required by professional and amateur musicians alike. Many of the techniques used today have evolved from practices developed by founder Sam Kamaka Sr. This ensures consistency in quality, resulting in ukuleles that are often handed down to future generations and cherished as valued family heirlooms.

Kamaka ukuleles begin as rough Hawaiian koa lumber, and are meticulously hand built into exquisite musical instruments enjoyed by ukulele players and audiences across the globe. The Kamaka name is synonymous with superior Hawaiian craftsmanship, and Kamaka ukuleles are world-class instruments enjoyed by everyone from elementary school beginners to professional musicians.

The Kamaka Story

Shortly after the turn of the century, Samuel Kaialiilii Kamaka began crafting koa ukuleles from the basement of his Kaimuki, Hawaii home. In 1916, he formed his one-man shop, "Kamaka Ukulele and Guitar Works," and soon established a solid reputation for making only the highest quality ukuleles.

In 1921, Kamaka Ukulele established a shop at 1814 South King Street. In the mid-20s, Sam Kamaka laid out a pattern for a new oval-shaped ukulele body. His friends remarked that it looked like a pineapple, so one of Sam's artist friends painted the front to duplicate the tropical fruit. A few years later in 1928, Sam Kamaka patented the design. Thus began the original Pineapple Ukulele, which produced a resonant, mellow sound distinct from the traditional figure-eight. The Pineapple Ukulele became an instant success worldwide, and continues to be Kamaka's signature ukulele to this day.

During the 30s, Sam Sr. introduced his two sons, Samuel Jr. and Frederick, to the craft of ukulele-making, even though the boys were only in elementary school. In 1945, the business was reorganized as "Kamaka and Sons Enterprises." Sam Jr. and Fred Sr. were then drafted into the Army, and after serving in WWII, both brothers attended college on the GI bill. After graduating from Washington State University, Fred Sr. began a career in the Army, while Sam Jr. earned a masters degree and went on to pursue a doctorate in entomology at Oregon State University.

In 1952, Sam Sr. went into semi-retirement and hauled his equipment to his Lualualei Homestead farm in Waianae. When he became seriously ill the following year, Sam Jr. abandoned his studies and moved back to Hawaii to care for his father. Sam Sr. died in December 1953, after hand-crafting koa ukuleles for over 40 years.

Immediately following Sam Sr.'s death, Sam Jr. put aside his personal career aspirations to continue the family business. Building on the knowledge he had picked up from his father, Sam Jr. restored the factory at the previous 1814 S. King Street location. Five years later in 1959, the company expanded to its current location at 550 South Street.

Kamaka and Sons incorporated in 1968 and became "Kamaka Hawaii, Inc." After retiring from the Army in 1972, Fred Sr. joined the business as its general manager. Along the way, Sam Jr.'s sons, Chris and Casey, also got involved with the company as did Fred Sr.'s son, Fred Jr. The sons now play major roles at Kamaka Hawaii, Inc.: Chris is the production manager, Casey crafts the custom orders, and Fred Jr. is the business manager. Other young family members are also helping with the business, carrying the Kamaka tradition into the fourth generation.

As the Kamaka legacy moves forward, it is important to reflect on what has made the company endure. The guiding philosophy at Kamaka Hawaii has always been the candid, but sensible advice handed down from Sam Sr. to sons, grandsons, and now, great-grandsons: "If you make instruments and use the family name, don't make junk."

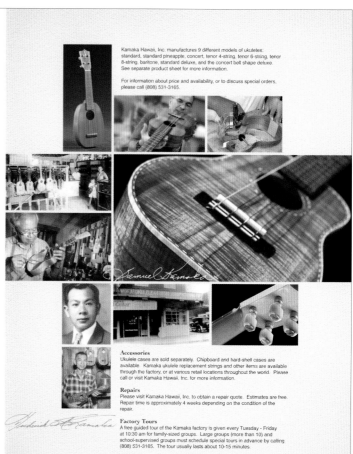

Kamaka Hawaii, Inc. manufactures 9 different models of ukuleles: standard, standard pineapple, concert, tenor 4-string, tenor 6-string, tenor 8-string, baritone, standard deluxe, and the concert bell shape deluxe. See separate product sheet for more information.

For information about price and availability, or to discuss special orders, please call (808) 531-3165.

Accessories
Ukulele cases are sold separately. Chipboard and hard-shell cases are available. Kamaka ukulele replacement strings and other items are available through the factory, or at various retail locations throughout the world. Please call or visit Kamaka Hawaii, Inc. for more information.

Repairs
Please visit Kamaka Hawaii, Inc. to obtain a repair quote. Estimates are free. Repair time is approximately 4 weeks depending on the condition of the repair.

Factory Tours
A free guided tour of the Kamaka factory is given every Tuesday - Friday at 10:30 am for family-sized groups. Large groups (more than 10) and school-supervised groups must schedule special tours in advance by calling (808) 531-3165. The tour usually lasts about 10-15 minutes.

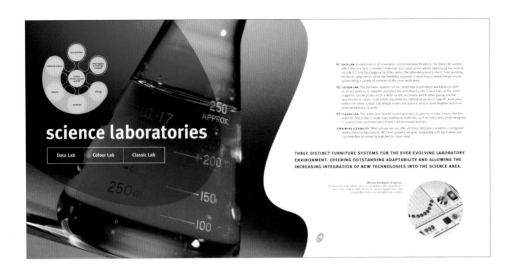

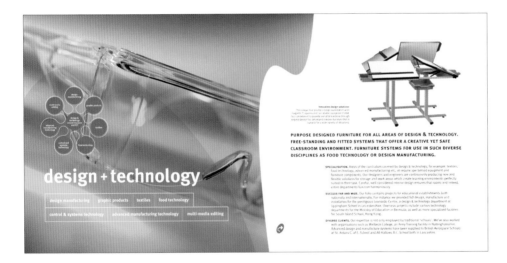

2_____

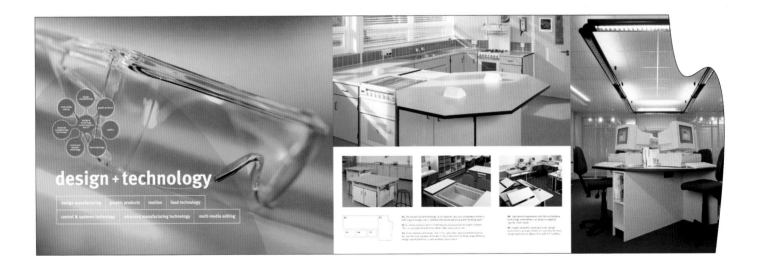

1_____
DESIGN FIRM
John Wingard Design
Honolulu, (HI) USA
CLIENT
Kamaka Hawaii
ART DIRECTOR, DESIGNER
John Wingard
PHOTOGRAPHER
Bud Muth

2_____
DESIGN FIRM
Imagine
Manchester, England
PROJECT
Keystage Brochure
ART DIRECTOR, DESIGNER
David Caunce

J.U.i.C.E.

justice by uniting in creative energy

REPLICATION MANUAL

J.U.i.C.E. is a project of Community Partners

DESIGN FIRM
JUNGLE 8 / creative
Los Angeles, (CA) USA
CLIENT
Justice by Uniting in
Creative Energy
CREATIVE DIRECTOR
Lainie Siegel
DESIGNERS
Justin Cram,
Amir Tohrani
COPY EDITOR
Lauren Kay
COPYWRITER
Dawn Smith
PRODUCER
Monica X. Delgado

OUR MISSION

The mission of J.U.I.C.E. is to address the root causes of juvenile crime and of youths' need for belonging by providing a safe center run by and for young people, focused on skill building in the arts surrounding hip-hop culture: word, music, art, and dance.

WELCOME, GROUNDBREAKER

We hope this book will serve as a guide, providing you with ideas and inspiration for bringing positive change to your community. Young people in need, a juvenile justice system gone awry, and the power of hip-hop as a creative force have inspired and informed our work. This manual is for anyone interested in learning more about what it takes to create a J.U.I.C.E. site, and about breaking new ground of your own. In this manual, you will find resources, tips, stories, and lessons learned to guide you on your own journey. Here's to you!

Much of the inspiration for J.U.I.C.E. came from activist, organizer, author, and graffiti writer Billy "Upski" Wimsatt, who wrote so eloquently about the importance of the journey to starting your own community organization in his book, "NO MORE PRISONS."

"(When) you walk in and look around you see all types of races, varying from young age to old age, and it's just a comfortable feeling. It's just inviting. It's just like family. Everyone knows each other. As soon as they walk in, everyone introduces themselves to each other, and it's just a pleasant place to be."

—Rawbzilla

J.U.i.C.E.

JUSTICE BY UNITING IN CREATIVE ENERGY

Excerpt from
Billy "Upski" Wimsatt's
NO MORE PRISONS:

I WANT YOU TO THINK SERIOUSLY ABOUT STARTING AN ORGANIZATION. IT DOESN'T HAVE TO BE A BIG ORGANIZATION. IT COULD JUST BE YOU. THINK ABOUT YOUR SKILLS, RESOURCES, CONNECTIONS, PASSIONS, AND DREAM UP A WAY TO FIGHT EVIL IN YOUR OWN LITTLE PERSONAL AND SPECIFIC WAY. MAKE UP A CLEVER NAME FOR IT. THEN CALL YOUR FRIENDS. GET THEM EXCITED ABOUT IT. IF THEY'RE NOT EXCTIED, THEN MAKE SOME NEW FRIENDS WHO ARE. HAVE THEM OVER FOR DINNER. MAKE IT FUN.

AND DON'T SPEND TOO MUCH TIME PLANNING. THE MOST IMPORTANT STEP IS TO START THE ORGANIZATION. LEARN BY DOING. IT WILL PROBABLY FLOP AND THAT'S OKAY. IT'S YOUR FIRST TRY. YOU'LL LEARN AS YOU GO.. I HAVE PROBABLY STARTED A DOZEN ORGANIZATIONS THAT FLOPPED. THAT'S OKAY. I HAD TO FAIL TO LEARN.

. . .

IT IS DIFFICULT TO GRASP THIS MOMENT IN THE HISTORY OF THE EARTH. THOSE OF US WHO GET IT SOME OF THE TIME—WHO APPRECIATE THE SANCTITY, AND WHO UNDERSTAND OUR POWER IN DETERMINING THE FUTURE—WE HAVE A LOT OF WORK TO DO.

"I've been in hip-hop for about a year now and before that I was into, I mean I wasn't getting into trouble but I didn't know who I was, I was into drugs, I did drugs and just followed whoever I was hanging with. Opportunities like this, like what J.U.I.C.E. provides, they just do so much for the children. And just being part of the hip-hop culture, it's opened so many doors for me and it's closed the ones I don't want to ever open again.

—Jackie, J.U.I.C.E. participant

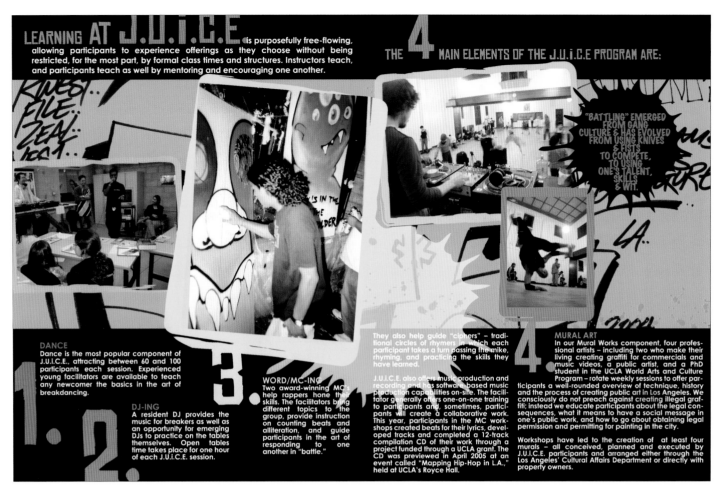

LEARNING AT J.U.i.C.E.

LEARNING AT J.U.i.C.E. is purposefully free-flowing, allowing participants to experience offerings as they choose without being restricted, for the most part, by formal class times and structures. Instructors teach, and participants teach as well by mentoring and encouraging one another.

THE 4 MAIN ELEMENTS OF THE J.U.i.C.E PROGRAM ARE:

"BATTLING" EMERGED FROM GANG CULTURE & HAS EVOLVED FROM USING KNIVES & FISTS TO COMPETE, TO USING ONE'S TALENT, SKILLS & WIT.

1. DANCE
Dance is the most popular component of J.U.i.C.E., attracting between 60 and 100 participants each session. Experienced young facilitators are available to teach any newcomer the basics in the art of breakdancing.

2. DJ-ING
A resident DJ provides the music for breakers as well as an opportunity for emerging DJs to practice on the tables themselves. Open tables time takes place for one hour of each J.U.i.C.E. session.

3. WORD/MC-ING
Two award-winning MC's help rappers hone their skills. The facilitators bring different topics to the group, provide instruction on counting beats and alliteration, and guide participants in the art of responding to one another in "battle."

They also help guide "ciphers" – traditional circles of rhymers in which each participant takes a turn passing the mike, rhyming, and practicing the skills they have learned.

J.U.I.C.E. also offers music production and recording and has software-based music production capabilities on-site. The facilitator generally offers one-on-one training to participants and, sometimes, participants will create a collaborative work. This year, participants in the MC workshops created beats for their lyrics, developed tracks and completed a 12-track compilation CD of their work through a project funded through a UCLA grant. The CD was previewed in April 2005 at an event called "Mapping Hip-Hop in L.A.," held at UCLA's Royce Hall.

4. MURAL ART
In our Mural Works component, four professional artists – including two who make their living creating graffiti for commercials and music videos, a public artist, and a PhD student in the UCLA World Arts and Culture Program – rotate weekly sessions to offer participants a well-rounded overview of technique, history and the process of creating public art in Los Angeles. We consciously do not preach against creating illegal graffiti; instead we educate participants about the legal consequences, what it means to have a social message in one's public work, and how to go about obtaining legal permission and permitting for painting in the city.

Workshops have led to the creation of at least four murals – all conceived, planned and executed by J.U.i.C.E. participants and arranged either through the Los Angeles' Cultural Affairs Department or directly with property owners.

assembling a **board of directors**

The most important attribute a board member can have is a strong belief in the mission and vision of the program. After all, these are your cheerleaders, your guides, your ambassadors to other sectors of the community. They must be fully invested in your cause.

In addition to finding individuals who are strong supporters, it's helpful to create a balance in terms of the sectors of the community that board members represent. Our J.U.i.C.E. board is comprised of a diverse group of individuals who bring experience in work with at-risk youth, with nonprofits and hip-hop to the table. A racially diverse make-up among the board also is important, particularly one that is representative of the community served. And because of our mandate to serve young people, we also have two young adults on the board.

Working with Dawn on different projects, I found a chemistry that was fueled by the need to educate and empower youth of color through hip-hop culture. My connection to J.U.I.C.E. was not only through Dawn, but as a former participant, enjoying the resources a b/girl needed. It was inevitable that joining J.U.I.C.E.'s executive board was the next step. Since then, it's been an honor to be a part of something I've seen develop into an important piece of Los Angeles' hip-hop history, present and future.

-- Lisa Ann (L.A.) Nevins, J.U.I.C.E. advisory board

J.U.I.C.E. staff and facilitators have become members of Los Angeles Local Organizing Committee (LALOC), which sent delegates to the National Hip-Hop Political Convention, and LALOC has worked closely with J.U.I.C.E. to help the organization fulfill it's full vision of engaging in community organizing. The experience has been truly rewarding.

-- Kyle Stewart, J.U.I.C.E. advisory board

"I not only look forward to seeing the program continue to develop into a self-sustaining entity, I also look forward to watching some of our participants continue to develop their art as well."

-- David Camacho, J.U.I.C.E. advisory board

"Both J.U.I.C.E. and the Hip-Hop Congress chapter programs were in their infancy at the time we met. Dawn was still looking for a location for the L.A. J.U.I.C.E and my Awareness Festival was the first event of the first HHC chapter. Now J.U.I.C.E. is thriving in LA and expanding into local schools, and the Hip-Hop Congress has 28 thriving chapters. It's great to see both have grown together and how both are successful today."

-- Jordan Bromley, J.U.I.C.E. advisory board member

"As a teacher in the inner city of Los Angeles, I longed to find a program that spoke directly to the needs of the high-risk students at my school. I finally found all that I had desperately searched for when I was connected to Dawn Smith and J.U.I.C.E. four years ago. Since then, on my own time, I have transported students with the most severe behavior challenges to the program. When Dawn Smith asked me to serve on the board of directors I was honored and excited to be a part of this life-altering program.

-- Leslie Baldwin, J.U.I.C.E. advisory board

"As an arts administrator and advocate I was intrigued to learn of an active arts organization in my local community. Although the Westlake/MacArthur Park area is the most populated urban area in the United States, there are very few programs geared toward providing an avenue for youth arts and community empowerment... I am now an active board member who is continually reminded of the positive impact that J.U.I.C.E. and its programs have. From community mural projects to music editing classes, the benefits are exponential as the organization continues to grow."

-- Erik Qvale, J.U.I.C.E. advisory board

Because J.U.i.C.E. operates as a project of Community Partners, a fiscal agent, our board legally serves in an advisory capacity and the CP board of directors is our official board. In practice, however, our advisory board serves all traditional board functions, fundraising, programmatic advisement and much more. (See Appendix for more on the role of a nonprofit board.)

It is only now, five years into the research and design of the center, that we have held a board retreat and spent a day discussing a strategic plan for the future of the program as well as how best to recruit new board members to meet our goals. To date, we have been incredibly blessed with the skills, background, and dedication of our advisory board members.

"Before J.U.I.C.E., I was into vandalism. I've been caught seven times. It's been a bad thing for me. I found J.U.I.C.E. and I found the right way to take my art form where I can make money off of it...Here I learned that graffiti is accepted by galleries. I've been in a couple galleries already and it makes you feel good. ... I sold my canvasses once or twice. It feels good to know that someone likes your art form and its accepted."
— J.U.I.C.E. participant

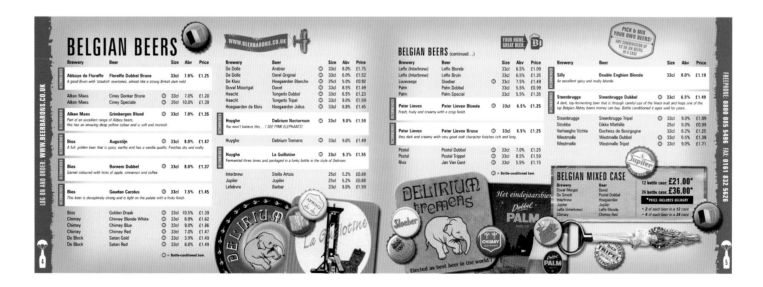

1_____

DESIGN FIRM
Imagine
Manchester, England

PROJECT
Beer Barons Brochure

ART DIRECTOR, DESIGNER
David Caunce

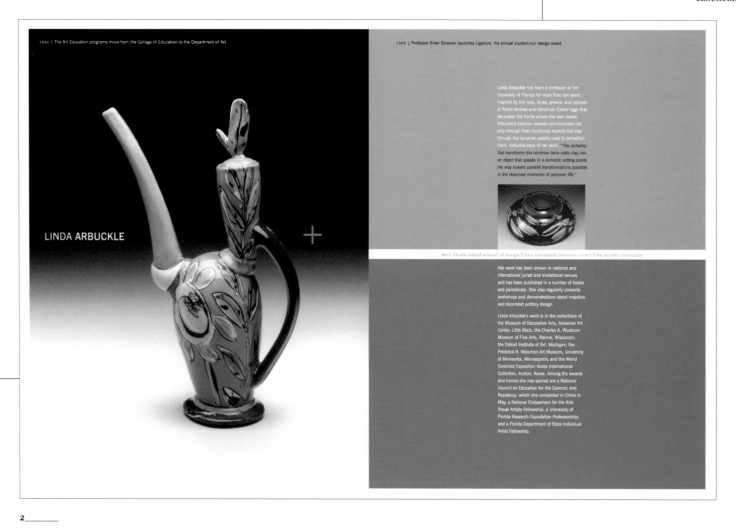

1990 | The Art Education programs move from the College of Education to the Department of Art.

1990 | Professor Brian Slawson launches *Ligature*, the annual student-run design event.

Linda Arbuckle has been a professor at the University of Florida for more than ten years. Inspired by the reds, blues, greens, and yellows of Polish textiles and Ukrainian Easter eggs that decorated the home where she was raised, Arbuckle's ceramic vessels communicate not only through their functional aspects but also through the dynamic palette used to embellish them. Arbuckle says of her work, "The alchemy that transforms the common terra cotta clay into an object that speaks in a domestic setting points the way toward parallel transformations possible in the observed moments of personal life."

LINDA ARBUCKLE

MFA rhode island school of design | BFA cleveland institute of art | BA miami university

Her work has been shown in national and international juried and invitational venues and has been published in a number of books and periodicals. She also regularly presents workshops and demonstrations about majolica and decorated pottery design.

Linda Arbuckle's work is in the collections of the Museum of Decorative Arts, Arkansas Art Center, Little Rock; the Charles A. Wustrum Museum of Fine Arts, Racine, Wisconsin; the Detroit Institute of Art, Michigan; the Frederick R. Weisman Art Museum, University of Minnesota, Minneapolis; and the World Ceramics Exposition Korea International Collection, Inchon, Korea. Among the awards and honors she has earned are a National Council on Education for the Ceramic Arts Residency, which she completed in China in May; a National Endowment for the Arts Visual Artists Fellowship; a University of Florida Research Foundation Professorship; and a Florida Department of State Individual Artist Fellowship.

 2_____

3_____

2_____
DESIGN FIRM
Connie Hwang Design
Gainesville, (FL) USA
PROJECT
UF School of Art + Art History
Capability Brochure
DESIGNERS
Connie Hwang,
Maria Rogal

3_____
DESIGN FIRM
Barbara Spoettel
New York, (NY) USA
CLIENT
Mobile Cook, Munich, Germany
ART DIRECTOR, DESIGNER, PHOTOGRAPHER
Barbara Spoettel

1_____
DESIGN FIRM
At First Sight
Ormond, Australia
DESIGNERS
Barry Selleck,
Olivia Brown

2_____
DESIGN FIRM
Adventium
New York, (NY) USA
DESIGNER
Penny Chuang

Visto Mobile: Wireless Solutions for Work Life Balance
Control Your Work... Control Your Life

balance

"7 out of 10 'on-the-go' professionals say mobile email would free up personal time."*

1_____

Intuitive, seamless, secure—the ultimate productivity tool.
That's worklife.freedom.

productivity

"8 out of 10 mobile workers want access to both work and personal email from their phone."*

NOKIA

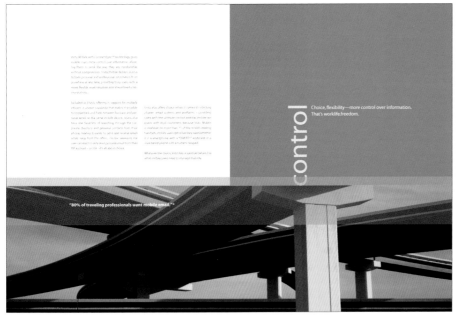

control

Choice, flexibility—more control over information.
That's worklife.freedom.

"80% of traveling professionals want mobile email."*

1_____
DESIGN FIRM
Visto Marketing
Redwood Shores, (CA) USA
CREATIVE MANAGER, LEAD DESIGNER
Todd Laur
COPYWRITER
Suzanne Panoplos
PHOTOGRAPHERS
Michael Sexton Photography,
Todd Laur

2_____
DESIGN FIRM
William Berry Campaigns, Inc.
Sacramento, (CA) USA
CLIENT
Committee for Yes on Measure C
CREATIVE DIRECTOR
William Berry
DESIGNER
Mike Wyman
(Wyman Designs)

2_____

3_____

3_____

DESIGN FIRM
Mayhem Studios
Los Angeles, (CA) USA

DESIGNER
Calvin Lee

197

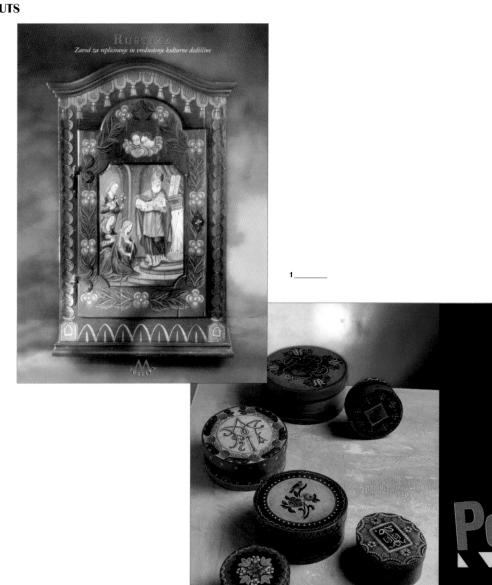

1_____

Prof. dr. Janez Bogataj

Ponovitve

zgodovinskega spomina in vezi z njim

WHEELS

VICTORY WHEELS, INC.

NASCAR
Officially Licensed

INDY RACING LEAGUE
IndyCar SERIES

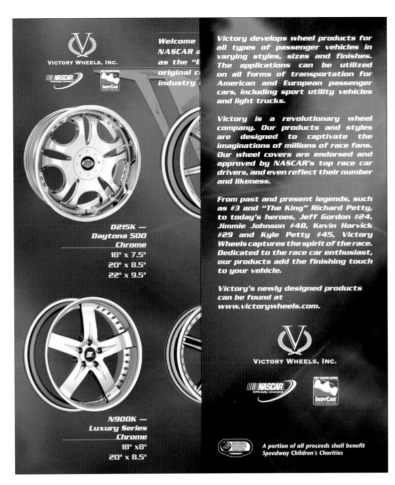

VICTORY WHEELS, INC.

NASCAR
Officially Licensed

INDY RACING LEAGUE
IndyCar SERIES

Welcome
NASCAR a
as the "E
original c
industry

D215K —
Daytona 500
Chrome
18" x 7.5"
20" x 8.5"
22" x 9.5"

N900K —
Luxury Series
Chrome
18" x8"
20" x 8.5"

Victory develops wheel products for all types of passenger vehicles in varying styles, sizes and finishes. The applications can be utilized on all forms of transportation for American and European passenger cars, including sport utility vehicles and light trucks.

Victory is a revolutionary wheel company. Our products and styles are designed to captivate the imaginations of millions of race fans. Our wheel covers are endorsed and approved by NASCAR's top race car drivers, and even reflect their number and likeness.

From past and present legends, such as #3 and "The King" Richard Petty, to today's heroes, Jeff Gordon #24, Jimmie Johnson #48, Kevin Harvick #29 and Kyle Petty #45, Victory Wheels captures the spirit of the race. Dedicated to the race car enthusiast, our products add the finishing touch to your vehicle.

Victory's newly designed products can be found at www.victorywheels.com.

VICTORY WHEELS, INC.

NASCAR
Officially Licensed

INDY RACING LEAGUE
IndyCar SERIES

SPEEDWAY CHILDREN'S CHARITIES

A portion of all proceeds shall benefit Speedway Children's Charities

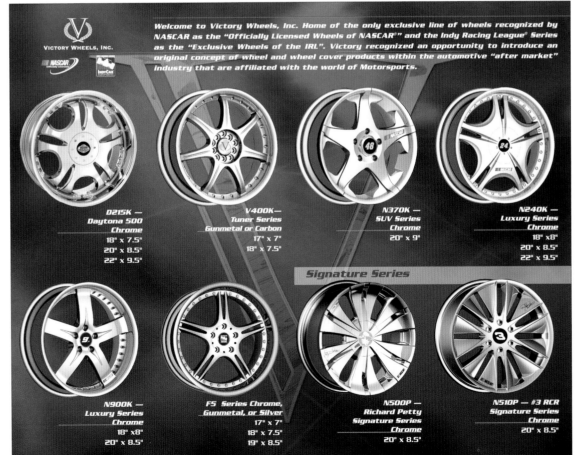

VICTORY WHEELS, INC.

NASCAR
Officially Licensed

INDY RACING LEAGUE
IndyCar SERIES

Welcome to Victory Wheels, Inc. Home of the only exclusive line of wheels recognized by NASCAR as the "Officially Licensed Wheels of NASCAR®" and the Indy Racing League® Series as the "Exclusive Wheels of the IRL". Victory recognized an opportunity to introduce an original concept of wheel and wheel cover products within the automotive "after market" industry that are affiliated with the world of Motorsports.

D215K —
Daytona 500
Chrome
18" x 7.5"
20" x 8.5"
22" x 9.5"

V400K —
Tuner Series
Gunmetal or Carbon
17" x 7"
18" x 7.5"

N370K —
SUV Series
Chrome
20" x 9"

N240K —
Luxury Series
Chrome
18" x8"
20" x 8.5"
22" x 9.5"

Signature Series

N900K —
Luxury Series
Chrome
18" x8"
20" x 8.5"

F5 Series Chrome,
Gunmetal, or Silver
17" x 7"
18" x 7.5"
19" x 8.5"

N500P —
Richard Petty
Signature Series
Chrome
20" x 8.5"

N510P — #3 RCR
Signature Series
Chrome
20" x 8.5"

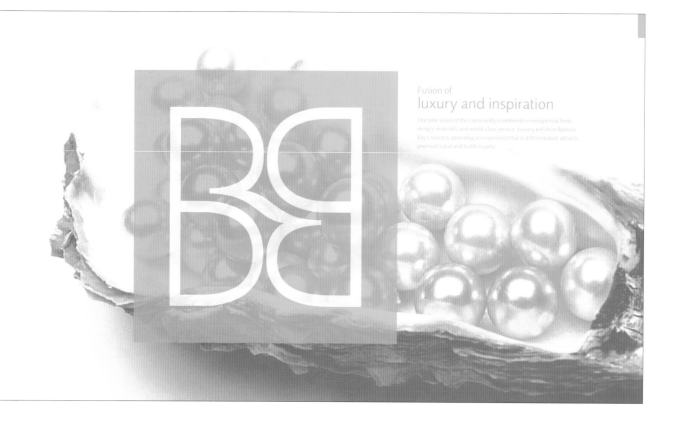

Fusion of
luxury and inspiration

The core vision of the community is centered on exceptional form, design, materials, and world-class service. Luxury will drive Bahrain Bay's success, providing an experience that is differentiated, attracts premium value and builds loyalty.

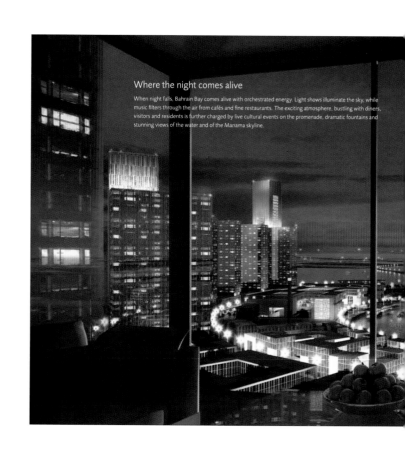

Where the night comes alive

When night falls, Bahrain Bay comes alive with orchestrated energy. Light shows illuminate the sky, while music filters through the air from cafés and fine restaurants. The exciting atmosphere, bustling with diners, visitors and residents is further charged by live cultural events on the promenade, dramatic fountains and stunning views of the water and of the Manama skyline.

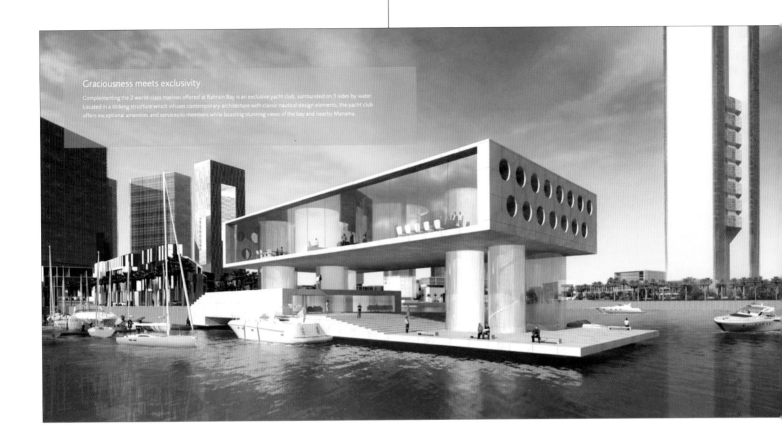

Graciousness meets exclusivity

Complementing the 2 world-class marinas offered at Bahrain Bay is an exclusive yacht club, surrounded on 3 sides by water. Located in a striking structure which infuses contemporary architecture with classic nautical design elements, the yacht club offers exceptional amenities and services to members while boasting stunning views of the bay and nearby Manama.

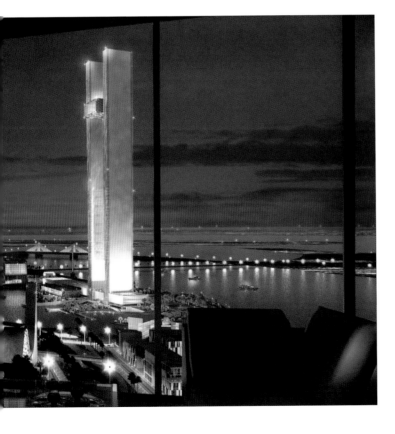

DESIGN FIRM
FutureBrand
Brand Experience
New York, (NY) USA
PROJECT
Bahrain Bay Brochure
CREATIVE DIRECTOR
Diego Kolsky
DESIGNERS
Cheryl Hills, Mike Williams,
Brendan Oneill, Tom Li
COPYWRITER
Stephanie Carroll
DIRECTOR OF VISUALIZATION
Antonio Baglione
VISUALIZATION ARTIST
Oliver de la Rama

1 _____

Are You Ready To Kick It Up A Notch?

Has your company's image grown stale on the shelf? Want to step up your marketing efforts...and increase sales? Convinced your marketing dollars could work harder... and achieve more measurable results?

We Know How to Spice Up Your Marketing!

At Group 55, we'll take your company to the next level. We know how to create a powerful brand image, from corporate and product identity to print, radio, tv and web. And we base everything we do for you on rock-solid strategy... and in-depth research.

Brace Yourself For Red Hot Results!

We're ready...to learn everything about you, your customer, and your competition. Then, we'll zero in on the unique benefits and personality of your company's product...and drive your message home. And when your message hits home, your sales go up.

Call us! We have the recipe for the results you want.

Now that's Hot!

Group Fifty-Five Marketing
Fresh ideas. Red hot strategies.

313.875.1155 | group55.com

MARKETING
ADVERTISING
COLLATERAL
TELEVISION
RADIO
INTERACTIVE
EVENTS
PUBLIC RELATIONS

2 _____

SALSA CASERA GRAN MORISCA MR

Somos una empresa Michoacana que inició en 1976 una producción artesanal de salsas caseras.

Nuestra misión es elaborar productos con higiene y calidad que satisfagan los gustos de los diferentes consumidores y crear empleos para los Michoacanos.

Debido a la demanda del mercado hoy contamos con una capacidad instalada de 10 toneladas.

Sus diferentes sabores son ideales para acompañar pescados y mariscos, carnes, pollos, caldos, pozole o cualquier otro platillo.

***Chile Morita con ajonjolí**
***Chile de Arbol**
Chile Perón
Chimichurri

Unas gotas de aceite realzan el sabor de ensaladas y sopas.

Acompañe sus comidas con exquisitas salsas sin tener que hacer preparaciones ni tostar chiles.

TARRO GOURMET DE VIDRIO
Caja con 12 frascos de 250g.
Para tiendas tipo charcutería,
artesanales, turísticas y minisuper.

TARRO POPULAR DE VIDRIO
Caja con 12 frascos de 250g.
para tiendas en general.

VASO PET
Caja con 45 piezas de 150g.
Para el mercado popular, accesible
a cualquier presupuesto.

* Vida en anaquel de hasta 4 años sin conservadores químicos.

1 _____
DESIGN FIRM
Group 55 Marketing
Detroit, (MI) USA
PROJECT
Group 55 Marketing
Brochure
ART DIRECTOR, DESIGNER
Jeannette Gutierrez
COPYWRITERS
Catherine Lapico,
Jeannette Gutierrez

2 _____
DESIGN FIRM
Caracol Consultores SC
Morelia, México
CLIENT
Salsas Gran Morisca
ART DIRECTOR
Luis Jaime Lara Perea
DESIGNERS
Myriam Zavala,
Luis Jaime Lara
PHOTOGRAPHER
Luis Jaime Lara

DESIGN FIRM
FutureBrand Brand Experience
New York, (NY) USA

PROJECT
Exomos Brochure

CREATIVE DIRECTOR
Avrom Tobias

DESIGNERS
Mike Williams, Brendan Oneill,
Tom Li, Tini Chen, Phil Rojas

VISUALIZATION DIRECTOR
Antonio Baglione

VISUALIZATION ARTIST
Oliver de la Rama

COPYWRITER
Stephanie Carroll

DIRECTOR OF IDENTITY SYSTEMS
Carol Wolf

PRINCIPAL
Mario Natarelli

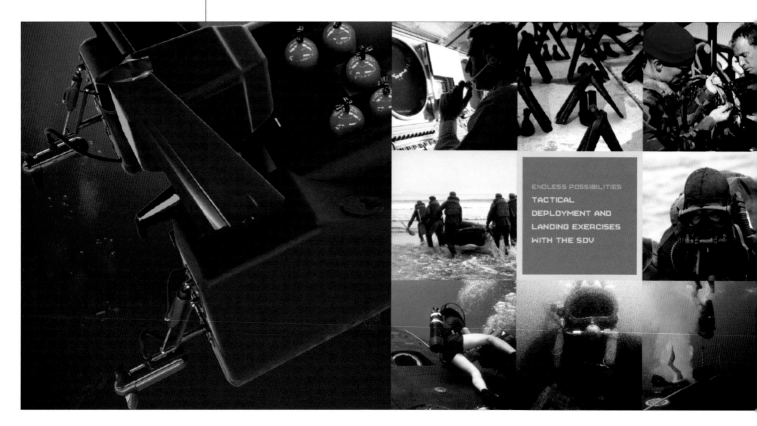

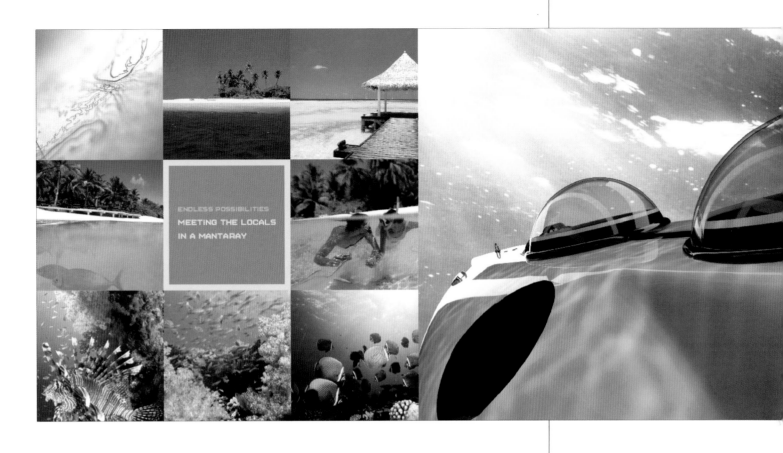

ENDLESS POSSIBILITIES
MEETING THE LOCALS
IN A MANTARAY

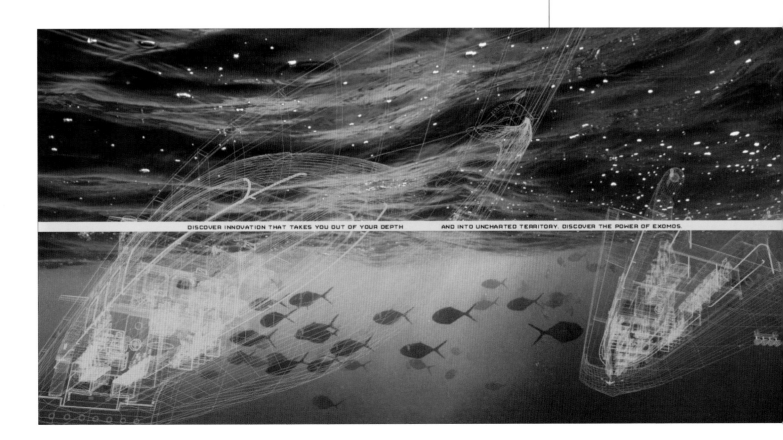

DISCOVER INNOVATION THAT TAKES YOU OUT OF YOUR DEPTH AND INTO UNCHARTED TERRITORY. DISCOVER THE POWER OF EXOMOS.

Secure Policy
Gateway

- Content
- Identity
- Process

Protect the
Enterprise

HTTP
SMTP
FTP
IM

VPN

Extend the
Network

Tumbleweed Secure Policy Gateway A centralized policy engine applies deep
intelligence to securely manage both inbound and outbound communications
across the entire extended enterprise.

NEXT-GENERATION INTERNET SECURITY

**Traditional solutions secure the network not the content
that flows through it.**

Tumbleweed secure content management raises the bar.

TUMBLEWEED AT A GLANCE

THE BUSINESS INTERNET: **TWIN CHALLENGES**

The Internet has revolutionized global business
communications, enabling a dramatic increase in the
flow of information across the extended enterprise while
reducing communication costs, maximizing business
efficiencies, and strengthening business relationships.
As today's organizations move more and more
business-critical communications and processes to the
Internet, this revolution brings with it twin challenges.

**On the one hand you must protect your enterprise like
never before.** You must ensure that confidential, proprietary, and sensitive
information such as trade secrets, financial reports, customer data, and future
product plans are not unintentionally disclosed to parties lacking authorized
access. You must be vigilant against the constant threat of viruses and
unsolicited e-mail that can bring a network to its knees, directly impacting your
bottom line and business goodwill. You must comply with increasing government
and industry regulations. And you must reduce your exposure to legal liabilities
and fraud through the universal and consistent application of corporate policies
and procedures.

**On the other hand you must extend your network outward
like never before.** To realize the full potential of the business Internet,
you must increase communication and collaboration with those outside your
corporate firewall—extending your reach and visibility to the farthest edges of
the network. You must provide high levels of interoperability with partners and
customers to streamline business processes and enhance customer service
and loyalty. You must maximize business efficiencies by using the Internet for
customer bill and statement presentment, partner relationship management,
order and forms processing—and more.

1 _____

2 _____

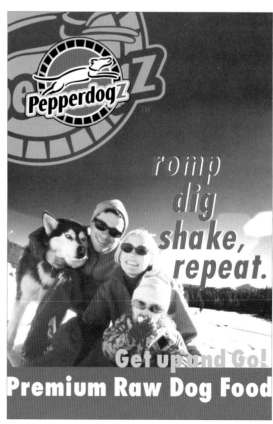

1 _____
DESIGN FIRM
Connie Hwang Design
Gainesville, (FL) USA
PROJECT
Tumbleweed Communications
Brochure
DESIGNER
Connie Hwang
COPYWRITER
Jessa Aubin

2 _____
DESIGN FIRM
Eben Design
Seattle, (WA) USA
CLIENT
Pepperdogz
ART DIRECTOR, DESIGNER
Dan Meehan
COPYWRITERS
Sean Youssefi, Karen Youssefi

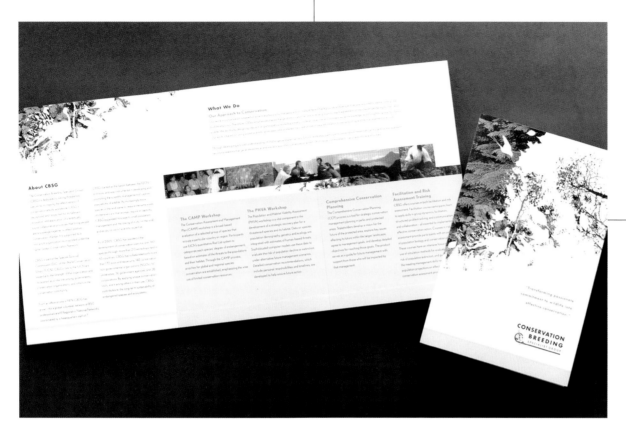

3_____

4_____

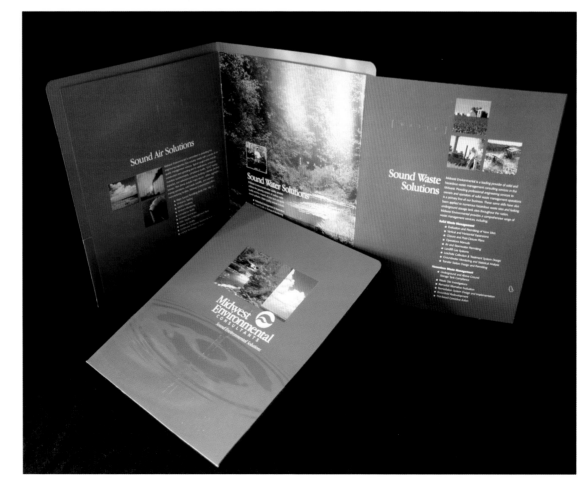

3_____

DESIGN FIRM
Evenson Design Group
Culver City, (CA) USA

PROJECT
CBSG Annual and Brochure

ART DIRECTOR
Stan Evenson

DESIGNER
Melanie Usas

4_____

DESIGN FIRM
Vangel Marketing
Communications
Columbia, (MO) USA

PROJECT
Midwest Environmental
Consultants Brochure

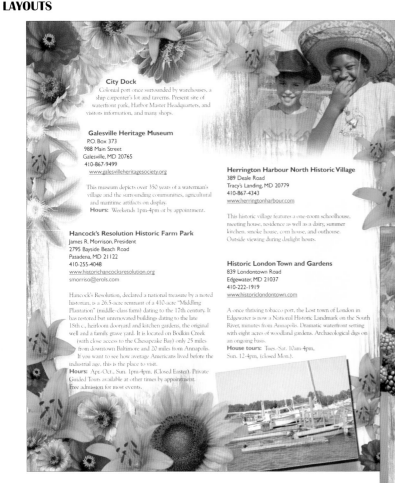

City Dock
Colonial port once surrounded by warehouses, a ship carpenter's lot and taverns. Present site of waterfront park, Harbor Master Headquarters, and visitors information, and many shops.

Galesville Heritage Museum
P.O. Box 373
988 Main Street
Galesville, MD 20765
410-867-9499
www.galesvilleheritagesociety.org

This museum depicts over 350 years of a waterman's village and the surrounding communities, agricultural and maritime artifacts on display.
Hours: Weekends 1pm-4pm or by appointment.

Hancock's Resolution Historic Farm Park
James R. Morrison, President
2795 Bayside Beach Road
Pasadena, MD 21122
410-255-4048
www.historichancocksresolution.org
smorriso@erols.com

Hancock's Resolution, declared a national treasure by a noted historian, is a 26.5-acre remnant of a 410-acre "Middling Plantation" (middle-class farm) dating to the 17th century. It has restored but unrenovated buildings dating to the late 18th c., heirloom dooryard and kitchen gardens, the original well and a family grave yard. It is located on Bodkin Creek (with close access to the Chesapeake Bay) only 25 miles from downtown Baltimore and 20 miles from Annapolis. If you want to see how average Americans lived before the industrial age, this is the place to visit.
Hours: Apr.-Oct., Sun. 1pm-4pm, (Closed Easter). Private Guided Tours available at other times by appointment. Free admission for most events.

Herrington Harbour North Historic Village
389 Deale Road
Tracy's Landing, MD 20779
410-867-4343
www.herringtonharbour.com

This historic village features a one-room schoolhouse, meeting house, residence as well as a dairy, summer kitchen, smoke house, corn house, and outhouse. Outside viewing during daylight hours.

Historic London Town and Gardens
839 Londontown Road
Edgewater, MD 21037
410-222-1919
www.historiclondontown.com

A once thriving tobacco port, the Lost town of London in Edgewater is now a National Historic Landmark on the South River, minutes from Annapolis. Dramatic waterfront setting with eight acres of woodland gardens. Archaeological digs on an ongoing basis.
House tours: Tues.-Sat. 10am-4pm, Sun. 12-4pm, (closed Mon.).

Hydromont Berry Farm
Jim and Denise Edelen
8020 Hawthorne Road
La Plata, MD 20646
301-932-0872
www.hydromontberryfarm.com

Enjoy pick-your-own or pre-picked farm fresh strawberries from three acres of fresh strawberries. Farm products, kids playgrounds and more. Sunday events for the family.
Hours: May-Mid Jun. 8am-7pm.
Directions: 301 South, right on Route 225 (Hawthorne Road) 3 miles on right.

Linden Farm
Karen Briggs
8530 Mitchell Road
La Plata, MD 20646
301-934-9003
karnbrgs@aol.com

Bed and Breakfast named for the trees that still shade the house. Linden has been a private residence since its construction in 1783 and is listed on the National Register of Historic Places. Horse riding programs to all level students in hunt-seat, side saddle, stock-seat, driving classes, over fences, lease program, training and summer camp. At Linden, the riding program is intended to introduce young people and adults to the wonderful world of horsemanship.

Serenity Farm Inc.
Frank & Theresa Robinson
6932 Serenity Farm Road
P.O. Box 305, Route 231
Benedict, MD 20612
301-274-3829
Cell: 301-399-1629 or Cell:301-399-1634
Fax: 301-274-9135

Field days, mazes and school tours, Halloween "Kasper's Castle" for schools, and for public during weekends in October.
Retail/Wholesale: Cattle (hereford), goat (meat), pig (meat), sheep (meat), jams, jellies, berries (blackberries, raspberries), field corn, rye, soybeans, hay (alfalfa-fescue), straw.
Hours: 8am-5pm.
Directions: Seven miles east of Hughesville on north side of Route 231, Serenity Farm Road.

Oak Hill Farm and Stables
Elmer Curry or Jackie Lynch
3805 Hance Road
Port Republic, MD 20676
410-586-0679

Horse boarding, horseback riding, horse-training lessons.
Retail/Wholesale: Horses (Arabian, thorough bred, standard-bred), hay (orchard grass mix), beans (snap, lima), cabbage, cucumbers, eggplant, greens (collards, kale, mustard, turnip), onions, potatoes (redskin, white), summer squash, turnips.
Hours: By appointment only.
Directions: Route 4 South to Route 264 (Broomes Island Road), right on Hance Road, left at fork, watch for Oak Hill Stables sign on right, turn right to big red barn.

Poplars Farm
Carolyn and Howard Anderson
7141 Old Bayside Road
Chesapeake Beach, MD 20732
410-257-0173, Fax: 301-855-0927

Products: Bass (large mouth), bluegill, catfish (hybrid striped), pond stocked.
Hours: Please call for reservation.
Directions: Route 260 to Route 261, right on Old Bayside Road, 1 mile to pond on left.

River View Farm
Donald T. Gott
8515 Mackall Road
St. Leonard, MD 20685
410-586-1240

Field days, open house days.
Products: Cattle (beef), field corn, oats, wheat, hay (alfalfa), straw.
Hours: Mon.-Sat. 7am-7pm.
Directions: Right on Route 264, 5 miles, left on Route 265, farm on right.

Stillwater Farm - Pony Express
1600 Emmanuel Church Road
Huntingtown, MD 20639
410-535-1989

Full service party provider. Horses, ponies (for sale), horse boarding (full or pasture), livestock hauling, pony parties, moon bounces, company picnics, petting farm, various inflatables.
Hours: Please call.
Directions: Route 2/4 South, East 2.5 miles on Plum Point Road, South .75 mile on Emmanuel Church Road, farm on right.

1 _____

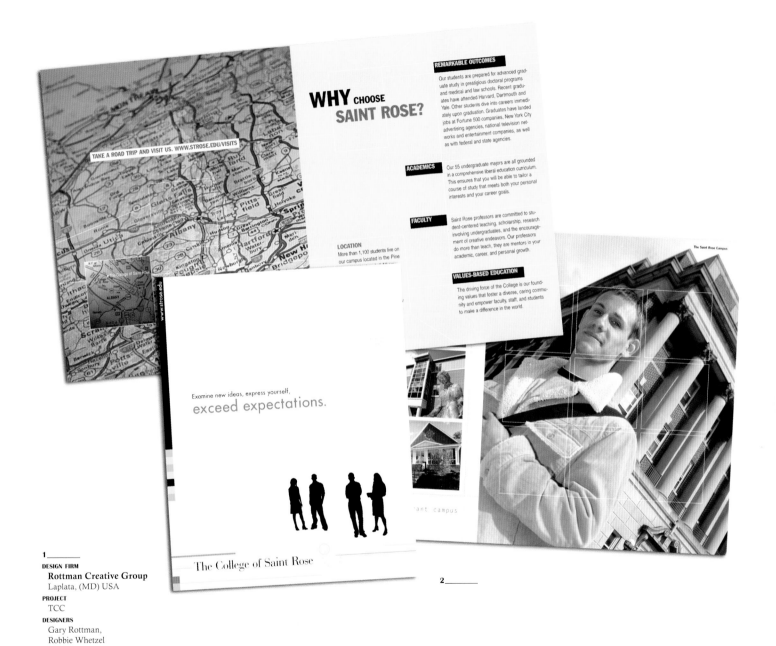

WHY CHOOSE **SAINT ROSE?**

REMARKABLE OUTCOMES

Our students are prepared for advanced graduate study in prestigious doctoral programs and medical and law schools. Recent graduates have attended Harvard, Dartmouth and Yale. Other students dive into careers immediately upon graduation. Graduates have landed jobs at Fortune 500 companies, New York City advertising agencies, national television networks and entertainment companies, as well as with federal and state agencies.

ACADEMICS Our 55 undergraduate majors are all grounded in a comprehensive liberal education curriculum. This ensures that you will be able to tailor a course of study that meets both your personal interests and your career goals.

FACULTY Saint Rose professors are committed to student-centered teaching, scholarship, research involving undergraduates, and the encouragement of creative endeavors. Our professors do more than teach, they are mentors in your academic, career, and personal growth.

VALUES-BASED EDUCATION

The driving force of the College is our founding values that foster a diverse, caring community and empower faculty, staff, and students to make a difference in the world.

LOCATION
More than 1,100 students live on our campus located in the Pine

TAKE A ROAD TRIP AND VISIT US. WWW.STROSE.EDU/VISITS

www.strose.edu

Examine new ideas, express yourself,
exceed expectations.

The College of Saint Rose

The Saint Rose Campus

1_____
DESIGN FIRM
Rottman Creative Group
Laplata, (MD) USA
PROJECT
TCC
DESIGNERS
Gary Rottman,
Robbie Whetzel

2_____
DESIGN FIRM
The College of Saint Rose
Albany, (NY) USA
PROJECT
Exceed Expectations Brochure
ART DIRECTOR
Mark Hamilton
DESIGNER
Chris Parody
COPYWRITER
Lisa Haley Thomson
PHOTOGRAPHERS
Paul Castle Photography,
Gary Gold Photography
PRINTER
Brodock Press, Inc.

1_____

1_____
DESIGN FIRM
substance151
Baltimore, (MD) USA
PROJECT
substance151 Promotional
Brochure
DESIGNERS
Ida Cheinman,
Rick Salzman

2_____
DESIGN FIRM
Riordon Design
Oakville, (Ontario) Canada
CLIENT
Adriana Toncic Interiors
ART DIRECTOR, DESIGNER
Alan Krpan

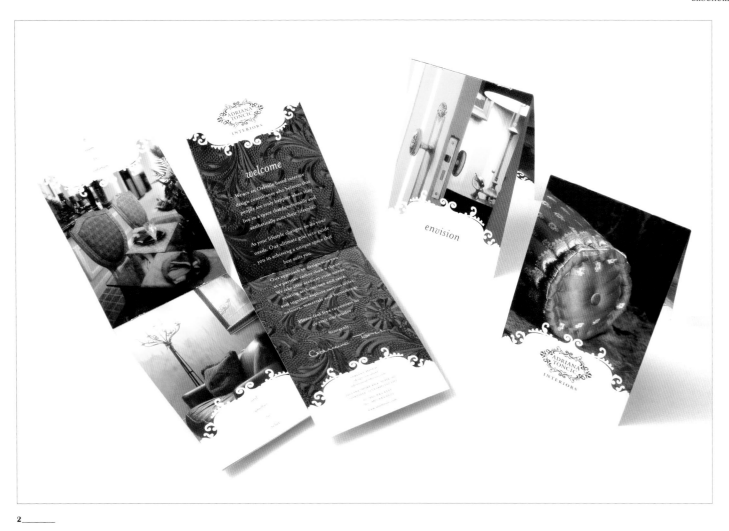

2_____

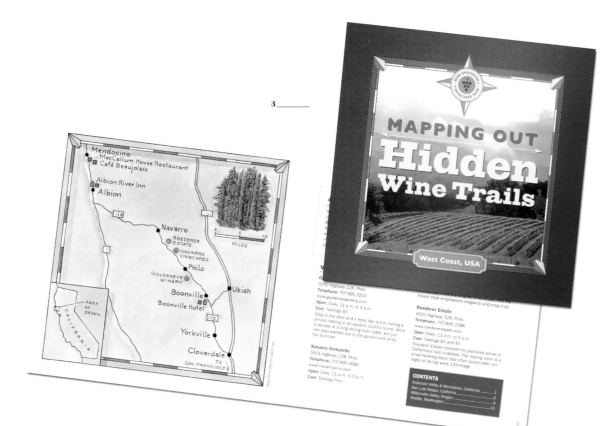

3_____

3_____
DESIGN FIRM
**M. Shanken
Communications, Inc.**
New York, (NY) USA

PROJECT
Wine Spectator
Promotional

ART DIRECTOR
Chandra Hira

DESIGNER
Cheryl McGovern

ILLUSTRATOR
David Caine

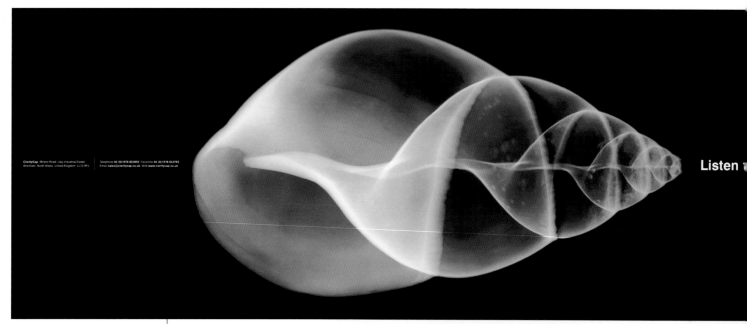

ClarityCap Miners Road, Llay Industrial Estate Telephone 44 (0)1978 853955 Facsimile 44 (0)1978 853785
Wrexham North Wales, United Kingdom LL12 0PJ Email sales@claritycap.co.uk Web www.claritycap.co.uk

Listen

PX

The PX range has been designed to provide characteristics
midway between our PW and SA capacitors.

Constructed from a 250Vdc(6μm) rated
film, this component is spindle wound.
It is then given a special heat treatment
before it has insulated copper terminals
hand soldered to give the best
possible connection.

The inherently low dissipation
and dielectric absorption factors of
polypropylene allied with an excellent
mechanical stability results in an
extremely detailed sonic performance.

The construction also results in a low
self-inductance and ESR (Equivalent
Series Resistance) and the devices are
highly stable with regard to temperature
and frequency.

Tape and resin colours are flexible
with options shown on page 14.
Unless specified, capacitors would be
supplied with blue tape and blue resin.

08 / 09

DTA

12 / 13

DESIGN FIRM
Imagine
Manchester, England
PROJECT
Exept ClarityCap Brochure
ART DIRECTOR
Tony Wynn
DESIGNER
David Caunce

the difference

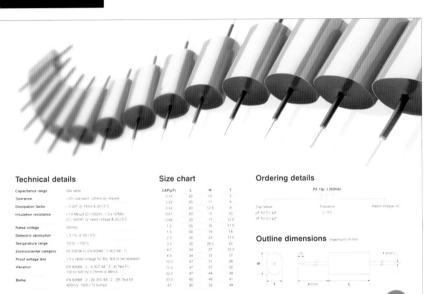

Technical details

Capacitance range	See table
Tolerance	±5% standard. Others by request
Dissipation factor	≤ 0.001 @ 1KHz & 20±3°C
Insulation resistance	≥ 10⁵MΩ.µF (C>330nF) ; ≥ 3 x 10⁴MΩ (C≤330nF) @ rated voltage & 20±3°C
Rated voltage	250Vdc
Dielectric absorption	≤ 0.1% @ 20±3°C
Temperature range	-55 to +100°C
Environmental category	55/100/56 to EN 60068 - 1 (IEC 68 - 1)
Proof voltage test	1.5 x rated voltage for 30s. Not to be repeated
Vibration	EN 60068 - 2 - 6 (IEC 68 - 2 - 6) Test Fc 100 to 500 Hz 0.75mm or 98m/s
Bump	EN 60068 - 2 - 29 (IEC 68 - 2 - 29) Test Eb 400m/s 1000 ± 10 bumps

Size chart

CAP(µF)	L	W	T
0.15	20	10	5
0.22	20	11	6
0.33	20	12.5	8
0.47	20	15	10
0.68	20	17	12.5
1.0	30	16	11.5
1.5	30	19	14
2.2	30	22	17.5
3.3	30	26.5	22
4.7	34	27	22.5
6.8	34	32	27
10.0	47	31	36
15.0	47	37	32
22.0	47	44	39
33.0	60	46	41
47	60	54	49

Please note that intermediate capacitance values are available. Contact our sales department for details.

Ordering details

PX 10µ J 250Vdc

Cap Value — Tolerance — Rated Voltage dc
µF for C≥ 1µF J - 5%
nF for C< 1µF

Outline dimensions (maximum) in mm

Terminations are PVC covered copper wire, length is a minimum of 40mm. Conductor diameter ⌀ is 1mm, sleeved diameter is 2.5mm

The DTAC range is the latest high performance addition to our range. It has been designed to produce the lowest possible resistance within the component, which we believe has a direct relationship to sonic performance.

A narrow 10µm(630Vdc) polypropylene film with a special spray and heat treatment contribute to the exceptional performance of this capacitor. These measures combined with hand soldered M8 male or female terminations ensure that the ESR is greatly improved when compared to the traditional axial leaded components.

The low ESR is particularly relevant in high quality crossover networks, ensuring that loudspeakers perform to their optimum.

Tape and resin colours are flexible with options shown on page 14. Unless specified, capacitors would be supplied with gold tape and black resin.

DTAC data

Ohmic Resistance (non-dielectric)
Comparison with standard SA with 0.5 metal thickness

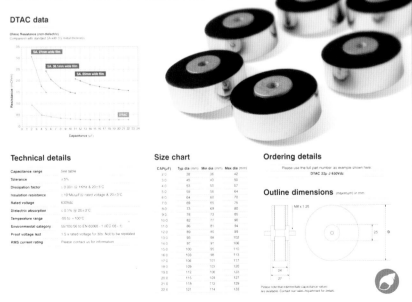

Technical details

Capacitance range	See table
Tolerance	±5%
Dissipation factor	≤ 0.001 @ 1KHz & 20±3°C
Insulation resistance	≥ 10⁵MΩ.µF @ rated voltage & 20±3°C
Rated voltage	630Vdc
Dielectric absorption	≤ 0.1% @ 20±3°C
Temperature range	-55 to +100°C
Environmental category	55/100/56 to EN 60068 - 1 (IEC 68 - 1)
Proof voltage test	1.5 x rated voltage for 30s. Not to be repeated
RMS current rating	Please contact us for information

Size chart

CAP(µF)	Typ dia (mm)	Min dia (mm)	Max dia (mm)
2.0	39	36	42
3.0	45	43	50
4.0	53	50	57
5.0	59	56	64
6.0	64	60	70
7.0	69	65	75
8.0	73	69	80
9.0	78	73	85
10.0	82	77	90
11.0	86	81	94
12.0	89	85	99
13.0	93	88	102
14.0	97	91	106
15.0	100	95	110
16.0	103	98	113
17.0	106	101	117
18.0	109	103	120
19.0	112	106	123
20.0	115	109	127
21.0	118	112	129
22.0	121	114	133

Ordering details

Please use the full part number as example shown here

DTAC 22µ J 630Vdc

Outline dimensions (maximum) in mm

M8 x 1.25

Please note that intermediate capacitance values are available. Contact our sales department for details.

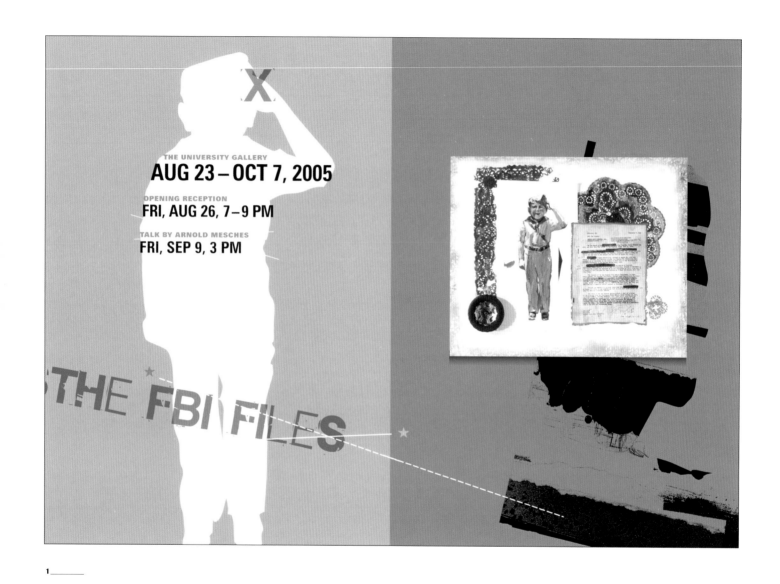

THE UNIVERSITY GALLERY
AUG 23 – OCT 7, 2005

OPENING RECEPTION
FRI, AUG 26, 7–9 PM

TALK BY ARNOLD MESCHES
FRI, SEP 9, 3 PM

THE FBI FILES

1_____

1_____

DESIGN FIRM
Connie Hwang Design
Gainesville, (FL) USA
PROJECT
The FBI Files
Exhibition brochure
DESIGNER
Connie Hwang
COPYWRITER
Amy Vigilante

2_____

DESIGN FIRM
University of Maryland Cooperative Extension—
FSNE
Columbia, (MD) USA
CLIENT
The University of Maryland Cooperative Extension—
Food Stamp Nutrition Education
Program
DESIGNERS
Trang Dam, Meredith Pearson, Lisa Lachenmayr

Healthy Food, Fitness and Fun!

Food Stamp Nutrition
Education Youth Programs

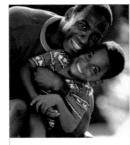

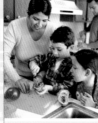

Heal...

Cooking healthy foods

Choosing low fat snacks

Becoming more active

Here is what some participating collaborators have said about the impact of FSNE programs in their organizations.

"Our students are more willing to try a variety of new foods. They brag about trying foods they had never seen before. It has become an esteem booster!"

"After learning about the food pyramid, children often ask me to help them read the fat content on their milk cartons at lunch and on items they bring for snack."

"A parent of a child in the Color Me Healthy program told me her daughter was going to the grocery store and helping her pick out vegetables and fruits. She said the child told her that she needed to eat all the different colors if she wanted to be healthy."

Contact Information

FSNE educators are available to implement programs in your youth organization. An alternative approach is for educators to "train-the-trainer" to enable your staff to deliver nutrition education programming.

Contact your local Maryland Cooperative Extension office for more information regarding how this innovative program can help your organization's learners develop new skills in healthy eating and physical activity.

2_____

Healthy Food, Fitness and Fun!

Cooking healthy foods–choosing low fat snacks–becoming more active–these are some of the skills the Food Stamp Nutrition Education program (FSNE) can help the youth in your organization develop.

FSNE is available throughout the state of Maryland. FSNE provides programs for limited-resource youth that promote healthy eating and physical activity. Food preparation, making healthier choices when eating away from home, and finding ways to be more physically active are all part of the FSNE youth program.

But that's not all! FSNE brings programs to wherever youth are—school classrooms, after-school programs, summer day camps and preschools. The emphasis is on fun, and there is no charge!

Here is what some participating collaborators have said about the impact of FSNE programs in their organizations.

"Our students are more willing to try a variety of new foods. They brag about trying foods they had never seen before. It has become an esteem booster!"

"After learning about the food pyramid, children often ask me to help them read the fat content on their milk cartons at lunch and on items they bring for snack."

"A parent of a child in the Color Me Healthy program told me her daughter was going to the grocery store and helping her pick out vegetables and fruits. She said the child told her that she needed to eat all the different colors if she wanted to be healthy."

Contact Information

FSNE educators are available to implement programs in your youth organization. An alternative approach is for educators to "train-the-trainer" to enable your staff to deliver nutrition education programming.

Contact your local Maryland Cooperative Extension office for more information regarding how this innovative program can help your organization's learners develop new skills in healthy eating and physical activity.

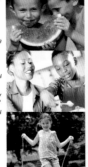

Want your students to eat more fruits and vegetables?

The Color Me Healthy (preschool curriculum) is designed to be integrated into the day's schedule, providing lessons, stories and activities that encourage children to try new fruits and vegetables. Color is key—a sign that there are nutrients in those oranges, bananas, peas and carrots. The leader's guide includes 14 lessons and parent newsletters to help parents reinforce the nutrition and activity messages children are learning in the classroom. FSNE educators will provide curriculum materials and train teachers to implement *Color Me Healthy* in their classrooms.

Wish your students knew more about cooking?

The Pyramid of Snacks curriculum will put kids ages 9-12 in the kitchen, preparing simple, healthy and delicious foods. Experiential learning activities will encourage them to make healthy food choices through games, science experiments and stories. The curriculum is designed to allow flexibility in planning and delivering programs in a variety of settings.

Cooking with Kids is a multicultural nutrition education curriculum that provides hands-on learning activities about culturally diverse foods that are healthy and appealing to children. Activities can be integrated into math, science, social studies, language arts, music and art. This program includes tasting classes and food preparation sessions appropriate for grades K-6.

Do your students get enough physical activity?

JumpSmart is an after-school program that will help students jump into fitness! By forming jump rope clubs, youth develop jump rope skills and create routines to their favorite music. FSNE educators will organize trainings for after-school program staff to become jump rope coaches and to help youth choose healthy foods. FSNE provides all materials including jump ropes, music, videos and leaders' guides at no charge.

Want your students to make healthier choices when eating out?

The Power of Choice curriculum is designed to empower young teens to develop a healthy lifestyle. They will develop skills in reading food labels, making low fat food choices at restaurants, and preparing meals and snacks safely. Activities can be integrated into a variety of settings—in classrooms, after-school programs and day camps.

219

PRESCRIPTION PRODUCTS

Feinstein Kean Healthcare for Novartis alerted readers about the benefits of EXELON for mild to moderate Alzheimer's disease. A toll-free number and Web site were offered for an "I.D.A.D. Resource Kit," containing educational materials such as a video, a memory questionnaire and informational brochures specifically for caregivers.

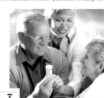

Health Bulletin
Medical Treatment Provides Hope For Alzheimer's Disease Patients And Their Families

Dorland Sweeney Jones for Merck created an awareness of its physician-respected Web site with credible, independent health information that could help readers to enhance their doctor visits.

Health Bulletin
Burning Questions About Digestive Health

Dorland Sweeney Jones for Eisai, Inc and Janssen Pharmaceutica used a Q&A format to create an awareness of ACIPHEX for GERD, heartburn and acid reflux disease.

HEALTH PR
Techniques of Great PR Teams

DESIGN FIRM
Adventium
New York, (NY) USA
PROJECT
Health PR Brochure
DESIGNER
Penny Chuang

Women's Basketball Star Edna Campbell Inspires Free Electronic Greeting Card For Breast Cancer Patients

Ogilvy for Ortho Biotech Products, marketer of PROCRIT, offered free electronic greeting cards for cancer patients. This innovative campaign demonstrated the company's ongoing commitment to cancer patients and their caregivers. Readers were directed to a Web site for prescribing information and additional information on PROCRIT and anemia.

A B C D E F G Children's Health

MCS for MedPointe Pharmaceuticals targeted parents with news of how allergies may affect concentration in the classroom and how OPTIVAR, a prescription eyedrop, can help. Compelling statistics from the NIH on missed school days per year and the negative impact that lost time can have on a child's ability to learn were offered. Parents were encouraged to see an allergist or ophthalmologist for an accurate diagnosis and treatment if their child suffers from nasal allergies.

HEALTH MATTERS
Survey Shows Americans Are Not Taking Heart Disease Risk To Heart

Edelman for Pfizer created an awareness, in English and Spanish, of the Web site for "The Pfizer Journal" by revealing the results of a survey about heart disease.

GOVERNMENT

Ogilvy for Centers for Disease Control (CDC) advised parents about what to do for colds and flu and warned of the risk of antibiotic resistance.

Sniffle Or Sneeze? No Antibiotics Please
CDC Advises Parents About Colds, Flu and Antibiotics

Pointers For Parents
Tips To Help Your Child Become A Strong Reader

Widmeyer for the National Institute for Literacy and the National Institute of Child Health offered tips to help parents help their children to read better. Readers were directed to an informative Web site for more information about the Partnership for Reading program.

SAFETY SENSE
Fire Safety Tips For Your Home

Protecting Our Children
Fire-Safe Kids

Hager Sharp for the U.S. Fire Administration, an entity of the Federal Emergency Management Agency (FEMA), offered tips to help reduce fire hazards.

Holiday Hints
Small Steps To Healthier Holidays

Hager Sharp for the NIH for National Diabetes Education Program offered healthy eating tips to diet-conscious people, especially those with type 2 diabetes, designed to enhance holiday party experiences.

The NIH for National Eye Institute offered a free booklet about low vision.

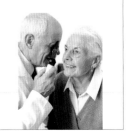

Learn what you can do to make the most of your vision.

1-877-LOW VISION
(1-877-569-8474)

If you're a businesswoman, and you don't think golf is important to your success...

THINK AGAIN!

Myths & Realities

Why don't women take advantage of the opportunity golf affords? Because women embrace certain golf myths as realities.

MYTH: To play in a golf business outing, you have to be a good golfer.

FACT: You need minimal golf skills. Mostly, you need to understand golf etiquette, and a few basic rules.

MYTH: Men who play in business outings are good golfers.

FACT: Most people, regardless of gender, are average golfers at best.

MYTH: You have to commit significant time to reach a skill level to play golf for business purposes.

FACT: You need a basic understanding of three things to play golf: 1) Safety on the course 2) How to maintain pace of play throughout a round and 3) Basic golf etiquette. These take hours, not months or years, to learn.

Discover what men have known for years: the powerful BUSINESS BENEFITS of golf.

- Develop stronger business relationships.
- Use golf outings as a business tool.
- Build confidence.
- Overcome fear of embarrassment on the golf course.
- Gain an activity for a lifetime.
- Have fun!

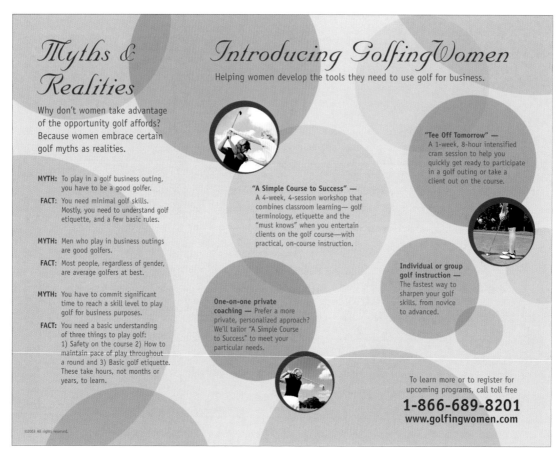

Myths & Realities

Why don't women take advantage of the opportunity golf affords? Because women embrace certain golf myths as realities.

MYTH: To play in a golf business outing, you have to be a good golfer.

FACT: You need minimal golf skills. Mostly, you need to understand golf etiquette, and a few basic rules.

MYTH: Men who play in business outings are good golfers.

FACT: Most people, regardless of gender, are average golfers at best.

MYTH: You have to commit significant time to reach a skill level to play golf for business purposes.

FACT: You need a basic understanding of three things to play golf: 1) Safety on the course 2) How to maintain pace of play throughout a round and 3) Basic golf etiquette. These take hours, not months or years, to learn.

Introducing GolfingWomen

Helping women develop the tools they need to use golf for business.

"A Simple Course to Success" — A 4-week, 4-session workshop that combines classroom learning— golf terminology, etiquette and the "must knows" when you entertain clients on the golf course—with practical, on-course instruction.

One-on-one private coaching — Prefer a more private, personalized approach? We'll tailor "A Simple Course to Success" to meet your particular needs.

"Tee Off Tomorrow" — A 1-week, 8-hour intensified cram session to help you quickly get ready to participate in a golf outing or take a client out on the course.

Individual or group golf instruction — The fastest way to sharpen your golf skills, from novice to advanced.

To learn more or to register for upcoming programs, call toll free

1-866-689-8201
www.golfingwomen.com

WESPaC Student
Manage Success.

2_____

WESPaC Finance
Manage Success.

1_____
DESIGN FIRM
Adventium
New York, (NY) USA
PROJECT
Golfing Women Brochure
DESIGNER
Penny Chuang

2_____
DESIGN FIRM
Eben Design
Seattle, (WA) USA
CLIENT
WSIPC
(Washington School
Information Processing Cooperative)
ART DIRECTOR
Dan Meehan
DESIGNER
Matthew Grimes
COPYWRITER
Marty Krouse

1_____

Home: where your dreams live.

KINGS-MEN
CONSTRUCTION
Custom Home Building
and Remodeling

2_____

1_____
DESIGN FIRM
Group 55 Marketing
Detroit, (MI) USA
PROJECT
All Seasons Brochure
ART DIRECTOR, DESIGNER
Jeannette Gutierrez
COPYWRITERS
Catherine Lapico, Jeannette Gutierrez
PHOTOGRAPHER
Jerry Beznos

2_____
DESIGN FIRM
Eben Design
Seattle, (WA) USA
CLIENT
Kings-Men Construction
ART DIRECTOR
Dan Meehan
DESIGNER
Matthew Grimes
COPYWRITER
Marty Krouse
PHOTOGRAPHER
Jim Garner

Aviation and tourism generate jobs, create business activity and help drive the regeneration of economies. Planning for the future can be challenging as well as exciting.

> Strategic planning
> Financial appraisal
> Investment research

> Privatisation
> Economic modelling
> Forecasting

> Employment studies
> Tourism opportunity analysis
> Air transport planning

> Route development
> Service appraisal
> Risk assessment

3 _____

4 _____

3 _____
DESIGN FIRM
Imagine
Manchester, England
PROJECT
Feather Consulting Brochure
ART DIRECTOR, DESIGNER
David Caunce

4 _____
DESIGN FIRM
Dezainwerkz Pte Ltd
Singapore
CLIENT
Air Division
CREATIVE DIRECTOR
Dezainwerkz
ART DIRECTOR
Xavier Sanjiman
PHOTOGRAPHER
Simon Low

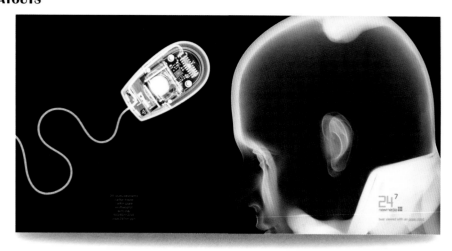

1 _____

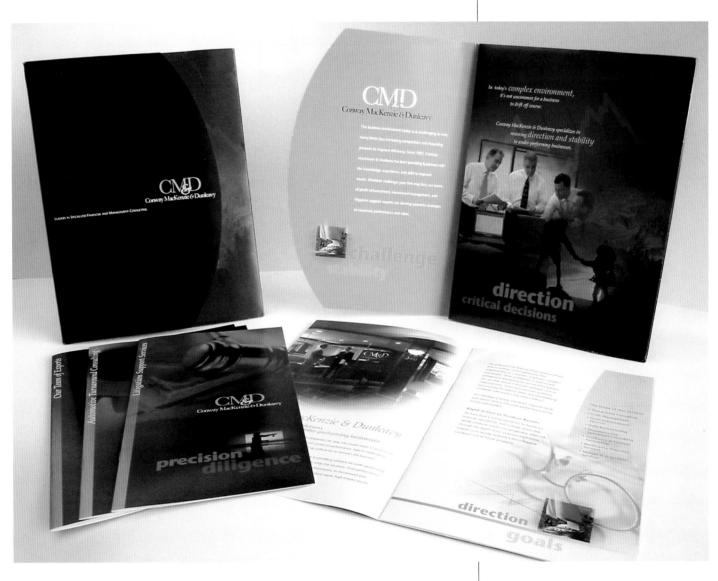

1_____
DESIGN FIRM
Jo Mew Creative
London, England
DESIGNER
Jo Mew

2_____
DESIGN FIRM
Group 55 Marketing
Detroit, (MI) USA
PROJECT
Conway Mackenzie and
Dunleavy Brochure
ART DIRECTOR, DESIGNER
Jeannette Gutierrez
COPYWRITER
David Stewart
PHOTOGRAPHER
Richard Hirneisen

1_____

And now for something
completely different…

A dentist who makes you smile.

LASTING
IMPRESSIONS DENTISTRY

DAVID LOSHIN, DMD, PLLC

1_____
DESIGN FIRM
Eben Design
Seattle, (WA) USA
CLIENT
Lasting Impressions Dentistry
ART DIRECTOR
Dan Meehan
DESIGNER
Masako Takeda
COPYWRITER
Marty Krouse

2_____
DESIGN FIRM
Liska + Associates
Chicago, (IL) USA
PROJECT
Attorney Street Brochure
ART DIRECTOR
Tanya Quick
DESIGNERS
Danielle Akstein Bear, Tanya Quick
PHOTOGRAPHER
Josh Levine

2_____

STANTON ST, 11:57 AM

HOUSTON ST
9:38 PM

LUDLOW ST, 1:25 PM

IGHTING

Zoo History

Lincoln Park Zoo is everyone's zoo. Formed in 1868, it is the oldest zoological garden in the country, yet it is also among the most modern – a leader in wildlife conservation and educational outreach. Each year the zoo welcomes 3 million visitors, providing them with remarkable learning experiences, as well as a peaceful park setting.

Since 1995 Lincoln Park Zoo has operated as a private institution with a limited subsidy from the Chicago Park District. With this privatized status, the zoo has refined its approach to operations and the achievement of its mission. The education programs are innovative and effective, reaching increased numbers of visitors; research programs shape operations and animal management issues at zoos across the country and around the world; conservation efforts rank among the top 10 zoos in the country; and the beautiful grounds are in the heart of one of the city's most bustling and vibrant neighborhoods.

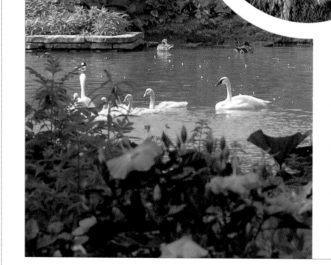

Zo
an

Large
every a
resents a
conservatio
objectives. Pro
wildlife ambassado
native environments is am
This central philosophy to
the auspices of *My Kind of*
Park Zoo, with the renova
ber of zoo facilities: Rege
opened May 2003; Reger
which opened July 2004;
Family Children's Zoo in

These renovations h
significant success in th
bandry of the animals
enhanced the zoo visitor'

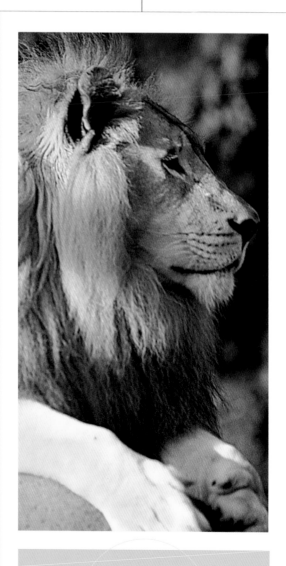

Welcome to the
Conservators' Circle
of Lincoln Park Zoo

DESIGN FIRM
Lincoln Park Zoo
Chicago, (IL) USA
PROJECT
Development Brochure
DESIGNER
Peggy Martin
PHOTOGRAPHERS
Greg Neise,
Grant Kessler

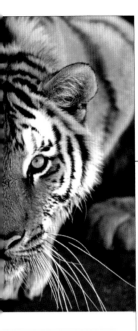

Collections
Exhibits

small, exotic or domestic,
at Lincoln Park Zoo rep-
means to accomplish our
ducation and recreation
g our more than 1,300
h habitats that reflect their
the zoo's highest priorities.

articular precedence under
The Campaign for Lincoln
nd construction of a num-
African Journey, which
Center for African Apes,
he opening of the Pritzker
2005.

ncreased the zoo's already
re and appropriate hus-
n its collection and have
rall experience.

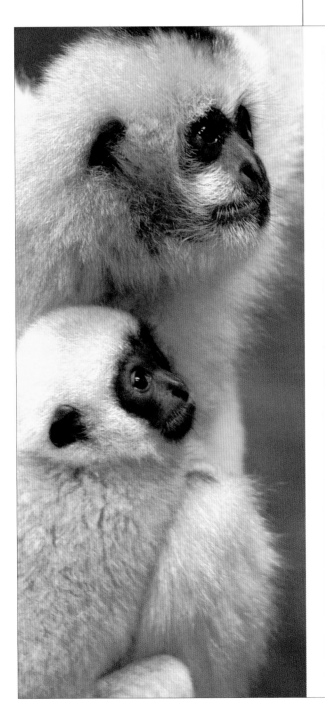

Facts About the Zoo

LINCOLN PARK ZOO IS:

•One of the most visited zoos in the country with an
estimated 3 million annual visitors.

•An urban oasis that covers 35 acres in the heart of the
city and has more than 1,300 animals in its collection.

•An institution with an operations budget of approxi-
mately $19 million.

•One of the oldest zoos in North America, which was
created with the gift of two swans in 1868.

•The only American Zoo and Aquarium-accredited, pri-
vately managed, free zoo in the nation.

•Home to one of the largest collections of lowland goril-
las in the country and one of the most successful captive-
breeding programs in the world (more than 47 gorilla
births since 1970).

•A world leader in the conservation of endangered
species and one of the top 10 zoos in the nation to fund
conservation research in the wild.

•Actively involved in more than 35
of the more than 100 Species
Survival Plans for threatened
and endangered species.

•Host to more than
1.6 million people each
year in a variety of
education programs
on zoo grounds and
in the community.

ZOO HOURS

GENERAL (April 1 –
Sept. 30): Grounds –
9 a.m. to 6 p.m.
Buildings and Farm –
10 a.m. to 5 p.m.; SUMMER
WEEKENDS (Memorial Day –
Labor Day, Saturdays, Sundays
and Holidays): Grounds open until 7
p.m., Buildings/Farm open until 6:30 p.m.
WINTER HOURS (Nov. 1 – March 31): Grounds –
9 a.m. to 5 p.m., Buildings/Farm – 10 a.m. to 4:30 p.m.

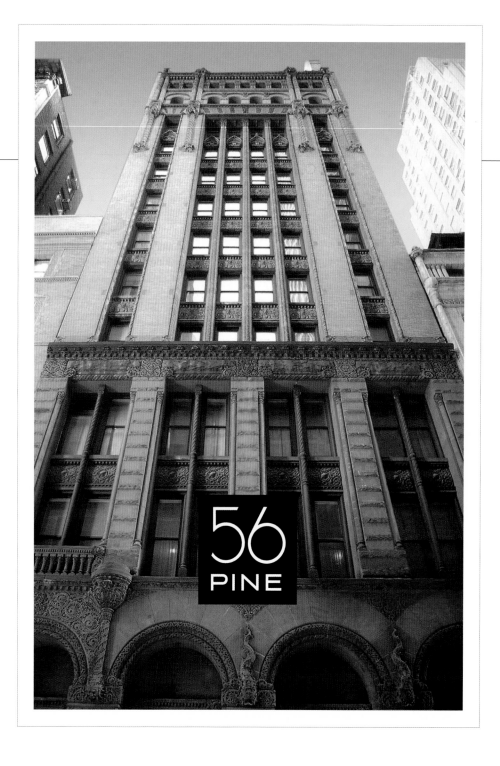

DESIGN FIRM
Liska + Associates
Chicago, (IL) USA
PROJECT
56 Pine Brochure
ART DIRECTOR, COPYWRITER
Tanya Quick
DESIGNERS
Tanya Quick,
Fernando Munoz
ILLUSTRATORS
Don Pietache,
Francesco Gianesini
PHOTOGRAPHERS
P. Margonelli, others

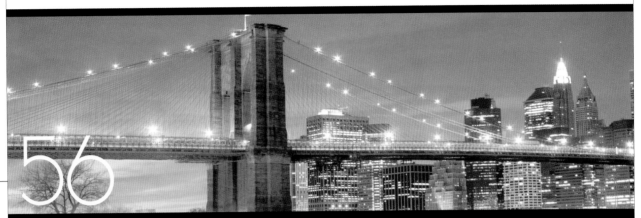

56 PINE IN THE MIDDLE OF... Classic and new restaurants: Bayard's · Bridge Cafe · Cabana · Delmonico's · Fraunces Tavern · 14 Wall Street · Il Porto · Les Halles Downtown · Quartino · Rise · Mark Joseph Steakhouse · Steamer's Landing · Stone Street Tavern Vine · Waterstone Grill Over 1,400 retail stores, including: J & R · Century 21 · Borders · J. Crew · Abercrombie & Fitch · The Sharper Image Coach · Gap · Bloomingdale's SoHo Over 100 parks, plazas and open spaces totalling 88 acres of green space: Battery Park · South Street Seaport · Bowling Green City Hall Park Downtown revitalization Wifi Hotspots New York landmarks City Hall · Brooklyn Bridge · American Stock Exchange · Ellis Island Federal Hall · Freedom Tower · Fulton Street Fish Market · NY Stock Exchange · St. Paul's Chapel · Statue of Liberty · Trinity Church · Wall Street · Woolworth Building Water on 3 sides: Ferries · Water Taxis and steps from practically every subway line: A, C, E, N, R, J, M, Z, 1, 2, 3, 4, 5, 6

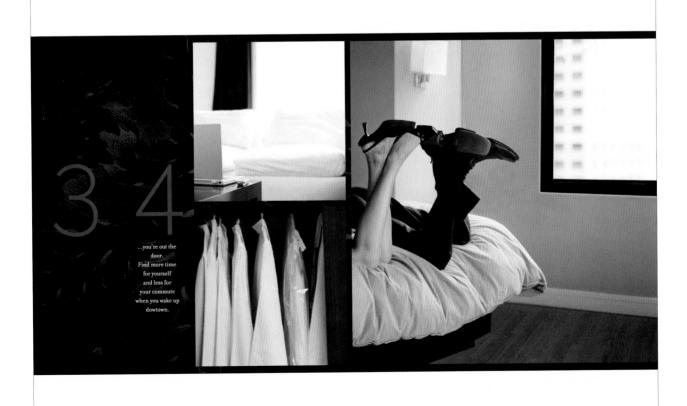

...you're out the door. Find more time for yourself and less for your commute when you wake up dowtown.

1_____

2_____

1_____
DESIGN FIRM
maycreate
Chattanooga, (TN) USA
CLIENT
American Archival
CREATIVE DIRECTOR, ART DIRECTOR,
DESIGNER, PHOTOGRAPHER
Brian May
COPYWRITER
Kristina Kollar
PRINTER
Creative Printing

2_____
DESIGN FIRM
Group 55 Marketing
Detroit, (MI) USA
PROJECT
Oro Vista Brochure
ART DIRECTOR, DESIGNER
Jeannette Gutierrez
COPYWRITER
Catherine Lapico

DESIGN FIRM
**Rizco Design &
Communications**
Manasquan, (NJ) USA

PROJECT
ACA Capital Brochure

ART DIRECTOR, DESIGNER
Keith Rizzi

1_____

DESIGN CRISIS?

X-ray Vision
skill level: 100%
+ creativity
max level for human

Graphic Design Support ::

www.mayhemstudios.com

info@mayhemstudios.com

Tel-323.533.8423

MAYHEM [M·S] STUDIOS.

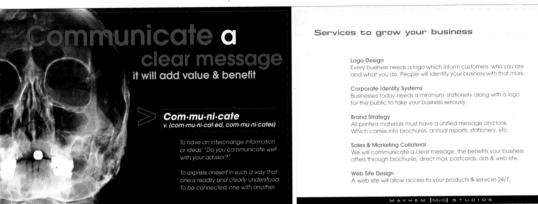

Communicate a clear message
it will add value & benefit

> **Com·mu·ni·cate**
> v. (com·mu·ni·cat·ed, com·mu·ni·cates)

To have an interchange information
or ideas; "Do you communicate well
with your advisor?"

To express oneself in such a way that
one is readily and clearly understood.
To be connected, one with another.

Services to grow your business

Logo Design
Every business needs a logo which inform customers, who you are
and what you do. People will identify your business with that mark.

Corporate Identity Systems
Businesses today needs a minimum, stationery along with a logo
for the public to take your business seriously.

Brand Strategy
All printed materials must have a unified message and look.
Which carries into brochures, annual reports, stationery, etc.

Sales & Marketing Collateral
We will communicate a clear message, the benefits your business
offers through brochures, direct mail, postcards, ads & web site.

Web Site Design
A web site will allow access to your products & services 24/7.

MAYHEM [M·S] STUDIOS

2 _____

BE A PART OF IT

for
party people
only

THE CLUB OF CLUBS

3 _____

1 _____

DESIGN FIRM
Liska + Associates
Chicago, (IL) USA

PROJECT
High Line Brochure

ART DIRECTOR
Tanya Quick

DESIGNER
Meghan Eplett

ILLUSTRATOR
Linda Roy

2 _____

DESIGN FIRM
Mayhem Studios
Los Angeles, (CA) USA

PROJECT
Mayhem Studios
Brochure

DESIGNER
Calvin Lee

3 _____

DESIGN FIRM
**Lebensart Media,
Berlin**
Berlin, Germany

CLIENT
Club of Clubs, Munich

ART DIRECTOR
Michael Schickinger

ILLUSTRATOR
Barbara Spoettel

The scientific research is clear, adverse reactions to common foods, known as hidden food allergies, prevent efficient fat burning. In a study from Baylor Medical College 98% of the subjects following an eating plan avoiding their own trigger food, as determined by the **Alcat test**, decreased scale weight and/or improved body composition (muscle to fat ratio). They also experienced improvement in skin, more energy, elimination of migraines, reduced sugar cravings, better mood and sleep, and other benefits.

"The Alcat test...will change the future of medicine."
William G. Crook, author, The Yeast Connection, and many other books.

The **Alcat test** is the **only** proven laboratory method for finding out which foods are causing weight gain, water retention, skin problems, fatigue, arthritis, and various other problems.

It is scientifically validated, has been awarded three US patents, and is performed under careful control by only one U.S. Government certified laboratory. The health benefits help ensure that you'll meet your weight goals safely, with less effort than you ever imagined possible, without the feeling of deprivation.

WHY WEIGHT?

Physicians and scientists now know that caloric restriction alone is not enough. The body is genetically programmed to lower metabolism and conserve energy stores during times of perceived famine. In contrast, the **Alcat test** produces the required improvement to metabolic function necessary for healthy and effective weight loss...fat is burned, energy increases, muscle mass is maintained or even increased...all without caloric restriction!

For more information

on the Alcat Test

please ask your

healthcare professional

The Alcat Test® is a simple, effective blood test that will determine which foods and chemicals YOU need to avoid.

The Alcat test has been proven successful in helping overcome

· Stomach Disorders
· Fatigue
· Migraines
· Asthma
· Skin Disorders
· Aching Joints
· Hyperactivity/ADD
· Obesity
· *And much more...*

The **Alcat test** eating plan is compatible with any other diet program. Many weight loss experts already realize this and have been relying on the **Alcat test** for years.

"For eight years I have used the Alcat test in my practice. No other test is as accurate or useful."
Fred Pescatore, M.D., former associate Medical Dir., The Atkins Center

"I've seen the (ALCAT) technique work when absolutely no other approach has made the scale budge."
Steven Lamm, M.D., author, Thinner at Last

"I have been tested and have been following the rotation diet sent to me for about two weeks. After only three days, the residual inflammation in my hands disappeared. I discontinued my arthritis medication, and the pain free condition continues. What a great relief that is! To say I am impressed would be totally inadequate"
Kathryn P. Noble, M.D., Columbus, OH

"My clients have certainly seen results with your Alcat test. You may not realize how you have improved the quality of life for many people by making this test available."
Registered Dietitian from Massachusetts

The following results were obtained in a study of subjects experiencing food intolerance related health problems (n=353)		
	Migraine/headache	95%
	Irritable Colon	87%
Condition of Subjects	Eczema	94%
	Perennial Rhinitis	95%
	Arthritis	85%
	Asthma	96%

(Experienced Improvement)

"I have been using the Alcat test consistently for weight loss, chronic fatigue, depression, arthritis, candidiasis and a host of other diseases and find it an invaluable tool."
Dr. John P. Salerno, formerly of The Atkins Center, Medical Director Salerno Center Rockefeller Center in New York, Medical Consultant Josai Clinic, Tokyo, Japan, Medical Director, Cell Science Systems, Ltd.

"...within just four weeks of taking the test and following the food plan, I lost 5 kilograms (11lbs.), my stuffy nose and throat problem has completely cleared up and I now have tremendously more strength during training."
Christian Mayer, World Champion Skier

"After the Alcat test I have probably 5% more strength and where I would take a rest after workouts in the afternoon I can carry straight through the day with no need or desire to stop for a break. To think that a mundane and harmless food like black pepper could be causing my problems is incredible...but it works! I recommend it to anyone looking for that edge on the competition and for health generally."
Dave Gauder - "Big Dave"
"The strongest man that ever lived"*
Holder of 22 Guinness World Strength Records.
Quote from Strength Athlete magazine

Each Year Millions of People Start Diets That Don't Work: **WHY?**

Dieting is frustrating and almost never brings long lasting results...

But fortunately, **there is** an answer.

The answer is finding an eating plan that's right for your own unique biochemistry.

Don't even think about starting a diet without reading this book!

ALCAT
WORLDWIDE

Your Hidden Food Allergies Are Making You Fat
How to Lose Weight and Gain Years of Vitality
Rudy Rivera, M.D., and Roger Davis Deutsch

1_____

1_____
DESIGN FIRM
Shelly Prisella Graphic Design
Lauderdale-By-The-Sea, (FL) USA
PROJECT
Alcat Worldwide Brochure
DESIGNER
Shelly Prisella

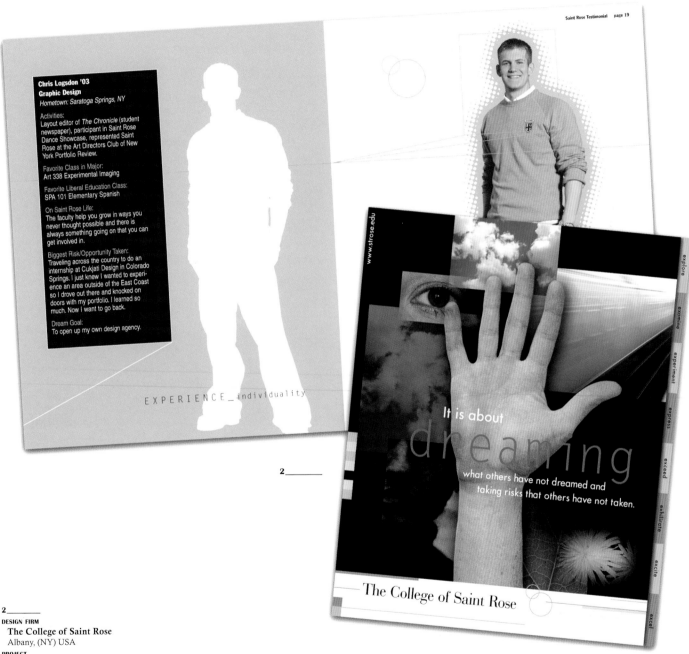

Chris Logsdon '03
Graphic Design
Hometown: Saratoga Springs, NY

Activities:
Layout editor of *The Chronicle* (student newspaper), participant in Saint Rose Dance Showcase, represented Saint Rose at the Art Directors Club of New York Portfolio Review.

Favorite Class in Major:
Art 338 Experimental Imaging

Favorite Liberal Education Class:
SPA 101 Elementary Spanish

On Saint Rose Life:
The faculty help you grow in ways you never thought possible and there is always something going on that you can get involved in.

Biggest Risk/Opportunity Taken:
Traveling across the country to do an internship at Cukjati Design in Colorado Springs. I just knew I wanted to experience an area outside of the East Coast so I drove out there and knocked on doors with my portfolio. I learned so much. Now I want to go back.

Dream Goal:
To open up my own design agency.

EXPERIENCE_individuality

It is about
dreaming
what others have not dreamed and
taking risks that others have not taken.

The College of Saint Rose

2_____

DESIGN FIRM
The College of Saint Rose
Albany, (NY) USA
PROJECT
"It is about dreaming..."
ART DIRECTOR
Mark Hamilton
DESIGNER, ILLUSTRATOR
Chris Parody
COPYWRITERS
Lisa Haley Thomson,
Renee Isgro Kelly
PHOTOGRAPHERS
Paul Castle Photography,
Gary Gold Photography
PRINTER
Brodock Press, Inc.

2005
Odyssey
By Forest River Marine

Chart Your Own Course

1

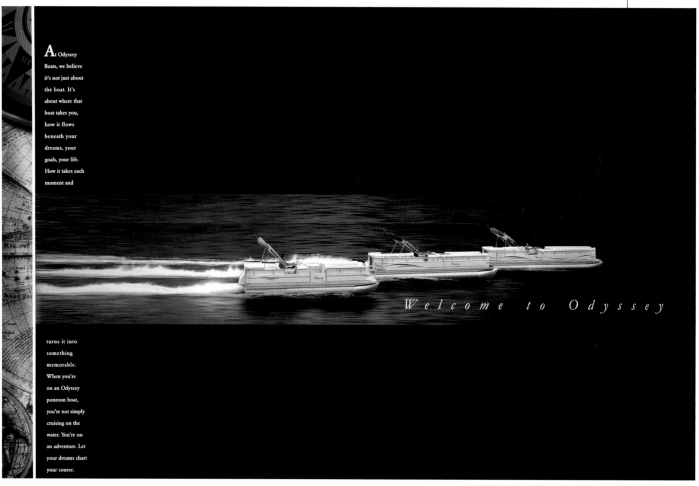

At Odyssey Boats, we believe it's not just about the boat. It's about where that boat takes you, how it flows beneath your dreams, your goals, your life. How it takes each moment and

Welcome to Odyssey

turns it into something memorable. When you're on an Odyssey pontoon boat, you're not simply cruising on the water. You're on an adventure. Let your dreams chart your course.

2_____

3_____

1_____

DESIGN FIRM
Studio D and
Lassiter Advertising
Fort Wayne, (IN) USA

PROJECT
Odyssey Brochure

CREATIVE DIRECTOR
Michael Earl

ART DIRECTORS
Holly Decker,
Jeremy Culp

PHOTOGRAPHER
Jeff Belli

2_____

DESIGN FIRM
Velocity Design Works
Winnipeg, (Manitoba) Canada

PROJECT
Velocity Design Works ID

CREATIVE DIRECTOR, ART DIRECTOR, DESIGNER
Lasha Orzechowski

3_____

DESIGN FIRM
**The Eden Communications
Group**
Maplewood, (NJ) USA

CLIENT
The Eden Communications Group

ART DIRECTOR, DESIGNER
Donna Malik

DESIGN FIRM
Annagram Studio and Design
Richmond, (KY) USA
CREATIVE DIRECTOR
Coda Projects
ART DIRECTOR
Graham Allen
DESIGNER
Kyle Sheldon
ILLUSTRATOR
Christopher Sharp
PRINTER
Host Communications

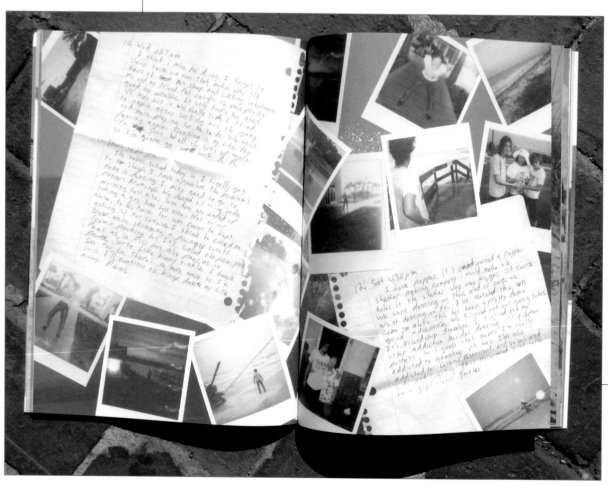

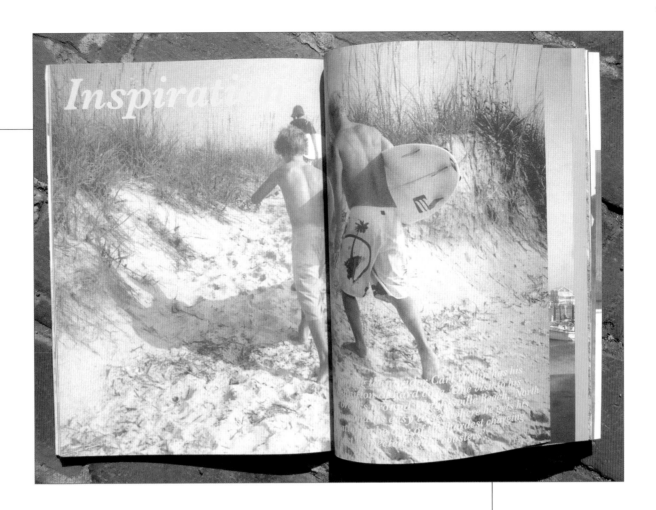

Inspiration

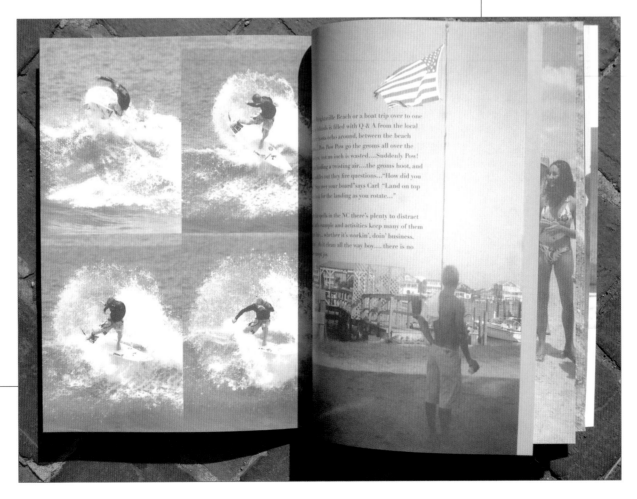

BE A PART OF IT

1_____

THE ARRANGEMENT

We promote your events to one or more of our two membership
levels. You enjoy increased exposure to a highly attractive target
group. In return, our members on attending your events, enjoy
the preferential treatment that they are used to.

WE PROMOTE YOU TO OUR MEMBERS. YOU
OFFER OUR MEMBERS THE STANDARD THEY
ARE USED TO.

HOW DOES THE CLUB OF CLUBS WORK?

To help you further identify your target group, our membership is broken down into two distinct
levels. We can promote your events to one or more of these carefully selected groups according to your
requirements.

JUNIOR INTERNATIONAL CLUB ™ Its members are between 18 and 35 years old.
They are going places and getting there fast. They live busy international lifestyles and need to make
sure that time off isn't time wasted. They want to go out to events that combine sophistication and
glamour. Membership of the Junior International Club is limited to 3000 with a limited quota for indi-
vidual countries, and is carefully selected by the committee - ensuring that we will be promoting your
events to precisely the people you would like to attend them.

THE COSMOPOLITAN CLUB ™ Its members are over 30 years old. They are looking to
indulge in the luxuries that their success affords and they don't mind paying for the privilege. They
are looking for refinement, sophistication and style, and expect the highest standards from events and
parties when they attend them. They are looking for events that they can enjoy personally and where
they can entertain professionally. Membership of the Cosmopolitan Club is limited to 3000 with a
limited quota for individual countries. Again, membership is carefully vetted by the committee.

THE CLUB OF CLUBS ... we want you to be a part of it.

1_____
DESIGN FIRM
Lebensart Media, Berlin
Berlin, Germany
CLIENT
Club of Clubs, Munich
ART DIRECTOR
Michael Schickinger
ILLUSTRATOR
Barbara Spoettel

ASSOCIATION OF PERFORMING ARTS OF INDIA

APA

Mission

Association of Performing Arts of India, is a non-profit organization, founded on June 1998. All our committee members and board of directors are working as volunteers. The goal is to promote Indian classical music and dance through lecture demo and concerts. There are classes given in Sitar, Tabla (Percussion) and Dance. We are located in Pembroke Pines, Florida.

Lakshmi Shankar

Shubha Mudgal

Quotes

Comments from "Music for the Soul" featuring Pt. Vishva Mohan Bhatt
"Balanced artistic program for the listener with traditional Indian style in the first half of the program, and the second half showcased Bhatt's contemporary sensibilities and his influence on the (contemporary) "world music" genre. Unique instrumental sound and great technical ability."
James Shermer, Grants Director
Broward Cultural Affairs

Comments from "From Prince To Buddha" by The Shakti Dance Group
"I enjoyed the concert very much. The music and dance were of a very high caliber. I was so pleased to see how many people were in the audience."
Daniel Lewis, Dean of Dance
New World School of the Arts

"The percussive beat of the tabla and the distinctive sounds of the sitar can be heard in Broward County this spring and summer thanks to the efforts of the Association of Performing Arts of India."
Helene Eisenberg Foster -
Cultural Quarterly,
Spring 2001, Volume XIV, Number 2.

"Though the raga was as long as Beethoven's Ninth Symphony, the musicians maintained audience interest in an unbroken span for 70 minutes, with a fiery virtuosity and provisional flair that was often awe inspiring"
Lawrence A. Johnson - Concert Review,
Sun Sentinel, June 18, 2001.

Organizational History

The Association of Performing Arts of India (APAI) was founded in 1998 with the mission to preserve and promote the ancient Indian Classical Music and Dance. Indian Music is the oldest written music in the world. The first evidence of written music, i.e musical notes, comes from the Vedas, Indian sacred documents written more than 4000 years ago.
In spite of such a rich heritage, Indian music, particularly Indian Classical music, while flourishing in India, is still an unknown art in the rest of the world. The primary purpose of APAI is to bring this art to the U.S. The secondary purpose is to educate the South Florida community, young and old, about this art through lecture-demonstrations, classes and concerts. There is a large group of Americans of Indian origin in South Florida, and these people would like to keep in touch with their cultural heritage. There are close to 50,000 Indian Americans from India and close to 50,000 Indian Americans from the Caribbean Islands in South Florida. If one includes other Americans who would want to learn about Indian Music and dance also, there is a large audience who would appreciate and participate in Indian music and dance. Therefore our work is a pioneering effort and hopefully will lead to enriching the cultural scope of all residents of Broward County.

Veena Sahasrabudde

Long Term Goals and Objectives

To present an annual series of Indian classical music and dance concerts for the general public.

To present educational programs for Broward school children to acquaint them to the artistry and cultural traditions of Indian classical music.

To provide opportunities for South Florida residents of Indian heritage to come together to promote and express their cultural heritage.

To offer workshops for musicians (both Indian and non-Indian) to learn Classical Indian musical repertoire and techniques.

To develop a financial support base to sustain and expand APAI activities.

Manju Mehta

Program History

The Association of Performing Arts of India has, since its inception, focused not only on featuring premier caliber artists, but has also sought to expand the scope of its presentations to include classical dance and dance-drama, folk art forms and cross cultural events. The Association's inaugural performance was held on November, 1998 presenting Ustad Rashid Khan, a leading Hindustani vocal artist accompanied by tabla (drums) and the now rarely seen classical Indian fiddle known as the sarangi. Subsequently, the Association succeeded in bringing a diverse variety of high caliber, in some cases, world known artists to our region including instrumental music featuring all of the principal instruments of the Hindustani tradition: sitar, sarod (a fretless multi-stringed lute,) shehnai (the Indian oboe), sarangi (the above mentioned fiddle) and the bamboo flute. Prominent sitarist such as Ustad Shujaat Hussain Khan, a leading exponent of the Imdadkhani gharana and son of the late great Ustad Vilayat Khan, has appeared on our programs here in South Florida, as well as Pt.Vishwa Mohan Bhatt, A versatile Guitar performer with a broad repertoire of traditional music, Bhatt received a Grammy Award in 1994 for a joint world music album entitled "A Meeting by the River" created with Ry Cooder. Vocal music has been heavily featured as well, including male and female artists from a number of different gharanas or musical "families" that are exponents of a particular style. These include singer Shubha Mudgal, vocalist on many film soundtracks, Lakshmi Shankar, sister-in-law to Ravi Shankar, as well as featured vocalist on the soundtrack to Richard Attenborough's epic film "Gandhi" and Veena Shastrabuddhe, a one of the most respected singers of the Gwalior gharana. With a view to demonstrating the commonalities of different musical traditions, the Association has twice presented fusion performances melding the musical and dance traditions of flamenco and Indian traditions. We have showcased the flamenco guitar alongside the sarangi and flamenco vocals (cante). At the same time, audiences experienced classical Indian dance (Kathak) side by side with the fiery steps of flamenco.

Shakti Dance Company

The common rhythmic and melodic foundation of these two very different traditions was evident in the performances and the ability of the artists to communicate with little or no rehearsal across language and stylistic barriers was impressive Perhaps the most popular and well-attended events sponsored by the Association are its dance concerts. On three occasions, the Association has presented the Shakti Dance Company, a Bharata Natyam dance company with a full complement of live musicians, including three vocalists, various percussion, violin, flute, and veena (a South Indian long-necked lute). The performances included virtuoso soloists and a full corps of dancers performing three separate works of dance-drama, one based on the Bhagavad-Gita, the others on the life of Buddha and Sant Meera. The Association has endeavored, and succeeded, in presenting variety, cultural diversity and art of the highest artistic integrity and quality without neglecting the very capable dancers, singers and instrumentalists in our own community who have participated and performed in our programs dedicated to local artists. The years since our inception have seen events ranging from small, intimate audiences and community outreach programs such as lecture demonstrations to sold-out houses at larger venues, each program contributing in its own way to furthering communication with our audience.

DESIGN FIRM
Shelly Prisella Graphic Design
Lauderdale-By-The-Sea, (FL) USA
PROJECT
APAI 2005 Brochure
DESIGNER
Shelly Prisella

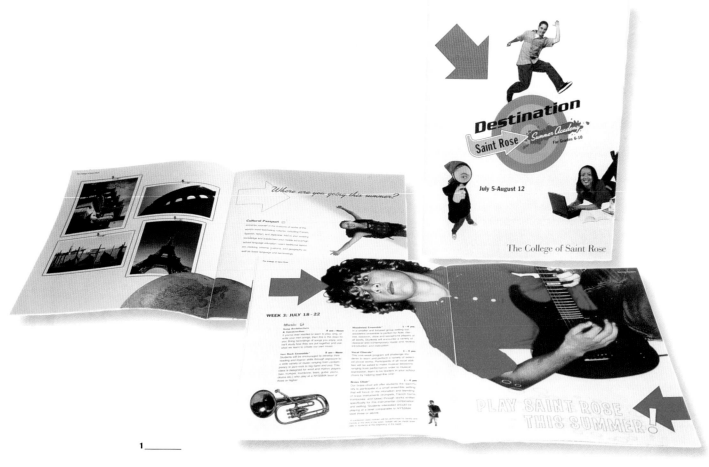

1 _____

DESIGN FIRM
The College of Saint Rose
Albany, (NY) USA

PROJECT
Destination Saint Rose
Summer Academy

ART DIRECTOR
Mark Hamilton

ILLUSTRATOR
Chris Parody

COPYWRITERS
John Hunter, Mark Hamilton

PHOTOGRAPHER
Jupiter Images Corp.

PRINTER
Ansun Graphics

2_____

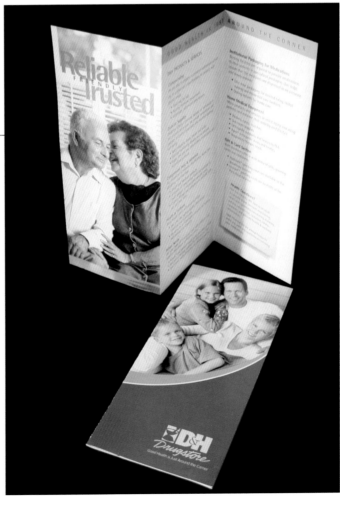

2_____
DESIGN FIRM
Velocity Design Works
Winnipeg, (Manitoba) Canada
PROJECT
Pixel Album
CREATIVE DIRECTOR, ART DIRECTOR, PHOTOGRAPHER
Lasha Orzechowski
DESIGNERS
Lasha Orzechowski, Rick Sellar

3_____
DESIGN FIRM
Vangel Marketing Communications
Columbia, (MO) USA
PROJECT
D&H Drugstore Brochure

3_____

enero

Un gobierno con la gente... un gobierno diferente

2006

Playa de La Manzanilla

diciembre

D	L	M	M	J	V	S
				1	2	3
4	5	6	7	8	9	10
11	12	13	14	15	16	17
18	19	20	21	22	23	24
25	26	27	28	29	30	31

febrero

D	L	M	M	J	V	S
			1	2	3	4
5	6	7	8	9	10	11
12	13	14	15	16	17	18
19	20	21	22	23	24	25
26	27	28				

D	L	M	M	J	V	S
1	2	3	4	5	6	7
8	9	10	11	12	13	14
15	16	17	18	19	20	21
22	23	24	25	26	27	28
29	30	31				

Coordinación
General de
Comunicación Social

2002·2008 Michoacán

Michoacán
un gobierno diferente

junio

Un gobierno con la gente... un gobierno diferente

2006

Paisaje desde Tzintzuntzan

mayo

D	L	M	M	J	V	S
	1	2	3	4	5	6
7	8	9	10	11	12	13
14	15	16	17	18	19	20
21	22	23	24	25	26	27
28	29	30	31			

julio

D	L	M	M	J	V	S
						1
2	3	4	5	6	7	8
9	10	11	12	13	14	15
16	17	18	19	20	21	22
23	24	25	26	27	28	29
30	31					

D	L	M	M	J	V	S
				1	2	3
4	5	6	7	8	9	10
11	12	13	14	15	16	17
18	19	20	21	22	23	24
25	26	27	28	29	30	

Coordinación
General de
Comunicación Social

2002·2008 Michoacán

Michoacán
un gobierno diferente

DESIGN FIRM
Caracol Consultores SC
Morelia, México

CLIENT
Gobierno del Estado
de Michoacán, Mexico

ART DIRECTOR
Luis Jaime Lara Perea

DESIGNER
Luis Jaime Lara

PHOTOGRAPHER
Coordinación General de
Comunicación Social

noviembre

Un gobierno con la gente... un gobierno diferente

2006

Flores de Cempazúchitl

octubre	diciembre
D L M M J V S	D L M M J V S
1 2 3 4 5 6 7	1 2
8 9 10 11 13 14	3 4 5 6 7 8 9
15 16 17 18 19 20 21	10 11 12 13 14 15 16
22 23 24 25 26 27 28	17 18 19 20 21 22 23
29 30 31	24 26 27 28 29 30
	31

D	L	M	M	J	V	S
			1		3	4
5	6	7	8	9	10	11
12	13	14	15	16	17	18
19		21	22	23	24	25
26	27	28	29	30		

 Coordinación General de Comunicación Social 2002·2008 Michoacán

 Michoacán un gobierno diferente

marzo

Un gobierno con la gente... un gobierno diferente

2006

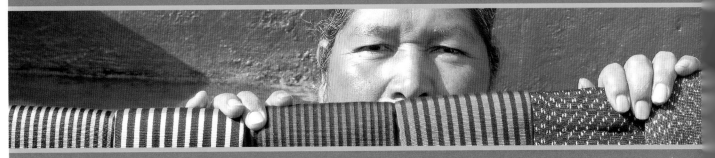

Paracho

febrero	abril
D L M M J V S	D L M M J V S
1 2 3 4	1
5 6 7 8 9 10 11	2 3 4 5 6 7 8
12 13 14 15 16 17 18	9 10 11 12 13 14 15
19 20 21 22 23 24 25	16 17 18 19 20 21 22
26 27 28	23 24 25 26 27 28 29
	30

D	L	M	M	J	V	S
			1	2	3	4
5	6	7	8	9	10	11
12	13	14	15	16	17	18
19	20	21	22	23	24	25
26	27	28	29	30	31	

 Coordinación General de Comunicación Social 2002·2008 Michoacán

 Michoacán un gobierno diferente

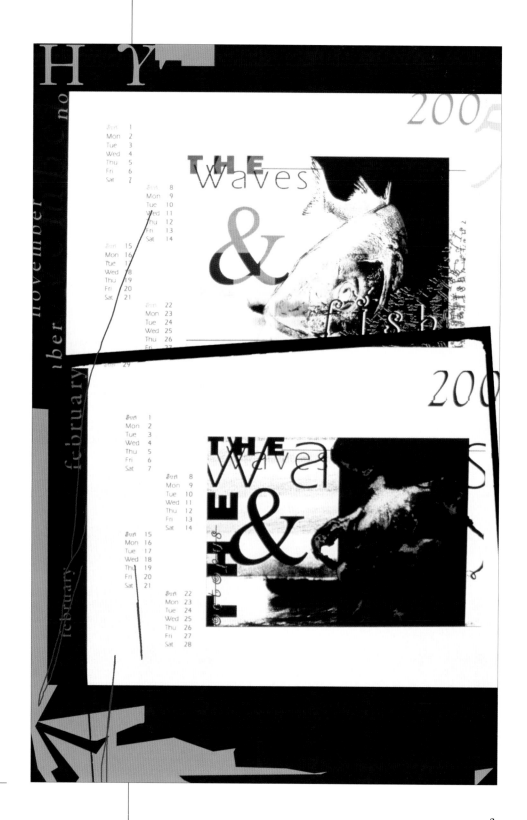

1_____

2_____
DESIGN FIRM
Riordon Design
Oakville, (Ontario) Canada
PROJECT
Coloratura Calender
CLIENT
Riordon Design
ART DIRECTOR
Shirley Riordon
DESIGNERS
Dawn Charney, Shirley Riordon

1_____
DESIGN FIRM
Didem Carikci Wong
Istanbul, Turkey
CREATIVE DIRECTOR, ART DIRECTOR, DESIGNER
Didem Carikci Wong

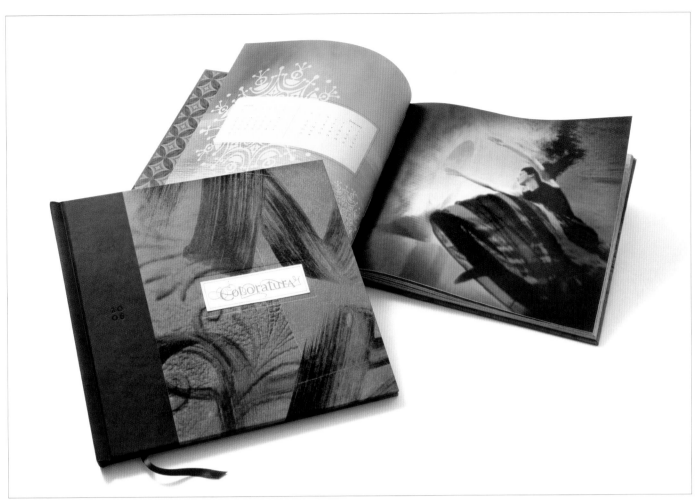

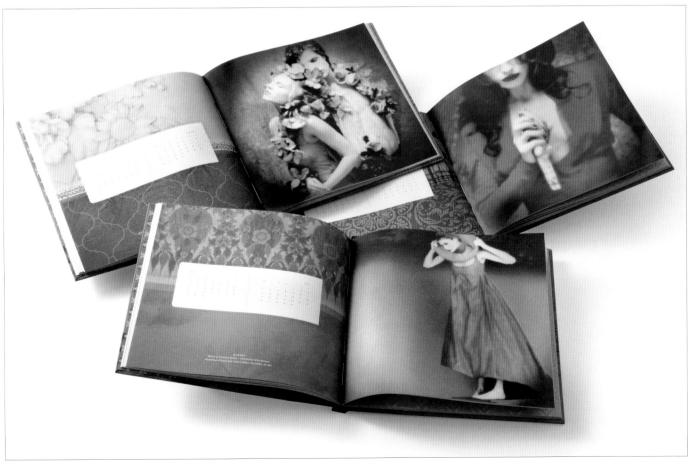

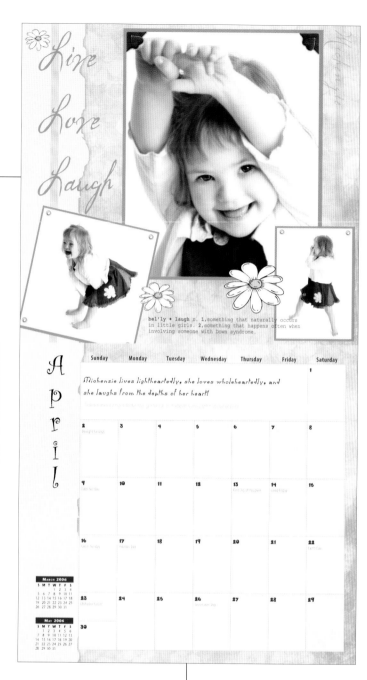

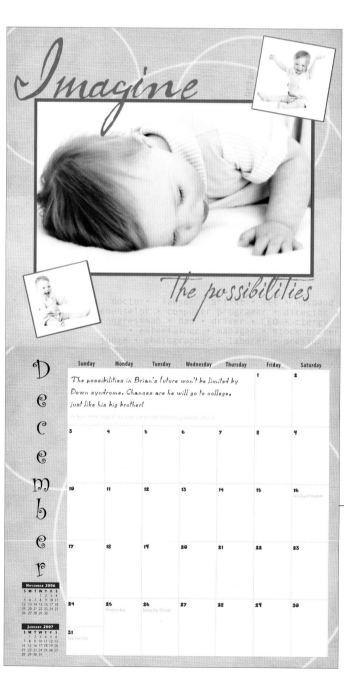

1 _____
DESIGN FIRM
JL Design
Plainfield, (IL) USA
PROJECT
Gigi's Calender
DESIGNER
JL Design

1 _____

2006

Food Stamp Nutrition Education
2006 Recipe Calendar

S	M	T	W	T	F	S
			1	2	3	4
5	6	7	8	9	10	11
12	13	14	15	16	17	18
19	20	21	22	23	24	25
26	27	28	February is: ■ American Heart Month ■ Potato Lover's Month			

MARYLAND COOPERATIVE EXTENSION
UNIVERSITY OF MARYLAND

February

2_____

Baked Potato & Toppings

Makes 1 serving

1 baked potato
1 topping
2 tablespoons grated cheese

Potato Toppings
 Chili
 Spaghetti sauce
 Cooked broccoli
 Salsa (add lettuce and tomato for a taco potato)
 Frozen vegetables (cook for 3-4 minutes)

1. Wash potato and pierce with a fork.
2. Microwave on high for about 16 minutes
 (turn over after 8 minutes).
3. Carefully cut open the potato.
4. Top each potato with one of the above toppings.
5. Top with grated cheddar or mozzarella cheese.

■ Add leftover chicken or ground beef to make a well-rounded dinner.
■ Try eating the skin of the potato to boost the fiber in your meal.

2_____
DESIGN FIRM
 University of Maryland
 Cooperative Extension—FSNE
 Columbia, (MD) USA

CLIENT
 The University of Maryland
 CooperativeExtension—Food
 Stamp Nutrition Education Program

PROJECT
 FSNE 2006 Recipe Calender

DESIGNERS
 Lisa Lachenmayr,
 Trang Dam

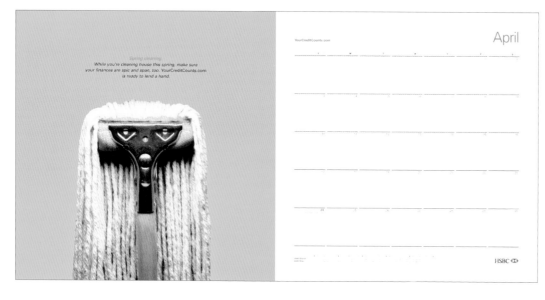

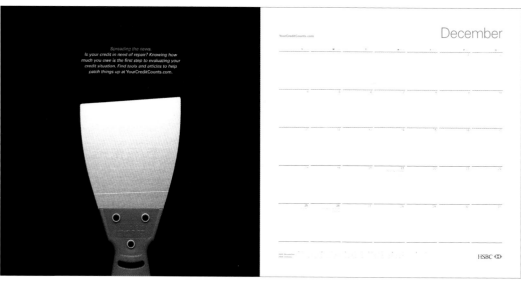

1

DESIGN FIRM
Coates and Coates
Naperville, (IL) USA
CLIENT
HSBC—North America
ART DIRECTOR, DESIGNER
Carolin Coates

We are bpTT

2005

bp

Trinidad and Tobago

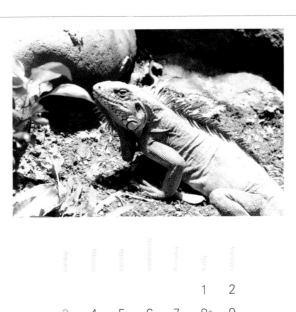

sunday	monday	tuesday	wednesday	thursday	friday	saturday
					1	2
3	4	5	6	7	8	9
10	11	12	13	14	15	16
17	18	19	20	21	22	23
24	25	26	27	28	29	30

april 2005

Resting yet alert, an iguana basks in the sun

bp

Trinidad and Tobago

...investing beyond petroleum

sunday	monday	tuesday	wednesday	thursday	friday	saturday
				1	2	3
4	5	6	7	8	9	10
11	12	13	14	15	16	17
18	19	20	21	22	23	24
25	26	27	28	29	30	

september 2005

Twin peaks rise majestically from the tranquil coastline

bp

Trinidad and Tobago

...investing beyond petroleum

sunday	monday	tuesday	wednesday	thursday	friday	saturday
				1	2	3
4	5	6	7	8	9	10
11	12	13	14	15	16	17
18	19	20	21	22	23	24
25	26	27	28	29	30	31

december 2005

Peace and splendour... Mayaro at sunrise

bp

Trinidad and Tobago

...investing beyond petroleum

259

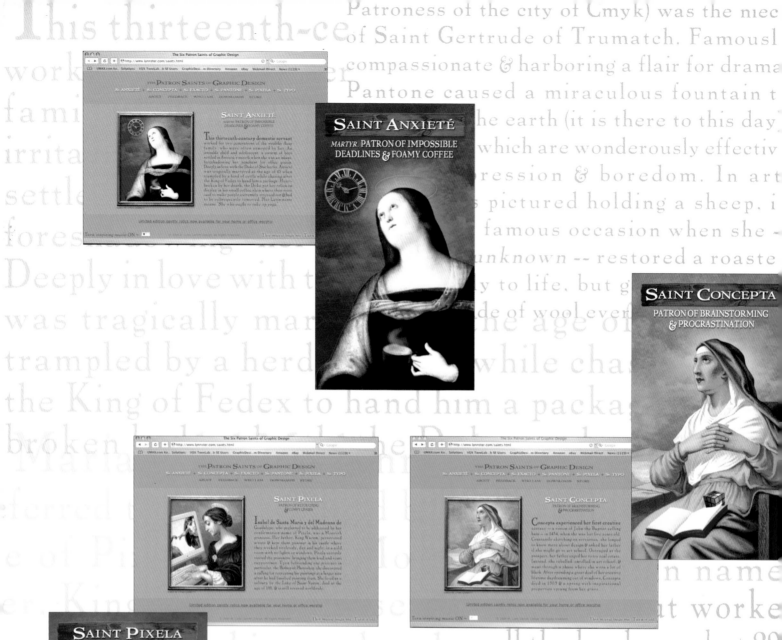

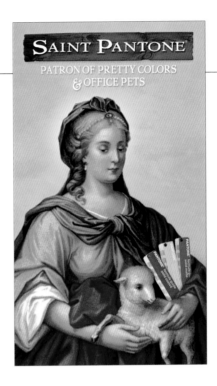

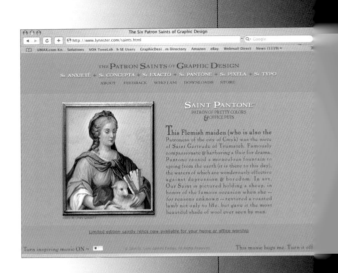

DESIGN FIRM
W. Lynn Garrett Art Direction + Design
San Francisco/Los Angeles, (CA) USA

CLIENT
W. Lynn Garrett Art Direction + Design

DESIGNER, COPYWRITER
W. Lynn Garrett

1 _____

1 _____

DESIGN FIRM
JUNGLE 8/creative
Los Angeles (CA), USA
CLIENT
Insight Group International
DESIGNER
Lainie Siegel
COPYWRITER
Michael Walsh

2_____

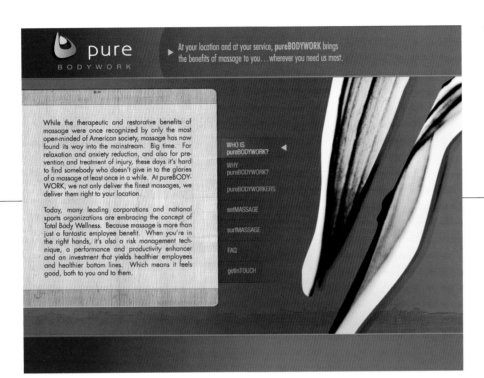

3_____

2_____

DESIGN FIRM
JUNGLE 8/creative
Los Angeles (CA), USA

CLIENT
Pure BodyWork

CREATIVE DIRECTOR
Lainie Siegel

DESIGNER
Justin Cram

COPYWRITER
Scott Silverman

3_____

DESIGN FIRM
JUNGLE 8/creative
Los Angeles (CA), USA

CLIENT
Carsey Werner

DESIGNER
Lainie Siegel

COPYWRITER
Michael Walsh

Life made better

Skip Intro >>

1 _____

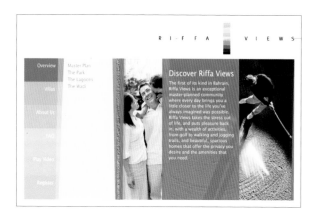

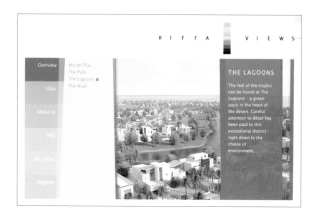

2 _____

1 _____
DESIGN FIRM
FutureBrand Brand Experience
New York (NY), USA
PROJECT
Riffa Views Website
CREATIVE DIRECTOR
Diego Kolsky
DESIGNERS
Cheryl Hills,
Brendan Oneill,
Tom Li,
Mike Williams
MULTIMEDIA DEVELOPER
Mike Sheehan
COPYWRITER
Stephanie Carroll
DIRECTOR OF VISUALIZATION
Antonio Baglione
VISUALIZATION ARTIST
Oliver de la Rama
PRINCIPAL
Raymond Chan

2 _____
DESIGN FIRM
JUNGLE 8/creative
Los Angeles (CA), USA
CLIENT
Donna & Shannon Freeman
CREATIVE DIRECTOR
Lainie Siegel
DESIGNERS
Justin Cram, Gracie Cota
COPYWRITER
Scott Silverman

Using Oils **Catalog** **Home**

WELCOME TO OMNESSENCE

We take pride in offering only the purest essential oils from the world's premium distillers and growers.

What our customers have to say about **OmnEssence**...

"I love these!"

"There is wisdom in these oils."

rose centifolia

How To Order **View The Catalog ▶**

genuine and Authentic essential oils

Single Oils | Synergistic Blends | Oil Kits | Carrier Oils | Accessories | Publications & Books | Educational Opportunities
How To Use Essential Oils | Catalog (Coming Soon) | How To Order | Product Return Policy | Contact | Downloadable PDF Catalog

3_____

3_____
DESIGN FIRM
 Octavo Designs
 Frederick, (MD), USA
CLIENT
 OmnEssence
ART DIRECTOR
 Sue Hough
DESIGNERS
 Sue Hough, Mark Burrier

1_____

DESIGN FIRM
**FutureBrand
Brand Experience**
New York (NY), USA

PROJECT
Exomos Website

CREATIVE DIRECTOR
Avrom Tobias

DESIGNERS
Tini Chen,
Mike Williams,
Brendan Oneill,
Tom Li

MULTIMEDIA DEVELOPER
Mike Sheehan

COPYWRITER
Stephanie Carroll

DIRECTOR OF VISUALIZATION
Antonio Baglione

VISUALIZATION ARTIST
Oliver de la Rama

IDENTITY SYSTEMS DIRECTOR
Carol Wolf

PRINCIPAL
Mario Natarelli

2_____

DESIGN FIRM
Engrafik
Oslo, Norway

CLIENT
Kisses on Platform 2

CREATIVE DIRECTOR, DESIGNER
Reinert Korsbøen

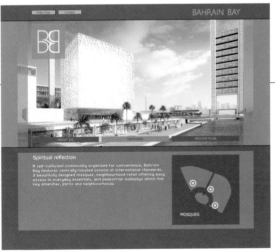

3_____

2_____

3_____
DESIGN FIRM
Maurius Fahrner Design
New York, (NY), USA
PROJECT
Elements-Winterhude Website
ART DIRECTOR
Marius Fahrner
ILLUSTRATOR
Barbara Spoettel

4_____
DESIGN FIRM
FutureBrand
Brand Experience
New York (NY), USA
PROJECT
Bahrain Bay Website
CREATIVE DIRECTOR
Diego Kolsky
DESIGNERS
Mike Williams, Cheryl Hills,
Brendan Oneill, Tom Li
MULTIMEDIA DEVELOPER
Mike Sheehan
COPYWRITER
Stephanie Carroll
DIRECTOR OF VISUALIZATION
Antonio Baglione
VISUALIZATION ARTIST
Oliver de la Rama

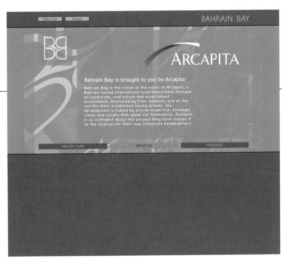

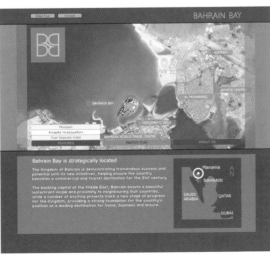

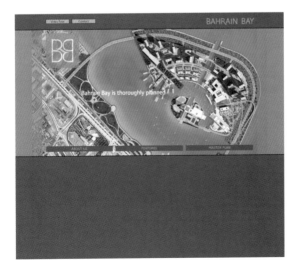

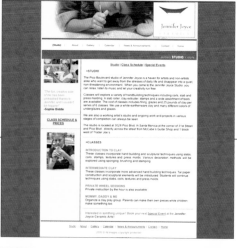

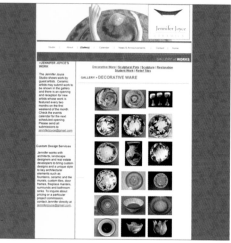

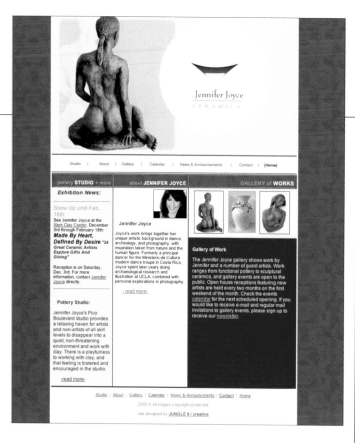

1

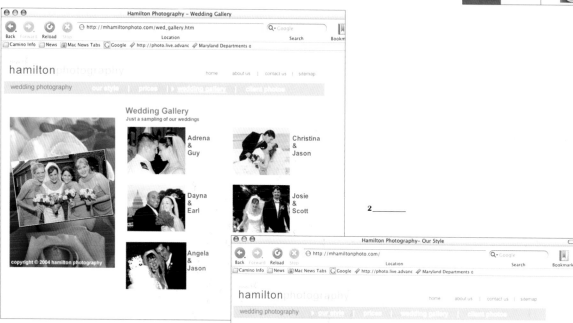

2

1

DESIGN FIRM
JUNGLE 8/creative
Los Angeles (CA), USA
CLIENT
Jennifer Joyce
PROJECT
Jennifer Joyce Ceramics
DESIGNERS
Lainie Siegel,
Gracie Cota

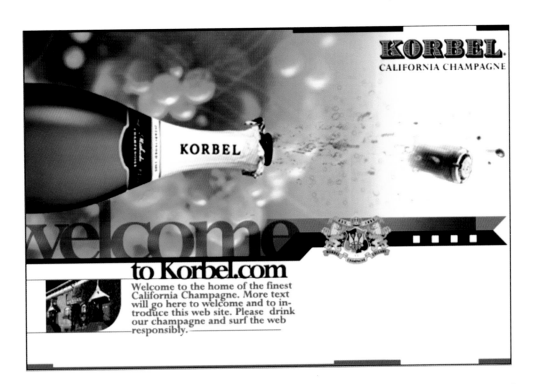

3_____

3_____

DESIGN FIRM
JUNGLE 8/creative
Los Angeles (CA), USA

PROJECT
Korbel Champagne Website

CLIENT
Korbel Media

CREATIVE DIRECTOR, DESIGNER
Lainie Siegel

CREATIVE DIRECTOR
Michael Walsh

PRODUCER
Elizabeth Burtis-Lopez

2_____
DESIGN FIRM
University of Maryland
Cooperative Extension—FSNE
Columbia, (MD) USA

CLIENT
Mark Hamilton,
Hamilton Photography Inc.

PROJECT
Hamilton Photography Website

DESIGNER
Trang Dam

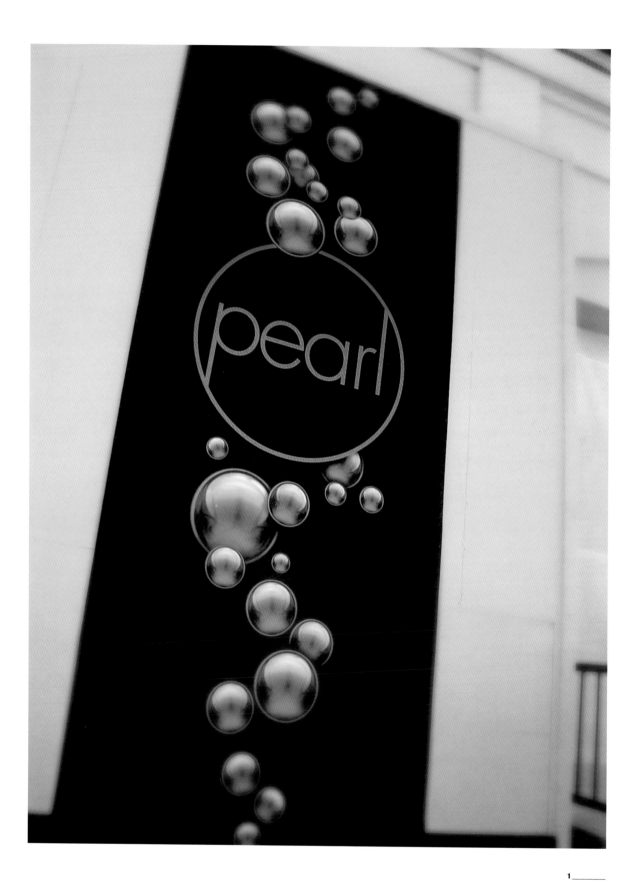

1_____

2_____

3_____

1_____
DESIGN FIRM
John Wingard Design
Honolulu, (HI), USA
CLIENT
Pearl Hawaii
ART DIRECTOR, DESIGNER
John Wingard

2_____
DESIGN FIRM
Velocity Design Works
Winnipeg, (Manitoba) Canada
PROJECT
Carriere
CREATIVE DIRECTOR, ART DIRECTOR,
DESIGNER
Lasha Orzechowski
PHOTOGRAPHER
Deborah Seguin

3_____
DESIGN FIRM
TAMAR Graphics
Waltham, (MA) USA
PROJECT
Road Rage Billboard
DESIGNER
Tamar Wallace

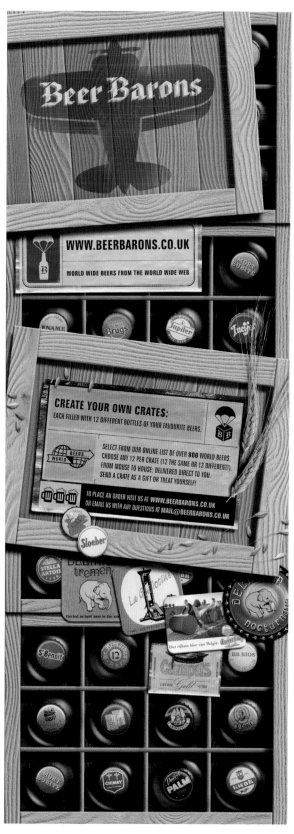

1_____

1_____
DESIGN FIRM
Imagine
Manchester, England
PROJECT
Beer Barons Banners
ART DIRECTOR, DESIGNER
David Caunce

2_____
DESIGN FIRM
McMillian Design
Brooklyn, (NY) USA
CLIENT
Buena Vida
ART DIRECTOR, DESIGNER
William McMillian

THE HEART OF A CARING COMMUNITY

Buena♡Vida
Continuing Care and Rehabilitation Center

48 CEDAR STREET • BROOKLYN, NY 11221-3253
(718) 928-3514 • WWW.BUENAVIDACENTER.ORG

2_____

3_____

OMN Є SSENCE™
genuine and Authentic essential oils

Organic

Wild-Crafted

Vintage

Ethically Farmed

aromatic HeaLing™

Educational resources
on the uses of essential oils
for health and well-being

3_____
DESIGN FIRM
Octavo Designs
Frederick, (MD) USA
CLIENT
OmnEssence/Aromatic Healing
ART DIRECTOR
Sue Hough
DESIGNERS
Sue Hough, Mark Burrier

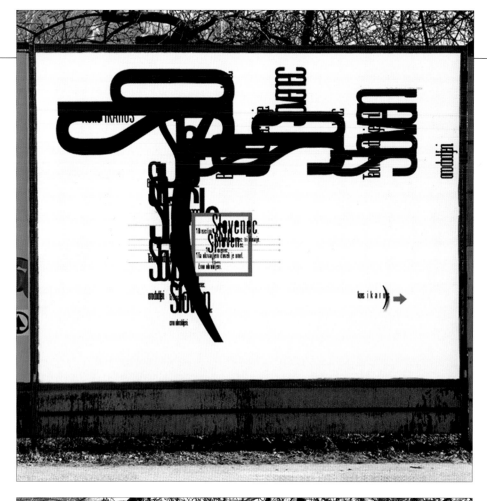

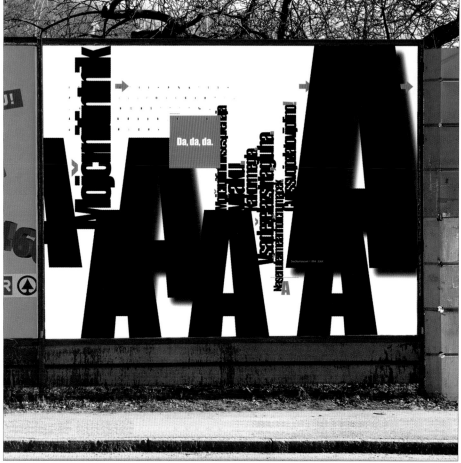

DESIGN FIRM
Eduard Cehovin
Ljubljana, Slovenia
PROJECT
SK04/Srecko Kosovel
1904 - 2004
DESIGNER
Eduard Cehovin

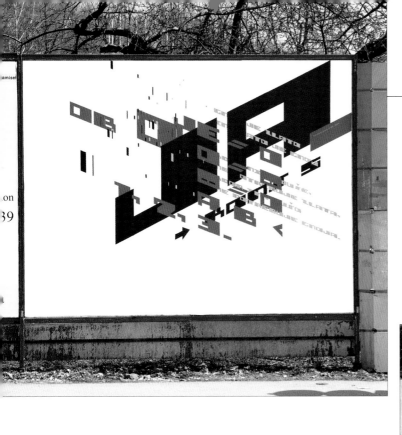

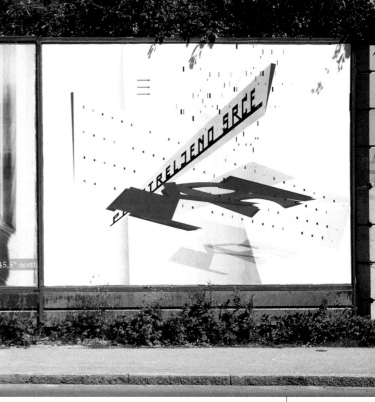

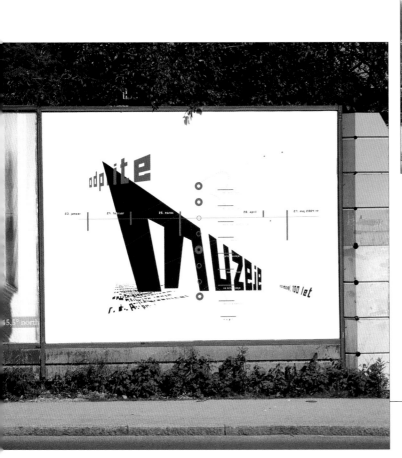

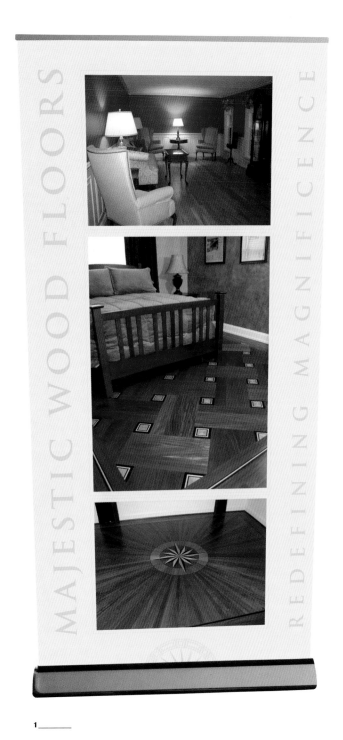

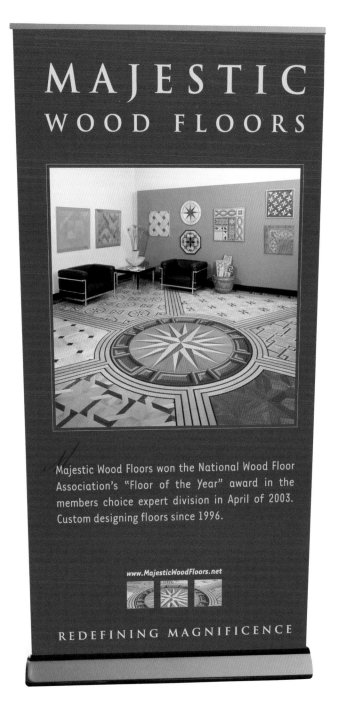

1 _____

1 _____
DESIGN FIRM
 Octavo Designs
 Frederick, (MD) USA
CLIENT
 Majestic Wood Floors
ART DIRECTOR, DESIGNER
 Sue Hough

2_____

2_____

DESIGN FIRM
Sandy Gin Design
San Carlos, (CA) USA
PROJECT
Limelight Networks
Trade Show Banners
CLIENT
Limelight Networks
DESIGNER
Sandy Gin
PHOTOGRAPHER
Digital Vision

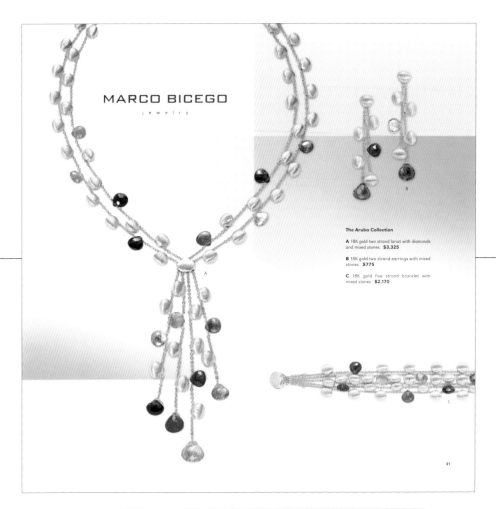

1_____

2_____

1_____
DESIGN FIRM
Ellen Bruss Design
Denver, (CO) USA
CLIENT
Hyde Park
CREATIVE DIRECTOR
Ellen Bruss
DESIGNER
Charles Carpenter

2_____
DESIGN FIRM
Joe Miller's Company
Santa Clara, (CA) USA
CLIENT
Girl Scouts of
San Francisco Bay Area
DESIGNER
Joe Miller

3_____

3_____
DESIGN FIRM
maycreate
Chattanooga, (TN) USA
CLIENT
Clarity Products
CREATIVE DIRECTOR,
ART DIRECTOR, DESIGNER
Brian May

1_____

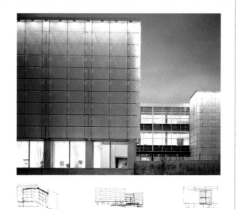

the inherent visual qualities of each, particularly as they intersect, or, characteristically, slide in large planes among each other. There is a definite Japanese quality to the finish and composition of the spaces, particularly in their fascination with joinery and their play between dark and light, transparent and opaque, soft and hard.

These hints of Wright and Mies reflect Brininstool + Lynch's fascination with the roots of Chicago modernism. To that end, it is interesting to note the firm's repeated runs at refining the Chicago apartment block, perhaps the area where the city's recent architecture has gone most dismally off track—enough to certify the soul searching of the "Where in the World" conference. In a series of projects like 300 West Huron, 630 North Franklin, and 327 North Sangamon, Brininstool + Lynch attack the problem through refining the curtain wall as a compositional device, rather than tonally manipulating massing, as other Chicago firms have attempted lately, with mixed success. 300 West Huron is particularly handsome, yet is at its most interesting as a study in the firm's ability to get more out of less.

Certainly the firm's most ambitious project to date, and the one which most fully synthesizes their modernist investigations, is the

Racine Art Museum. Designed in part to help revive the city's decaying downtown, RAM (2003) is at once dramatic, polite, clever, and beautiful. Although it looks like a new building, the museum is actually a repurposing of three existing structures that had been crudely patched together over a 100 year period. The architects were challenged to transform the motley ensemble into a single, coherent facility for the proper display of craft art, and to do so within a budget that would be tight even for residential construction.

They succeeded remarkably. RAM is a striking, though elegantly simple, addition to its otherwise unremarkable Midwestern small-town context. By day, it is a clear, grey limestone box wrapped with an alluring armature of translucent plastic panels. By night, the panels are backlit, rendering the building a glowing apparition. It is truly a vision, this box of light buzzing softly against the darkened downtown around it. And yet it is completely true to Brininstool + Lynch's Chicago-born vision of modernism. The building rationalizes an irrational set of existing structures by unifying them into a single, comprehensible form, then enriches the volume with the simply, but beautifully detailed second skin. The hat trick, of course, is the dramatic night

lighting. But the aluminum-framed panel system is such a handsomely tailored garment that the museum is visually powerful even by day. The architects expose the entire curtain wall assembly, as any good modernist would, offering erotics and passersby (happily, there are many of both; the museum has far exceeded attendance projections, and downtown Racine has more people in it—day and night—than it has seen in decades) an easily understood lesson in visual and budgetary economy.

Maybe Chicago's architectural identity crisis is just a hangover from the post-modernist bender the city went on in the 1990's, culminating in such projects as Roche Dinkeloo's Leo Burnett building or Hammond Beeby Babka's Harold Washington Library, buildings whose very presence called into question the city's commitment to modern architecture. With the arrival of Rem Koolhaas' McCormick Tribune Campus Center at IIT, Wood and Zapata's addition to Soldier Field, and Frank Gehry's Pritzker Pavilion, modernism has marked a dramatic return to the Chicago scene. Exciting a herald as this trio makes, however, none of their can honestly claim the mantle of the Sullivan-Wright-Mies-SOM tradition. The work is simply too flamboyant. Brininstool + Lynch, on the other hand, aspire

to that distinction, and the effort is refreshing in a period when theatrics threaten to overwhelm substance in architecture; their work offers a quieter, considered alternative. The ideas trace a clear, logical path, and they mature with each project. The latest commissions, particularly RAM and the Dunes House #1 (2008), evidence a willingness to push the language in new directions. But if one building glows and the other cantilevers boldly over the landscape, they arise from a tradition forged by Wright and Mies, rather than Starck or Calatrava. Their modernism is not revolutionary, it's evolutionary. It contains the genetic material of Chicago's great tradition, and the seeds of its future.

Reed Kroloff
Dean, School of Architecture
Tulane University

1_____

DESIGN FIRM
Liska + Associates
Chicago, (IL) USA

PROJECT
Brininstool + Lynch
Space Exhibition Catalog

ART DIRECTOR
Steve Liska

DESIGNER
Carole Masse

COPYWRITER
Reed Kroloff

2_____

DESIGN FIRM
maycreate
Chattanooga, (TN) USA

CLIENT
Marlin Nutritional

CREATIVE DIRECTOR
Brian May

ART DIRECTOR, DESIGNER
Grant Little

PHOTOGRAPHER
Tom Farmer

PRINTER
Creative Printing

3_____

DESIGN FIRM
Excelda Manufacturing
Brighton, (MI) USA

PROJECT
Cadillac Catalog

DESIGNER
Melissa McIntosh

3_____

works/san josé

the first quarter-century

DESIGN FIRM
Joe Miller's Company
Santa Clara, (CA) USA
CLIENT
Works/San José
DESIGNER
Joe Miller

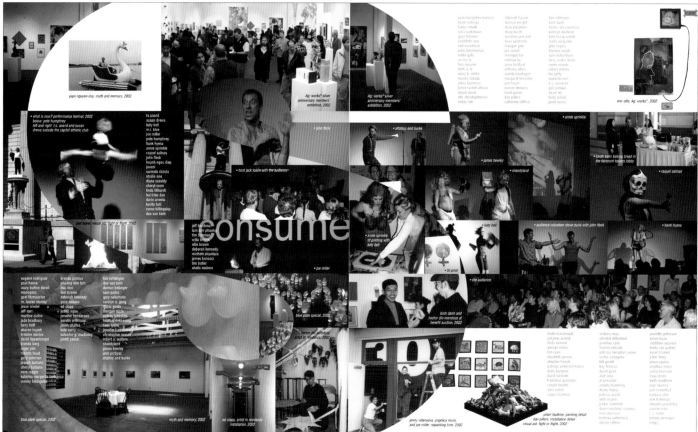

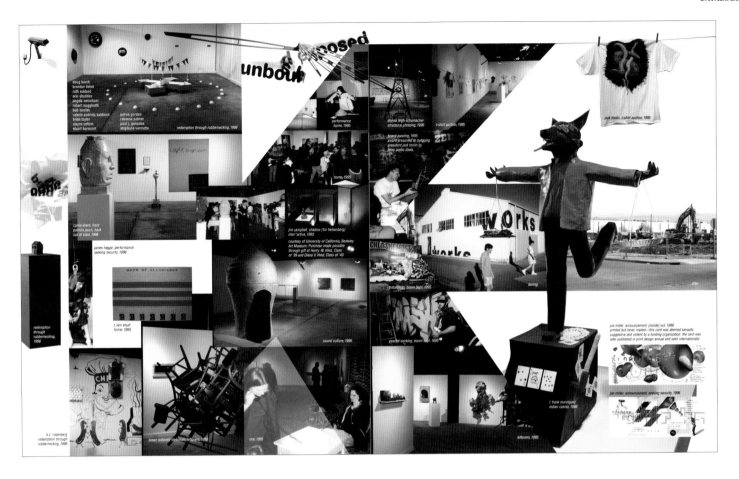

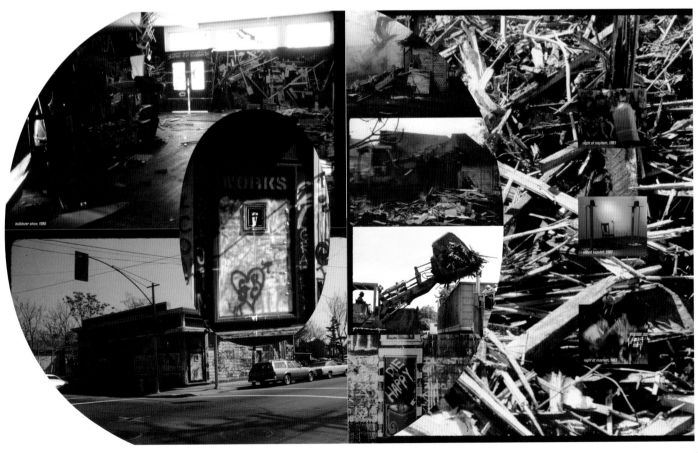

1

1_____

DESIGN FIRM
Excelda Manufacturing
Brighton, (MI) USA
PROJECT
XtremeScents
DESIGNER
Melissa McIntosh

2_____

DESIGN FIRM
Rule29 Creative
Geneva, (IL) USA
PROJECT
Tour Edge Catalog 2006
ART DIRECTOR
Justin Ahrens
DESIGNERS
Justin Ahrens, Josh Jensen
PHOTOGRAPHER
Brian MacDonald

DESIGN FIRM
 Studio D
 Fort Wayne, (IN) USA
PROJECT
 RCI Catalog
CREATIVE DIRECTOR
 Michael Earl
ART DIRECTORS
 Holly Decker,
 Jeremy Culp
CREATIVE
 Lassiter Advertising

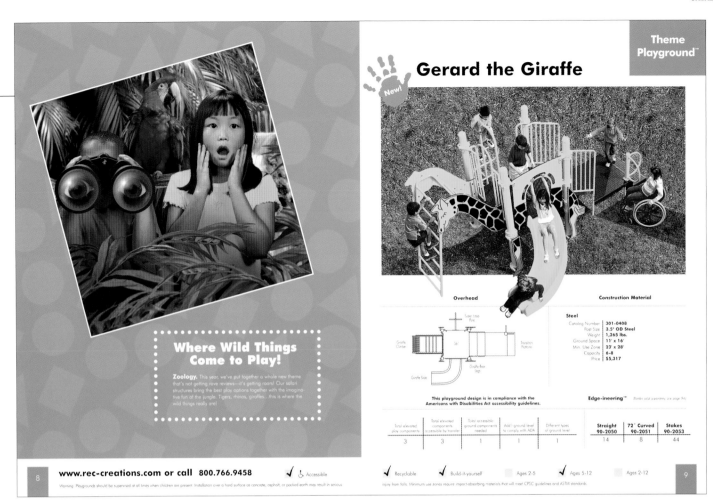

Where Wild Things Come to Play!

Zoology. This year, we've put together a whole new theme that's not getting rave reviews—it's getting roars! Our safari structures bring the best play options together with the imaginative fun of the jungle. Tigers, rhinos, giraffes...this is where the wild things really are!

Theme Playground™

Gerard the Giraffe

New!

Overhead

Construction Material

Steel	
Catalog Number	301-0408
Post Size	3.5" OD Steel
Weight	1,265 lbs.
Ground Space	11' x 16'
Min. Use Zone	23' x 28'
Capacity	6-8
Price	$55,317

This playground design is in compliance with the Americans with Disabilities Act accessibility guidelines.

Edge-ineering™

Total elevated play components	Total elevated components accessible by transfer	Total accessible ground components needed	Add'l ground level to comply with ADA	Different types of ground level		Straight 90-2050	72" Curved 90-2051	Stakes 90-2053
3	3	1	1	1		14	8	44

www.rec-creations.com or call 800.766.9458

✓ ♿ Accessible

✓ Recyclable ✓ Build-it-yourself ☐ Ages 2-5 ✓ Ages 5-12 ☐ Ages 2-12

Warning: Playgrounds should be supervised at all times when children are present. Installation over a hard surface as concrete, asphalt, or packed earth may result in serious injury from falls. Minimum use zones require impact-absorbing materials that will meet CPSC guidelines and ASTM standards.

8 | 9

PlayDAZE™

Gilbert Marcia's Park

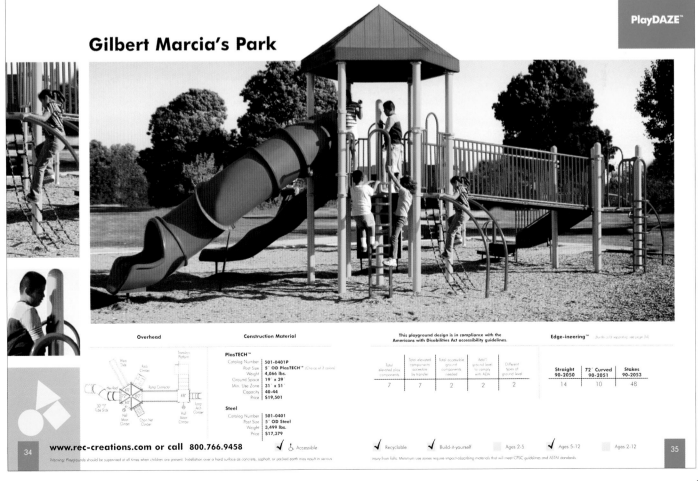

Overhead

Construction Material

PlasTECH™	
Catalog Number	501-0401P
Post Size	5" OD PlasTECH™ (Choice of 3 colors)
Weight	4,066 lbs.
Ground Space	19' x 39'
Min. Use Zone	31' x 51'
Capacity	40-44
Price	$19,501

Steel	
Catalog Number	501-0401
Post Size	5" OD Steel
Weight	3,499 lbs.
Price	$17,379

This playground design is in compliance with the Americans with Disabilities Act accessibility guidelines.

Edge-ineering™

Total elevated play components	Total elevated components accessible by transfer	Total accessible ground components needed	Add'l ground level to comply with ADA	Different types of ground level		Straight 90-2050	72" Curved 90-2051	Stakes 90-2053
7	7	2	2	2		14	10	48

www.rec-creations.com or call 800.766.9458

✓ ♿ Accessible

✓ Recyclable ✓ Build-it-yourself ☐ Ages 2-5 ✓ Ages 5-12 ☐ Ages 2-12

Warning: Playgrounds should be supervised at all times when children are present. Installation over a hard surface as concrete, asphalt, or packed earth may result in serious injury from falls. Minimum use zones require impact-absorbing materials that will meet CPSC guidelines and ASTM standards.

34 | 35

DESIGN FIRM
Riordon
Oakville, (Ontario) Canada
CLIENT
The John Forsyth Shirt Company Limited
ART DIRECTOR
Shirley Riordon
DESIGNERS
Shirley Riordon, Sharon Pece
PHOTOGRAPHER
Grimes Photography

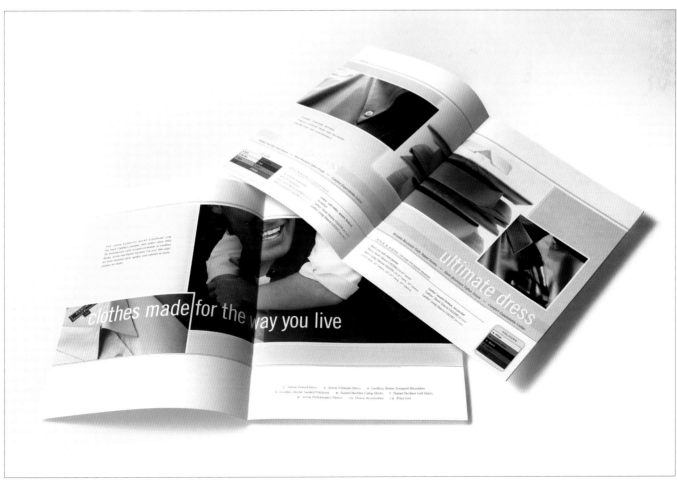

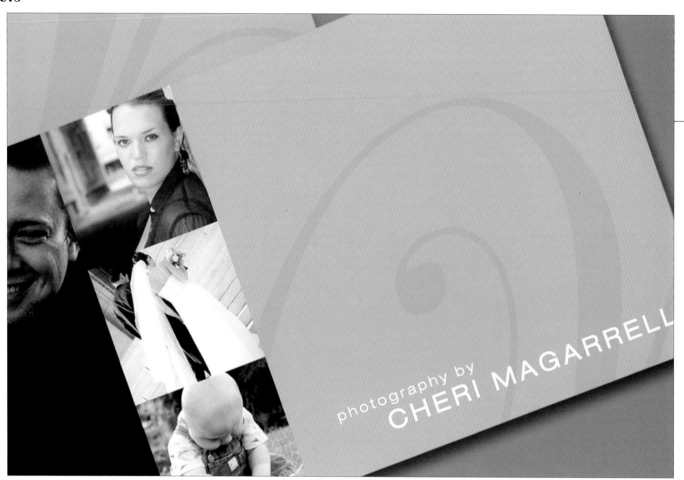

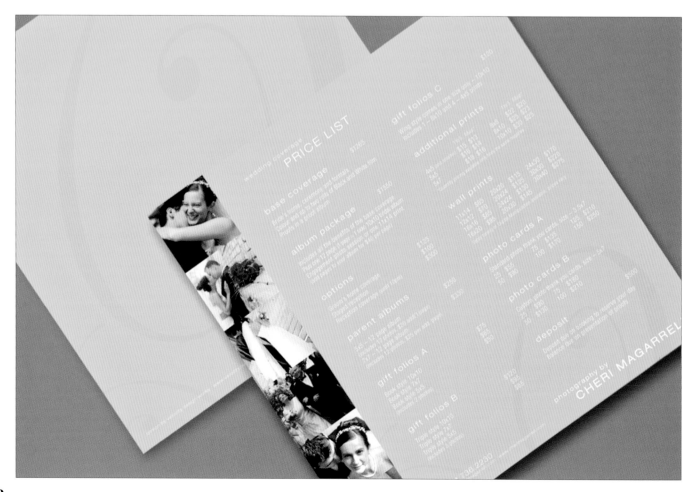

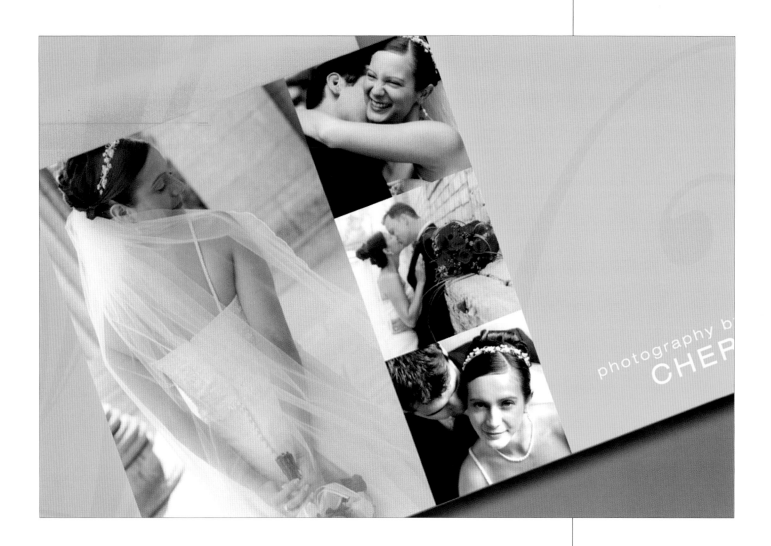

DESIGN FIRM
Velocity Design Works
Winnipeg, (Manitoba) Canada
PROJECT
Cheri Magarrell
CREATIVE DIRECTOR, ART DIRECTOR
Lasha Orzechowski
DESIGNERS
Lasha Orzechowsk, Krista Kline
PHOTOGRAPHER
Cheri Magarrell

DESIGN FIRM
Riordon
Oakville, (Ontario) Canada

CLIENT
Canadian Linen and Uniform Services

ART DIRECTOR
Ric Riordon

DESIGNER
Dawn Charney

DIBBERN

FINE BONE CHINA
MADE IN GERMANY

2005/2006

DESIGN FIRM
Haase & Knels
Bremen, Germany
CLIENT
B.T. Dibbern GmbH & Co.
DESIGNERS
Sibylle Haase,
Hans Hansen,
Katja Hirschfelder

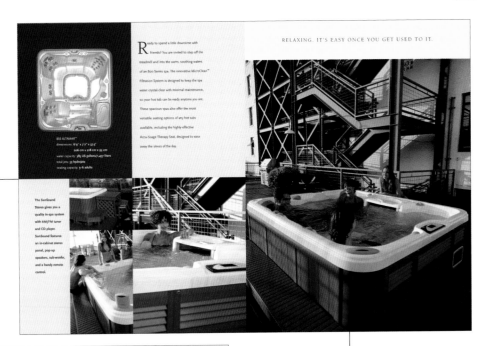

RELAXING. IT'S EASY ONCE YOU GET USED TO IT.

Ready to spend a little downtime with friends? You are invited to step off the treadmill and into the warm, soothing waters of an 800 Series spa. The innovative MicroClean™ Filtration System is designed to keep the spa water crystal-clear with minimal maintenance, so your hot tub can be ready anytime you are. These spacious spas also offer the most versatile seating options of any hot tubs available, including the highly effective Accu-Ssage Therapy Seat, designed to ease away the stress of the day.

850 ALTAMAR®
dimensions: 6'5" x 7'3" x 37.5"
206 cm x 218 cm x 95 cm
water capacity: 385 US gallons/1,457 liters
total jets: 53 hydrojets
seating capacity: 5-6 adults

The SunSound Stereo gives you a quality in-spa system with AM/FM tuner and CD player. SunSound features an in-cabinet stereo panel, pop-up speakers, sub-woofer, and a handy remote control.

For centuries, people have recognized the rejuvenating, healing powers of warm water. Today, Sundance Spas takes an innovative approach to the art of warm water healing, or hydrotherapy. The three elements of hydrotherapy are heat, buoyancy and massage. The water's heat dilates blood vessels to increase blood flow, healing sore or damaged tissue, and easing movement, which is important for relieving the symptoms of arthritis and back pain. Buoyancy reduces body weight by 90 percent, alleviating pressure on joints and muscles. The jet-driven force of the water massages the muscles, and further stimulates healthy circulation to aid digestion and improve skin tone.

Hydrotherapy can promote the production of endorphins, the "feel-good" neurotransmitters known to reduce the intensity of pain and contribute to a sense of overall well-being. Since hydrotherapy is a natural way to relax, it can also set you up for a good night's sleep.

DAILY HYDROMASSAGE THERAPY.
FEELING GOOD BECOMES A HABIT.

It has been estimated that 75 to 90 percent of visits to physicians for primary care are related to stress.* Regular hydrotherapy can be an effective way to help relieve the symptoms of stress. The strategically placed jets, advanced heating systems and ergonomically correct seating in every Sundance spa create an ideal place for practicing a variety of calming, stress-reducing routines.
*Source: The American Institute of Stress

880 MAXXUS™
dimensions: 7'6" x 9'5" x 41.5"
229 cm x 229 cm x 105 cm
water capacity: 580 US gallons/2,196 liters
total jets: 55 hydrojets
seating capacity: 6-7 adults

AN EVERYDAY REMINDER OF WHAT
IT'S LIKE TO BE ON VACATION.

As roomy as the Maxxus is, you can feel like it's built for you alone by adjusting the massage controllers, accessible from every seat in the spa. You can also operate the AquaTerrace waterfall and its lights, even when you're not using the jets.

The precedent-setting Maxxus continues to live up to its reputation as the most superbly engineered hot tub in the world. Simply the best of everything is here: dual AquaTerrace waterfalls, with an adjustable water stream and colored lights glowing from within; a full-body lounge seat; Euro Jets custom-designed for the neck; a footmount accessible from all points in the spa; and our famous Accu-Ssage Therapy Seat. A total of 55 jets are arranged to maximize your choice of massage variations.

The AquaTerrace™ water feature brings the naturally soothing sights and sound of water to your backyard.

DESIGN FIRM
Kevershan Testerman
San Diego, (CA) USA
CLIENT
Sundance Spas
DESIGNERS
Patty Kevershan,
Patti Testerman,
Lynn Fleschutz

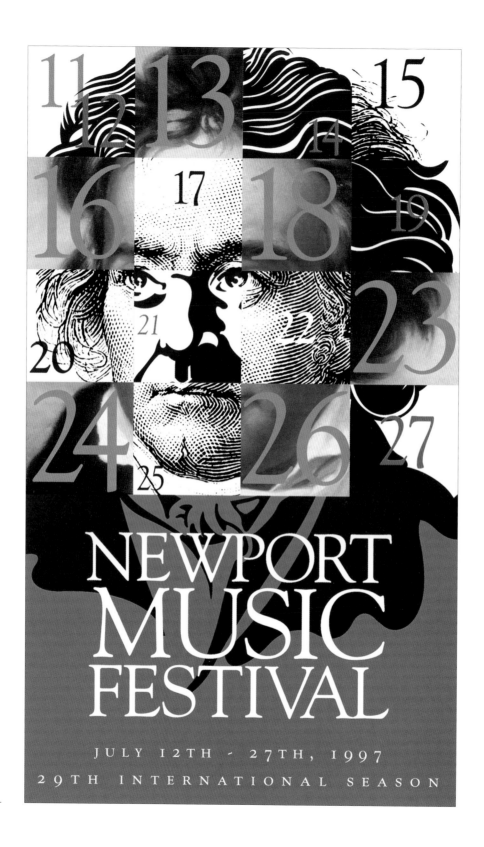

1_____

1_____
DESIGN FIRM
 Tom Fowler, Inc.
 Norwalk, (CT) USA
CLIENT
 Newport Music Festival
ART DIRECTOR, DESIGNER, ILLUSTRATOR
 Tom Fowler

2_____

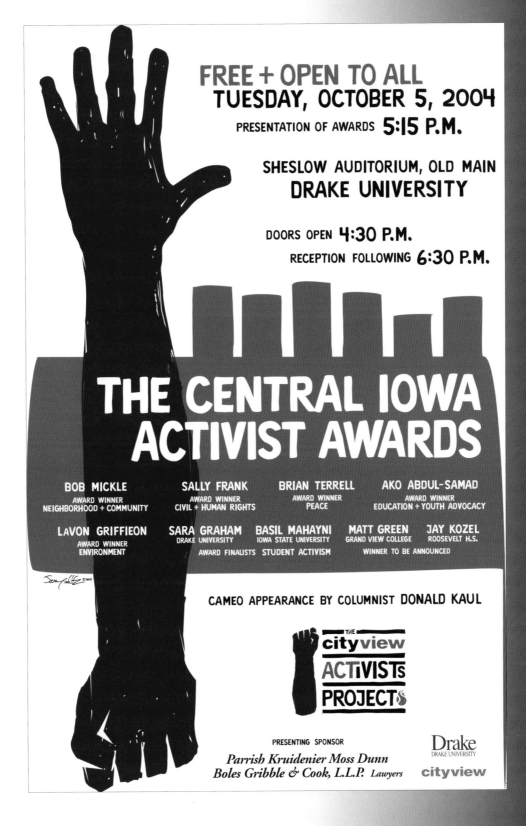

2_____
DESIGN FIRM
Jeremy Schultz
West Des Moines, (IA) USA
PROJECT
Cityview Activists Poster
DESIGNER
Jeremy Schultz

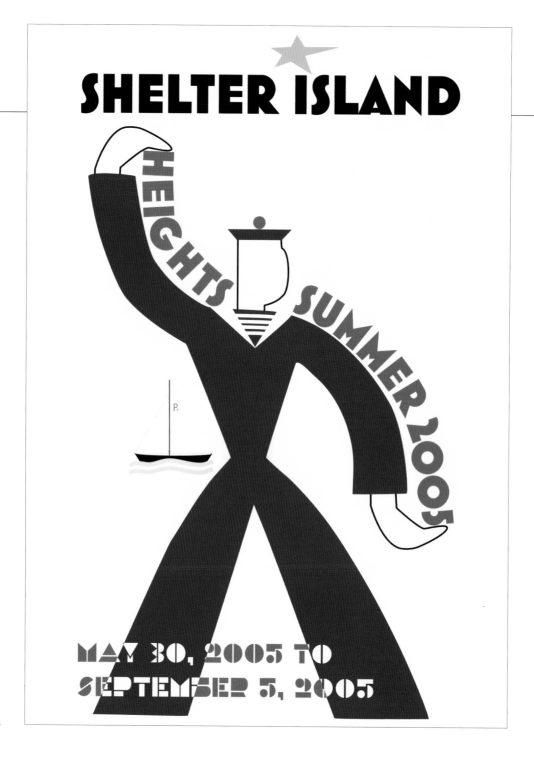

1

1_____
DESIGN FIRM
Acme Communications, Inc.
New York, (NY) USA
PROJECT
Shelter Island Poster
DESIGNER
Kiki Boucher

ric williams has a secret...
the secret book of god

www.DaltonPublishing.com

2_____

2_____
DESIGN FIRM
TAMAR Graphics
Waltham, (MA) USA
CLIENT
Dalton Publishing
DESIGNER
Tamar Wallace
PHOTOGRAPHER
Sharon Dominick

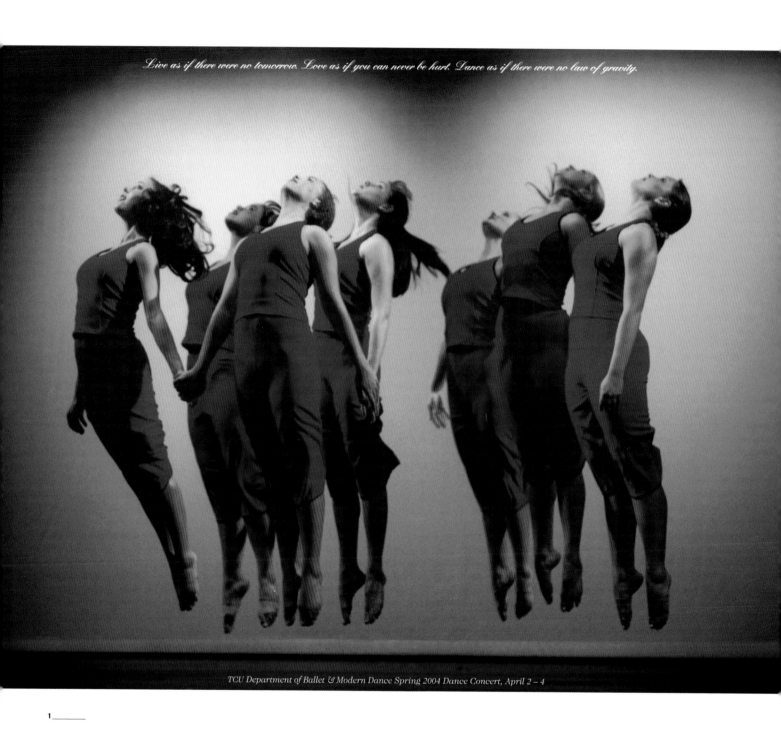

Live as if there were no tomorrow. Love as if you can never be hurt. Dance as if there were no law of gravity.

TCU Department of Ballet & Modern Dance Spring 2004 Dance Concert, April 2 – 4

1 _____

1 _____
DESIGN FIRM
Atomic Design
Crowley, (TX) USA
CLIENT
Ellen Shelton,
TCU Department of
Ballet & Modern Dance
DESIGNER, COPYWRITER
Lewis Glaser
PHOTOGRAPHER
Linda Kaye

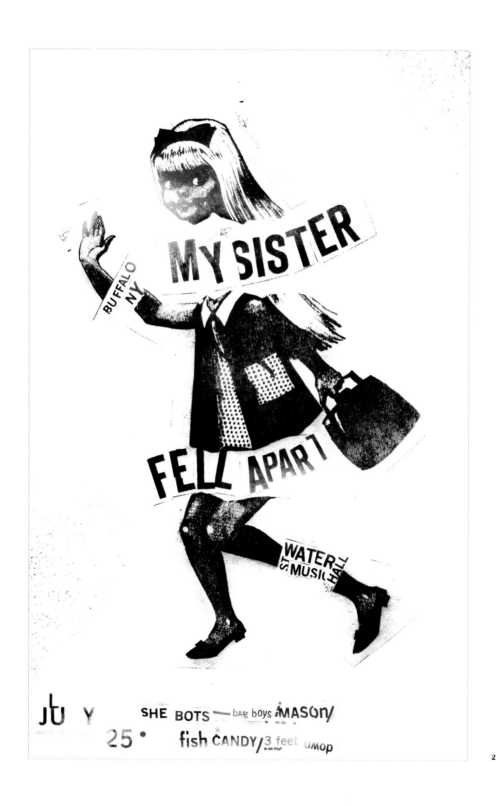

2_____
DESIGN FIRM
A3 Design
Charlotte, (NC) USA
PROJECT
My Sister Fell Apart
DESIGNERS
Alan Altman,
Amanda Altman

305

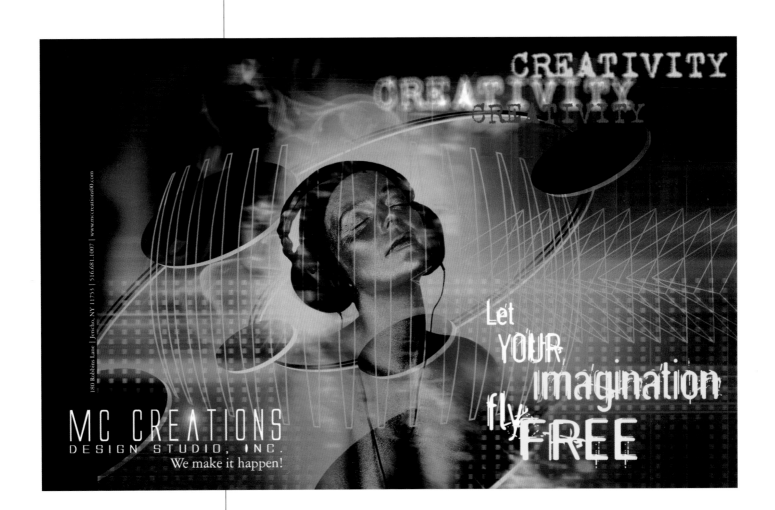

1_____

1_____
DESIGN FIRM
MC Creations Design Studio, Inc.
Hicksville, (NY) USA
DESIGNERS
Michael Cali,
Cynthia Morillo

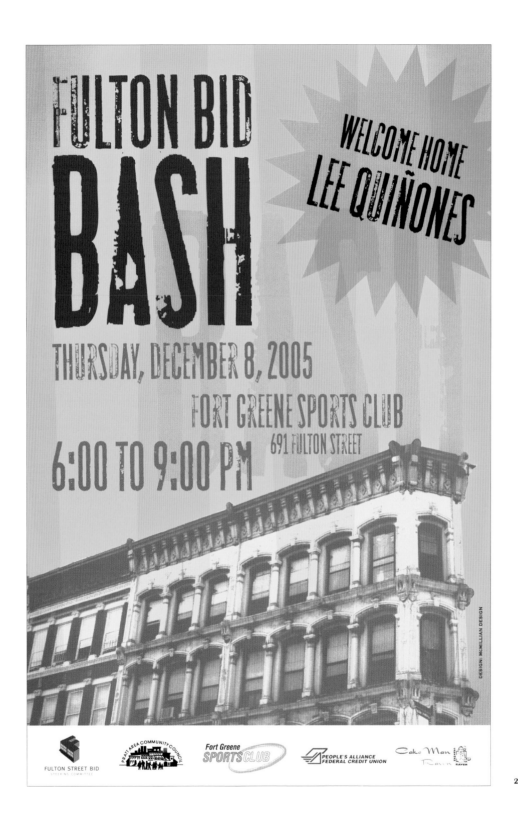

2_____
DESIGN FIRM
McMillian Design
 Brooklyn, (NY) USA
CLIENT
 Fulton Street BID
ART DIRECTOR, DESIGNER
 William McMillian

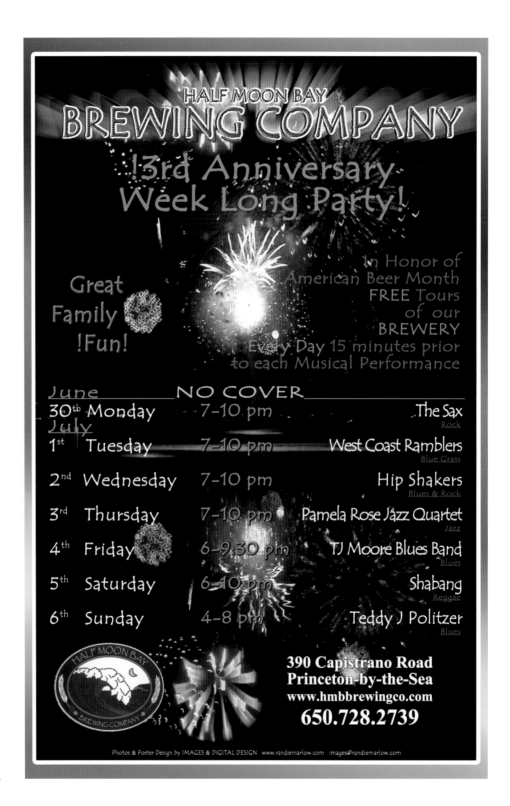

1

DESIGN FIRM
Images & Digital Design
Half Moon Bay, (CA) USA

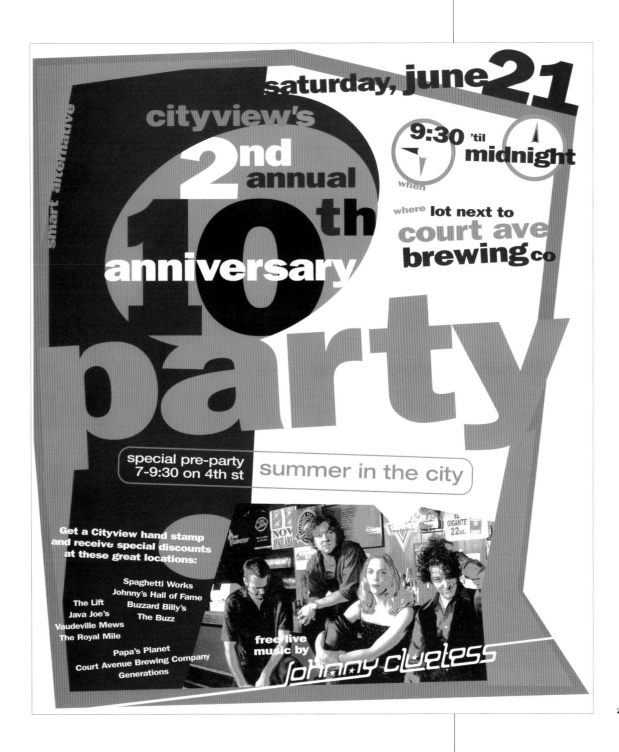

2

2_____
DESIGN FIRM
Jeremy Schultz
West Des Moines, (IA) USA
PROJECT
Cityview 11th Anniversary Poster
DESIGNER
Jeremy Schultz

OPEN SOON

cole haan

marc jacobs

stuart weitzman

donald j pliner

charles david

cordani

daniblack

isaac mizrahi

andre assous

prevata

michael kors

magnolia

rangoni

sesto meucci

ellen tracy

EMBELLISH

DESIGN FIRM
maycreate
Chattanooga, (TN) USA
CLIENT
Embellish Shoes
CREATIVE DIRECTOR, ART DIRECTOR,
DESIGNER, COPYWRITER, PHOTOGRAPHER
Brian May

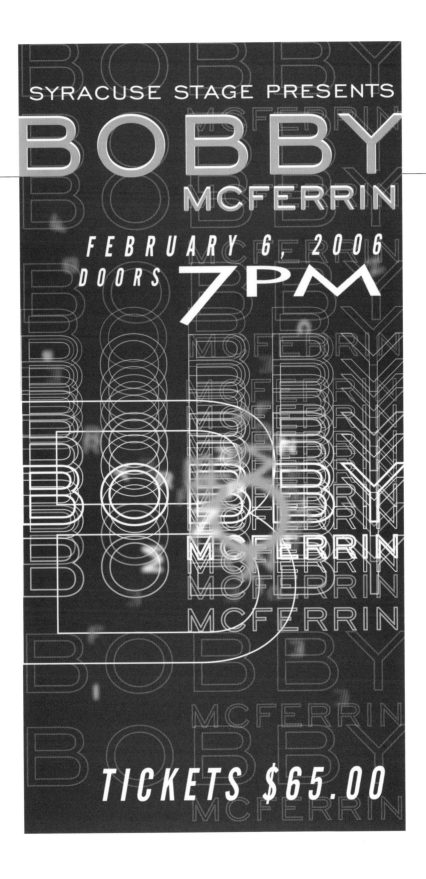

2_____
DESIGN FIRM
EMartinDesigns
Liverpool, (NY) USA
PROJECT
Bobby McFerrin
Concert Poster
DESIGNER
Eric Martin

1_____

1_____
DESIGN FIRM
Wet Paper Bag Visual
Communication
Crowley, (TX) USA
CLIENT
Ellen Shelton, Chair,
TCU Department of
Ballet & Modern Dance
ART DIRECTOR, DESIGNER,
TYPOGRAPHER, COPYWRITER
Lewis Glaser
PHOTOGRAPHER
Richard Lane

2_____

DESIGN FIRM
At First Sight
Ormond, Australia

PROJECT
Career Advisers' Seminar Poster

DESIGNERS
Barry Selleck,
Olivia Brown

1 _____

1 _____
DESIGN FIRM
Jeremy Schultz
West Des Moines, (IA) USA
PROJECT
Cityview 12th Anniversary Poster
DESIGNER
Jeremy Schultz

SYNTH
THESIS
DIS
TRIBUT
TION

SYNTHESIS AND DISTRIBUTION: EXPERIMENTS IN COLLABORATION

CURATED BY WILL PAPPENHEIMER, RON JANOWICH AND MERIJN VAN DER HEIJDEN
PACE UNIVERSITY ART GALLERIES

CHARLIE AHEARN AND COLETTE

JULIE ANDREYEV AND VJ FLEET

MIA BROWNELL AND MARTIN KRUCK

MARY CARLSON, JEANNE SILVERTHORNE
AND MONICA DE LA TORRE

BARBARA CIUREJ AND LINDSAY LOCHMAN

LYNN CAZABON AND HASAN ELAHI

ART CLAY AND GUNTER HEINZ

ANGIE DRAKOPOULOS AND DANIEL HILL

LAUREN GARBER, TATE BUNKER
AND NEIL ELLIOTT

ROBIN HILL AND STEPHEN KALTENBACH WITH
LAURIE SAN MARTIN AND SAMUEL NICHOLS

LAS HERMANAS IGLESIAS

LAURA LISBON AND SUZANNE MAURA SILVER

KRISTIN LUCAS AND FACT

MICHAEL MANDIBERG AND JULIE STEINMETZ

JILLIAN MCDONALD, KELTY MCKINNON
AND BECKLEY ROBERTS

JOHN MILLER AND TAKUJI KOGO

WILL PAPPENHEIMER AND GREGGORY ULMER

SAL RANDOLPH AND GLOWLAB

AURA ROSENBERG, JANE DICKSON
AND "WHO AM I?" ARTISTS

ROBIN TEWES AND MARK TANSEY

MERIJN VAN DER HEIJDEN AND RON JANOWICH

2_____

2_____
DESIGN FIRM
Connie Hwang Design
Gainesville, (FL) USA
PROJECT
Synthesis and Distribution
Exhibition Poster
DESIGNER
Connie Hwang

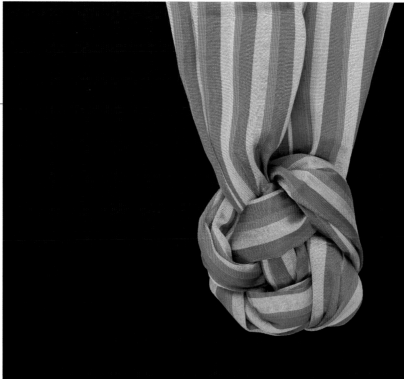

R E B O Z O S
MICHOACANOS

Exposición

Del 1 al 30 de septiembre de 2003
Casa de las Artesanías

Una extensa colección de rebozos de todas las regiones de Michoacán.
Piezas elaboradas artesanalmente por manos michoacanas.
Disfruta estas prendas que son un mosaico de sentidos, dibujos, hilos y colores,
cada uno representa una expresión distinta de nuestras tradiciones.

Consume lo nuestro....

Septiembre, mes de rebozos michoacanos

1

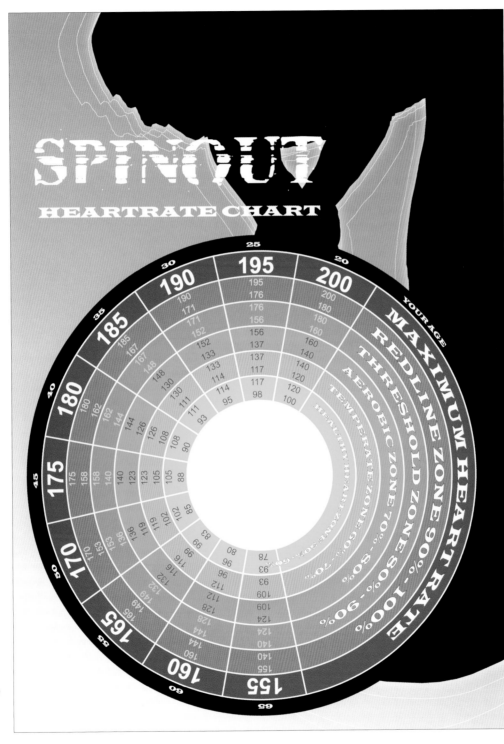

1_____
DESIGN FIRM
**Caracol
Consultores SC**
Morelia, Mexico
CLIENT
Casa de las Artesanias
de Michoacán, Mexico
ART DIRECTOR
Luis Jaime Lara Perea
DESIGNERS
Luis Jaime Lara,
Myriam Zavala
PHOTOGRAPHER
Luis Jaime Lara

2_____
DESIGN FIRM
At First Sight
Ormond, Australia
PROJECT
Spinout Poster
DESIGNERS
Barry Selleck,
Olivia Brown

2_____

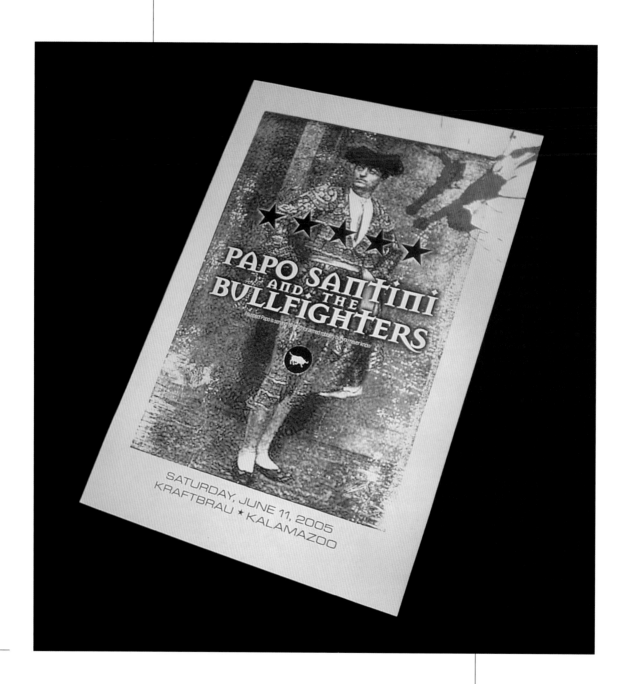

1_____

1_____
DESIGN FIRM
John Wingard Design
Honolulu, (HI) USA
CLIENT
Hewg Productions, Inc.
DESIGNER
John Wingard

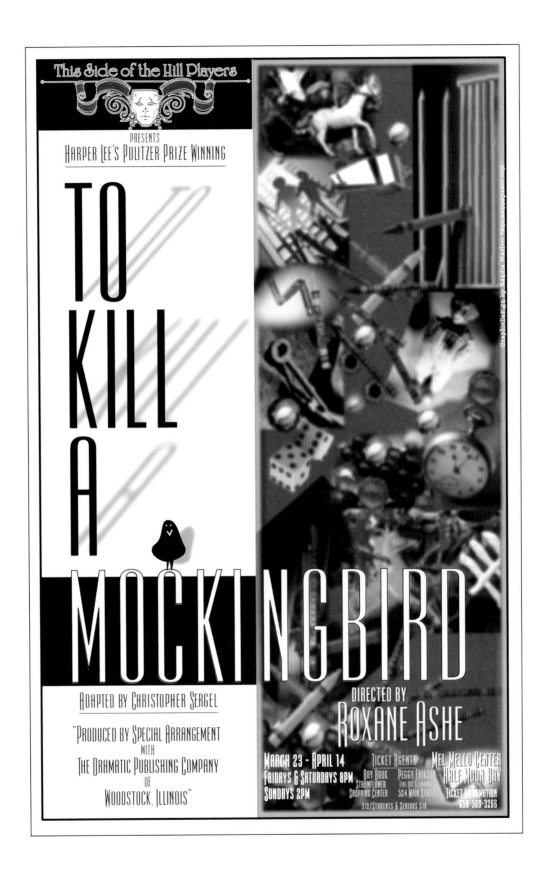

2
DESIGN FIRM
Images & Digital Design
Half Moon Bay, (CA) USA

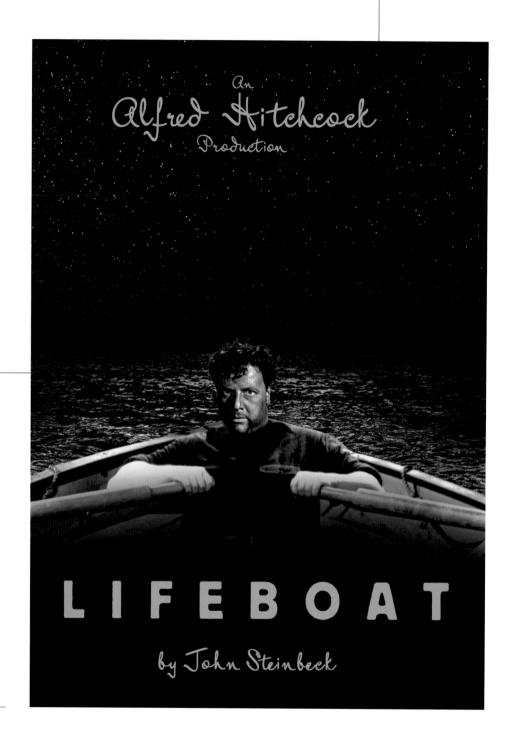

1_____

1_____
DESIGN FIRM
 30sixty Advertising+Design
 Los Angeles, (CA) USA
CLIENT
 20th Century Fox
 Home Entertainment International
CREATIVE DIRECTOR
 Henry Vizcarra
ART DIRECTOR
 David Fuscellaro

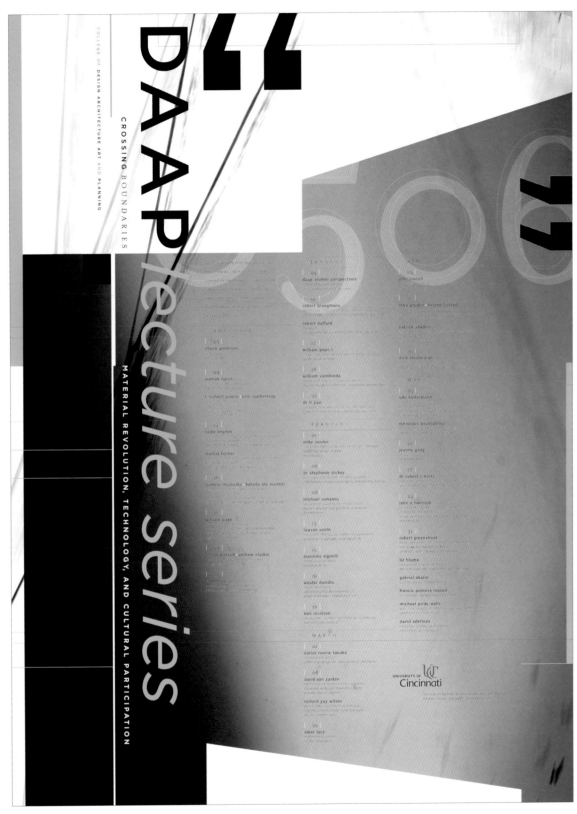

2_____

DESIGN FIRM
kristincullendesign
Cincinnati, (OH) USA

CLIENT
University of Cincinnati,
College of Design, Architecture,
Art, and Planning

DESIGNER
Kristin Cullen

At left, the 1959 Varsity Basketball team prepares for a game with Joe Girard leading the team onto the court.
The 1951 football team, at right, works on its blocking skills.

the **Fabulous**

Bob Consadine and Tom Philo, at right, smile their approval of the sign, after SMA won the Baseball Championship of the Northern Conference for 1955. Below, tumblers Harold Brooks, Robert Rheinlander, Richard O'Brien and James Counter show their stuff.

S.M.A. Conference CHAMPS

1950s

1

1_____
DESIGN FIRM
Lehman Graphic Arts
Queensbury, (NY) USA
PROJECT
LGA Poster
DESIGNER
Lisa M. Lehman

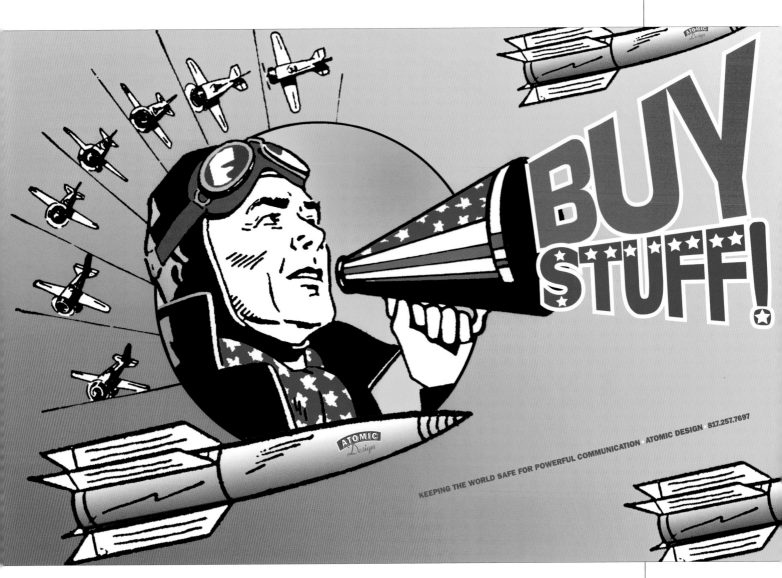

2_____
DESIGN FIRM
 Atomic Design
 Crowley, (TX) USA
CLIENT
 Atomic Design
DESIGNER, COPYWRITER
 Lewis Glaser

331

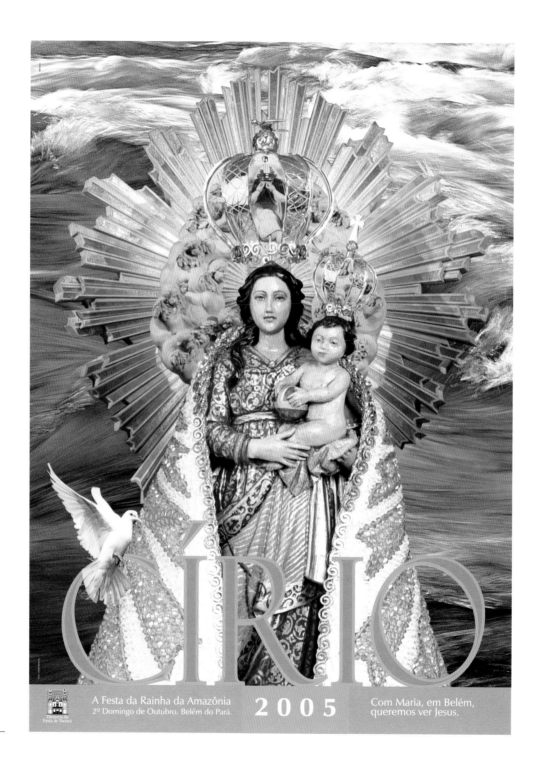

1_____

1_____
DESIGN FIRM
Mendes Publicidade
Belém, Brazil
PROJECT
Cartaz do Cirio 2005
DESIGNERS
Oswaldo Mendes,
Maria Alice Penna,
Walda Marques

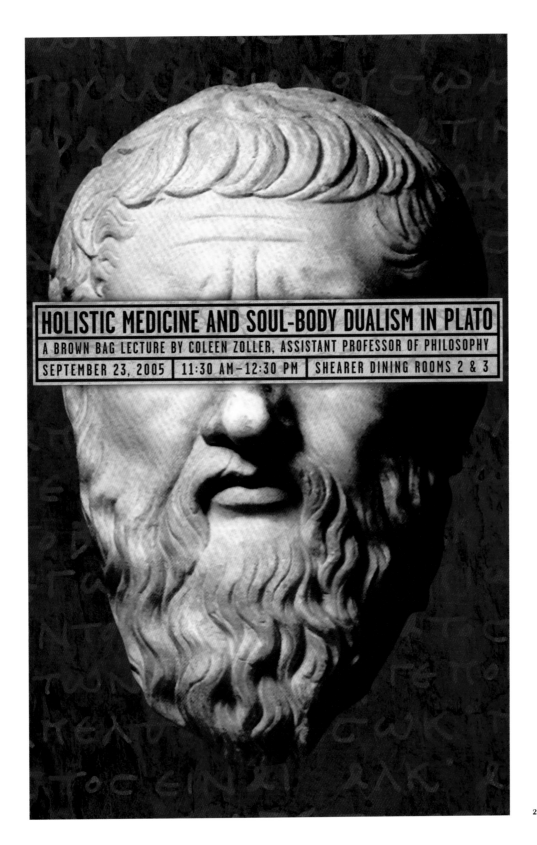

2_____

2_____
DESIGN FIRM
MFDI
Selinsgrove, (PA) USA
PROJECT
Plato Poster
DESIGNER
Mark Fertig

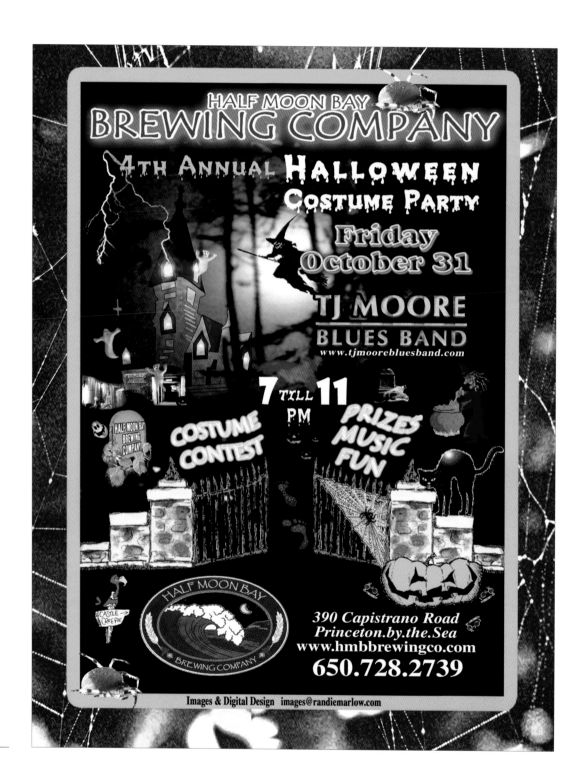

1

1
DESIGN FIRM
Images & Digital Design
Half Moon Bay, (CA) USA

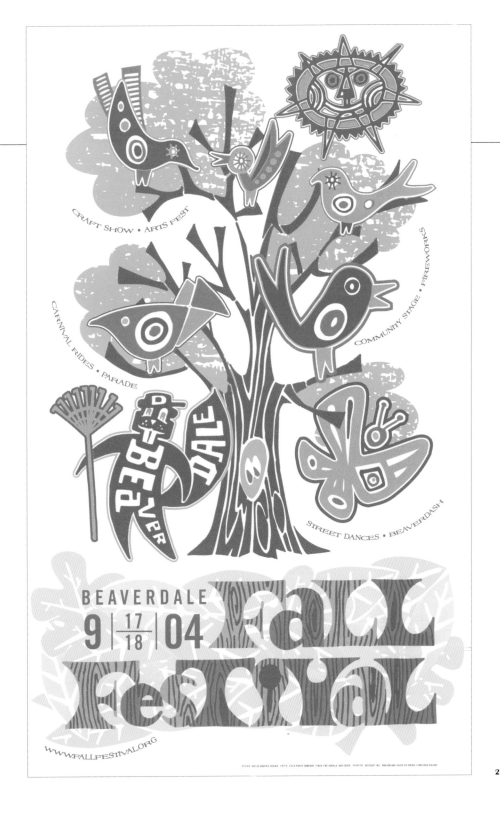

2_____
DESIGN FIRM
Sayles Graphic Design
Des Moines, (IA) USA
PROJECT
Beaverdale Fall Festival
DESIGNER, ILLUSTRATOR
John Sayles

1 _____
DESIGN FIRM
John Wingard Design
Honolulu, (HI) USA
CLIENT
Kamaka Hawaii
ART DIRECTOR, DESIGNER
John Wingard
PHOTOGRAPHER
Bud Muth Photography

WE HOLD THESE TRUTHS
TO BE SELF-EVIDENT
THAT
ALL MEN ARE CREATED EQUAL
THAT THEY ARE ENDOWED
BY THEIR CREATOR
WITH
CERTAIN UNALIENABLE RIGHTS
THAT
AMONG THESE ARE LIFE, LIBERTY
AND THE PURSUIT OF HAPPINESS.

2

2

DESIGN FIRM
 Atomic Design
 Crowley, (TX) USA
CLIENT
 Wet Paper Bag Graphic Design
DESIGNER
 Lewis Glaser
COPYWRITER
 Thomas Jefferson

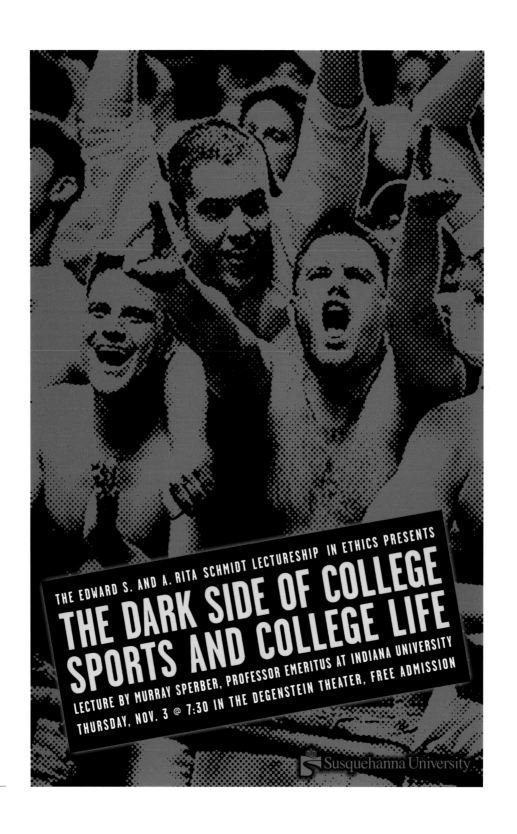

1

1
DESIGN FIRM
MFDI
Selinsgrove, (PA) USA
PROJECT
The Dark Side Poster
DESIGNER
Mark Fertig

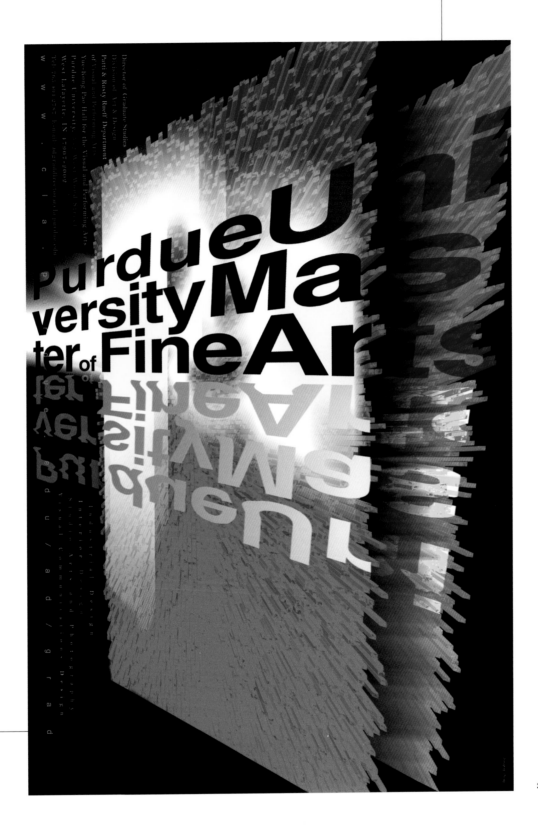

2_____
DESIGN FIRM
 Purdue University
 West Lafayette, (IN) USA
PROJECT
 Master of Fine Arts 2006
DESIGNER, PHOTOGRAPHER, ILLUSTRATOR
 Li Zhang

343

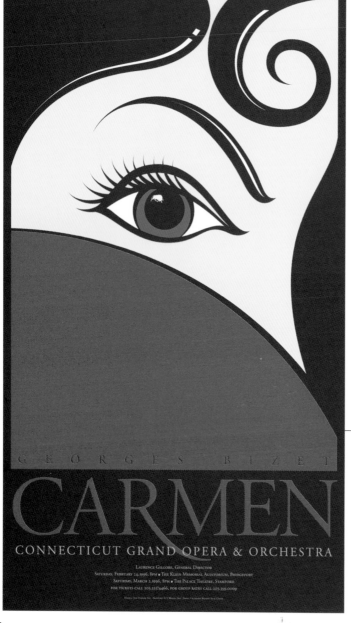

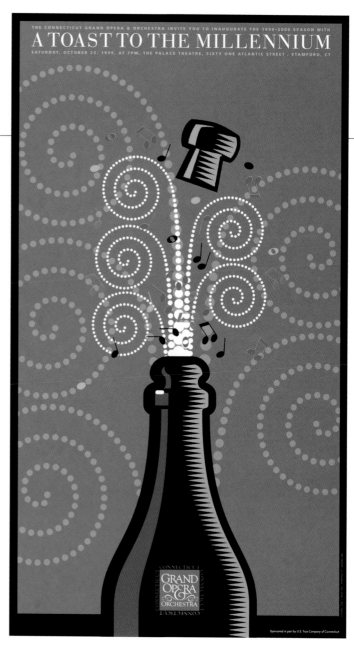

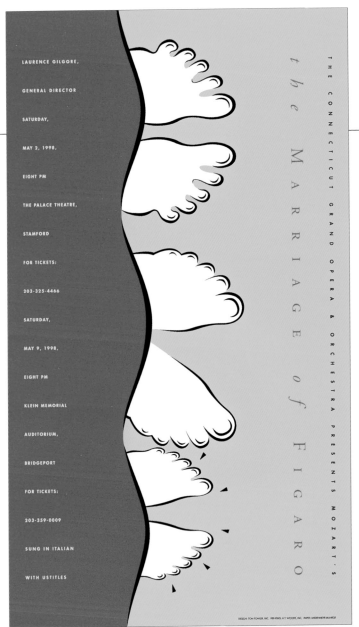

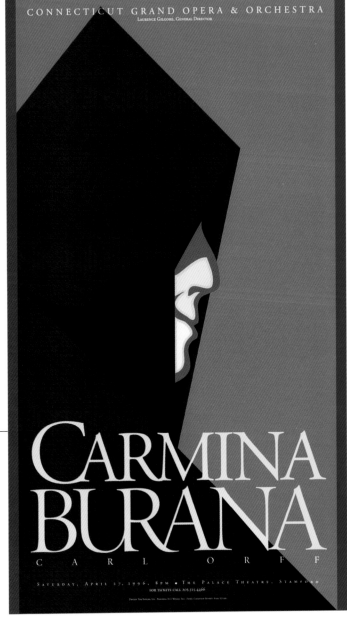

DESIGN FIRM
Tom Fowler, Inc.
Norwalk, (CT) USA

CLIENT
Connecticut Grand Opera & Orchestra

ART DIRECTOR, DESIGNER, ILLUSTRATOR
Tom Fowler

PRINTER
H.T. Woods

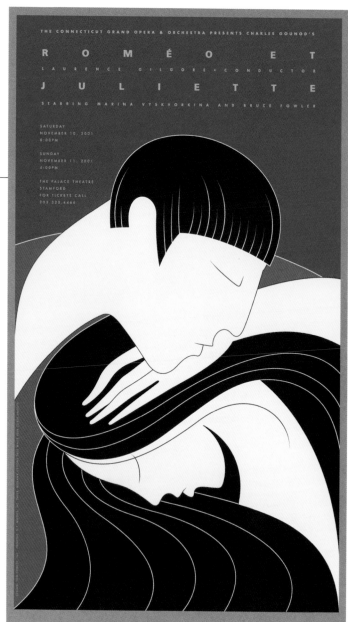

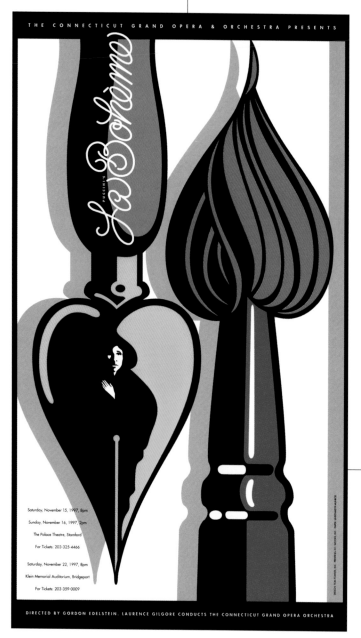

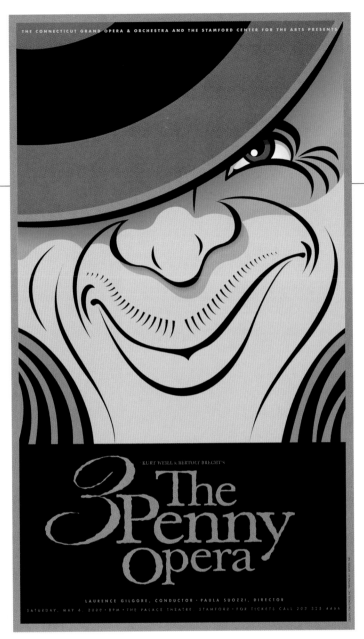

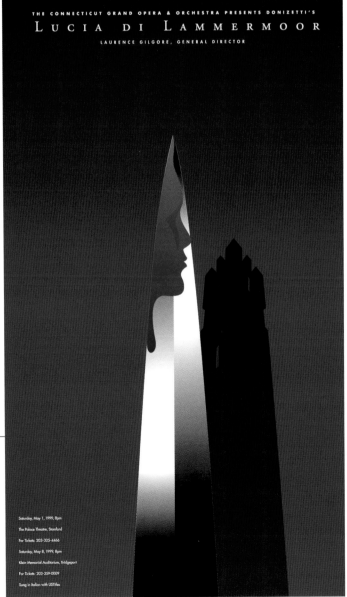

DESIGN FIRM
Tom Fowler, Inc.
Norwalk, (CT) USA

CLIENT
Connecticut Grand Opera & Orchestra

ART DIRECTOR, DESIGNER, ILLUSTRATOR
Tom Fowler

PRINTER
H.T. Woods

1_____
DESIGN FIRM
Engrafik
Oslo, Norway
CLIENT
Kisses on Platform 2
CREATIVE DIRECTOR, DESIGNER
Reinert Korsbøen

TYPE DESIGN

A Tribute To Bodoni

"Studying typography is not only exhilarating but fundamentally imperative for any graphic designer."
~Eric R. Martin

2_____

2_____
DESIGN FIRM
EMartinDesigns
Liverpool, (NY) USA
PROJECT
A Tribute to Bodoni
DESIGNER
Eric Martin

349

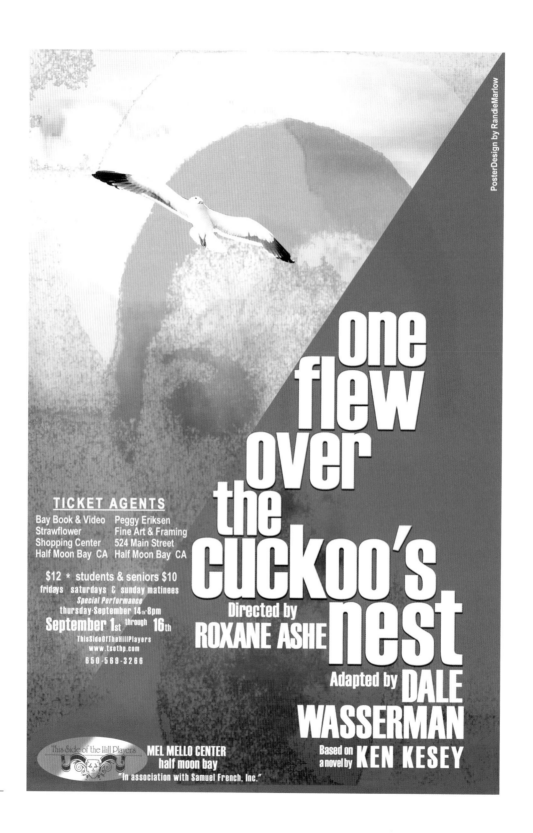

1

1
DESIGN FIRM
Images & Digital Design
Half Moon Bay, (CA) USA

2
DESIGN FIRM
Terri DeVore
Hewitt, (TX) USA
PROJECT
Mad Hatter Poster
DESIGNER
Terri DeVore

355

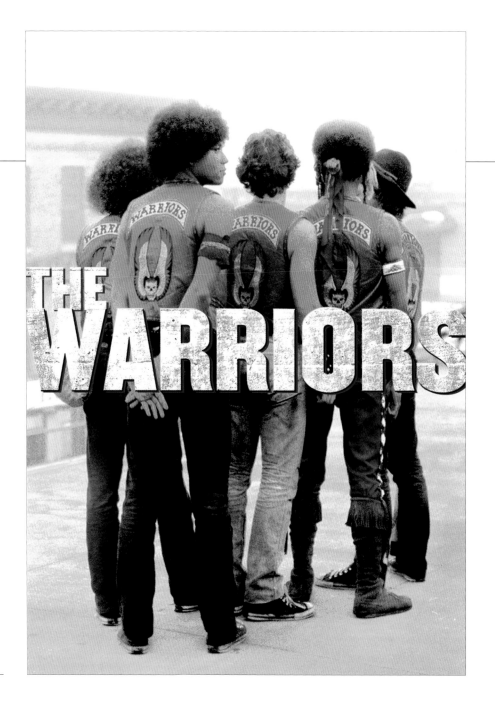

1_____

1_____
DESIGN FIRM
30sixty Advertising+Design
Los Angeles, (CA) USA
CLIENT
Paramount
Home Entertainment
CREATIVE DIRECTOR
Henry Vizcarra
ART DIRECTOR
David Fuscellaro

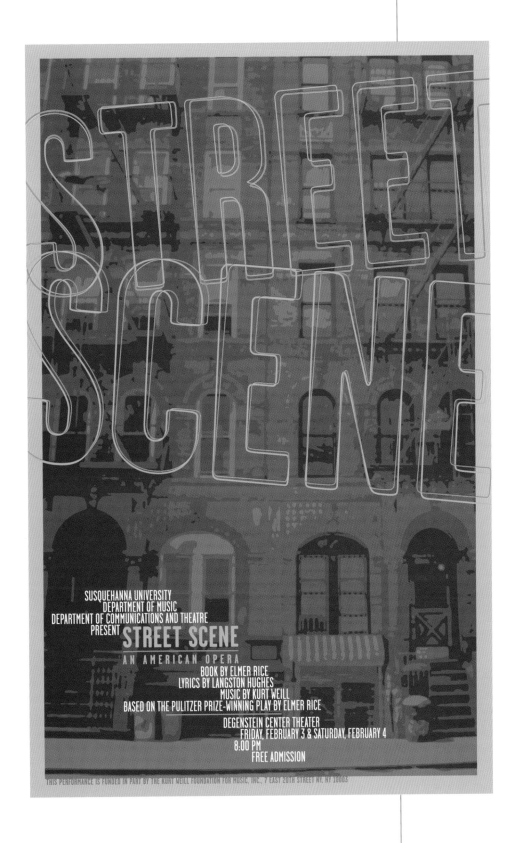

2_____
DESIGN FIRM
 MFDI
 Selinsgrove, (PA) USA
PROJECT
 Street Scene Poster
DESIGNER
 Mark Fertig

357

1_____

1_____
DESIGN FIRM
The Bubble Process
Brooklyn, (NY) USA
DESIGNERS
Nicholas Rezabek,
Sean Higgins

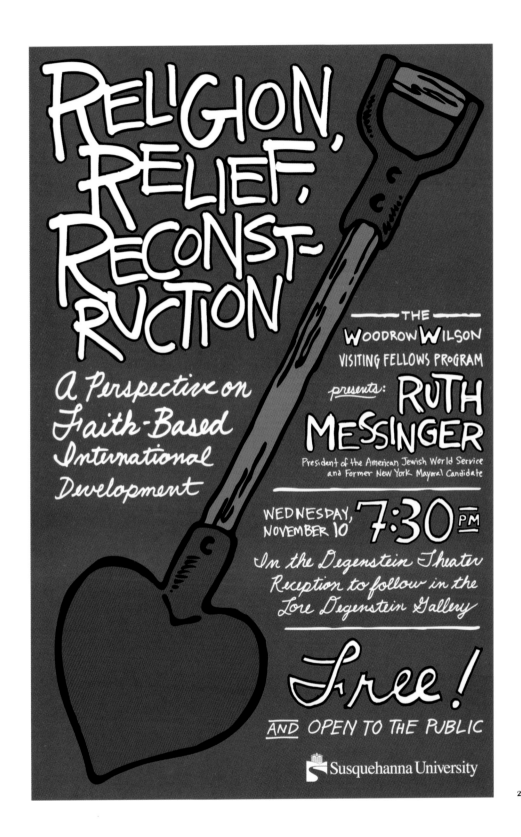

2_____
DESIGN FIRM
MFDI
Selinsgrove, (PA) USA
PROJECT
Wilson Lecture Poster
DESIGNER
Mark Fertig

The brand identity industry has undergone a dramatic change in the past few decades. ID designers have transitioned from providing clients → with their visual identity to becoming overall brand specialists — a task that goes well beyond putting together comprehensive identity → manuals and offering a professional advise regarding color options for corporate interiors and exterior signage.

CREATING FLEXIBLE, MODULAR
BRAND IDENTITY SYSTEMS THROUGH
EXAMINING THE CONNECTIONS
BETWEEN DESIGN, BRAND STRATEGY
AND SCIENTIFIC RESEARCH

EVOLVE

GROW

By looking at the living systems theory
for inspiration,
it is imperative to design
frameworks that
would be adaptable to change.
Flexibility and
a modular quality of systematic
approach in nature
can be adapted to creating
identity modules,
which are able
to withstand even greater
levels of complexity.
Applying nature's design principles to the
brand identity needs
of multinational corporations
can facilitate a successful
implementation of global brand
expansion or
a launch of new products.

CHANGE

By scrutinizing a global conglomerate as if it were an ecosystem, I can then apply the living system's principles to create a brand strategy which works with the corporate business plan. By allowing for an existence of flexible and evolving relationships between brand components [i.e., corporate brand, sub-brands, endorsed brands, independently branded products and services, etc.], I can create relevant and effective brand architecture, which is able to withstand and adapt to the test of time and changes in economic, political and cultural infrastructures.

DESIGN FIRM
substance 151
Baltimore, (MD) USA
PROJECT
"Evolve", "Grow", "Change" Poster Series
DESIGNER
Ida Cheinman

1

1
DESIGN FIRM
MFDI
Selinsgrove, (PA) USA
PROJECT
2 Minutes Poster
DESIGNER
Mark Fertig

2

2_____
DESIGN FIRM
 Vaca Loca
 Thessaloniki, Greece
DESIGNERS
 Joanna Adamogianni,
 Olga Chrysochoou

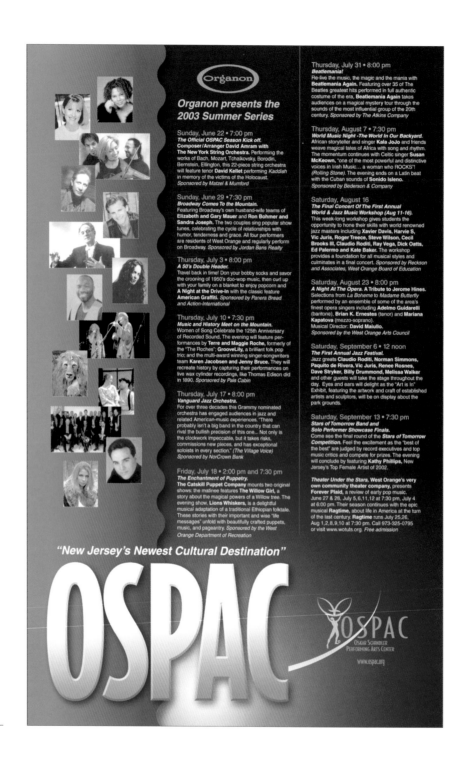

1_____

1_____
DESIGN FIRM
Stephen Longo Design Associates
West Orange, (NJ) USA
CLIENT
The Oskar Schindler
Performing Arts Center
ART DIRECTOR, DESIGNER
Stephen Longo

RESPECT OUR DIFFERENCES

Put Downs, Ethnic, Homophobic, Racial, and Sexist Remarks Are Not Accepted in Our School.

2_____

2_____

DESIGN FIRM
Octavo Designs
Frederick, (MD) USA

CLIENT
National Association of
School Psychologists

ART DIRECTOR, DESIGNER
Sue Hough

1

2_____

DESIGN FIRM
Sayles Graphic Design
Des Moines, (IA) USA

PROJECT
Drake University Student Activities Board
Ben Folds Concert Poster

DESIGNER, ILLUSTRATOR
John Sayles

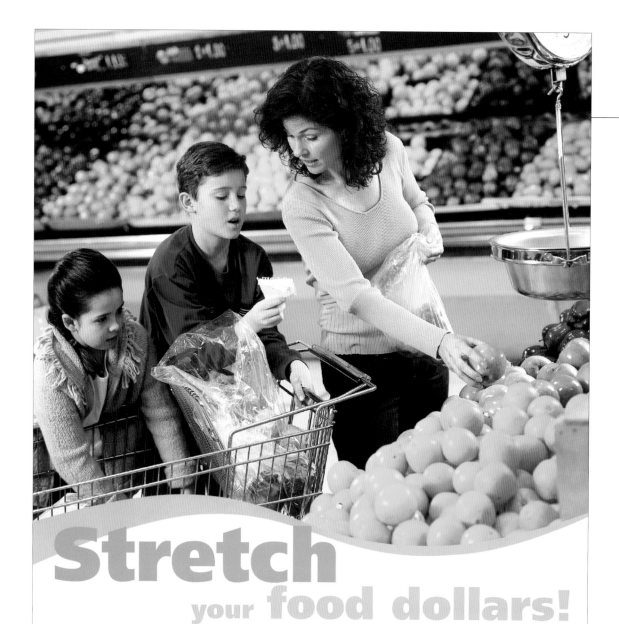

Stretch
your food dollars!

Use a shopping list to help stretch your food budget and make healthy choices at the grocery store.

To find out more about eating healthy and being active, visit the *Eat Smart, Be Fit, Maryland!* website at:

www.eatsmart.umd.edu

EQUAL ACCESS PROGRAMS
Funding for the Food Stamp Nutrition Education Program provided
by USDA in cooperation with the Maryland Department of Human
Resources and the University of Maryland.

 PUBLIC HEALTH INFORMATICS

 MARYLAND COOPERATIVE EXTENSION

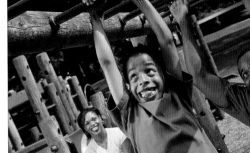

be active

Be active with your family!
Stay healthy and have fun while spending time together.

To find out more about eating healthy and being active, visit the *Eat Smart, Be Fit, Maryland!* website at:
www.eatsmart.umd.edu

EQUAL ACCESS PROGRAMS
Funding for the Food Stamp Nutrition Education Program provided by USDA in cooperation with the Maryland Department of Human Resources and the University of Maryland.

PUBLIC HEALTH INFORMATICS

MARYLAND COOPERATIVE EXTENSION

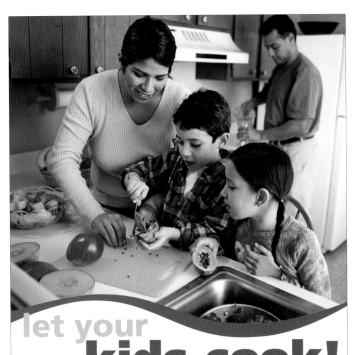

let your kids cook!

Kids who help prepare meals and snacks
are often more willing to try new foods.

To find out more about eating healthy and being active, visit the *Eat Smart, Be Fit, Maryland!* website at:
www.eatsmart.umd.edu

EQUAL ACCESS PROGRAMS
Funding for the Food Stamp Nutrition Education Program provided by USDA in cooperation with the Maryland Department of Human Resources and the University of Maryland.

PUBLIC HEALTH INFORMATICS

MARYLAND COOPERATIVE EXTENSION

DESIGN FIRM
University of Maryland
Cooperative Extension—FSNE
Columbia, (MD) USA

CLIENT
The University of Maryland Cooperative Extension—
Food Stamp Nutrition Education Program

DESIGNERS
Amy Billing, Trang Dam, Meredith Pearson

want more energy?

Increasing physical activity will give you
more energy throughout the day.

To find out more about eating healthy and being active, visit the *Eat Smart, Be Fit, Maryland!* website at:
www.eatsmart.umd.edu

EQUAL ACCESS PROGRAMS
Funding for the Food Stamp Nutrition Education Program provided by USDA in cooperation with the Maryland Department of Human Resources and the University of Maryland.

 PUBLIC HEALTH INFORMATICS MARYLAND COOPERATIVE EXTENSION

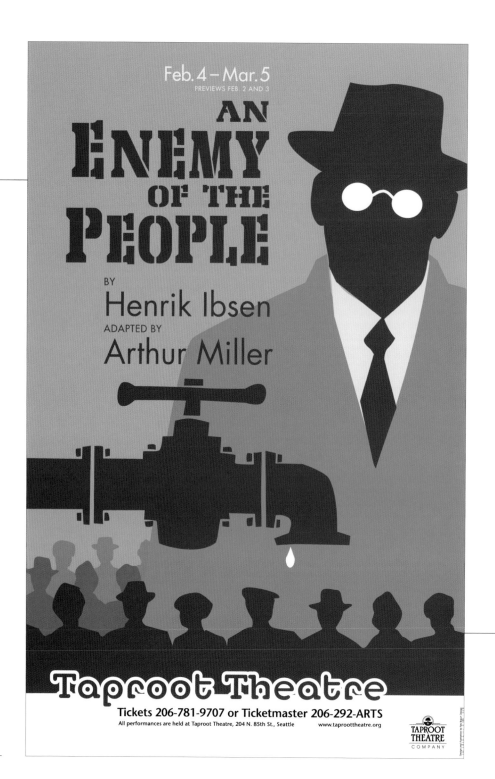

1

DESIGN FIRM
Ray Braun Design
Seattle, (WA) USA
PROJECT
"Enemy of the People" Poster
DESIGNER, ILLUSTRATOR
Ray Braun

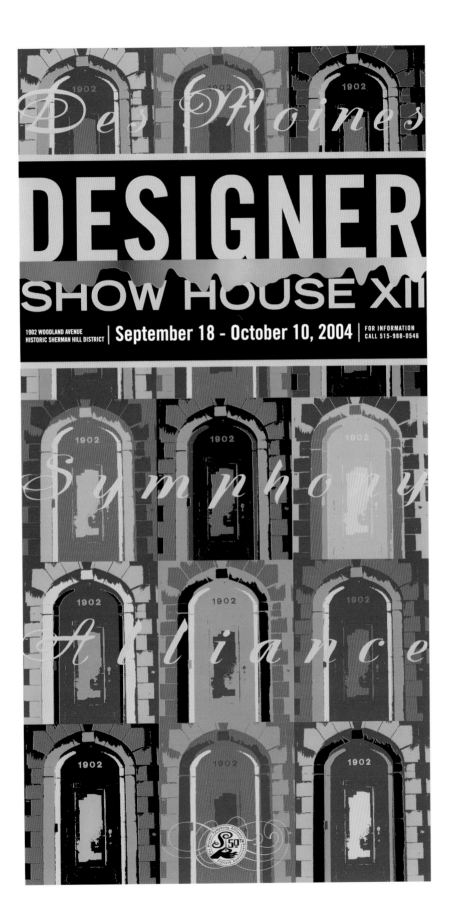

2_____

DESIGN FIRM
Sayles Graphic Design
Des Moines, (IA) USA

PROJECT
Designer Show House Poster

DESIGNER, ILLUSTRATOR
John Sayles

2_____

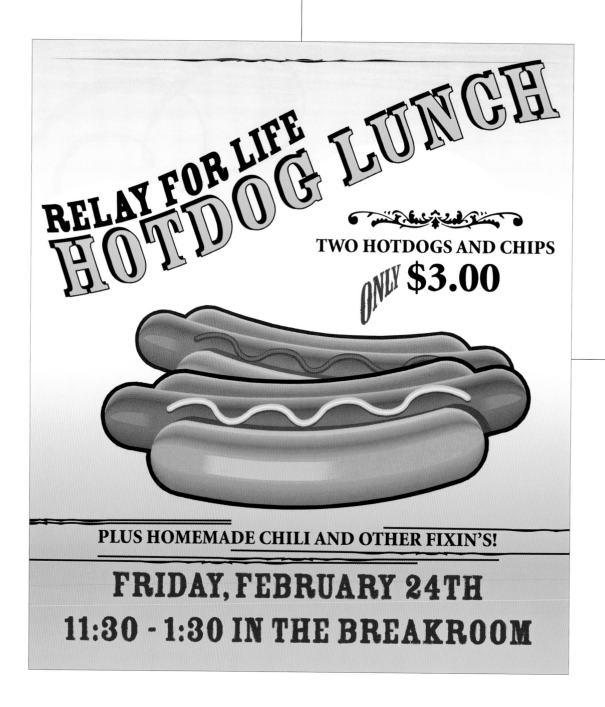

DESIGN FIRM
Sports Endeavors
Cary, (NC) USA
PROJECT
Relay For Life Series
CREATIVE DIRECTOR
Robert Stein
DESIGNER
Katie Guess

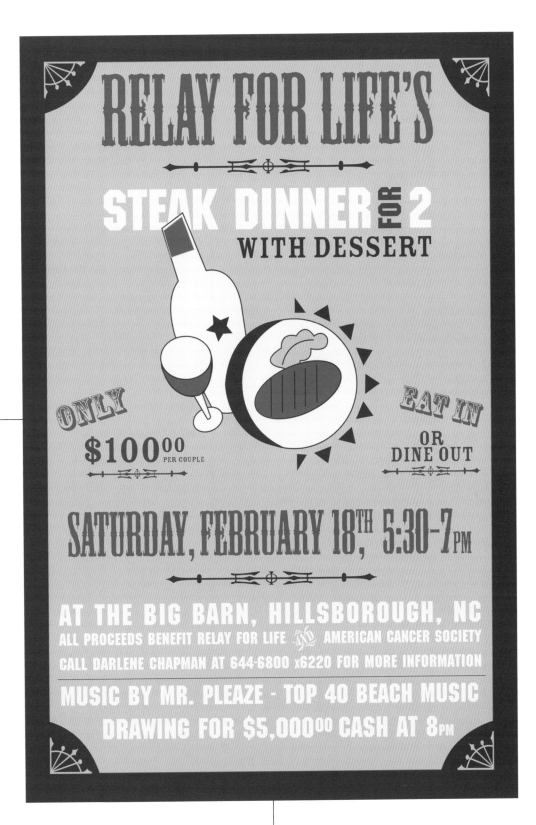

DESIGN FIRM
30sixty Advertising+Design
Los Angeles, (CA) USA
CLIENT
New Line Home Entertainment
CREATIVE DIRECTOR
Henry Vizcarra
ART DIRECTOR
Pär Larsson

INDEX